The Lawn Road Flats

HISTORY OF BRITISH INTELLIGENCE

ISSN 1756–5685

Series Editor
Peter Martland

With the recent opening of government archives to public scrutiny, it is at last possible to study the vital role that intelligence has played in forming and executing policy in modern history. This new series aims to be the leading forum for work in the area. Proposals are welcomed, and should be sent in the first instance to the publisher at the address below.

Boydell and Brewer Ltd, PO Box 9, Woodbridge, Suffolk, IP12 3DF, UK

Previous volumes in this series:

British Spies and Irish Rebels: British Intelligence and Ireland, 1916–1945, Paul McMahon, 2008
Available in hardback and paperback editions

The Spy Who Came In From the Co-op: Melita Norwood and the Ending of Cold War Espionage, David Burke, 2008
Available in hardback and paperback editions

The Lawn Road Flats

Spies, Writers and Artists

David Burke

THE BOYDELL PRESS

First published 2014
The Boydell Press, Woodbridge

ISBN 978–1–84383–783–1

The Boydell Press is an imprint of Boydell & Brewer Ltd
PO Box 9, Woodbridge, Suffolk IP12 3DF, UK
and of Boydell & Brewer Inc.
668 Mt Hope Avenue, Rochester, NY 14620–2731, USA
website: www.boydellandbrewer.com

A catalogue record for this book is available
from the British Library

The publisher has no responsibility for the continued existence or accuracy
of URLs for external or third-party internet websites referred to in this book,
and does not guarantee that any content on such websites is,
or will remain, accurate or appropriate.

Papers used by Boydell & Brewer Ltd are natural, recyclable products
made from wood grown in sustainable forests

Printed and bound in Great Britain by
CPI Group (UK) Ltd, Croydon, CR0 4YY

Contents

List of Illustrations vi

Foreword by Christopher Andrew ix

Acknowledgements xiii

List of Abbreviations xiv

Dramatis Personae xvii

Prologue 1

1 Remembrance of Things Past; Hampstead Man Among 'The Modernists' 5

2 National Planning for the Future and the Arrival of Walter Gropius 27

3 1935: 'Art crystallises the emotions of an age.' Musicology and the Art of Espionage 53

4 Arnold Deutsch, Kim Philby and Austro-Marxism 83

5 The Isobar, Half-Hundred Club and the Arrival of Sonya 106

6 The Plot Thickens: Jurgen Kuczynski, Agatha Christie and Colletts Bookshop 132

7 Refugees, The Kuczynski Network, Churchill and Operation Barbarossa 152

8 Klaus Fuchs, Rothstein once more, and Charles Brasch 171

9 Vere Gordon Childe 194

10 *The New Statesman*, Ho Chi Minh and the End of an Era 208

Epilogue 223

Notes 226

Bibliography 255

Index 263

Illustrations

Between pp. 74 and 75,
170 and 171

1 Jack and Molly Pritchard with their children Jonathan and Jeremy.

2 Wells Coates.

3 Edith Tudor-Hart.

4 Lawn Road Flats under construction.

5 Lawn Road Flats under construction, lunch break.

6 The rear of the Flats under construction.

7 Lawn Road Flats under construction front.

8 Completion.

9 Thelma Cazalet M.P. declares the Lawn Road Flats open by breaking a beer bottle over its side. Wells Coates architect on right behind Cazalet. Jack on the left wearing a trilby, Molly by his side.

10 Lawn Road Flats opening ceremony

11 Lawn Road Flats.

12 Lawn Road Flats (rear)

13 Interior, Ground Floor Flat.

14 Interior, minimalist kitchen.

15 Interior, minimalist bathroom and dressing room.

16 Interior, living room ground floor.

17 Interior.

18 The Isokon Long Chair by Marcel Breuer.

19 Isobar restaurant. Furniture by Marcel Breuer.

20 The Isobar complete with short chair by Marcel Breuer.

21 Isokon Long Chair, Isobar garden restaurant.

22 Isokon garden restaurant furniture by Marcel Breuer.

23 Invitation: The Isobar Club and Private Air-Raid shelter

24 The Austrian Architect and designer Egon Riss building the Isokon Line. Second World War.

25 Jack and Molly Pritchard's Flat. Furniture by Marcel Breuer.

26 The Pritchard's Flat and roof garden.

27 Philip Harben. Flats 21st birthday party.

28 Wells Coates and Jack Pritchard Lawn Road Flats 21st birthday party.

29 Gordon Childe (Flats 21st birthday party).

30 Walter and Ise Gropius. Marcel Breuer standing behind Ise's left shoulder.

31 List of Tenants: 'In the margin: "Who else moved out – eg Rothstein (Tass No 16 & 8 during war. ? School of Oriental Languages."'

Illustrations 3–7, 9–10, 16 and 26 Courtesy of Wolfgang Suschitzky. Illustrations 1, 13, 17, 21–25 and 27–31 Reproduced with permission of the Pritchard Papers, University of East Anglia. Illustration 2 Courtesy of Laura Cohn. Illustrations 8 and 12 by Sydney Newbery © Architect and Building News. Illustration 11 by John Maltby. Illustrations 14 and 15 © Sam Lambert. Illustration 18 © Council of Industrial Design. Illustrations 19–20 by Dell & Wainwright © Architectural Press Archive / RIBA Library Photographs Collection.

The author and publishers are grateful to all the institutions and individuals listed for permission to reproduce the materials in which they hold copyright. Every effort has been made to trace the copyright holders; apologies are offered for any omission, and the publishers will be pleased to add any necessary acknowledgement in subsequent editions

Foreword

I first discovered Lawn Road Flats in Hampstead while working on a history of KGB foreign operations in the late 1980s with Oleg Gordievsky, a KGB officer who had worked for eleven years as an agent of the British Secret Intelligence Service (better known as SIS or MI6), supplying it with a remarkable range of KGB documents and other top-secret intelligence. Gordievsky greatly impressed the 'Centre' (KGB headquarters) as well as SIS. In 1985 he was appointed head ('resident') of the KGB's London station ('residency'), one of the most important foreign postings in Soviet intelligence. Soon after his appointment, however, he was summoned back to Moscow for important consultations, only to discover that the KGB had discovered his work for SIS. Gordievsky then made one of the most extraordinary escapes of the Cold War, fleeing across the Finnish frontier in the boot of an SIS car en route to Britain.

I first met Gordievsky a year after his escape, at meetings in London and Cambridge during which we agreed to collaborate on the first of our three books. The first questions that I put to him included the two main unsolved mysteries about the 'Magnificent Five', five young Cambridge graduates recruited in the mid-1930s whom the KGB considered their ablest group of foreign agents. The identities of four of them – Kim Philby, Guy Burgess, Donald Maclean and Anthony Blunt – were already known. But controversy raged over who had been the Fifth Man. Gordievsky revealed that he was John Cairncross, a graduate (like Philby, Burgess and Blunt) of Trinity College, Cambridge. As well as being the only Soviet agent to penetrate Bletchley Park, Britain's most successful World War Two intelligence service, Cairncross had also worked at various times as private secretary to one of Churchill's ministers and as an official in the Foreign Office, Treasury and SIS.

The second mystery resolved by Gordievsky at our early meetings was the identity of the recruiter of the Magnificent Five. Gordievsky revealed that he was Dr Arnold Deutsch, a Soviet intelligence 'illegal' who was a graduate of Vienna University. When I obtained his university transcript,

I discovered that his academic record was even more brilliant than that of any of the Five or other young British graduates whom he recruited for Soviet intelligence. Deutsch had gone from undergraduate entrance at Vienna University to the degree of PhD with distinction in only five years. While working on our history of KGB foreign operations, Gordievsky remembered that Deutsch and his wife had had a daughter while they were living in London in the mid-1930s. Having obtained a copy of their daughter's birth certificate, I discovered for the first time that Deutsch's address was 7 Lawn Road Flats.

In 1990, while presenting a Granada TV documentary on the Fifth Man timed to coincide with the publication of the first of the books by Gordievsky and myself on the KGB,[1] I visited Lawn Road Flats with a film crew. As I was doing a piece to camera outside Deutsch's flat at No. 7, a woman came out of the next-door flat and surprised me by saying, 'Oh no, not another film about her!' I asked who she meant by 'her'. 'Agatha Christie, of course!' was the reply. Only then did I discover that Britain's greatest detective novelist, as well as Soviet intelligence's most successful recruiter in Britain, had lived in Lawn Road Flats.

I wrote later that it was tempting to imagine Christie and Deutsch discussing the plot of *Murder on the Orient Express* while chatting on the walkways in their deck-access block of flats. But, I added regretfully, 'they may never have met'. David Burke shows that they did not meet. Christie did not move into Lawn Road until after Deutsch had left London. But Dr Burke reveals for the first time that she wrote her only spy novel while living at No. 20. There are many more surprises in this remarkable book. It also reveals that no fewer than seven Soviet agents lived in the flats at various times between the mid-1930s and mid-'40s. At least twenty-five other people had connections with both Lawn Road and Soviet intelli-

1 Christopher Andrew and Oleg Gordievsky, *KGB: The Inside Story of its Foreign Operations from Lenin to Gorbachev* (London: Hodder & Stoughton, 1990; New York: Harper & Row, 1990). We later published two volumes of the top-secret KGB documents which Gordievsky secretly supplied to SIS: *Instructions from the Centre: Top Secret Files on KGB Foreign Operations, 1975–1985* (London: Hodder & Stoughton, 1991; published in USA as *Comrade Kryuchkov's Instructions* by Stanford U.P., 1993); and *More Instructions from the Centre: Top Secret Files on KGB Global Operations 1975–1985* (London/ USA: Frank Cass, 1992)

gence. No other privately-owned building in Britain provided such a haven for a foreign intelligence service.

But there was much more to the Isokon building than its Soviet connections, fascinating though Dr Burke's espionage discoveries are. Lawn Road Flats, at the heart of Hampstead's chattering classes, were home to an extraordinary mix of well-known writers, artists and architects as well as spies. Dr Burke adds a new dimension to our understanding of many of them – not least of Agatha Christie: 'That her bridge partner was the Australian communist and pre-historian Gordon Childe would suggest that there was more to Agatha Christie than retired vicars, cucumber sandwiches and the discovery of the body in the library.' Appropriately for a study of a block of flats whose residents included Britain's best-known detective novelist, David Burke has himself carried out a brilliant piece of detective work.

CHRISTOPHER ANDREW
Emeritus Professor of Modern and Contemporary History,
University of Cambridge
Convenor of the Cambridge Intelligence Seminar

Acknowledgements

I am indebted to a number of people who have made this book possible. First and foremost I would like to thank Bridget Gillies of the Archives Department, The University Library, University of East Anglia, for her help in navigating the Pritchard Papers, and for her untiring efforts in responding to requests for documents. A good archivist is a godsend!

Secondly, I would like to thank contributors and participants at the Cambridge University Intelligence Seminar, particularly Dr Peter Martland whose observations on the various drafts were always illuminating. His knowledge of the period and his editorial skills have been invaluable.

I would also like to thank Professor Christopher Andrew for the original idea. His academic leadership skills and expert knowledge of the intelligence world have inspired many, myself included. Finally, I would like to thank Rohais Haughton, Megan Milan and Catherine Larner for their patience and skill in preparing the text for publication.

Abbreviations

APGB	Associated Press of Great Britain
ARCOS	All-Russian Co-operative Society
ARP	Air Raid Precautions
AUT	Association of University Teachers
BBC	British Broadcasting Corporation
BCE EvH	*Britannica Concise Encyclopaedia*: Erich Moritz von Hornbostel
BIPO	British Institute of Public Opinion
BSP	British Socialist Party
CBI	China-Burma-India
CEMA	Committee for the Encouragement of Music and the Arts
CHEKA	*Vserossiiskaya Chrezvychainaya Kommissiya po Borbe s Kontr Revolyutsiyei i Sabotazhem*: All-Russian Extraordinary Commission for Combating Counter-revolution and Sabotage
CIA	Central Intelligence Agency
CIAM	*Congrès Internationaux d'Architecture Moderne*
CPGB	Communist Party of Great Britain
CSCA	Civil Service Clerical Association
DCC	Deputy Chief Censor
DDR	*Deutsche Demokratische Republik*: German Democratic Republic
DIA	Design and Industries Association
DSIR	Defence Security Intelligence Report
EH	Electra House
ES.WLSR	English Section. World League for Sexual Reform
FO	Foreign Office
FPA	Federated Press of America
GRU	*Glavnoye Razvedyvatelnoye Upravleniye*: Soviet Military Intelligence
HOW	Home Office Warrant
ILP	Independent Labour Party
ISOKON	Isometric Unit Construction
JAXPLAN	Working title for an outline of a national plan for Great Britain
KGB	*Komitet Gosudarstvennoy Bezopasnosti*: Committee for State Security

KPD	*Kommunistische Partei Deutschlands*: Communist Party of Germany
KURI	*Konstruktive, Utilitaire, Rational, Internationale*
LCC	London County Council
LMSR	London Midland & Scottish Railway
LRD	BBC Listener Research Department
LSE	London School of Economics
MARS Group	Modern Architectural Research Group (British Section of CIAM)
MOI	Ministry of Information
NKVD	*Narodnyi Kommissariat Vnutrennikh Del*: People's Commissariat for Internal Affairs.
NPWU	National Passenger Workers' Union
NSDAP	National Socialist German Workers' Party – The Nazi Party
OGPU	*Obyedinennoye Gosudarstvennoye Politicheskoye Upravleniye*: Joint State Political Directorate (predecessor of the NKVD)
OKP	*Kommunistische Partei Osterreichs*: Communist Party of Austria
OMS	*Otdel' Mezhdunaronykh Svyazey*: Department of International Communications of the Communist International (Comintern), also known as the International Liaison Department.
OSS	Office of Strategic Studies
PEP	Political and Economic Planning
PF	Personal File (MI5)
PP	Pritchard Papers
PWE	Political Warfare Executive
RAF	Royal Air Force
RIBAJ	Royal Institute of British Architects Journal
ROSTA	Russian Telegraph Agency
S&T	Scientific and Technical Intelligence
SA	*Sturmabteilung*, Storm Troopers also known as Brownshirts
SB	Special Branch
SCO	Security Control Officer
SDAP	Social Democratic Party of Austria
SDAPO	Social Democratic Workers Party of Austria
SIME	Security Intelligence Middle East
SLP	Socialist Labour Party
SPD	*Sozialdemokratische Partei Deutschlands*: Social Democratic Party (Germany)
TASS	Telegraph Agency of the Soviet Union

TGWU	Transport and General Workers' Union
TNA	The National Archives (Kew)
TUC	Trades Union Congress
UCL-LSSS	London School of Slavonic Studies
UDC	Union of Democratic Control
USSR	Union of Soviet Socialist Republics
WO	War Office
WSF	Workers' Socialist Federation
W/T	Wireless/Telegraph Agency

Dramatis personae

Lawn Road Flats' residents

Harold Montgomery Belgion	Writer and journalist.
Phyllis Blewitt	Wife of Trevor Blewitt. Translator of Stefan Zweig and Arthur Koestler from German to English.
Trevor Blewitt	British broadcaster, links with CPGB, suspected Soviet sub-agent.
Charles Brasch	New Zealand poet, worked at Bletchley Park.
Robert Braun	Swiss national. Took over from Philip Harben as manager of the Isobar in March 1940.
Marcel Breuer	Hungarian furniture designer. Member of the Bauhaus.
William Brown	General Secretary, Civil Service Clerical Association; broadcaster.
Vere Gordon Childe	Australian. Marxist pre-historian.
Agatha Christie	Crime writer.
Wells Coates	Canadian. Architect of the Lawn Road Flats.
S. Cooke	Assistant to the secretary of Arthur Greenwood's Cabinet Committee on Reconstruction.
L. W. Desbrow	President Students' Union LSE, lecturer.
Arnold Deutsch	Austrian. Soviet spy 'illegal' lived in the Flats 1935–1938. Teodor Maly's principal agent.
Hermann Deutsch	Uncle to the Kuczynskis. Suspected Soviet agent.
Josefine Deutsch	Married to Arnold Deutsch. Austrian. Communist, Soviet spy.
Lionel Elvin	Principal in the finance division of the Air Ministry.
Charles Fenn	Writer. CIA agent.
Maxwell Fry	Architect.
Ralph Edward Gathorne-Hardy	Writer.
Hans Goldschmidt	German émigré.
Walter Gropius	German architect. Founder of the Bauhaus. Lived in the Flats 1934–1937.

Kathy Harben	Manager of the Isobar and Half Hundred Club.
Philip Harben	Chef and manager of the Isobar and Half Hundred Club, took over from Tommy Layton.
E. F. Herbert	Children's book writer.
Erich Moritz von Hornbostel	Austrian musicologist.
Edmond Kapp	Painter.
Helen Kapp	Manager. Art historian.
Barbara Kuczynski (Barbara Taylor)	Jurgen Kuczynski's sister. German communist. Soviet spy.
Brigitte Kuczynski (Bridget Lewis)	Jurgen Kuczynski's sister. German communist. Soviet spy.
Jurgen Kuczynski	German communist. Soviet spy.
Margueritte Kuczynski	Married to Jurgen Kuczynski. Alsatian. Communist. Soviet spy.
Tommy Layton	Founder of Layton's Wine Merchants. First manager of the Isobar.
Anthony Gordon Lewis	British communist married to Brigitte Kuczynski, worked for the BBC's Listener Research Department. Suspected Soviet sub-agent.
René Little	Manager of the Lawn Road Flats.
Charles Madge	Creator of Mass Observation.
László Moholy-Nagy	Hungarian painter, linked with the Hungarian Communist Party. Member of the Bahaus. Lived in the Flats 1935–1937.
Nicholas Monsarrat	Writer.
Henry Moore	Sculptor and painter.
Lena Neumann	Manager of Lawn Road Flats. Austrian.
Louis Osman	Architect and goldsmith.
Fleetwood Pritchard	Civil servant. Director of Public Relations at the Ministry of Transport.
Jack Pritchard	Entrepreneur, built and owned the Lawn Road Flats.
Molly Pritchard	Psychologist.
Michael Rachlis	Russian-Jewish architect.
Eva Collett Reckitt	Reckitt & Colman mustard heiress. Owner of Colletts left-wing bookshop, Charing Cross Road, London. Soviet agent.
Egon Riss	Austrian architect.

Dr Rothfels	German-Jewish émigré.
Andrew Rothstein	British/Russian communist and Soviet agent. TASS correspondent. Possible wartime resident.
Diana Rowntree	Architect.
Kenneth Rowntree	Architect.
Lance Sieveking	Broadcaster.
Adrian Stokes	Writer and painter.
Duncan Murnett Macrae Taylor	British communist. Suspected Soviet agent.
Hugh Weeks	Director of Central Statistics at the Ministry of Supply.

Non-resident members of the Half-Hundred Club

Pearl Adam	*Observer* journalist.
James Bone	London editor of the *Manchester Guardian*.
Margaret Cole	Crime writer married to historian G. D. H. Cole.
S. R. Elliott	*Reynold's News* journalist.
William Norman Ewer	Journalist. Soviet agent.
Barbara Hepworth	Sculptor and painter.
J. F. Horrabin	Cartoonist (left wing).
Julian Huxley	Scientist. Director Zoological Gardens, Regents Park.
Cyril Joad	Broadcaster. Soviet sub-agent.
R. S. Lambert	Editor of the *Listener*, journalist.
Francis Meynell	Journalist. Soviet sub-agent.
Ben Nicholson	Artist.
Daisy Postgate	Daughter of Labour MP George Lansbury. Married to Raymond Postgate.
Raymond Postgate	Historian. Founder of *The Good Food Guide*.
D. N. Pritt	Labour MP and lawyer.
Dick Russell	Architect and industrial designer.
Aylmer Vallance	Journalist, *News Chronicle* and *New Statesman*.
Phyllis Vallance	School friend of Margaret Postgate. Married Aylmer Vallance in 1932.

Regular visitors to the Flats associated with CPGB and the Soviet Intelligence Services

Len Beurton	British communist. Soviet agent.
Alexander Foote	British communist. Soviet agent.

Berta Kuczynski	German communist. Mother of the Kuczynski family.
Robert (René) Kuczynski	German communist. Father of the Kuczynski family.
Renate Kuczynski	Youngest of the Kuczynski daughters.
Ursula Kuczynski (Sonya)	German communist. Soviet spy, controller of the atomic spies Melita Norwood and Klaus Fuchs.
Sabine Kuczynski	German communist. Suspected Soviet agent.
Francis Loeffler	Solicitor. German communist married to Sabine Kuczynski. Suspected Soviet agent.
Harry Pollitt	General Secretary of CPGB. Visitor to Eva Collett Reckitt.
Beatrix Tudor-Hart	Nursery school teacher ('of the Montessori type'). Lover of Jack Pritchard, mother of Pritchard's illegitimate child, Jennifer. Member of the World League for Sexual Reform.
Edith Tudor-Hart (née Suschitsky)	Bauhaus-trained photographer, school teacher ('of the Montessori type'). Took the photos of the opening of the Lawn Road Flats.

Lawn Road residents or visitors linked with the CPGB and Soviet Intelligence

Edith Bone	Hungarian communist. Suspected Soviet agent.
Bryan Goold-Verschoyle	Irish communist. Soviet agent.
Berta Kuczynski	German communist.
Robert (René) Kuczynski	German communist.
Teodor Maly	Hungarian communist. Soviet 'illegal'.
Charlotte Moos	German communist. Suspected Soviet agent.
Melita Norwood	British communist. Soviet spy.
Gertrude Sirnis	Melita Norwood's mother. Soviet agent.
Gerty Sirnis	Melita Norwood's sister. Member of the Independent Labour Party.

Prologue

Lawn Road Flats, also known as the Isokon building, comprises 32 units of equal size in Lawn Road, Belsize Park, North London.[1] It was, and remains, a remarkable building with an equally remarkable history.

The name, Isokon arose from the architect Wells Coates' use of isometric perspective in his drawings and, as the Lawn Road Flats were to be in 'a form of modular units, "Isometric Unit Construction" soon became Isokon'.[2] While this was not the first modernist building in Britain – that accolade should go to 'New Ways' in Northampton, a whitewashed, cement-rendered, two storey structure with a crested parapet, designed by the German architect, Peter Behrens in 1925 – the construction of the Isokon building was the first time reinforced concrete was used in British domestic architecture.

On the face of it, the Isokon building is a curious subject for an intelligence historian but the idea for this book was sparked by a paragraph in *The Mitrokhin Archive*, an account of the KGB, written by Christopher Andrew and Vasili Mitrokhin. There, the Austrian communist spy Arnold Deutsch, controller of 'The Magnificent Five,'[3] the five Cambridge graduates who spied for the Soviet Union between 1934 and 1963, is found living in Lawn Road Flats, next door to the crime novelist Agatha Christie:

> Early in 1934 Deutsch travelled to London under his real name, giving his profession as 'university lecturer' and using his academic credentials to mix in university circles. After living in temporary accommodation, he moved to a flat in Lawn Road, Hampstead, the heartland of London's radical intelligentsia. The 'Lawn Road flats', as they were then known, were the first 'deck-access' apartments with external walkways to be built in England (a type of construction later imitated in countless blocks of council flats) and, at the time, was probably Hampstead's most avant-garde building. Deutsch moved into number 7, next to a flat owned by the celebrated crime novelist Agatha Christie, then writing *Murder on the Orient Express*. Though

it is tempting to imagine Deutsch and Christie discussing the plot of her latest novel, they may never have met. Christie lived elsewhere and probably visited Lawn Road rarely, if at all, in the mid-1930s. Deutsch, in any case, is likely to have kept a low profile. While the front doors of most flats were visible from the street, Deutsch's was concealed by a stairwell which made it possible for him and his visitors to enter and leave unobserved.[4]

Andrew and Mitrokhin were perfectly correct, the Lawn Road Flats had a number of distinct advantages for spies, not least the site layout, which was governed by two railway tunnels running close together under the site. The London County Council (LCC) would not allow more than one storey to be built over the tunnels, which had left the architect Wells Coates very little room for manoeuvre. In the end, the south corner of the Flats marked one tunnel edge while the garage was built over the other tunnel. This meant that the building, which was long and thin, was angled to the road in such a way as to make surveillance difficult. There was also easy access to Belsize Park tube station from the rear of the Flats, which were situated in secluded woodland. Just as important, access to the Flats would have exposed any casual visitor to unwanted curiosity. Staircases at the north and south ends were the only means of entering the building. The north staircase was internal, while the south staircase was external. These were the only links between the various levels of the deck-access galleries. Once a visitor had entered the Flats it would have been extremely difficult to keep a track of their movements from Lawn Road itself, and any character on a resident's or visitor's tail would have been conspicuous.

As always, though, reality is less romantic than fiction and Arnold Deutsch never lived next door to Agatha Christie. In fact, *Murder on the Orient Express* was published in 1934, but Deutsch lived in Lawn Road Flats between 1935 and 1938, and Agatha Christie from 1941 to 1947. However Agatha Christie was no stranger to communists, nor would it seem to the numerous Soviet spies who colonised the Isokon building during her stay. Curiously enough, when she and her husband Max Mallowan, moved into Flat 20 it had been vacated by alleged communist spy, Eva Collett Reckitt, the Reckitt & Colman's mustard heiress and owner of Colletts left-wing bookshop in Charing Cross Road. And Christie's bridge partner,

and their neighbour in Flat 22, was the Australian communist and archae-
ologist, Vere Gordon Childe. It is feasible that Agatha Christie may well
have spoken to the German communist agents living in the Flats or eaves-
dropped on their conversations in the Isobar, the bar and restaurant in the
basement of the Isokon building. Certainly her only spy novel *N or M?* was
written here and is impressive for its knowledge of spy tradecraft and Fifth
Column activity in wartime Britain.

The Mitrokhin Archive was responsible, though, for exposing the activ-
ities of a quite remarkable female agent, Melita Norwood, the longest-
serving Soviet spy (hitherto discovered) in British espionage history;
altogether she spied for 38 years, nine years longer than Kim Philby.

When *The Mitrokhin Archive* was published in 1999 I was working with
Melita Norwood on a biography of her father, Alexander Sirnis, who had
known the Russian revolutionary, Vladimir Ilyich Lenin, and Tolstoy's
literary executor, Count Vladimir Chertkov. At the time, I was living and
working in Leeds and one weekend a month I travelled to London to take
Sunday lunch with Melita Norwood at her home in Bexleyheath, to discuss
the book's progress. I didn't know then that she had been a spy or that she
had worked on Britain's atomic bomb project during the Second World
War. I only found out when I got off the bus at the old National Express
bus stop on the outskirts of Milton Keynes to buy a newspaper at the kiosk
and saw her staring out at me from the front page of *The Times* under the
banner headline 'The Spy Who Came In From The Co-op'. When I eventu-
ally got to London, having missed my bus, I telephoned her and listened
while she told me that she had been 'rather a naughty girl', that the world's
media were gathering at her garden gate, and that I had better come back
next week, which I did.

When I called the following Sunday she was still in a state of shock, but
cheerful. She wanted to talk and put across her side of the story as to why
she did what she did. We had many conversations and on one occasion she
mentioned a German professor who had escaped from Nazi Germany and
was found accommodation by her mother and sister Gerty, in Lawn Road
Flats. His son was still alive and living in Hampstead and would I like to go
and see him? I duly made my way to Hampstead and met a very interesting
man who was somewhat reluctant to speak. When I mentioned the Lawn
Road Flats he was visibly shaken and said that it wasn't his father who

lived there but Professor Jurgen Kuczynski and one or two of his sisters. Now this was very interesting to me, because I knew that Kuczynski had been a Soviet agent and had recruited the atomic bomb spy Klaus Fuchs to the Soviet intelligence body, the GRU. I also knew that it was Kuczynski's sister and fellow spy, Ursula, who ran Melita Norwood as an atomic spy during the Second World War, and again for a while in the immediate post-war period.

Further research revealed no fewer than seven Soviet agents living in the Flats over the period 1934–1947 with a possible 25 sub-agents connected to the Flats or to Lawn Road itself. In 1997 the security service MI5 released its first batch of historical files, sending them to The National Archives, Kew. Based largely on a study of these Personal Files (PFs), and others that MI5 has released every six months since 1997, a portrait of the spies in Lawn Road Flats was painstakingly put together. It shone a fascinating light on the history of Soviet espionage in Britain and was all the more fascinating for conjuring up an image of the famous crime writer, Agatha Christie, sitting there amongst all this espionage activity writing *N or M?*

The Lawn Road Flats now began to throw up one surprise after another. The Pritchard Papers at the University of East Anglia and particularly the registers of tenants resident in the Lawn Road Flats, although incomplete, threw up an intriguing list of occupants. The number of writers and artists who lived there, apart from Agatha Christie, was as remarkable as the number of spies. They included writers Nicholas Monsarrat, Adrian Stokes, Montgomery Belgion, Charles Brasch, and painter Kenneth Rowntree, sculptor and artist Henry Moore, and the Bauhaus's Walter Gropius, Lázló Moholy-Nagy and Marcel Breuer to name but a few, alongside a myriad of interesting and well-connected people. The difficulty that now presented itself was building a narrative that remained focused on the spies, while discussing architecture and 'the arts' in the Isokon building. Nicholas Monsarrat, author of *The Cruel Sea* and *The Ship That Died of Shame*, came to the rescue; modernity and his escape from the drab confines of a Victorian boarding house in 1930s Nottingham did the rest.

Remembrance of Things Past, Hampstead Man among 'The Modernists'

WHEN Cambridge graduate Nicholas Monsarrat arrived in Nottingham in 1932 to train as an articled clerk with the law firm of Acton, Marriot and Simpson, like many a promising young newcomer to the city, he found his way to 'Edgmont'. There the rooms were lofty, boasted 'ornamented ceilings and threatening chandeliers' and were 'comfortably carpeted on the ground floor … a little austere on the first and second' and 'frigid at the top' where 'the carpeting gave way to linoleum and worn boards'. It was everything anxious mothers hoped for: 'respectability, strict rules, a certain *esprit de corps*, and an iron hand at the helm' in the shape of a 'strong-willed, capable and despotic no-nonsense English landlady', Mrs Pierce, 'part of the authentic backbone of England' who gave 'full value for money'. In return she expected 'to be paid on the nail'.[1]

Mrs Pierce was quite an old lady when Nicholas Monsarrat arrived. His description of her was formidable: 'dressed in shiny black with lace trimmings, armoured about with a breast-plate of cameo brooches' and 'more than a match for any young whipper-snapper, just down from Cambridge, who might think himself too good for his new surroundings'.[2]

Nicholas Monsarrat had graduated in 1931 from Trinity College, Cambridge, where he had been one of the inner-circle of scientist Victor Rothschild, and a friend of the novelist Malcolm Lowry whom he remembered as, 'drunk by every noon and at the same time writing a hair-raising book which would lay bare all the wild life of the wicked world outside'.[3] That was Malcolm Lowry's first novel, *Ultramarine*, published in 1933. Nicholas Monsarrat had got to know him quite by accident as they shared a common bond, having both been born in Liverpool.

Life at Cambridge in those days, Monsarrat remembered, 'seemed to

have great stature and ceremonial, and great indulgence at the same time ... This, he remarked, 'was the golden age of privilege allied to laziness, a dreamlike progress only marred once a year, by an end-of-term examination which must be scraped through, in order that we qualify for the next act of this first rate comedy of manners. We were there to play and to grow up; if we were drawn into anything else, such as serious application, unremitting toil, it would be to miss the point of our stay entirely. We had evolved, and now enjoyed, a cross between the worlds of Bertie Wooster and Dornford Yates, the one idle and funny, the other elegant and chivalrous; and this enjoyment was quite enough, without bothering about merits or money or strict entitlement.' We were all Conservatives, he recalled, to be anything else was to be 'a traitor to one's class'.[4]

'Edgemont' started life as four late-Victorian dwellings congealed into one, 'home to forty-six people, headed by Mr Marshall, an ancient grey fixture who was reputed to be the oldest practising solicitor in Nottingham and District'. There were 'newcomers' hoping that they wouldn't be there too long, and 'permanents' like Miss Pyecroft, who had been there for twenty-two years, 'loved for playing *Silver threads among the gold* on the piano and calling out: "Come on, everyone – dance!" before settling down to Pelman Patience', while her audience 'melted from the lounge'.[5]

'The rules of the house were inviolable. There was to be no noise after ten o'clock. There was to be no gambling except with counters, no rowdiness, no excessive drinking at any time, and no one was to be more than ten minutes late for meals. Breakfast was sharp at eight o'clock, lunch at one, dinner at seven ... Above all, there was to be no 'nonsense' – which meant no girls being sneaked in by one of the four back doors after nightfall, and never, never any internal slippered traffic between bedroom and bedroom. ... It was all so dull. Nothing ever happened.'[6] Nicholas Monsarrat, tucked up in bed, sought solace in the pages of Marcel Proust's *Remembrance of Things Past*:

I was already up to Volume Two in the translation by Scott-Moncrieff (ex-Winchester, of course); he had called it *Within a Budding Grove*, but I still thought that its proper title, *A L'Ombre des Jeunes Filles en Fleur*, was one of the most beautiful phrases in any language. That was the world for me. Proust lived and wrote ... in a silent, cork-

lined room, totally removed from the rude world, surrounded only by the exquisite and the rare. I envied him sometimes, above all other mortals; and when before very long, since it had been a hard day ... I stopped reading, and clicked off my light, and began to drift into sleep, I longed to have just such another room as Proust. It would be elegant, and private, and sound-proofed against the throng. Perhaps there might be a girl as well, who could make as much noise as she liked. That should be my world, the world of luxury and soft-footed service: the world of Odette and Albertine, of the Baron de Charlus and the Duchesse de Guermantes. But it was not going to be so. Tomorrow, I knew just before I began to dream about it, I would still be imprisoned in my own world: the world of Nottingham, beige wallpaper, porridge, trams, and Messrs Acton, Marriott and Simpson, Solcs ... I must have a girl, really have her, absolutely naked, in bed, no fooling. I must write a book. I must get away.[7]

He did. Escaping with a half-finished novel, a typewriter and forty pounds sterling, he settled first in a grim box of a room just off the Edgware Road. In exchange for 1s 6d a week, he was given access to a cold water tap on the landing, a communal lavatory downstairs and insects which at night 'made the dank wallpaper throb and bulge'.[8] Accommodation for both the struggling and the successful young professional in inter-war Britain was not attractive. The market didn't rise to the challenge despite the increasing number of transient young people living alone. Monsarrat's fortunes, however, did change for the better, and he later moved to a cleaner bed and breakfast boarding house in nearby Southwick Street at 2s 6d a week. But the London equivalent of Proust's cork-lined Parisian bedroom on the Boulevard Haussmann continued to elude him until 1934 when, after publishing his first novel *Think of Tomorrow*, he moved into No. 29 Lawn Road Flats, the Isokon building. There, in 1935, he wrote his second novel, *At First Sight*, which like his first 'sank without trace, even in Boots Library'.[9]

'I often envied a thriller writer called Agatha Christie,' he wrote, 'who, when relatively unknown (or at least, a bad third to Dorothy Sayers and Ngaio Marsh), had mysteriously disappeared just after her new novel was published, leaving behind her a motor-car, complete with what could have

been bloodstains, abandoned on the edge of a quarry ('Missing Author Sensation: Foul Play Suspected'). After a nationwide hunt, and false clues galore, she was found a week later staying at a hotel in Harrogate, under a different name, a victim of amnesia. Her new book called *The Murder of Roger Ackroyd*, which included a character who also disappeared, was a prompt bestseller; and after that Agatha Christie had never looked back. If only I could have a stroke of luck like that!'[10]

He should have waited; he remained in the Flats for little over a year while in 1941 his object of envy, Agatha Christie, moved in, living there until 1947. Nicholas Monsarrat may have gone on to publish *The Cruel Sea* in 1951 and *The Ship That Died of Shame* in 1955, achieving fame and fortune without ever making the famous thriller writer's acquaintance, but the atmosphere of the Flats inspired many artists, writers and painters.

On the occasion of the Lawn Road Flats' twenty-first birthday party in 1955, the artist Adrian Stokes sent a letter apologising for his absence: 'It was sad to leave your lovely building and the kind of life one enjoyed there … Well, I wrote a book at Isokon.'[11] Agatha Christie also sent her apologies with a note saying that she had been 'a very contented inhabitant of Lawn Road Flats and couldn't possibly object to your saying so! My chief memories are of the fascination of finding a place where like the wood in "Dear Brutus", trees really seemed to have moved close up to the windows. That, meals in the garden, and one particularly beautiful white blossoming cherry tree are the things I have never forgotten. The social side of life I have always been bad at and seldom remember! But places make their mark. Coming up the street the flats looked just like a giant liner which <u>ought</u> to have a couple of funnels, and then you went up the stairs and through the door of one's flat and there were the trees tapping on the window.'[12]

The magical wood of J. M. Barrie's play 'Dear Brutus' promised opportunities for those who had chosen the right path; Agatha Christie was not wrong when she described the Lawn Road Flats in similar vein. Many of the tenants in the 1930s and 1940s, refugees from Hitler's Germany and the Fascist takeover of Austria (among them the founder of the Bauhaus, Walter Gropius and the Hungarian artist Moholy-Nagy), were given a magical opportunity to remake their lives there.

<div align="center">*</div>

The Isokon building was the brainchild of Jack and Molly Pritchard and Canadian architect Wells Coates. It was built in 1934 at Belsize Park, on Hampstead's lower slopes. The Pritchards and Wells Coates held a common fascination with the problems of city living in the modern age, and the Flats were intended as a deliberate move away from both the unnecessary ornamentation and restrictions of the Victorian boarding house and the dank living conditions described by Nicholas Monsarrat. Inspired by the work of the radical French architect Le Corbusier and the 1923 book *Vers Une Architecture*, this was an impassioned manifesto proclaiming 'a house is a machine for living in', and each Isokon flat conformed to a standard plan using modern materials.[13] A convert to Le Corbusier and Amédée Ozenfant's theory of Purism, which called on architects to always 'refine and simplify design, dispensing with ornamentation'[14], Wells Coates designed minimalist apartments or studio flats with built-in furniture. Laundry facilities were located on site, an innovation for those times, as well as a communal restaurant; young professional couples or single people would move in as tenants with a minimum amount of belongings and get on with their lives. It was to be a new way of living for a new age. Wells Coates, a stylish figure who drove a Lancia Lambda, cooked Eastern cuisine, and was known to sit comfortably in the lotus position, set out his *modus vivendi* in an article for the BBC journal *The Listener* in 1933: 'We cannot burden ourselves with permanent tangible possessions as well as our real new possessions of freedom, travel, new experience – in short, what we call life.' According to his daughter, Laura Cohn, Coates had a 'lack of realism about money', and was a very difficult man to get on with.[15] Jack Pritchard, on the other hand, was the complete opposite: a pragmatist, very good with money, and a self-righteous modernist, truly believing 'that a rational, brave new approach to all problems would make for a better world.'[16]

The two men first met in 1928 when Wells Coates was commissioned by the Cornish painter and textile designer, Alec Walker, to design standardised shop fittings for his Crysede Silks shop in Cambridge[17] using plywood – 'to form bold curves and unbroken planes'. Jack 'Plywood' Pritchard, as he was affectionately known, was a prominent figure in the world of plywood, importing the material from Estonia for the Venesta Plywood Company. He was a good publicist, never missing an opportunity to praise

it as a strong and durable construction material and searching for alternative, imaginative uses. In 1928, with E. A. Brown, he designed a small sideboard in Plymax, a new metal-faced plywood of great strength and rigidity, which was later used to make flush doors.[18] The following year the manager of Crysede Silks, Tom Heron, left the firm to set up Cresta Silks in Welwyn Garden City and commissioned Wells Coates to design the factory's interior and shop fittings. This led to a further commission at Cresta Silk's outlet in London, in fashionable Brompton Road, which won widespread acclaim for the abstract lettering of the company's name. Designs by Tom Heron's son – the abstract painter and writer, Patrick Heron – and the artist and textile designer Paul Nash, made Cresta Silks a leading multinational company.

Jack Pritchard's and Wells Coates' collaboration on materials at Crysede and Cresta Silks, together with their mutual admiration for the work of Le Corbusier and European Modernism, led to them discussing working on a number of joint projects. Their architectural mantra, the *machine à habiter*, invoked the founding declaration of the *Congrès Internationaux d'Architecture Moderne* (CIAM) signed by twenty-four architects at the Château de La Sarraz in Switzerland in 1928. The La Sarraz Declaration (none of the signatories were British) was a political statement asserting that 'architecture could no longer exist in an isolated state separate from governments and politics, but that economic and social conditions would fundamentally affect the buildings of the future'.[19] The Declaration was a manifesto for an increasingly ideological age where Fascist architecture in Italy and Constructivist architecture in Soviet Russia were beginning to impact on architectural design across Europe.

In 1925 Jack Pritchard joined the Design and Industries Association (DIA) (eventually becoming its Vice-President), and visited the International Decorative Arts Exhibition in Paris. Returning to the city in 1930, while working for Venesta, he went to look at the work of Le Corbusier visiting his villa, Les Terrasses, at Garches, in the western suburbs of Paris, one of the progenitors of Art Deco. On behalf of Venesta, Pritchard then commissioned Le Corbusier, Charlotte Perriand and Le Corbusier's cousin, Pierre Jeanneret, to design a stand for the Building Trades Exhibition held at Olympia in September that year. Jack Pritchard was then thirty-one and could have been the model for the Hampstead progressive,

drawn by cartoonist Osbert Lancaster in a twentieth-century functional room in his book *Homes Sweet Homes*. The resemblance was pointed out by Alan Mackley, the historian of Blythburgh, Suffolk, where Pritchard had his Isokon country house.[20]

Born on 8 June 1899 at 6 Compayne Gardens, 'the less fashionable side of Finchley Road',[21] Jack Pritchard was the youngest of five children; his brother Fleetwood and his twin sisters May and Nancy were five and four years his senior respectively. Their father, Clive Fleetwood Pritchard, a successful barrister, was a generous man who would often treat the family to a very large, brown cardboard box of de Bré chocolates. On the occasion of Jack's birth he asked his two daughters what would they prefer – a box of chocolates or a baby brother. Without any hesitation, they both said 'a box of chocolates'. Fleetwood is reported to have been very shocked. 'He was a very proper, upright elder brother.'[22] Jack Pritchard's mother, Lilian Craven, from Keighley in Yorkshire, claimed to be a direct descendant of the first Earl of Craven, William Craven, described by Pepys in his Diary as a coxcomb. The Pritchards were, in all respects, a fairly stolid, on the up, middle-class Hampstead family. It wasn't long after Jack's birth that the family moved to 17 Maresfield Gardens 'on the more upper-class side of Finchley Road'.[23]

Pritchard's childhood was very happy and in his autobiography he describes laying out 'yards and yards of a model train track from room to room on the top floor'[24] of their house in Maresfield Gardens. His early schooldays were spent at West Heath Preparatory School and at various prep schools in Hampstead, and he described those days as being 'on the whole not unfortunate'.[25] Unable to read until he was eleven, however, he was always considered to be something of a dunce. 'No one had yet heard of dyslexia,' he commented wryly, 'perhaps that was part of my trouble and not the supposed inefficient teaching at West Heath. All the same, I was reasonably happy.'[26] This was not the case at his next school, Heath Mount, where the headmaster was a fearful character. A fellow pupil, Alec Waugh later painted a portrait of the school in his semi-autobiographical novel *The Loom of Youth* 'as being disagreeable, very strict, with a martinet of a headmaster.'[27]

At about twelve or thirteen Jack followed his elder brother, Fleetwood, to Oundle School, Peterborough, an experience he regarded on the whole

as a success, largely due to the headmaster, F. W. Sanderson – 'the first scientist to be headmaster of a public school.'[28] Under his influence Oundle became the foremost school in the country for science and engineering and Jack thrived under its liberal regime. Sanderson once remarked, 'I never like to fail with a boy', and famously encouraged the boys to form their 'own opinions, based on the facts'.[29] After the Russian Revolution of October 1917 Jack Pritchard returned to Oundle as a naval cadet, and remarked to Sanderson that 'perhaps the Bolsheviks were very wicked'. He later recalled: 'Sanderson just looked me straight in the eye and asked me: "What is wrong with the Bolsheviks?"'[30]

Sanderson's good friend, H. G. Wells described him as 'beyond question the greatest man I have ever known with any degree of intimacy'.[31] Sanderson's sudden death in 1922 was a great loss to Oundle School. He had just finished speaking to a major gathering of scientists at University College, London, when the chairman, H. G. Wells, called for a vote of thanks and questions from the floor. Sanderson stepped forward and dropped dead on the platform.

Jack Pritchard left Oundle School in 1917 for Keyham Naval College, Devonport, and joined HMS *Lion* as a midshipman one year later. He didn't see naval action during the First World War, although his ship had formed part of the British squadron that took the surrender of the German fleet in Scapa Flow. He left the navy in 1919 and enrolled as a student at the London Polytechnic in Regent Street before being accepted by Pembroke College, Cambridge, to read economics and engineering. It was there that he first met Philip and Lella Florence.

Philip Florence, a lecturer of industrial psychology at Cambridge University was researching a book on the economics of industrial fatigue and labour unrest. His wife Lella, a member of the Women's International League, was active in Cambridge's energetic feminist movement. In the United States she had openly come out in support of the Bolshevik Revolution and had been a prominent figure in the communist-inspired Mass Meeting Committee of Friends of New Russia. While in England, the Florences joined G. D. H. Cole's National Guilds League. Their forceful arguments in favour of workers' control of industry were in accordance with Guild Socialist ideas and their campaign to safeguard the craft traditions of skilled workers threatened by mechanisation, particularly in the building

trades, struck a chord with Jack Pritchard. A more radical influence on Pritchard, however, was the Marxist economic historian Maurice Dobb, a founder member of the Communist Party of Great Britain (CPGB) and the economics fellow at Pembroke College. Dobb was a controversial figure at Cambridge in the inter-war period and was introduced to Jack Pritchard by Philip Florence. As a member of J. M. Keynes's Political Economy Club, and a prominent figure in the Cambridge University Socialist Society, Dobb made a significant and lasting impression on many of his students, including the future Cambridge-educated communist spy, Kim Philby.

Philip Florence also introduced Jack Pritchard to 'The Heretics Society', a lively debating club founded in 1909 by Dr W. Chawner, Master of Emmanuel College, 'to challenge traditional authorities in general, and religious dogmas in particular'.[32] Philip Florence had become president of the society in 1924, replacing the somewhat eccentric linguist, C. K. Ogden. An offshoot of this was the rebellious Pavement Club, a student group which encouraged large numbers of undergraduates to sit on the pavement for prolonged periods of time reading, writing, playing cards and having a late breakfast. When asked to move on they did so with the greatest courtesy, and then sat down again somewhere else. Pritchard was a member of the club along with H. G. Wells's son, Gip, an old Oundelian who introduced him to the delights of another society called the 'Tea Pots'. Once a year they invited 'a well-known personage to give a paper', and on one occasion hired the Guildhall in Cambridge for Sir Arthur Conan Doyle to speak on 'Materialisations', to be followed by a discussion on 'Spirits in Everyday Life' and 'Sex Equality after Death'.[33] Tickets were sent to several dons:

> The announcement had gone out only a few days before the meeting; nevertheless the Guildhall was full and there were even some dons on the platform. After five or ten minutes my job was to pull the string that lowered a large notice. The dons and others on the plat-form could not see it but those in the body of the hall could. The notice read: 'We very much regret that Sir Arthur Conan Doyle has failed to materialise.' He was, at the time, in Canada.[34]

After graduating in Engineering and Economics in 1922, Pritchard joined the Michelin Tyre Company as a trainee and was sent to Clermont-Ferrand

in France to study Scientific Management, 'not unlike the substance of Philip Florence's lectures'.[35] In August 1924 he married Molly Cooke, a graduate of Girton College, Cambridge, where she had studied medicine before training as a psychiatrist. In September 1925, after a brief period as advertising manager for the hunting and shooting magazine, *The Field*, Pritchard joined Venesta Ltd working for them until 1936.

He had been in his job with Venesta for only a few months when workers in the warehouse in Millwall and at the factory in Silvertown downed tools in the General Strike of 1926. The TUC printed a newspaper, called the *British Worker*, on the presses of the *Daily Herald* (while the government turned out an exceptionally well-printed daily, the *British Gazette*, on the presses of the ultra-Conservative *Morning Post* newspaper) and Pritchard along with his wife Molly and a trainee solicitor, Jack Neap, volunteered to deliver copies to Leicester, calling in at Cambridge and Oundle on the way. At Oundle they left a bundle of the papers with the newsagents opposite Oundle School House only to be confronted by an irate Kenneth Fisher, who had replaced F. W. Sanderson as headmaster:

> They (the newsagents) knew me, of course, as a respectable Ounde-lian and therefore accepted the papers. Sanderson had died and the new head, Kenneth Fisher, saw the wicked workers' paper in the shop and demanded how it came to be on sale. His boys should not see such rubbish. Fisher then found us in the market place and gave us both a severe dressing-down.[36]

Pritchard's left-wing inclinations owed much to Hampstead, his family, Sanderson, Oundle School, and Cambridge University; his experience with Fisher proved something of a shock.

In 1929 the couple bought 79 Platt's Lane, Hampstead, their home until 1934 where their sons, Jonathan and Jeremy, were born in 1926 and 1928. In 1929 Pritchard helped set up the Frobisher Fruit Company and was commissioned to advertise and market Rowntree & Co's products. That same year he bought the site of the Lawn Road Flats and met Wells Coates for the first time.

Wells Wintemute Coates, 'Wonderful Wells', was born in Tokyo on 17 December 1895; he was four years younger than Jack and very attractive. In a letter to his future wife, Marion Grove, written at the age of 31, he

described himself as 'passionate, mystical, proud, inquisitive and fearless'.[37] The eldest of six children, his parents, Harper Havelock Coates, a Canadian professor of theology in Tokyo, and Sarah Agnes Wintemute Coates, a Methodist missionary, bestowed upon their son 'an innate restlessness of character' and 'a sense of alienation – of being different'. [38] His mother, who had studied architecture under Louis Sullivan in Chicago, was an extremely talented woman. She had designed the missionary school where she worked and engaged a number of private tutors who imparted to Wells a 'distinct approach to architecture and design'. [39] Addressing architectural students in Vancouver in 1957 he told them: 'I have never been to a school of architecture. Indeed I have never been to school at all for I was born in the Far East, in Japan, where no such facilities existed, and my own course was directed by private teachers: a French governess; a Japanese painting master; and a Japanese architect-builder who taught the skills of shaping materials into elements of structure and the arts of regulation of dimensions pleasing to the eye and the mind ...' One tutor, G. E. L. Gauntlet taught him paper-making, printing, spinning, weaving, dyeing, boat-building, cooking and the ritual of serving food. [40]

In 1912 Coates accompanied his father on a round-the-world trip that finished in Vancouver where he enrolled at the university to study engineering. His studies were interrupted in August 1914 by the outbreak of the First World War when, after a brief spell in the trenches, he became an RAF pilot before returning to university in 1918. He was awarded a BA in 1919 and a BSc in engineering in 1924. He then moved to London to study for a PhD in 'The Gases of the Diesel Engine' where he initially had a tough time 'socially, economically and emotionally. Pride in his own film-star looks and high IQ, allied with innate insecurity and shyness made him seem arrogant and brash, arousing animosity in those who could have helped him.'[41] For a while he worked as a journalist in Paris on the *Daily Express* and 'could well have been a character in Evelyn Waugh's *Scoop*. ... Wonderful Wells, who looked like Ronald Colman, speeding in his Lancia, breaking women's hearts: free, untrammelled man, mythic figure of the thirties'.[42]

In 1925 Wells Coates covered the Exposition Internationale des Arts Decoratifs in Paris for the *Daily Express* and came across the work of Le Corbusier and his concept of the 'Maison Minimum'. That same year he

met Marion Grove, a student at the London School of Economics who, like Coates, had been born in Asia, in China, where her father built railways. Marion Grove was all the things that Wells Coates desired – emancipated, very left-wing, beautiful, daring and 'modern' in the style of the 1920s.[43] Their brief but intense romance ended the following year when Wells Coates set out on a soul-searching journey to British Columbia, Canada, hopping freight trains with his friend Alfred Borgeaud. The journey ended tragically when Alfred was killed falling from a train and Coates, in a depressed state, returned to England. There, Marion lost no time contacting him and in August 1927 they were married in Brighton. The following year he began his career as an architect with Cresta Silks and met Jack Pritchard. In 1930 the two friends, inspired by the La Sarraz Declaration, joined with Mansfield Forbes, an English lecturer at the University of Cambridge, Howard Robertson, an architectural journalist, and the architects Serge Chermayeff and Raymond McGrath, to establish the Twentieth Century Group to promote the work of CIAM.[44] The Group owed much of its creative genius to Mansfield Forbes and the Australian-born architect Raymond McGrath. Together, it is fair to say, Forbes and McGrath introduced Britain to modernism.

Mansfied Forbes was a Scotsman of independent means who aroused deep admiration and affection from many of those who knew him. His close friend, the literary critic Ivor Armstrong Richards, wrote of him in 1973: 'Forbes gave its original character to the English tripos.[45] No one saw, as he did, its unique invitations and hazards or feared more realistically what it might become.' L. C. Knights, an authority on Shakespeare, spoke of his 'moment of awakening in the classroom of Mansfield Forbes, that teacher of genius at Clare College ...'[46] The stories surrounding Forbes and his idiosyncratic teaching style are many; pride of place must go to his course of lectures on Shakespeare and Tolstoy that included two hours on *Moby Dick*, 'since he could never resist discoursing on the whiteness of the whale.' His nine o'clock lectures at Clare College would be interrupted by 'the appearance of his breakfast, brought in from the college kitchens, as was then the mode, on a wooden tray covered with green baize with each succulent dish under a metal cover'. He was known to be 'quite incapable of moving about Cambridge unless he was carrying huge quantities of books and papers. An offer of help from a kind lady, who observed him

staggering along with a pile of books higher than his head, was met with the remonstrance: 'Pray do not disturb me, madam, I have the stability of a pregnant kangaroo.'[47]

Raymond McGrath, a graduate in English and architecture from the University of Sydney was no less formidable. He had taken up a fellowship at Clare College in 1926, during which time Forbes commissioned McGrath to remodel the interior of the College's house, 'Finella', a large Victorian building on the Backs in Cambridge now owned by Gonville and Caius College. The design was characterised by the free use of glass and reflective surfaces, and the 'adventurous use of materials, with copper-clad doors, an aluminium-walled bathroom, mirrored ceilings and a rubberised floor decorated with Pictish motifs' including 'the painting of a fully uniformed guardsman in the servants' bath, designed to keep them cheerful.'[48] Jack Pritchard, who was employed by Venesta at the time, was called upon to supply Plymax foil-laminated plywood for Finella's experimental metal-plywood doors.[49] The project attracted considerable attention, as did Forbes himself; visitors in the summer months would occasionally stumble across him, fully nude, immersed in one of the fountains of Finella's gardens. In 1932 the *Varsity Weekly* hailed Finella 'an experiment in modernism', and over time Finella became 'the most-visited house in England'.[50] One notable visitor was the Austrian-born photographer, Edith Tudor-Hart, née Suschitsky, whose work during the Second World War became widely known through the *Picture Post* magazine, and who, along with Maurice Dobb, helped in the recruitment of the Cambridge spy, Kim Philby, to the Russian intelligence service in 1934.

Finella was completed in 1929 and in 1930 Raymond McGrath set up practice in London. He received a commission from the British Broadcasting Corporation (BBC) to design the interiors of the studios in Portland Place and solicited the help of Wells Coates and Serge Chermayeff, then the chief designer of the Modern Art Studio at the top-of-the-range English furniture-making firm of Waring and Gillow. Wells Coates' design of a recording studio introduced a number of innovative technical features to Broadcasting House, not least a microphone stand that featured an overhead counterbalanced arm, which allowed the microphone to be taken to any part of the studio while remaining perfectly balanced. Wells Coates also undertook his largest commission as an interior designer for George

Straus and his wife at 1 Kensington Park Gardens where he was asked to strip the elaborate Victorian interior (not unlike Monsarrat's 'Edgmont') and re-design everything, 'replacing the richly carved Victorian furniture with clean lines and flush surfaces'.[51]

> In the drawing rooms, he removed the decorative Venetian glass candelabrum, stripped the walls and fireplace and converted it into a mirrored ballroom, illuminated in a variety of intensities, by a series of lighting troughs. At night the bay windows could be closed off by sliding screens of shantung silk, which became false walls by day. The concept of Coates' interior was functional design within a strongly unified scheme.[52]

In August 1930 Jack Pritchard and Wells Coates set up in practice together as Wells Coates & Partners Ltd, whose watchwords were, among others, 'standardisation of parts', 'rationalisation of processes and methods', 'modern industrial design, based on the principle of conspicuous economy' (as opposed to 'conspicuous waste'), 'decoration is desecration', 'a matter of taste is usually a matter of ignorance', and 'solemnity, sincerity, sobriety, gaiety ... all may characterise architecture but humanity will best love creative work characterised by joy'.[53]

In its functional aspects the company was to be divided into two departments: '(a) The department of design and the technical sciences of modern construction; (b) The department of finance, and the technical sciences of modern economics, including publicity and selling'.[54] Final decisions on problems arising in department (a) were to be made by Wells Coates, while those arising in department (b) were to be made by Pritchard. The first aim of the company was to be the erection ('out of the ground into the light') of 'two modern houses in one composite unit, on a site at Lawn Road, Hampstead, to be used primarily for demonstration and publicity purposes, to provide modern accommodation for the two families of Pritchard and Coates, and to provide accommodation for the carrying on of the business of the company'. Finally, having agreed that the company was to be 'opposed to the promotion of luxury and extravagance, whether in building or in the habits of life',[55] the two men left for Germany in October to visit the Weissenhof Estate. This was a housing complex built in 1927 for the Stuttgart exhibition of the *Deutscher Werkbund* (German

Association of Craftsmen), an organisation founded in 1907 by a group of architects, artists and industrialists inspired by William Morris's Arts and Craft Movement, with the aim of integrating art and industry and raising the level of German product design.

The *Werkbund* exhibition was the creation of the German architect, Ludwig Mies van der Rohe, and was to be the main inspiration for the Lawn Road Flats. To Mies van der Rohe, the son of a mason, who had served his apprenticeship among the dirt and noise of building sites, architecture was to be 'uncomplicated', 'uncompromising' and driven by 'human need':

> The first step is the brick, the simple fact of the material. The second step is to understand the meaning of one material, and the meaning of all materials. The third step is to understand the materials characteristic of our time – steel, concrete, and glass. The fourth step is to understand the needs of our epoch: the need to provide vast amounts of shelter (the mass need); and the need to make each man free (the individual human need).[56]

Mies van der Rohe had been a member of the *Novembergruppe*, a left-wing organization of artists named after the month in 1918 of the German revolution which created the Weimar Republic.[57] In 1926 he had entered into the minefield of political architecture when he built the monument to the martyred German communist leaders, Karl Liebknecht and Rosa Luxemburg. This led to him being appointed vice-president of the *Deutscher Werkbund* and responsible for organising the 1927 *Werkbund* exhibition in Stuttgart. In drawing up the general plan of the exhibition, he proposed the design of thirty-three residential units – single-family houses and apartment blocks containing as many as twenty-four flats.[58] He invited all the leading modernists across Europe to contribute experimental buildings to the exhibition including Le Corbusier, Pierre Jeanneret, Walter Gropius and J. J. P. Oud, the leading Dutch architect of the *De Stijl* group. Gropius, anticipating the prefabricated houses that were to be built in large numbers across Britain after the Second World War, designed two houses made entirely of prefabricated walls and roof panels, equipped with prefabricated storage units and furnished with tubular-steel chairs designed by the Hungarian-born designer, Marcel Breuer. Mies van der Rohe himself contributed a block of apartments: 'steel-framed, finished in stucco, topped

with sheltered roof gardens, and endowed with long bands of glass and prefabricated partitions and storage walls.'[59] Oud's contribution – a strip of five terraced houses – was a demonstration of small-scale housing which would form the initial inspiration for the Lawn Road project. In essence, the Weissenhof development was the prototype for mass production in the building industry. Mies van der Rohe's 1924 prescription that 'the work at the site will consist only of assemblage, requiring extremely few man-hours'[60] had undoubtedly influenced the ethos of the Stuttgart exhibition and made a strong impression on both Wells Coates and Jack Pritchard. In March 1931, along with Serge Chermayeff, the two men travelled to Berlin and the Bauhaus at Dessau, on behalf of Venesta, in search of new uses for plywood and 'the fully flush door'. In his autobiography, Pritchard described his meeting with the architect Erich Mendelsohn in Berlin, who showed him round the building he had designed for the Metal Workers' Union where 'all the doors down the corridors were flush and made of built-up timber'. The Bauhaus, however, was not accessible.

In the turbulent years that marked the end of the Weimar period in Germany, the Bauhaus was beset by political difficulties eventually leading to the closure of its Dessau building in October 1932. Its director, Walter Gropius, resigned in 1929 and the school, when Wells Coates and Pritchard arrived, was more or less deserted. 'All the same,' Pritchard wrote, 'the Bauhaus looked fine amid the unkempt grass, and at least we could look round the building, which, in itself, had a very powerful impact on me.' Pritchard's subsequent report to Venesta gave rise to the reasonably priced Venesta Flush Door that apparently sold very well in Leeds.[61]

Venesta's quest for the perfect light plywood to be used in aircraft and marine building took Pritchard to Le Bourget where the French branch of the Estonian plywood furniture-making company, Luterma, made Gaboon (Okoumé) plywood. There he met Louise Goepfert, the manageress of the Opportunity Gallery in Manhattan and a well-known figure on New York's cultural scene. She introduced him to the Greek-Armenian mystic and 'evolutionary psychologist', George Ivanovich Gurdjieff who had earned the unenviable reputation of being 'the man who killed Katherine Mans-field'. The famous New Zealand novelist had died from tuberculosis at his Institute for the Harmonic Development of Man in Fontainebleu on 9 January 1923.[62] At the time Gurdjieff entertained the odd notion that the

breath and aroma of cows healed chest complaints and had converted his hayloft above the cowstalls at the Institute into a lounge with couches, where patients suffering from TB could rest. This had the unwelcome effect of hastening Katherine Mansfield's death.

When Jack visited the Institute very little had changed. The playwright and actress Dorothy Massingham, who had been diagnosed with some form of tuberculosis, was living there on a platform especially erected for her over the horses in the stable.

Pritchard had been introduced to Louise Goepfert in 1926 by Beatrix Tudor-Hart, described in the files of the British Security Service, MI5, as a communist nursery school teacher 'of the Montessori type'. She was also Jack Pritchard's lover. 'A fine tall girl, handsome and intelligent ... passionately concerned with education,' she was one of the original teachers at Beacon Hill, the progressive boarding school opened by the philosopher Bertrand Russell and his wife Dora in 1927.[63] The Russells, at this time, were regarded with some disquiet by the British Establishment who regarded them as a threat to the nation's morals. MI5, given the task of identifying threats to domestic security, viewed the heady combination of sexual liberation and communist subversion associated with the Russells with some concern. Dora Russell, like Molly Pritchard, was a graduate of Girton College, Cambridge, where she too had been a member of the Heretics Society and an active feminist. An ardent campaigner for the birth control movement, Dora Russell had been imprisoned during the First World War for her pacifist activities. In 1920 she travelled to the Soviet Union to witness the ideal future, first hand. On her return to England she began to preach the twin causes of Bolshevism and sexual liberation. A practitioner of 'free love', Dora Russell became the very personification of promiscuity and revolution in the minds of many. The rumour that the Bolsheviks had nationalised women exacerbated fears among Britain's respectable classes that birth control and sexual reform were synonymous with Bolshevism, and that communism was the Trojan horse of promiscuity and homosexuality.[64]

At that time Dora Russell was Secretary of the English Section of the League for World Sexual Reform (ES.LWSR), a body advocating health clinics, sex education and free contraception, with its headquarters in Vienna. The Director of the ES.LWSR was Norman Haire and he, along

with Beatrix Tudor-Hart and V. A. Hyett (a senior schoolmistress at Holland de Birkett School), had been put under MI5 surveillance.[65]

The League's permissive manifesto maintaining that sexual pleasure was both healthy and desirable and should, therefore, be 'legitimately obtainable in any and every form provided there is no interference with the rights of others,'[66] caused as much consternation among the upper echelons of British society as the *Communist Manifesto*. It was condemned by both the Establishment and the Church as a threat to the sacrament of marriage and for advocating homosexuality, which was then illegal and condemned outright as a sin. The English communists Eden and Cedar Paul, early translators of Karl Marx's *Das Kapital*, had recently published an English translation of the book *Sexual Freedom* by the French left-wing sexologist René Guyon, with an introduction written by Norman Haire. This called on comrades 'who realize the immense importance of adequate sexual satisfaction for physical and mental well-being', to resist those who would curtail their opportunities for sexual pleasure. The denial of any form of sexual pleasure, on religious, moral or legal grounds was, he argued, 'an unwarrantable interference with the liberty of the individual.'[67] While Jack and Molly Pritchard were not members of the ES.LWSR, they were certainly fellow-travellers as both openly enjoyed extra-marital affairs: Jack with Beatrix Tudor-Hart, with whom he had a daughter, Jennifer, born in 1929; and Molly with Jack's partner and close friend, Wells Coates.

Beatrix Tudor-Hart was also responsible for introducing Jack Pritchard to Edith Suschitzky, an Austrian photographer and a member of the CPGB under the name Edith White. Born in Vienna on 24 August 1908 into a politically active left-wing Jewish family, Edith Suschitzky's father and uncle owned a successful left-wing publishing house, 'Anzengruber-Verlag', and a socialist bookshop in the working-class district of Favoriten; they were both members of the Social Democratic Workers Party of Austria (SDAPO), as was Edith Suschitzky's mother, Adele. At the time, the SDAPO was visibly transforming the Austrian capital, Vienna, into a modern city state with a progressive welfare programme, building 'huge blocks of well-designed workers' flats, free clinics, baths, schools, kindergartens and gymnasiums' that were receiving praise from various quarters, including the *New York Times*.[68] The Tudor-Harts and other exiles from the Austrian

experiment in 'communist social-democracy', arguably, inspired the social experiment that was Lawn Road Flats, with its emphasis on a 'design for living', progressive education, nursery education and 'sexual reform'; as much as Le Corbusier, the Bauhaus and the *Deutscher Werkbund* had been the inspiration behind its construction and design.

Edith Suschitzky's educational background and formative years were very similar to those of Beatrix Tudor-Hart. Her relationship with the Prague-born educationalist, Lili Roubiczek, resembled the professional relationship between Beatrix Tudor-Hart and Dora Russell. In 1924 Edith Suschitzky had begun working as an unpaid teacher at the Haus der Kinder, a Montessori nursery school in Favoriten, where she underwent a rigorous training programme under the tutelage of Lili Roubiczek.[69] During the week teachers were expected to live in the school and undertake 'theoretical training in the evenings, including study in the natural sciences, languages, sociology, psychology and architecture'.[70] Those who did well were then sent abroad to earn a Montessori diploma that would qualify them to teach children aged three to ten. Edith Suschitzky did exceptionally well and in April 1926 was despatched to London, her first visit to Britain, to study Montessori methods for three months. It was during her stay in London that she met Beatrix Tudor-Hart's brother, Alexander, a militant communist who had studied orthopaedics in Vienna under the famous surgeon Professor Boehler.[71] The following year she left England for Germany registering under her own name as a photography student at the Bauhaus in Dessau.[72] Her time at the Bauhaus 'coincided with its most radical phase under the directorship of the architect, Hannes Meyer', and in 1931 she published a defence of the school's revolutionary functionalism in the English art journal *Commercial Art*.[73] A communist cell had been established at the school in the summer of 1927, recruiting around 10 per cent of the student body, and throughout Meyer's spell as director the cell was increasingly active outside the school. Meyer, in fact, was dismissed from his directorship of the Bauhaus by Dessau's social-democratic mayor, Fritz Hesse, who cited the increased politicisation of the school as the reason. On her return to London in October 1930, Edith Suschitzky moved in with Alexander Tudor-Hart at the house he shared with several other Austrian communists, including Rosa Shar the future wife of Percy Glading, at 5c Westbourne Gardens, Paddington.

In 1938 Glading, a leading member of the CPGB, would be sentenced to six years' imprisonment as the chief organiser of the Woolwich Arsenal spy ring.[74]

In 1930 Edith Suschitzky engaged in an interesting correspondence with an English translator of German literary works, Trevor Eaton Blewitt, a future Lawn Road Flats' resident who would become the BBC's German specialist during the Second World War. In keeping with the WLSR's advocacy of sexual liberation, Blewitt was the lover of Phyllis Dobb, wife of the communist don, Maurice Dobb; he married her in 1934. Blewitt, like Phyllis, was a fluent German speaker and together they translated the works of Arthur Koestler and Stephan Zweig into English. MI5 kept a file on Blewitt and were extremely interested in his dealings with Edith Suschitzky. She was put under surveillance and in late October 1930 was observed taking 'a prominent part' in a demonstration in Trafalgar Square organised by the CPGB in support of the Workers' Charter.[75] As a result she was expelled from Britain in January 1931.

Support for the Workers' Charter would not have been sufficient reason for her deportation. The Charter's demands were very modest – a seven-hour day, increased unemployment benefit, and a minimum wage – and the demonstration was sparsely attended. Nevertheless, a Home Office Warrant (HOW) was issued on 5c Westbourne Terrace permitting the interception of her correspondence and a deportation notice was served upon her. Blewitt, who was in Poland at the time reporting on the torture of political opponents of the Pilsudski government, sent her a letter expressing his dismay at the authorities' treatment of her. The letter was added to Edith Suschitzky's security service file and was a black mark against both correspondents:

My dear Edith, What is this about you leaving England? Please let me know.

I don't know whether the *Daily Worker* has any interest in Poland. It will find all it wants in *Izvestiya* and *Pravda* and something in the *Manchester Guardian.* I sent a message to the *Morning Post* on the torture of prisoners which appeared on p. 14 of the late London Edition of December 8th. I should like you to get this, read it and pass it on to the *Daily Worker* with the comment that torture of

political prisoners has existed since 1918 and only recently has it extended to non-Communists.

The weak spot in the Fascist armour here is the Ukraine, Eastern Galicia, which would repay a visit.

The *Izvestiya* man here thinks things are very ripe for revolution and I am inclined to agree, but can't quite understand why the Party lost votes in the election – not entirely explained by repressive methods. The economic situation is very bad for various reasons. But I'm enclosing the rough draft of an article I sent to the *Chicago Daily News* – I don't know whether they will print it.

I shan't stay long here, but either move on to Russia or return to England. God I wish I could make a living in England and do some work.[76]

After Edith Suschitzky's expulsion a postcard from Maurice Dobb, addressed to Alexander Tudor-Hart at 5c Westbourne Gardens, was intercepted by MI5 mentioning a meeting between Dobb and Alexander's sister, Beatrix, where the prospect of a job for Edith Suschitzky at the Middle East Institute in Moscow was discussed:

Beatrice has just told me the latest monstrous news about E. [Edith] Probably you know that the Middle East Institute in Moscow are wanting two translators from German into English, of whom I believe one has been appointed. Henry [*sic*] P.[77] has it in hand; and you might ask him about it. I was partly entrusted with the job of getting someone when I was there; so if it's any use do use me as a recommendation to Hy.[78] – tho' my recommendation is hardly needed. I am more sorry than I can say about this: especially when it happens to one of the nicest and most charming people one knows.[79]

Dobb's connection with the Tudor-Harts, especially Beatrix, was to prove critical in setting up the Lawn Road Flats as a centre of Soviet espionage in London during the 1930s. Maurice Dobb and Jack Pritchard had remained on friendly terms ever since Pritchard's left-leaning student days at Cambridge; while Beatrix Tudor-Hart, as Pritchard's lover, was in a position to see that he became far more useful than the usual communist 'fellow-traveller'. As Fascism spread rapidly across Central Europe, a

number of Jews, many of them communists linked to the Soviet intelligence services, would find refuge in Lawn Road Flats. On Edith Suschitzky's return to Vienna, she began working as a photographer for the Soviet news agency TASS and began to learn Russian.[80]

National Planning for the Future[1] and the Arrival of Walter Gropius

I N December 1931 Wells Coates and Partners, the fledgling partner-ship between Jack Pritchard and Wells Coates, became Isokon Ltd. The name echoed Wells Coates' fondness for isometric drawings and for unit construction, and Jack Pritchard's long-standing concern with economic planning.[2] Earlier that same year Pritchard had joined the influential policy think tank Political and Economic Planning (PEP), the forerunner of the Policy Studies Institute, suggesting its name at the society's inaugural meeting. Its guiding spirit was Sir Basil Blackett, a director of the Bank of England:

> Basil Blackett was proposing a new society ... he wanted a name that would suggest new ideas. 'The aim of the society,' he said, 'would be concerned with political and economic planning.' I suggested, more as a joke than seriously, that the name might be just that, Political and Economic Planning, PEP for short. Blackett thought that was marvellous and the name was adopted.
>
> In his memoirs Israel Sieff[3] quotes an advertisement drafted by Clough Williams Ellis: 'PEP – try it in your bath.'[4]

PEP had its origins, somewhat paradoxically, in the personal nostrum of press baron Lord Beaverbrook: 'Empire Free Trade', coined at a time when planning, as opposed to imperial preference, was in the air. Beaverbrook had persuaded the then owner of the long-established and influential magazine the *Saturday Review*, Lady Houston, an admirer of Mussolini and an implacable opponent of the Labour leader Ramsay MacDonald, to pledge her magazine's full support for his 'Empire Free Trade Crusade'.[5] She did this without any prior consultation with her staff; a decision that prompted the resignation of the *Saturday Review*'s young and talented

editor Gerald Barry, together with almost the entire editorial team. One of those was John Pinder who later recalled: 'In a miraculously short time with new backing, [we had] brought out a new and brighter *Week-End Review*, produced by a lively band of young contributors who set themselves to exposing the "Old Gang" and their out-of-date, ineffectual ways of running the country ... Planning was in the air.'[6] Pinder was entrusted with the task of 'preparing ... a kite-flying *Week-End Review National Plan*' to appear as a supplement to the *Week-End Review* of 14 February 1931. The writer of the piece was the ornithologist instrumental in the foundation of the World Wildlife Fund (now the Worldwide Fund for Nature), Max Nicholson, whose essay entitled *A National Plan for Great Britain*, called for the 'replacement of the present chaotic economic and social order by a national planned economy capable of working with other national planned economies, partial or complete, both within the Empire and abroad.'[7]

Other founder members of PEP, apart from the *Week-End Review's* editor Gerald Barry and John Pinder, were the scientist and zoologist, Julian Huxley; the agronomist and founder of Dartington School, Leonard Elmhirst; the civil servants, Dennis Routh and Sir Henry Bunbury; the research chemist, Michael Zvegintzov; and Israel Sieff, a director and later chairman of Marks and Spencer. Its first president, Sir Basil Blackett, was a leading expert on international finance, architect of Britain's departure from the Gold Standard, and an elected member to the court of directors of the Bank of England.

Under Sir Basil Blackett's leadership, PEP saw its prime objective as the ending of party political differences and the development of a shared cross-party planning policy. The organisation was only marginally influenced by socialist ideas and claimed to represent the progressive features of the three main political parties:

> The Plan is calculated to secure a maximum of achievement with a minimum of insoluble disagreement. It conforms to enlightened Conservatism in the moulding of private capital to socially useful purposes in place of its supersession by the State. It satisfies all moderate Socialist ambitions by its provision for increasing public control and its aim to associate the worker in its exercise and benefits. It satisfies Liberal ideas of national reconstruction as an instant

necessity and of the importance of strengthening Great Britain's position as a clearing-house.[8]

PEP was undoubtedly part of the general drift towards global planned economic systems which came in the wake of the Wall Street Crash of 1929 and the onset of the Great Depression. PEP's approach to planning, however, was a far cry from what British admirers of planning in the Soviet Union understood by the term, and was characterised by a wish to avoid the pitfalls more commonly associated with economic models; in reality it owed more to Heath Robinson than to Gosplan:[9]

> The answer to the question 'Why are things arranged this way?' is hardly ever 'Because it is the best method so far devised for filling that function,' but almost always 'Because that was how they happened to develop'. Redundance, duplication, lacunae and chaos are normal conditions of our present stage of development. It is futile to erect modern machinery in modern factories with modern systems of production if most of the invisible machinery to which this is connected is a Heath Robinson contrivance composed of the clutter of past generations and tied together with rotten bits of string.[10]

Claiming to be at least 'forty years ahead of the game of party politics as at present played at Westminster', the founding fathers of PEP called for the Plan to oversee the limitation of state control to essentials, and to permit the development of responsible self-government for industry. *A National Plan for Great Britain* as it appeared in *The Week-End Review* of 14 February 1931 (re-issued on 22 August 1931 to coincide with the World Social Economic Congress held in Amsterdam[11]) was an idealistic document that advocated corporate, as opposed to political, solutions to economic problems and was, unsurprisingly, funded by corporations. It drew much of its inspiration from the Public Utility Services Group (which was regarded by PEP as a natural alternative to Municipal Socialism) with the goal of transforming 'all transport, industry, commerce and so forth into a series of great amalgamations or federations of more or less similar type to the Central Electricity Board, with consumers' and workers' representation'.[12]

On 29 October 1931 Pritchard wrote to Maurice Dobb seeking informa-

tion about the Soviet experience of planning and inviting him to address a meeting of PEP on 'the technique of planned economy with special references to priorities and balances'. 'By priorities,' he explained, 'I mean selecting which activities are to have preference over other activities.'[13]Dobb replied in a manner that was totally dismissive of PEP, telling Pritchard that it was impossible to 'separate the lively "technical" problems of planning from its economic-social elements,' and that the latter would involve a discussion of the class nature of British society 'which most discussions of planning in this country seemed to ignore'. He declined Pritchard's invitation to address a meeting of PEP enthusiasts citing pressures of work during term-time, a lack of 'inside' knowledge of Gosplan workings, and the futility of drawing parallels between the aims of planning 'in a post-revolutionary society, where the propertied class has been expropriated and its influence and ideology largely destroyed' and 'a predominantly individualist capitalist society'.[14] Pritchard was not altogether unsympathetic. He had recently expressed his own frustrations with PEP and the general reluctance on behalf of industrialists to use the word 'planning' freely. As one member of PEP later explained 'planning' was hardly flavour of the month:

> There was good reason for this reluctance. The word 'planning' was at that time undergoing a subtle change of meaning and of weight … I used to say that any economic system must be in some sense planned, but that since the Russian emphasis on its then novel five-year plans and the introduction of the Fascist-controlled state in Italy, Continental writers in socio-economics and politics were increasingly using the word 'planning' as an alternative to totalitarianism. 'Planwirtschaft' spoken with the tone of a Sergeant-Major was replacing the older and quieter Anglo-Saxon word 'planning', meaning considering how you get from here to there. This implies an accurate knowledge of the advantages and disadvantages of 'Here' and as accurate an appraisal as possible of the advantages to be obtained when we get 'There'. The statistical sources and the technique of making and using forecasts were in Britain in 1931 markedly deficient. Planning the development of these was as important as mapping out carefully the pathway of change.[15]

Dobb should have been more realistic; there were very good reasons why a left-wing economist should have taken the opportunity to advise the new society. 'The early birth pangs of PEP,' as the first Secretary of PEP Kenneth Lindsay was the first to observe, 'occurred during the dying months of the second Labour Government.... It must be remembered that in 1931 not only were there two million unemployed; local Boards of Guardians still existed; there was no national Supplementary Benefit, old age pensions were derisory and social and health services fragmented; the school leaving age was only 14. There was an absence of international bodies, except a listless League of Nations. A body like PEP therefore met a real need, but it faced considerable criticism at its birth.'[16] Jack Pritchard concurred. PEP's 'inception', he wrote, 'must be measured against the rapidly deteriorating condition of Britain, with well over two million unemployed and the prospect of financial bankruptcy.'[17] There was also a bankruptcy of political ideas. It is difficult to recapture the national mood of the year 1931.

From the very beginning PEP had been heavily influenced by the personality of Sir Basil Blackett and by the economic theories of John Maynard Keynes. Keynes had extolled the advantages of planning; as one writer so aptly put it, he 'began to wonder about the universal validity of the theory of a stable equilibrium of supply and demand, given that such a stable equilibrium seemed to exist below the level of full employment in normal, as opposed to crisis, conditions. Perhaps it was not enough to envisage the British economy as a Rolls-Royce purring along smoothly until there was a crater in the middle of the road. You might also have to fine tune the engine as it went along.'[18]

With Sir Basil Blackett's departure for De Beers Consolidated Mines in 1932 Jack Pritchard, who took a more pronounced Keynesian view than Sir Basil, now sought a wider remit for PEP by collecting information on the technical methods of planning from a broader range of sources. In 1931 he wrote to the architect Maxwell Fry inviting him to advise PEP on town planning. Fry agreed, and the following year he organised with them an Exhibition for Planned Industrial Construction, intended to be part of the Building Trades Exhibition to be staged that September at Olympia. Fry canvassed support from a number of people, including Christian Barman, of the *Architects' Journal*; Hilda Martindale, Deputy Chief Inspector of

Factories; the newspaper publisher, W. W. Astor; the editor of the *News Chronicle*, Gerald Barry; and various industrialists. In the end, however, the organizers of the Building Trades Exhibition turned down the proposal on grounds of cost, prompting Pritchard's resignation from PEP in September 1932. He then brought together a dissident group of like-minded friends[19] to form a separate organization, JAXPLAN, and began drafting a separate blueprint for planning, *A View on Planning*, published as a supplement to the magazine *New Atlantis* in 1933. JAXPLAN was heavily influenced by the ideas developed by Pritchard and Wells Coates when setting up Isokon Ltd. Wells Coates, while not a member of JAXPLAN, wrote a seminal paper entitled *Response to Tradition* in the same year as *A View on Planning* appeared in *New Atlantis*, endorsing its philosophy:

> As young men, we are concerned with a Future which must be planned rather than a Past which must be patched up, at all costs. ... As architects of the ultimate human and material scenes of the new order, we are not so much concerned with the formal problems of style as with an architectural solution of the social and economic problems of today. And the most fundamental technique is the replacement of natural materials by scientific ones, and more particularly the development of steel and concrete construction.[20]

<p style="text-align:center">*</p>

Wells Coates began work on the design of the Isokon building that became the Lawn Road Flats in 1933. It was a revolutionary departure in architectural design that irreversibly changed the course of domestic architecture in Britain. It was intended as an expression of both the Isokon idea and the JAXPLAN ideal, an experiment in social living that would educate the building industry and demonstrate that private enterprise was not only capable of planning but also of responding to the 'demand for decent living'.[21] Isokon, however, met with initial scepticism and was even viewed in certain circles with considerable alarm. In 1931 Jack Pritchard had written to the Hampstead-based architect F. S. Thomas asking him to comment on his plans for Isokon Ltd and the suitability of using reinforced concrete for the construction of a number of 'unit dwellings' on the site in Lawn Road. In a four-page letter Thomas could barely contain his horror at the New Architecture and its plans for England:

A modern house, severe and rectangular in form, with strip windows, built in concrete, may be efficient and cheap, but ugly. Built in a 2" Sussex multi-coloured brick it may be efficient and expensive but beautiful. If the New Architecture renounces all claim to any aesthetic quality, and relies upon efficiency and low cost alone, it may possibly prosper commercially, as have petrol pumps, but if it is to succeed in revolutionising domestic architecture, it must find expression in some material which has beauty and which will not make costs high. Concrete is soulless, colourless and repulsive. Let us not make England a Country of Concrete Cubes.[22]

Jack Pritchard's reply, given the circumstances, was very polite:

My Dear Thomas,

It was exceedingly kind of you to go in to my memorandum in such detail. The main gist of your remarks are I think –

1. That you believe I have overlooked the aesthetic factor.

2. That there are not sufficient technical details for you to give a sound opinion.

1. As you know my whole aesthetic outlook is based upon fitness for purpose. I am inclined to base more importance on form and shape than on materials: at the same time I appreciate the importance of the latter. As I see it you tend to weight the balance more in favour of material than form.

2. This I hope to remedy in the near future by showing you details of construction and method.

So I will send you no more words until the arithmetic and the shapes emerge.[23]

The 'arithmetic' and the 'shapes' would be the responsibility of Wells Coates while the 'words' remained Pritchard's; much to his own annoyance as they often conveyed a meaning he did not intend.

The most pressing problem at this stage, however, was the question of finance. The creation of the Modern Architectural Research Group (MARS), a British section of CIAM, in June 1933 by Maxwell Fry, Wells Coates and Serge Chermayeff in the wake of the hugely successful British

Industrial Art Exhibition at Dorland Hall, proved useful in this respect. The erection of a specimen flat at Dorland Hall led to a number of deposits being secured from prospective tenants and introduced Jack Pritchard to a firm of solicitors acting for financiers willing to back the construction of the Flats. Jack and Molly Pritchard's inexperience in such matters, however, exposed the vulnerability of the project:

> We were introduced to a firm of solicitors acting for financiers who were prepared to advance building finance at about 7.5% (a high rate for those days) provided we put up £5,000, which was just about all Molly and I could find between us. The estimate for the building was £18,000. We were to provide certificates each fortnight for work done, allowing us to then draw out £2,000. But each fortnight the lenders seemed to be adding extras. We had no experience in these matters and felt caught.[24]

Uncertain how to proceed, Pritchard took the advice of the General Manager of London Transport, 'the great Frank Pick', a close friend who advised them to ditch the financiers right away and go for a bank loan instead. This he got easily enough on the strength of the list of prospective tenants garnered at Dorland Hall.[25] Estimating that the Flats would cost just under £15,000, including the price of the land that Pritchard already owned, of which two-thirds was to be provided by a mortgage and the rest to be raised privately, he planned to let the flats at rents ranging from £96 to £170 per annum. This would include rates and services that included constant hot water, central heating, cleaning and dusting, the collection of refuse, bed-making, shoe-cleaning, window-cleaning, meals and laundry, and the provision of essential Isokon equipment:

> Floor coverings, light fittings and a radiator, a sliding table, divan with over-lay, wash basin with mirror and glass shelf, hanging cupboard with a long mirror, and a dressing table with drawers and cupboards underneath, electric cooker, refrigerator, sink and refuse bucket, and additional storage space.[26]

There were 32 flats in total, 22 'Minimum Flats' as exhibited at Dorland Hall, four double flats with rooms divided by sliding birch-plywood faced

screens at the south end, three studio flats at the north end, a staff flat on the ground floor and a large garden penthouse flat on the roof of the building with a self-contained flat adjoining. There was also a garage with space for ten cars. Situated close to town with nearby Belsize Park tube station serving the West End and the City, with the London Midland & Scottish Railway (LMSR) running close by, and a good service of local buses and trams, the Lawn Road Flats were perfectly situated to live up to the Isokon ideal of modern functional design applied to houses, flats, furniture and fittings. Isokon would oversee the creation of a variety of buildings from standard units at rents 'geared to what a young professional man could be expected to earn, starting at a salary of around £500 a year'.[27] Building work was scheduled to begin in July; it was, however, delayed until September.

A number of problems beset the Lawn Road Flats project from the outset. Work was prescribed by the planning authority, the LCC, with the design of the self-closing fuel hatch to the boiler room causing the most concern.[28] In detailing the inside story of the planning and building of the Lawn Road Flats, and the stormy relationships that developed between Coates and the Pritchards, Laura Cohn, Wells Coates' daughter, drew an interesting comparison with the labours of the fictional architect James Spinlove in H. B. Cresswell's book *The Honeywood File*. Wells Coates and Pritchard may well have revolutionized architecture in the 1930s but when it came down to it they were really trying to impart the values of the polite-society depicted by H. B. Cresswell and Osbert Lancaster in the book *Homes Sweet Homes* on British architecture. Not surprisingly there were setbacks. The 'social aims' of Lawn Road, Cohn writes, came to fruition at a time when the 'idealistic, though harsh, society of the 1930s' was 'a world away from Cresswell's genteel suburban environment'.[29]

The problems were practical as well as emotional. There was, for example, the LMSR running beneath the site, which Wells Coates solved by situating the Flats at a slight angle to the site's boundaries. The angled position left most of the south-west aspect overlooking nursery gardens and tennis courts. While Wells Coates thought he had solved the main practical problem, gaining the necessary planning permission proved a nightmare and, although building regulations for steel and concrete construction had

been recently relaxed, the LCC delayed the start of the project by several months. Building did not get underway until 25 September 1933, with a completion date for prospective tenants of 12 March 1934. Pritchard took full responsibility for the late start to building work:

> There was some delay in getting the building started. I had assumed that permission from the LCC would come in the form of a definite statement, "yes" or "no", but their letter referred to no particular objections. At the time this vagueness was disconcerting. I learnt later that that letter could be taken as approval. Wells kept saying get on with it, I held back, trying to get a firm OK.[30]

The vagaries of the English weather upset plans even further. The Flats were to be built in a four-storey, reinforced concrete block, with four-inch thick walls insulated internally with one inch of compressed cork slabs cast into the shuttering and then plastered. Externally, the walls were to be given a two-coat water-proofed and tinted cement wash which would be applied directly to the untreated face of the cement, with no attempt to conceal the shuttering. 'It was,' as the *New Statesman* later remarked, 'an extremely honest treatment.'[31] The builder (Barkers) was to be paid £1,000 per fortnight starting on 23 October 1933. But from the middle of November 'building was delayed by bad weather'. The winter of 1933 was unusually severe with prolonged bouts of freezing weather; the LCC District Surveyor would not allow concreting to take place when the air temperature was below 3.9 degrees Celsius and the extended delays jeopardised the completion date (with tenants waiting for occupation on 25 March), and inevitably adding to costs. In a letter to Jack Pritchard dated 27 February 1934, Coates listed the time lost from 13 November to 27 February. The worst period was two weeks in December and a number of days in January; in all, 37 days and 5 hours were lost, and still there were delays. 'A completion date looked a long way off. Coates apologised to Pritchard – but pleaded that the events were virtually an "act of God" ... the delay meant waiting till the following spring.'[32] A number of minor disagreements between Wells Coates and Pritchard over the colour of the building and the shape of the door knobs, and the more serious problem of costs, began to seriously strain their relationship. On 28 May 1934 Wells Coates sent the following letter to Pritchard:

I note you prefer the present cream colour to the outside, and not the 24 parts white, 1 part buff which I had chosen. I personally believe that you will find the present first coat, which is almost a dead white, will get extremely dirty ... and I do suggest a light tint in the final coat ... I note you do not like the handles to the front doors. I do not myself ... Other samples are being sought after.[33]

On 1 June 1934 Wells Coates wrote again, this time enclosing an invoice:

Would you please be good enough to settle the old items which go back nearly a year, otherwise they will have to be written off as debts ... and our accountants will have to carry out the usual procedure for debt collection.[34]

Pritchard was furious with the tone of the letter and, in his reply, left Wells Coates in no doubt of the harm he had done: 'Molly and I take great exception to your impertinent letter,' he wrote.[35] Thankfully, as the completion date for the Flats drew near, Wells Coates' love affair with Molly calmed things down. As Isokon made plans for a 'Grand Opening,' relations between the three grew noticeably warmer:

Jack sent Wells a note on 18 June asking if he wanted to bring anyone along. Wells replied courteously, asking in turn if Jack would like to borrow his model of the building for the party. Wells, eager to gain plaudits for his work, was in touch with H. De Cronin Hastings of the *Architectural Review*, a friend and supporter of the modern movement, about the content of the article they were to publish on the flats.[36]

This should have been Wells Coates' supreme moment. On 9 July 1934 Thelma Cazalet, Conservative MP for Islington East, declared the Lawn Road Flats open by breaking a bottle of beer against the side of the building in a ceremony mimicking the monarch's launching of an ocean liner. Cazalet, however, was second choice. The invitation sent to the Labour Party leader of the LCC, Herbert Morrison, to the opening ceremony of the Flats had betrayed Jack Pritchard's real sense of purpose. He asked Morrison to consider the Flats as a blueprint for the 'construction of large blocks of working-class tenements,' that would embrace modernism and

avoid the red-bricked 'Peabody atmosphere' of Victorian social housing.[37] The LCC had already embarked on a policy of building large LCC estates in Conservative voting areas and Morrison had proudly boasted of building the 'Tories out of London'.[38] Nevertheless, despite Pritchard offering to pick him up at his office in his automobile and return him back home, promising that 'the whole visit need not occupy more than an hour of your time', Morrison declined the invitation. The Tory MP, Thelma Cazalet was altogether more responsive, but for different reasons.[39] In a letter to Pritchard dated 4 July 1934, warmly accepting his invitation to preside over the opening of the Flats, her secretary successfully turned the tables on him: 'Miss Cazalet is concerned that there are no attractive dwellings in Islington for the middle strata of people', she wrote, 'and that this and not slum clearance is the real problem in her constituency.'[40] Pritchard's reply was more than accommodating. He acknowledged that the Flats had in fact been 'designed for middle-class people of moderate means, who are in business in London and do not want to be bothered with tiresome domestic troubles and yet wish for the privacy of a flat'.[41] He held up the Flats as a new departure in modern living. The young professionals who came to live there, he told her, would be 'supplied with full service' as well as built-in furniture. This would guarantee the 'greatest convenience and space in the living-rooms within a small compass'. They were not to be 'showy flats: there is no grand entrance to suggest an air of prosperity beyond the means of the tenants'. His intentions were purely noble: 'as the outside galleries from which, in the case of the small flats, the private doors give directly onto the sitting-room demonstrate, it is at real convenience that we aim ... a useful and practical solution of the needs of the particular class that we hope to attract.'[42] That particular class was not Peabody; but rather wealthy, successful, Bohemian types who were, in the main, left-wing Labour and not Conservative at all in attitude.

The Flats received a glowing testament from De Cronin Hastings, the editor of the *Architectural Review*, in what has often been described as the 'fabulous volume of the *Architectural Review* (Vol. 76, 1934)'. This featured articles on Berthold Lubetkin's Penguin Pool at London Zoo, Sir Owen Williams' Empire Pool at Wembley, Morton Shand's serialized history of the pioneers of modern design, Cyril Connolly's 'epoch-marking essay' on the new publicity of Shell and London Passenger Transport Board (LPTB),

Richard Neutra's Coco Tree restaurant, and a first review of F. R. S. Yorke's *The Modern House*.[43] The Grand Opening from Wells Coates's point of view, however, was a pure disaster. The publicity about the flats – 'an entirely new point of view in living comfort' as Isokon put it – gave the impression that the whole idea had originated with the Pritchards, and especially with Molly. It seemed as if the Pritchards were largely responsible for the ideas behind the building and had virtually designed it. Nothing could have been more damaging to Wells Coates. Four years' work, his first building, his ideals and his inventions, were documented as the inspiration of his clients. After this relations became painfully strained.[44]

Nevertheless, the Isokon building was at least completed and tenants could look forward to furnished flats with everything 'from shoe-cleaning to meals in your flat for between 3 and 4 guineas per week'. The building soon filled up with a diverse array of characters, some colourful, some not; among them Winston Churchill's friend the Honourable Ralph Edward Gathorne-Hardy the son of Gathorne Gathorne-Hardy, the 3rd Earl of Cranbrook and Lady Dorothy Montagu Boyle. To make things simpler, the Honourable Ralph Edward Gathorne-Hardy usually went by his middle name, Edward. Educated at Eton College and Christ Church College, Oxford, the Isokon building was not always to Edward's liking and he wrote in terms that would have caused the most reluctant of DIY enthusiasts, only too well aware of the true meaning of the acronym DIY – *Don't Involve Yourself!* – to question the wisdom of his judgement:

Dear Sir

I wish to protest most strongly about some of the deficiencies in my flat, and I hope that your company will see their way to remedying them fairly quickly. I may say, before particularising my complaints, that a landlord who advertises his building as the first attempt to provide modern living arrangements should be careful first to provide comforts above those of a Mornington Crescent lodging house. 'Modern' life, I dare say, will be even more uncomfortable and untidy than Lawn Road Flats, but it is not encouraging for your tenants to feel that they have been made the victims of anti-Soviet propaganda.

Twice a week since I have been in my flat the bath water has not been hot. This is quite intolerable, and it is obvious that it must be due to inefficiency of the most elementary character.

The lock on my door is in such condition that it is now almost impossible to get in or out of my flat, without using a great deal of physical force ...

The carpenter's work is very bad indeed. The doors are not the shape of the openings they are intended to close, some of them will not shut, some will not open, and the door of the kitchen will not remain shut if the door on the balcony is open.

The paintwork is of the shoddiest character imaginable. Apart from the actual quality of the paint, apart from the lumps, the bristles, the clumsy brushwork, the glutinous drops depending from the doors, the trembling line where one colour meets another, it seems likely that in a few months very little paint will be left at all. I should like you to look at the crevasses in my walls. The real trouble is, that although the design of the flat is admirable, I cannot help feeling that there has been a good deal of cheese-paring in the joinery and decoration and arrangements. Finally, my bath must be hot, my doors must open and shut, my paint must remain on the walls. I may add that I do not propose to pay my rent until active steps are taken.[45]

Wells Coates, who was on friendly terms with Edward Gathorne-Hardy, quickly seized on these complaints in his ongoing dispute with Jack and Molly Pritchard who had forwarded a copy of the offending letter to him. On 3 November he wrote to Pritchard with the observation that 'there is no question that the matters which he [Gathorne-Hardy] discusses are due to what he calls "cheese paring" in the interior fittings. Both the Quantity Surveyor [Cyril Sweet] and I have advised you from time to time that the sums in the contract have been so reduced ... that trouble would occur ...' He also wrote to Gathorne-Hardy thanking him for his 'amusing letter'.[46]

Undoubtedly, Gathorne-Hardy's letter of complaint was splendidly done and would have graced the literary output of the Flats in 1934, had anyone thought of compiling such an anthology. Apart from Nicholas Monsarrat, who had moved into the Flats around the same time as Gathorne-Hardy, there were a number of interesting authors residing there, among them

the writer and confidant of the American poet T. S. Eliot, Harold Montgomery Belgion.

Montgomery Belgion, always referred to as 'Monty' by his friends, and by others as 'Pouge', was a confirmed Francophile. Born in France in September 1892, he was christened in St George's English Church, Paris, on New Year's Day 1893. By the time he moved into Flat 27 in June 1934 he had already written two books: *Our Present Philosophy of Life*, published in 1929 by T. S. Eliot at Faber & Faber, in which he tore into André Gide, Bernard Shaw, Sigmund Freud and Bertrand Russell; and *The Human Parrot and Other Essays*, published by the Oxford University Press in 1931. He had also enjoyed quite a distinguished newspaper career working on the *New York Herald* (European edition) in Paris, from 1915 to 1916, as editor-in-charge before returning to England to volunteer for military service. After the war he became sub-editor of the *Daily Mail*, then joined the editorial staff of the *New York World*. He quickly returned to the *Daily Mail* and remained there until 1924 when he became chief sub-editor of the *Westminster Gazette* until 1925. During the period of his stay at Lawn Road Flats, from 1934 to 1940, he worked on the *Daily Mirror* and the *Daily Sketch* and completed a third book, *News of the French*, which was published in 1938. In keeping with the political ethos of the Flats, Monty's politics were left wing and he dined frequently with members of both the Labour and Communist parties. Once he left the Flats he found himself drifting towards the extreme right of the Conservative Party and in the 1960s embarked on a spiritual journey to the Monday Club. This course is engagingly described in his very readable, albeit pessimistic, unpublished autobiography *From Left to Right*:

> I now belong to the Monday Club and I suppose I am to be classed as on the extreme political right. Yet till after the Second World War and the general election of 1945 I voted Labour and I suppose I may have been indistinguishable from a socialist. It was the failure of Labour in office to give the country what it needed that finally made me change sides, but I see that the process of political education had been going on for years ...
>
> Long before 1945, in the thirties, I resumed going to church. I had been christened as a baby, and in due course I had been confirmed

in the Church of England. But by the time I was eighteen or twenty I had lapsed. Accordingly most of the people with whom I associated in the years that followed were of the irreligious left. When I returned to church-going I was slow to grasp that to practise Christianity is the logical corollary of voting Conservative. Those who imagine that they can be both Christian and Labour are unconsciously confusing the incompatible. At best they are mistaking humanitarianism for Christianity. They do not realise that Labour is pursuing the impossible because they fail to acknowledge properly and in themselves that man is a fallen creature. Man is tainted with original sin.[47]

During his residency at Lawn Road Flats, however, Monty had been as comfortable with the communist sympathies of his friend and fellow resident, Charles Madge, the originator of the left-leaning Mass Observation, as he was with T. S. Eliot's more strident Christianity of the Anglican Church. Such crossovers of social intercourse were a common feature of Lawn Road Flats. The writer and painter Adrian Durham Stokes, who moved into the Flats shortly after their opening in 1934, was also a member of the Monty-T. S. Eliot circle of Faber & Faber *bon diables*; a group which included Herbert Read the anarchist poet, writer and critic and visitor to the Flats.

Adrian Stokes was born in Bayswater on 27 October 1902, the third son of Durham Stokes, a wealthy businessman of independent views, and his wife Alice. He was educated at Rugby School and Magdalen College, Oxford, where in 1923 he was awarded a second class degree in philosophy, politics and economics. Adrian Stokes blossomed as a writer as a result of 'two important friendships' – with Osbert Sitwell and Ezra Pound. He met Sitwell in 1924 and he was, Stokes claimed, 'the first to open my eyes', while Ezra Pound indulged his passion on the tennis court at Rapallo in 1926 for the then neglected Tempio Malatestiano, the cathedral church of Rimini. Their friendship, however, soon 'foundered on their very different assessments of Sigismondo Malatesta (1417–1468), whom Pound admired as a protofascist'.[48] Pound was nevertheless sufficiently impressed by the youthful Stokes to commend him to his friend T. S. Eliot at Faber & Faber who then became Stokes' publisher.[49] Back in London, Stokes moved into Lawn Road Flats and became a devotee of the ballet, publishing two

books on the subject: *To-night the Ballet* (1934) and *Russian Ballets* (1935) 'to communicate his enthusiasm'.[50] A bi-sexual, he suffered from depression and underwent psychoanalysis with Melanie Klein whose London School of Psychiatry was just beginning to challenge the supremacy of Freud's Viennese School. In the mid-1930s he took up painting – 'for the avowed reason that no one else seemed ready to paint the kind of painting he thought should be painted' – and joined a group of abstract artists living in nearby Hampstead who were consciously developing an English style of the European Abstract movement. Sculptor Barbara Hepworth, her husband Ben Nicholson, Irina and Henry Moore (who moved into Lawn Road Flats in 1941) would all become regular visitors to the Isokon building following the arrival of the Bauhaus exiles Walter Gropius, Marcel Breuer and Moholy-Nagy in 1934 and 1935. A nucleus of abstract artists now formed. They were inspired by the philosophy of the Bauhaus. Stokes and the English abstract movement provided a uniquely British contribution to the continental modernist movement, while Montgomery Belgion, T. S. Eliot and Adrian Stokes' colleague, Herbert Read of Faber & Faber, published their theoretical writings.

<div align="center">*</div>

The new arrivals from the Bauhaus brought with them not only their art, but also their personal experiences of continental Fascism and communism that made living in the Lawn Road Flats a political as well as an artistic experience, as the Pritchards and Wells Coates had originally intended it to be. Walter Gropius, the founder and spiritual father of the Bauhaus, was 51 when he came to live in the Flats, Jack Pritchard was 35 and Wells Coates was 31. Arguably Gropius was at the top of his profession enjoying a highly-productive career both as an architect and a designer. In industry, his work covered a broad spectrum of interior design – fabrics, mass-produced furniture, motor car bodies and a diesel locomotive.

In 1914 he designed the Hall of Machinery and the Administrative Building for the Cologne exhibition of the *Deutscher Werkbund,* with Adolf Meyer. A highly-decorated German officer of the First World War, Gropius was awarded the Bavarian Military Merit Order Fourth Class with Swords, and the Iron Cross for bravery following a mad-cap effort to locate the enemy by deliberately drawing fire upon himself. He was

rewarded with a promotion to German military intelligence and was sent to a communications school at Namur, Belgium, to study new methods of military communications (homing pigeons). Three years into the war he wrote to his mother: 'I have a nice room in a peasant's house and very independent work. Almost nobody checks up on me. My task, apart from the dog training, is to coordinate the different communication means, like light signal apparatus, signal throwers, and homing pigeons.'[51]

Gropius was sent on a secret mission to Italy where he instructed Austrian soldiers on how to train dogs as message carriers under fire and was awarded the Austrian King's and Queen's Military Merit Medal Third Class with War Decoration. He received yet another decoration in May 1918, the 'Insignia for Wounds Received in Combat'. He had been buried alive in the collapse of a supposed stronghold during a bombardment on the Soissons-Rheims and was found three days later, the only one of his contingent to survive, owing to 'a nearby flue that opened to the air above the debris.'[52] The war was now effectively over for Gropius and four months later the German war effort itself collapsed completely.

The armistice came in the wake of the Bolshevik Revolution of October 1917 and, like Russia, Germany descended into chaos with a mutiny among the *Kaiserliche Marine* in Kiel spreading quickly to other parts of the country. In a vain attempt to save the situation, the Kaiser abdicated as German Emperor and King of Prussia on 9 November in favour of the German Chancellor, Prince Max of Baden. Later that same day the Prince was himself dismissed from office and the leader of the Social Democratic Party (SPD), Friedrich Ebert, backed by the *Freikorps* (paramilitary organizations of ex-soldiers), declared Germany to be a 'People's Republic'. Two hours later, Karl Liebkchnect a leading member of the Spartacus group, a left-wing breakaway faction of the SDP that had vehemently opposed the war, sought to emulate Lenin's seizure of power in Russia and issued a rival proclamation declaring Germany to be a 'Workers' Republic'. The country now descended into civil war and the Kaiser fled to Holland. Unrest was widespread, with street fighting and a general strike spreading from Berlin to other cities. The crisis was brought to a close on 15 January 1919 when government troops loyal to Ebert's Social Democratic government brutally murdered the Spartacus leaders, Rosa Luxemburg and Karl Liebknecht, opening up a deep schism between the Social Democrats and the far left

in Germany. It was an act of barbarity that not only weakened the left but also undermined Germany's fledgling democracy. The following month the Social Democrat Ebert was elected as first president of the German Weimar Republic.

The eventual destruction of Weimar by Fascist forces in January 1933 owed much to the unresolved grievances on the left caused partly by the slaying of Liebknecht and Luxemburg fourteen years earlier. Reluctant to defend democracy, the left did little to protect the Weimar Republic from collapse and failed to prevent the final triumph of Nazism over Germany society. With the destruction of Jewish Bolshevism in Germany as its main domestic objective, the Nazis sought to cleanse Germany of both Jews and communists. Other minorities were targeted as part of the Nazi's ethnic and political cleansing programme. In their pursuit of a racially pure society, Germany's artistic community was to be purged of its 'degenerate' tendencies. Walter Gropius and the Bauhaus were accused of favouring foreigners and condemned as the epicentre of *kulturalbolshevismus* (cultural bolshevism).

After leaving the army in 1918, Walter Gropius had taken over the running of two schools, the *Grossherzögliche-Sächsische Kunstgewerbeschule* and the *Grossherzögliche-Sächsische Hochschule für Bildende Kunst,* which he later amalgamated to form the *Staatliches Bauhaus* (Bauhaus) at Weimar, Thuringia, in 1919. There he gathered around him a brilliant group of teachers, including the artists Wassily Kandinsky and László Moholy-Nagy, to put into effect his theories about the relationship of design to industry. Social and political disorder, however, continued to destabilize Germany and when the leftist governments in Saxony and Thuringia were overthrown by the German army in 1923, Thuringia was placed under martial law. Gropius's house was searched and, in ensuing state elections, the conservative Coalition for Law and Order was elected. It sought to close down the Bauhaus on grounds of communism, destruction of private enterprise, immorality of faculty and students, and misuse of public funds. The enemies of the Bauhaus 'did not overlook the opportunity to convince students that they were being "used", hoodwinked and inappropriately trained. Students themselves singled out Kandinsky and Moholy-Nagy for criticism.'[53] Former members of the school now openly attacked Gropius; among them Carl Schlemmer who had been

dismissed from the Bauhaus for intrigue in 1922. In April 1924 a 'Yellow Brochure' was published detailing the allegations and charges against the Bauhaus and its members: 'the Bauhaus', it claimed, 'was political, its communal activities smacked of Bolshevism and Spartacism, foreigners were favoured (receiving the best housing and largest scholarships), the Bauhaus was therefore anti-German, as attested by exhibition material in three languages.'[54] Gropius summed up the situation in a letter to a close friend, Lily Hidebrandt shortly after the 'Yellow Brochure' was published in late April or early May 1924:

> When the dirty "Yellow Brochure" was published, the students printed posters supporting me for [distribution in] the city. And the masters made a public statement in which they castigated its obscenity. The signer of it, Arno Müller, is a straw man who has admitted that he hasn't even read the pamphlet and has named as its authors: Hans Beyer, Josef Zachmann, Carl Schlemmer, the three who were summarily dismissed.
>
> The State and I immediately got in touch with the public prosecutor to bring suit because of offense; even this government cannot but protect me against a mean act of vengeance. Beyer had been dismissed as a swindler because he had *bought* his title of doctor. The State has forbidden that he use it.[55]

Despite protests from a range of European intellectuals including Peter Behrens, Marc Chagall, Albert Einstein, Oskar Kokoshka and Igor Stravinsky, and the Circle of Friends of the Bauhaus, calling on the public to support the Bauhaus morally and practically, Gropius left Weimar in the spring of 1925 'to start afresh in the smaller town of Dessau.'[56] There he brought together a distinguished team of professors that included the artists Johannes Itten, Oskar Schlemmer, Wassily Kandinsky, László Moholy-Nagy and Paul Klee. The Bauhaus building itself, begun in autumn 1925 and finished in December 1926, was hailed as 'a triumphant vindication of the principles of its architect, and of the lines on which he educated the students who worked on the design. All the interior fittings and designs were produced in its own workshops.'[57] Nevertheless, Gropius's difficulties with the authorities continued. His second wife Ise later recalled that the Bauhaus had 'a much earlier introduction to Nazi methods than other

people because we were their target long before they became the national government.... They knew exactly where their enemies were and feared quite rightly that ideas were more dangerous than material power.'[58]

Although Gropius 'had forbidden any kind of political activity in the school, it was constantly urged by his enemies that the Bauhaus was a centre of "bolshevism".'[59] In 1928 he finally gave up the struggle, resigning his directorship of the Bauhaus to concentrate on housing and urban planning and he began experimenting with standardised building components for mass-produced housing. His most acclaimed work in Germany from this period was his contribution to the Siemensstadt estate in the Charlottenburg-Wilmersdorf district of Berlin where he served as the supervising architect and designed two of the estate's blocks. Such innovative experiments in worker housing would lead to further accusations of 'cultural bolshevism' on the grounds that he had become 'too international'.[60] Fascist Italy, however, expressed great admiration for his work and in 1933, the year the Nazis came to power, he was invited by the Board of Directors of the Fifth Triennale exhibition of modern decorative and industrial arts in Milan to exhibit his work, along with nine other architects from different countries, under the banner of the 'modern art of architecture'. Shortly before the opening, however, 'the Board was officially approached and told to eliminate two of the three invited German architects [Gropius, Mendelsohn and Mies van der Rohe] on the grounds that their exhibits were undesirable from the German point of view.'[61] Gropius's lantern slides were removed from the *Deutscher Werkbund* slide collection prepared for the exhibition and a lecture requested from the Italians was cancelled. However, the Italians refused to remove Gropius's exhibits, which were already hanging in place.

Gropius wrote to the German Foreign Office in an attempt to discover the reasons for these actions, and was informed that the Prussian Minister of Culture, Dr Wendland 'had undertaken this request to the Board of Directors of the Triennale, via the Militant Organisation for German Culture. The then director of the *Werkbund*, whom Gropius requested to inquire into the matter, told him that Dr Wendland considered Gropius "too international".'[62] On 10 July 1933 an Investigation Committee appointed by the Dessau magistrate to look closely at the Bauhaus, accused Mies van der Rohe and Gropius of 'suspicion of disloyalty and embezzlement', and on

12 December Gropius was summoned to give evidence to the Committee. The accusations laid out against him claimed that he was a man with particularly strong communist tendencies and had exploited Bauhaus products for his personal gain – specifically a Bauhaus doorknob for which he had issued a general licence to the Berlin company, S. A. Loevy.[63] Gropius had, in fact, designed the offending doorknob at his private studio in Weimar in 1922 and the Thuringian Education Commission had given him 'official permission' to develop the knob for commercial purposes. On 13 December there now appeared a threatening article in the newspaper of the Nazi Party, the *Völkischer Beobachter* by a Dr Nonn attacking Gropius and the new architecture with the title 'Still Building Bolshevism?' The article was intended as a prelude for a meeting of the Militant Association of German Architects and Engineers where the Swiss-born architect Alexander von Senger was to outline how 'the new architecture is a bolshevist affair.'[64] The 'political slur' of 'cultural bolshevism' coupled with the 'frivolous accusations' surrounding Bauhaus doorknobs now placed Gropius in considerable danger. One ominous sign that the Nazis were intending to prosecute him was the continued appearance of his name alongside that of Walter Rathenau[65] in a number of Nazi publications. On 18 January 1934 he wrote a letter to the President of the Reich Committee for the Fine Arts in Berlin, Professor Honig, defending himself against the 'political slur' that he had 'communist leanings':

> It is of decisive importance for me to find a way to protect myself against the libellous and false accusations which put me especially under political suspicion. My origin and the conduct of my entire life testify to my constructive and socially conservative attitude. Never in my life have I been politically active, nor did I belong to any party; I merely attended to my own affairs. I consider the events which I am now experiencing deeply humiliating (for their perpetrators). I cannot, and never could, do better for myself nor for my native land than to work conscientiously and in awareness of my responsibilities. Just as I myself am thoroughly German and Prussian in all my characteristics, so is my personal work, for which I remain fully responsible, and from which I cannot retract a thing.[66]

This letter was not merely a last ditch attempt to save his career: Gropius feared for his life. His name had been listed under the general title of 'Culture Bolshevism' on p. 805 of the *Sigilla Veri* – an encyclo-paedic work of anti-Semitism compiled by the Nazi anti-Semite, Phillip Stauff – with the note, 'questionable whether of Jewish origin'. His name was again linked with that of Walter Rathenau, leading Gropius to defend his racial purity: 'Thirty quotations are cited that are supposedly attributed to Walter Rathenau and myself. Not a single one of these quotations is authored by me. Furthermore I am of pure Aryan, German origin.'[67]

In fact, Gropius's position could not have been worse. The standing of the *Sigilla Veri* in influential German circles meant, at the very least, that Gropius's career as an architect in Germany was all but over. The fact that the fifth volume of the *Sigilla Veri* was never finished, breaking in the middle of an entry on Walter Rathenau, was also worrying. Ominously, the *Sigilla Veri* was never available in the shops and could only be ordered direct from the publisher. Anyone buying a copy was required to sign a declaration that 'I am not of Jewish descent, have no Jewish blood nor Jewish relatives. I pledge myself not to sell or present this book to anyone. I give my word of honour that I am not acting as a man of straw for anyone.'[68]

The publishing house responsible for the *Sigilla Veri* was U. Bodung-Verlag and was owned by a notorious anti-Semite, Ulrich Fleischauer. In 1925 Fleischauer had appeared as a defence witness at the trial in Berne, Switzerland, of the notorious anti-Semitic forgery *The Protocols of the Elders of Zion*. He was the publisher of a violently anti-Semitic periodical called *Weltdienst* and, for a number of years, his publishing house was secretly funded by the Nazis until it was incorporated into the propaganda empire of Joseph Goebbels.

On 27 March 1934 Gropius again wrote to Professor Honig – who, in a recent lecture attended by Gropius, had described the New Architec-ture as 'a "packing-case architecture" which had to be rejected by the new Reich' – to express his dismay that the New Architecture and the achieve-ments of the New German architectural movement in social housing were in danger of being lost to Germany, Gropius complained to Honig that the Italian futurist leader Marinetti had arranged to speak in Berlin and was expected to 'claim the German architectural movement ... as being of

Italian origin, for Italy's glory'. In Germany, he continued, New Architects were simply lampooned as 'the creators of structural cubes with flat roofs without taking into consideration the widely comprehensive formative and sociological labour which we accomplished on behalf of the broad German masses'. More seriously, Gropius dismissed the Nazi movement's claim to speak for German nationalism in the cultural sphere:

> You challenge the German man. I consider myself entirely German, and who can set himself up as judge to determine which of my ideas and of those of my spiritual brethren are German and which are not? Nobody is in a position to delineate this concept "German" accurately. You may be surprised about the impression your lecture made on me, but since it was delivered from so high a position, I felt afterwards that, with all that I have built up in my lifetime. I am outlawed in Germany, and so – as I was forced to conclude – are many of my colleagues. Conscious of your humanity and the purity of your intentions, I felt the inner obligation to point, from my own point of view, to the dangers which I see arising out of the public suppression of the new German architecture movement. For this reason I could not be silent.[69]

Gropius now travelled to England having been invited to attend the opening of an exhibition of his work at the Royal Institute of British Architecture (RIBA) on 15 May 1934. There he met Jack Pritchard and the English architect and design critic, Philip Morton Shand.[70] The following day Gropius was invited by the Design and Industries Association (DIA) to give a talk on 'The Formal and Technical Problems of Modern Architecture and Planning' in which he called for a rational scheme for high density urban housing.[71] Chaired by Maxwell Fry, the meeting was packed and Gropius struggled in poor English to put his views across. Nevertheless, his lecture appealed to the advocates of planning and recalled the early ideals of PEP:

> Except for a handful of people who were aware of the true nature of developments on the Continent, there seems generally to have been a rather muddled and suspicious view as to just what constituted the philosophies of the Modern Movement. However, the lecture was of

no mean significance in the history of architecture in England. It was the first time that one of the leaders of the Modern Movement had come personally to advocate the general proposition that architecture had a sociologically and economically significant role to play in a system of national planning for the future.[72]

In June, Gropius was back in Germany and, facing ever-increasing difficulties, he received a letter from Morton Shand holding out the possibility of work designing a block of flats in London for Jack Pritchard. On 20 June Pritchard wrote to Gropius himself, offering him work with Maxwell Fry on the design of fifty flats in West Didsbury, Manchester, and the promise of free accommodation in Lawn Road Flats. On 3 July Maxwell Fry also wrote to Gropius fleshing out the details – fees at 6 per cent of the total cost leaving £450 to be shared between them after the deductions for office and draughtsman's expenses; Gropius wrote back accepting the offer. Luck was on his side; he received an invitation to lecture on the subject of 'Total Theatre' at the Volta Conference to be held in Rome in the coming October.[73] Before his resignation from the Bauhaus, Gropius had collaborated with the German theatre director and producer Erwin Piscator, a member of the German Communist Party, on what they called the 'Total Theatre' project. Their goal 'was to design a theatre that could be changed to accord with the subject of the play, changed, that is, from the Greek theatre to the circus, to the proscenium arch'.[74] The theatre seats could be moved during a performance and the audience would be surrounded by projection screens for mixed media productions. The theatre, unfortunately, was never built. Piscator went on to develop a political theatre of the left before moving to Moscow in 1931.

Before he left Berlin for Rome in October 1934, Gropius made the necessary preparations to leave Germany permanently. The Nazi government would only permit an allowance of 10 Marks per person to be taken out of the country and Gropius had to arrange for the organisers of the conference to pay the travel and accommodation expenses for him and his wife Ise. He requested that their return tickets to Berlin should be routed through London where they planned to abscond. Consequently, when the couple arrived at Victoria Station, London, on 18 October 1934, they had little money and few possessions. They were met at the station by Jack

Pritchard, who had arranged for them to stay at 15 Lawn Road Flats as his guest for six months, and Maxwell Fry. Pritchard had already discussed commissions for Gropius with a number of his friends, including the headmaster of Dartington School, Leonard Elmhirst and his wife Dorothy, and the Secretary to the Cambridgeshire County Council Education Committee, Henry Morris, who occupied a *pied-a-terre* at the Flats.

The following week Pritchard drove Gropius and Ise to Cambridge where they met Henry Morris and stayed in his splendid rooms in Trinity Street, decorated in 'gay and powerful colours', with 18th century furniture, French impressionist pictures, and Georgian silver candlesticks.[75] Morris was then the inspiration behind the Village College movement – an innovative school building programme that aimed to meet the educational needs of children aged 11 plus in rural Cambridgeshire. The Hadow Report, published in 1926 as *The Education of the Adolescent*, had called for the abandonment of all-age schools in England and Wales and the building of secondary modern schools. Morris had seen this as a unique opportunity to promote the Village College idea and to commission the construction of specialist buildings that would not only meet the requirements of the Hadow Report but would also provide much-needed rural community centres for outlying villages in Cambridgeshire. Morris's vision rested upon defending the traditions of village life, which he believed had been subjected to rapid change in the aftermath of the First World War and were in danger of disappearing altogether. He was also one of the first to see that modern communications in the shape of the motor car and the auto-bus had made it unnecessary to restrict rural communities to the scale of the village. His goal – the creation of 'healthy and vigorous' communities and 'human happiness' in the countryside – would, he believed, halt the drift of the rural population to the nearby towns and cities and reinvigorate the countryside. He spread out his vision before Gropius in the regal splendour of his rooms in Trinity Street, initiating a friendship that in 1935 would involve Gropius in the design of Impington Village School. To formally accept Gropius into the fraternity he was made an honorary member of PEP in November and began working with Maxwell Fry.

1935: 'Art crystallises the emotions of an age.' Musicology and the Art of Espionage

1935 was an eventful year. It opened ominously with the Italian dictator Benito Mussolini creating Libya out of the Italian colonies of Tripolitania and Cyrenaica. A week later he signed an agreement with the French Foreign Minister, Pierre Laval, where they accepted each other's colonial claims. On 13 January a plebiscite in the Saarland showed that 90.3 per cent of voters wished to rejoin Germany. Two months later Adolf Hitler tore up the Versailles Treaty and launched a programme of German rearmament. In Germany, National Socialist denunciations of modern architecture and 'Degenerate Art' reached their height in 1935 with examples of modern art hung next to photographs of people with deformities and diseases, graphically reinforcing the idea of modernism as sickness.[1] Artists from the Bauhaus, closed down in July 1933, left Germany *en masse* for friendlier, more supportive, climes; Klee went to Switzerland and Kandinsky to Paris. László Moholy-Nagy followed Gropius to London, staying initially as Jack Pritchard's guest in the Lawn Road Flats before moving into Flat 16. The radical furniture designer Marcel Breuer spent two years in Zurich working with the art historian Sigfried Giedion, before he too moved into the Flats, also in 1935.

<div align="center">*</div>

Marcel Breuer and Moholy-Nagy shared similar backgrounds. Breuer was born in Pécs in 1902, near the southern border of Hungary; Moholy-Nagy in 1895 in Bácsborsód, a large village and municipality in Bács-Kiskun county in the Southern Great Plain region of southern Hungary. Both families were comfortably off. Marcel Breuer was the son of a physician; Moholy-Nagy's father was a landowner, although Moholy-Nagy fell on hard times as a child after his father gambled away the family estates.

Compared with Moholy-Nagy, Marcel Breuer's transition to the Bauhaus was a relatively easy one. In 1920 Breuer won a scholarship to the Academy of Fine Arts in Vienna where 'he inadvertently ruined the blade of a carpenter's plane' he was using on a temporary job. He left Vienna for Weimar in some haste and enrolled as a student at the Bauhaus where he introduced new materials into furniture design, most famously the chrome steel tubing of his bicycle handlebars. He also designed innovative new furniture concepts such as nesting tables, wall-hung modular storage units and the use of free-standing cabinetry as space dividers.[2] In 1923 as part of the first Bauhaus exhibition he was assigned by Gropius to design the principal interiors of an experimental house, the Haus am Horn. He left the Bauhaus the following year at a time of right-wing pressure from the city council of Weimar, coupled with Gropius's financial mismanagement of the school. This forced the Bauhaus to look elsewhere for municipal support. Between 1924 and 1925 Breuer worked at an architect's office in Paris living at the Hotel Pont Royal in the Latin Quarter; it was a haunt of artists who were far from affluent and where he first made the acquaintance of Le Corbusier. Breuer returned to the Bauhaus in 1926 after Gropius had moved the school to Dessau, and there he perfected and patented the Cesca, a tubular chair that he named after his mother Francesca, which was mass-produced by the celebrated furniture-making company, Thonet Brothers. As a result of the Cesca's success he became the interior designer of choice for many figures of the avant-garde among them the great Berlin theatrical producer Erwin Piscator.[3] In 1928 Breuer left the Bauhaus once more, this time to open his own architectural office in Berlin. It was not a success and in 1931 it closed for lack of work, and over the next few years he toured southern Europe and North Africa by bicycle and Ford motor car. Towards the end of 1932 he began working with his friend Sigfried Giedion in Zurich; Giedion had established two acclaimed Swiss furniture stores in 1931 called Wohnbedarf, which were major outlets for Breuer's furniture, as well as that of Alvar Aalto, Le Corbusier and other prominent designers.[4] When Breuer arrived in London in 1935, Gropius introduced him to MARS, and to F. R. S. Yorke, a young London architect and author, with whom Breuer went into partnership.

Following Jack Pritchard's decision the following year that the Isokon Company should move into furniture production, it was Gropius who once

again championed Breuer. Although Isokon had been producing furniture since 1933, the first products were plywood 'book boxes' designed by Wells Coates and manufactured by Pritchard's employer Venesta. The arrival of Gropius and Breuer persuaded Pritchard to expand Isokon's range of products using plywood as the main raw material. In 1936 Gropius suggested to Breuer that he should consider producing plywood variants of his aluminium chairs and Breuer came up with the plywood nesting table and a very popular reclining armchair – named the Isokon Long Chair:

> When in an Isokon Long Chair the weight of a person is spread over an area of some 700 square inches, whereas in an ordinary old-fashioned chair it is usually spread over some 250 square inches. Thus the pressure of the whole body is concentrated on a narrow area. The profile is shaped to give the natural reclining position with the knees slightly raised. The head is rested separately so are the shoulders and back and the thighs, knees and legs and therefore each part of the body has only to support itself. You have the amazing sensation of the principle of Archimedes without being in water![5]

After László Moholy-Nagy's father had gambled away the family's large wheat farm, Moholy-Nagy, along with his brother and mother, had been forced to live with an uncle before enrolling in the School of Law at the University of Budapest. His studies were interrupted by the First World War when he served as an artillery officer on the Russian and Italian fronts. In late 1916 he was the only survivor of his battery in a battle along the Isonzo River in Fruili-Venezia Giulia, escaping with a shattered thumb and a fast-spreading infection that kept him in military hospitals for months.[6] He was said to have been 'stunned by the experience of war and the inordinate carnage of the eastern battle zones',[7] and became caught up in the revolutionary turmoil sweeping across Eastern and Central Europe. He was one of 'a whole generation', his wife Sibyl Moholy-Nagy remarked, 'straddling history' that had been ill-prepared for the events that engulfed them:

> With the last shot fired in World War I, the Age of Imperialism exploded. Revolutions of all shades, from the Bolshevist extreme to a bureaucratic Social Democracy, propelled Germans, Russians, and

the peoples of the vast Austrian Empire into an age of collectivism for which they were not prepared. Apart from a handful of intellectual leaders who had nursed a Marxian theorem into political reality, a whole generation was straddling history.[8]

After graduating in law at the University of Budapest in 1919, Moholy-Nagy applied to join the Hungarian Communist Party and enthusiastically supported the short-lived Hungarian Soviet Republic of Béla Kun. 'With the flaming enthusiasm of youth,' Sibyl wrote, 'he offered himself, his art and his willingness to teach, to the Communist regime.'[9]

Moholy-Nagy's rank as an officer in the army coupled with the land-holding status of his family, however, cast him under suspicion, and his attempts to join the Communist Party were, allegedly, rebuffed. According to Sibyl, 'the real basis of his non-acceptance was not political but artistic. Between him and the Communist Party', she wrote, 'stood his newly won assurance of non-representational art as an essential revolutionary weapon.'[10] Sibyl, however, had other reasons for distancing Moholy-Nagy from the Hungarian Communist Party. Her biography of her husband was first published in the United States in 1950 when McCarthyism was at its height, and there was a real danger of repercussions if she had admitted that Moholy-Nagy had once been a communist. His brother Jeno recalled in 1975 that Laszlo's views were 'progressive' and that virtually anyone who wished to join the Communist Party had been allowed to do so. He had himself joined the Party and he believed his brother had also joined.[11] Nevertheless, with the collapse of the Hungarian Revolution on 1 August 1919 and the brutality of the counter-revolutionary 'White Terror' that followed in its wake, Moholy-Nagy left Hungary for the relative security of Vienna.

Disillusioned, he criticised communism for its reliance on 'historical materialism', for blowing what he called 'a red tin trumpet', and for a lack of cultural bravery that saw communistic artists sheltering behind 'the deceptive name of "proletcult"':

This is the bitter anniversary of the birth and death of the Hungarian Revolution, which died in infancy because to be able to live it had to have revolutionary content. Instead, it was born within unshake-

able nationalistic walls, attended by the faithlessness of the Social Democrats and the stifling dogmas of the bourgeoisie. The leaders of this revolution, instead of solving the spiritual and material needs of the wanting masses, were bust with *historical* materialism, with neutral zones and national power. A heap of contradictions! Under the poorly dyed red cover, the revolutionaries forgot the real meaning of a revolution. They forgot to promote the inner revolution of life. They forgot about culture. Their revolution is not a 'revolutionary change'. Their form of Communist economy does not mean a new system of production and distribution. It merely changes the powers of those who decide about production and distribution. The economic Communism is another form of capitalism, based on trusts, syndicates, state credit, patronage, and a hierarchy of unassailable state leaders.

The present Communist Party ... blows a red tin trumpet while imitating the cult of the dead and base past under the deceptive name of 'proletcult'. ... we hope for new human raw material, prepared in the right kind of school-kettles to build and maintain a society dedicated to a totally new culture.[12]

In Vienna, the post-war Hungarian émigré community of artists regarded itself as the driving force behind a more 'radical synthesis of art and social activism'.[13] Their journal *MA: Aktivista Müvészti és Társadalmi Folyóirat* (*Today: Activist Art and Social Issues* magazine) excluded metaphysics and mysticism in favour of direct social action in art and was distinctly Marxist in outlook.[14] However, following the collapse of the Austro-Hungarian Empire in 1918 the two capital cities Vienna and Budapest became increasingly isolated from the artistic currents of the western world, and Moholy-Nagy left Vienna for Berlin in January 1921, working his way across eastern Germany as a letterer and sign painter. The journey was arduous and when he arrived in Berlin he was suffering from a severe bout of flu. He collapsed in the lobby of a hotel when he was refused a room and a passing teacher, Reinhold Schairer, took pity on him and arranged for him to be carried to his home. Schairer and his wife nursed Moholy-Nagy back to health before finding him lodgings in an attic room in West Berlin where he began painting and writing again for *MA*,

contributing articles on constructivism and the proletariat, and outlining his socialist vision for art in the age of technomania:[15]

> ... [the] reality of our century is technology: the invention, construction and maintenance of machines. To be a user of machines is to be the spirit of this century. It has replaced the transcendental spiritualism of past eras. Everyone is equal before the machine. I can use it, so can you. It can crush me; the same can happen to you. There is no tradition in technology; no class-consciousness. Everybody can be the machine's master, or its slave.[16]

For Moholy-Nagy the machine formed the basis of constructivism; it was the saviour of the proletariat and the hand-maiden of socialism. Art by crystallizing the emotions of an age would guarantee the triumph of the new era:

> This is the root of Socialism, the final liquidation of feudalism. It is the machine that woke up the proletariat. We have to eliminate the machine if we want to eliminate Socialism. But we know there is no such thing as turning back evolution. This is our century: technology, machine, Socialism. Make your peace with it; shoulder its task.... Past traditions cling to their meanings. But there is art, the language of the senses. Art crystallizes the emotions of an age; art is mirror and voice. The art of our time has to be fundamental, precise, all-inclusive. It is the art of Constructivism.[17]

Moholy-Nagy was expressing the anxiety of a new generation and new departures in art: 'the agony of a whole people torn between the ageless tradition of decorative art and the new forms of technological existence.'[18] It was a philosophy of art that would commend itself to the Bauhaus and find independent expression in Britain in the work of Wells Coates and the architectural theories of Jack Pritchard. A reaction against tradition reflected in the artistic works of Barbara Hepworth, Ben Nicholson, Henry Moore, Adrian Stokes and Herbert Read. It also gave a coating of continental socialism to the work of Isokon. 'Constructivism,' Moholy-Nagy wrote, 'is not confined to picture-frame and pedestal, it expands into industry and architecture, into objects and relationships. Constructivism is the socialism of vision.'[19]

In Berlin, Moholy-Nagy's paintings now began exploring the artistic characteristics found in the highly developed technology of industrialised Germany. Writing some years later, he described the paintings of this period as an expression 'of the industrial landscape of Berlin'. 'They were not,' he proclaimed, 'projections of reality rendered with photographic eyes, but rather new structures, built up as my own version of machine technology, reassembled from the dismantled parts.'[20]

In January 1921 Moholy-Nagy married the photographer Lucia Schulz, an ethnic German from Prague; under her influence he became interested in the anti-art cultural works of Dada. Moholy-Nagy's language of art remained international and he was attracted by those movements, such as De Stijl and Russian constructivism, that promoted the idea of an international community of artists. The Dadaists, however, wanted to open up and exploit divisions within modernism employing 'machine imagery as symbols for the evils of society, tradition and the past', while the Russian constructivists continued to revere 'technology for the positive values they assigned to it: logic, clarity, geometry, precision, efficiency'. In post-revolutionary Russia, technology was portrayed as 'the salvation of the post-war period'; constructivism 'would deliver their agrarian economy into modernity'.[21]

In 1922 Moholy-Nagy participated in the Dada-Constructivist Congress in Weimar where he helped set up a 'constructivist international' committee. The principal organiser of the Congress was a Dutch artist, Theo van Doesburg, then teaching a constructivist design course to a group of Bauhaus students – offering a balance, he said, 'to what he thought was the expressionist orientation of the school'. A 'student group called KURI (*Konstruktive, Utilitaire, Rationale, Internationale*), consisting mostly of Hungarians, was also demanding 'a more constructivist curriculum'.[22] Walter Gropius, under pressure from van Doesburg and others, introduced the current constructivist movement into the curriculum of the Bauhaus.[23] In 1923 he rejected the old Bauhaus Romanticism and Expressionism with its emphasis upon handicraft instruction and painting represented by Paul Klee, Walter Kandinsky and Lyonel Feininger. Instead a 'two- and three-dimensional design, graphic design and typography' course was introduced with a view to creating 'prototypes for mass production'.[24] As a result, in 1923, Gropius invited Moholy-Nagy to join the Bauhaus and take over as

master of the *Vorkurs* – the basic design course, and the metal workshop, that had been formerly taught by Johannes Itten, 'a Swiss national with a predilection for mysticism'.[25] Moholy-Nagy was then twenty-eight, and had arrived at the Bauhaus 'as "the champion of youth" in contrast to the "old" faculty members Kandinsky, Feininger, and Klee who were all between forty and forty-five'.[26]

Moholy-Nagy remained at the Bauhaus for the next five years leaving in January 1928 following the resignation of Gropius as Director.[27] 'The synthesis of art and technology' that the Bauhaus had stood for now ended. In Sybil Moholy-Nagy's opinion the Bauhaus programme had been 'slowly destroyed by a cancerous growth of the technological cells ... Political reaction [had] joined forces with technocratic utilitarianism, demanding that state-endowed education serve no other purpose than the training of specialists'.[28] Faced with 'abandoning his lifework or consenting to a compromise', Gropius resigned, followed by Moholy-Nagy, Herbert Bayer, Marcel Breuer and Xanti Schawinsky.[29] Twenty years later, Moholy-Nagy's resignation letter to the *Meister* of the Bauhaus has 'lost nothing of its validity for the acute problem of endowed education', according to Sybil Moholy-Nagy. It was also a restatement of the principles of William Morris's Arts and Craft Movement that helped launch the *Deutscher Werkbund*:

> As soon as creating an object becomes a speciality, and work becomes trade, the process of education loses all vitality. There must be room for teaching the basic ideas which keep human content alert and vital. For this we fought and for this we exhausted ourselves. I can no longer keep up with the stronger and stronger tendency toward trade specialization in the workshops.
>
> We are now in danger of becoming what we as revolutionaries opposed: a vocational training school which evaluates only the final achievement and overlooks the development of the whole man. For him there remains no time, no money, no space, no concession. ... The school today swims no longer against the current. It tries to fall in line. This is what weakens the power of the unit. Community spirit is replaced by individual competition, and the question arises whether the existence of a creative group is only possible on the basis

of opposition to the *status quo*. It remains to be seen how efficient will be the decision to work only for efficient results. Perhaps there will be a new fruitful period. Perhaps it is the beginning of the end.[30]

It was the beginning of the end. During the next four years different men tried to save the Bauhaus by compromising with the growing Nazi threat. A last attempt by Bauhaus director, Ludwig Mies van der Rohe to continue it as a private school in Berlin failed when the Hitler regime wiped it out as a 'centre of *Kulturbolschewismus*' (Cultural Bolshevism). 'The great illusion of a creative unison between government and education,' Sybil Moholy-Nagy wrote, 'had been destroyed.'[31] The creative philosophy of the Bauhaus that had hoped to restore man – 'the fractional tool of industrial revolution' – to the lofty status of master of art, science and technology, had ended. Civilisation in Germany seemed to have abandoned all creative hope.[32]

*

In 1928 Moholy-Nagy returned to Berlin and divorced Lucia the following year. In 1931 he met Sibylle Pietsch, a scenario writer for the Tobis Film Company and a former theatre actress whom he later married. By then thirty-six and no longer 'the champion of youth', Moholy-Nagy could now only watch the gradual elimination of German youth from daily life as the country slid ineluctably towards totalitarianism. With Hitler's election success in 1933, the National Socialist regime completed the process – drafting youth into the many Nazi organisations, imprisoning the recalcitrant, and driving the creative into exile. In the summer of 1933 Moholy-Nagy participated in the CIAM Congress which took place on a cruise between Marseille and Athens. He filmed the proceedings and met P. Morton Shand who tried to attract him to London. He did visit London in November, meeting up with Herbert Read, before taking up a post in December in Amsterdam, where a large printing company had promised him facilities for experimenting with colour film and photography.[33] He returned briefly to London in August 1934 to study the colour-copy process at Kodak. On 19 May 1935 he left Amsterdam for good and settled in London. He had been invited by Jack Pritchard to design advertising material for the Isokon Furniture Company and on 20 May he moved into

Lawn Road Flats. He stayed there for three months renewing his acquaintance with the Gropiuses and Marcel Breuer, before moving to 7 Farm Walk, Golders Green in September.

Moholy-Nagy spent two years in England, where his friends affectionately knew him as 'Holy Mahogany', before leaving for America in June 1937. On his arrival in London, Sybil recalled, 'he was like Prometheus, dedicated to his fellow men who "saw, yet did not see; heard, yet did not hear; ignorant of how to profit from creation." ... With a Titan's prodigality he poured his strength into three professions: design and display, film and photography, painting.'[34]He collaborated with the Hungarian-born painter and designer György Kepes, who had worked alongside him in his design studios in Berlin; after a long illness Kepes joined Moholy-Nagy in London in 1935.

The two men moved smartly into the world of commercial design winning a number of very lucrative contracts. Their success was hard won: 'If art had to invade industry and commerce, it was the task of the artist to find the right solution,' Sybil wrote. 'That's what he was being paid for – not to bother serious men with a lot of doodling.' There was considerable trouble with the shirt-manufacturing industry. The 'Trubenizing'[35] people wanted one good poster for their pre-shrunk shirts, not a sequence of drawings that explored every visual aspect of the non-wilting collar. When the Abdullah Cigarette Company asked them to design a new cigarette packet, Moholy-Nagy and Kepes submitted four designs, and this was met with some disapproval: 'I want to be served, not educated,' the Managing Director wrote back.[36] By the end of 1935, however, the pedagogue in Moholy-Nagy was back in the ascendancy. Imperial Airways had not only commissioned him to design a mobile exhibition destined to tour the British Empire in a railroad car selling the idea of air travel, but the company had also employed him to 'redesign all their publicity material, from letterheads to posters'. He was also designing posters for the London Underground.[37]

Such high-profile commissions led to Alexander (Alec) Simpson, probably the most famous bespoke tailor of the 1930s, offering both Moholy-Nagy and Kepes permanent positions as art advisors for his newly-built men's store at 203–206 Piccadilly. Alec Simpson was then producing high-quality mass-produced attire for the English gentlemen's clothing market.

As the creator of the DAKS trouser with its patented 'self-supporting' waistband, Alec Simpson had almost single-handedly done away with braces as a functional garment. Simpsons of Piccadilly, now perhaps better known as the inspiration for the 70s/80s television sitcom *Are You Being Served?* and subsequently the flagship branch of the Waterstones chain of bookshops, was built between 1935 and 1936, opening for business in April of that year. Like its 1934 Lawn Road counterpart, Simpsons broke new ground in the field of architecture; it was the first building in London to use welded (as opposed to riveted) steel in the construction of the frame. It was the creation of the architect, Joseph Emberton, and was described by Sybil as 'the most Continental adventure on which an old English firm had ever dared to embark.'[38]

Simpsons was a revolutionary departure from the Saville Row tradition of men's tailoring where men's suits were created according to a prescribed ritual. The century-old rule was one 'of no show windows or display cases for men's stores'. It was now to be cast aside, and 'high-quality clothes and accessories were to be sold in the Continental manner in large, light halls from stocks on display. The success of the venture depended on unimpeachable taste, which would quell any objections to cheapness or vulgarity by the quality of presentation.'[39] Alec Simpson gave Moholy-Nagy the opportunity 'to translate his knowledge of light and colour into reality, addressing not merely a select group of gallery-goers, but everyone.'[40] The design of the front display windows, concave to prevent reflections spoiling the view, was another innovation in the world of retailing. Moholy-Nagy waxed poetic about the challenge and applauded the ever-changing nature of the display. Potential onlookers would respond to shifting light patterns depending on whether it was day, dusk, or made by electricity. As Sybil explained 'the problem posed by a Simpson window display was basically no different from a setting for *Madame Butterfly*. Both had to convey a message; they had to appeal to perception and emotion in the onlooker, just as do painting and sculpture.'[41]

While working on Simpson's window display, Moholy-Nagy was also experimenting with the movie camera and in 1935 he produced a sixteen minute film *In the Cradle of the Deep*, a naturalistic record of the growth of lobsters from babyhood to old age, and the fisherman's struggle to hunt them down. The making of this film introduced Moholy-Nagy to 'British

society' and to the pretentious snobbery that marked daily life in the English country house. The subject fascinated Moholy-Nagy although his German-born wife, Sybil, was not seduced. 'The producer of the lobster film, John Mathias,' she wrote, 'was a wealthy young Englishman who in the best amateur tradition had switched from polo to movies. Living with him and his eccentric family in a Sussex manor, Moholy-Nagy absorbed another pattern – that of British society. Things which irritated me – the feudal relationship between master and servant, the clannishness of the men, the coldness of the women, and the drilled, unnatural politeness of the children – were for him object lessons to which he devoted himself with uncritical attention. He hadn't come to England to judge the English. He had come to demonstrate a new vision, and he was grateful for each clue handed him toward a right psychological approach.'[42]

In The Cradle of the Deep also brought Moholy-Nagy to the attention of the Hungarian-born film producer, Alexander Korda. Like Moholy-Nagy, Korda had supported Béla Kun's communist government and had been forced to flee Hungary during the 'White Terror'. [43] After a brief and unsuccessful career as a film producer in America, he had moved to London in 1931 where he became the inspiration behind London Film Productions. In 1933 he had 'risked everything on a deceptively-lavish movie *The Private Life of Henry VIII* starring Charles Laughton and Elsa Lanchester'.[44] The film was a tremendous success and in 1935 he began work on a $1.5 million adaptation of H. G. Wells' recently published science fiction novel *The Shape of Things To Come.* Korda had watched Moholy-Nagy's *Lichtspiel Schwarz-Weiss-Grau* (*Light Play Black-White-Gray*), made in 1930 – 'a montage of shining machine parts, filmed through a faceted lens and in multiple exposure' – a kinetic sculpture of a 'Light Display Machine',[45] and commissioned Moholy-Nagy to do the special effects for his new film.

This new venture rewarded Moholy-Nagy with the 'almost unlimited chance for experimentation with new plastic materials, and he was fascinated by the idea of constructing scale models which through a skilful use of camera angle and lighting would create the illusion of superhuman dimensions'.[46] The film, *Things to Come*, starring Raymond Massey and Ralph Richardson, while loosely based on Wells's novel, was eerily prescient – predicting a Second World War that would begin on Christmas Day 1940. The film, distributed by United Artists in 1936 and shown in

Odeon cinemas up and down the country, was described by Christopher Frayling as 'a landmark in cinematic design'. That same year two Soviet agents moved into the Lawn Road Flats: in June Arnold Deutsch, a cousin of Oscar Deutsch the influential Jewish owner of the Odeon cinema chain took over Flat 1 from Edgar Lovensteen; in July Brigitte Kuzcynski, after her marriage to Anthony G. Lewis, moved into Flat 4. A key agent, Brigitte anglicised her forename and became known as Bridget Lewis. Her uncle, Hermann Deutsch moved into Flat 10.

<center>*</center>

The spies Bridget Lewis and Arnold Deutsch, and the artists Moholy-Nagy, Marcel Breuer, Walter and Ise Gropius were not the only highly-talented refugees from Fascism to find a safe haven in the Lawn Road Flats. Professor Erich Moritz von Hornbostel, a German Jew living in Flat 6 since 1934, was one of the leading exponents of experimental psychology and ethnomusicology in Europe. Professor Hornbostel was a pioneer in the application of acoustics, psychology and physiology to non-European musical cultures and in the study of 'comparative musicology'. He had been dismissed from his post as director of the Berlin Phonogramm-Archiv in 1933 by the Nazi Party because his mother was a Jew. His decision to move abroad (he went first to Switzerland, then to New York, before moving to London and the Lawn Road Flats in 1934) to work on an archive of non-European folk music recordings was further evidence of the haem-orrhaging of talent from Nazi Germany owing to anti-Semitism and the ideology of 'racial purity'.

In 1912 Erich Moritz von Hornbostel had devised, along with the German musicologist Curt Sachs, the Sachs-Hornbostel 'cross-cultural system of classification of musical instruments' that remains in use to this day.[47] He had been born in Vienna in 1877 into a musical family and had studied piano, harmony and counterpoint as a child. A gifted pianist and composer, he moved to Berlin in 1900 where he met the psychologist Carl Stumpf and the Berlin physician, Otto Abraham. In September of that year Abraham and Stumpf recorded a Siamese theatre group of musicians and dancers performing at the Berlin Zoological Gardens with an Edison cylinder phonograph, and had used the recording to establish the Berlin Phonogram-Archiv later that year. An interesting partnership developed

between Stumpf and von Hornbostel; Stumpf's main interest was in acoustics and music psychology while Erich von Hornbostel, who took over the archive in 1905, developed a keen interest in ethnology. As a result von Hornbostel established important links between the Berlin Phonogram-Archiv and the Berlin Museum fur Volkerkunde (Ethnology).

In 1902 the then director of the museum, Professor Felix von Luschan, took a phonograph with him on an expedition to Sendshirli (in present-day Turkey), where he recorded Turkish and Kurdish songs. Inspired by von Luschen's example, von Hornbostel, equipped with a phonograph and a supply of blank wax cylinders, visited the Pawnee in the United States in 1906 to conduct field recordings, keeping a detailed journal of all necessary information about the recordings (such as place, date, details of those involved etc.).[48] The Berlin Phonogram-Archiv produced galvano-plastic negatives ('galvanos') making two copies – one for the collector and one for the Archiv. Von Hornbostel then created a system to transcribe Western and non-Western primitive music from sound recordings to a hand-written score. He went on to specialize in African and Asian music, making many recordings and transcribing his results. His 'goal was the creation of a musical International Phonetic Alphabet for the standardised representation of musical sounds in comparative musicology.'[49] A highly regarded teacher, his students included the American composer Henry Cowell and the Hungarian-born, anthropologist and linguist, George Herzog whose fieldwork with the Native Americans of the south-western United States for the American Museum of Natural History, the Smithsonian, and in Liberia for the University of Chicago, laid the foundation for the emerging discipline of ethnomusicology.[50] Erich von Hornbostel died in Cambridge on 28 November 1935.

<p style="text-align:center">*</p>

The majority of those who moved into Lawn Road Flats in 1934 were not quite so distinguished and, apart from Nicholas Monsarrat in Flat 29, very little is known of them.[51] E. F. Herbert, the resident in Flat 17, had some success as an author of children's books during the Second World War. *Blossom the Brave Balloon* was published in 1941 and was advertised as a story to help English children understand what barrage balloons were for and to familiarise them 'with extraordinary circumstances'.[52] The book was

illustrated by the *Daily Mirror* cartoonist Philip Zec before he famously upset Winston Churchill with his cartoon on the government's decision to increase the price of petrol in 1942. The cartoon, depicting an oil-smeared British sailor clinging to a raft with the caption: "'The price of petrol has been increased by one penny" Official', was said to have thrown Churchill into a fearful rage. Upset by the cartoon's suggestion that the life of sailors had been put at risk to enhance the profits of the oil companies, Churchill ordered MI5 to open a Personal File on Zec, who was Jewish, and considered closing down the *Daily Mirror* altogether for the duration of the war. Home Secretary, Herbert Morrison called it a 'wicked cartoon' and Ernest Bevin, the Minister of Labour, spoke against Zec's work in the House of Commons for lowering the morale of the armed forces and the general public.

*

Another 1934 Lawn Road tenant who should be mentioned in this chapter was a young BBC employee, A. G. Lewis, who lived in Flat 4. Anthony Gordon Lewis was a member of the CPGB and was courting a very interesting German woman, Brigitte Kuczynski, who lived with her parents and three of her four sisters at 12 Lawn Road, a large Victorian house converted into apartments and directly facing Lawn Road Flats. Like Gropius and von Hornbostel, Brigitte was a refugee from Hitler's Germany, a member of the German Communist Party (KPD), and a talented and prodigious secret agent working for Stalin's secret service along with her parents and siblings, two of whom, Jurgen and Ursula would play a critical role in securing Britain's atomic secrets. Whether or not Russian intelligence had taken a formal decision to direct spying operations from Lawn Road Flats and its neighbouring streets is an interesting question. However, over the course of the next twenty or so years no less than eleven people associated with the Russian secret services lived in the Flats. All of them were at some time or another investigated by the British Security Service MI5. Moreover, there were five suspected spies living in Lawn Road itself, while a further five visited the Flats on a regular basis. All were at one time or another under MI5 surveillance. They were not all, it should be pointed out, living in the Flats or Lawn Road at the same time, although their collective stay there certainly overlapped; nor did they all belong to the same organisa-

tion. Some, like Arnold Deutsch belonged to the Comintern's intelligence body, the OMS, others like Brigitte, Barbara and Jurgen Kuczynski worked for Soviet military intelligence, the GRU, while others had been recruited to the NKVD. Did they know each other? Did they know that each was involved in some capacity or another in the Soviet intelligence system? Did they work alongside each other, offer mutual support etc.? What was the role of each and every one of them? What tasks did they perform? What were their nationalities? Were they all dyed-in-the-wool Stalinists or did some of them nurture Trotskyite sympathies? And why did they all gravitate to this small corner of North London? These are interesting questions. George Orwell writing on the decline of the English murder remarked that the English murderer unlike his American counterpart liked to keep his victims corpse close by, buried in the garden or the cellar, whereas the American puts distance, as much as possible, between him and his corpse. American and British spies working for the Soviet Union appeared to be no different from their homicidal counterparts, at least in this respect.

The Kuczynski family were the first Soviet agents to arrive in Lawn Road, brought there in 1934 by another long-serving family of spies, Gertrude Sirnis and her daughters Gerty and Melita. Gertrude Sirnis's career as an opponent of the establishment in Britain could be traced back to her activities as a suffragette, and as an opponent of the imperialist policies of the Great Powers in the years leading up to the First World War. Her opposition to that conflict, alongside a belief that the Bolshevik Revolution of October 1917 was the 'revolution to end all wars' and the dawn of the long-awaited socialist utopia, acted as a strong motivating factor in her decision to spy for the Russians. Born in Pokesdown on the outskirts of Bournemouth in 1878, she had been introduced to the vagaries of Russian politics at a very early age. At the time, the nearby village of Tuckton hosted a number of Russian political émigrés who had become something of a curiosity to the local inhabitants. They occupied a large Victorian mansion called Tuckton House where, under the watchful eyes of Tolstoy's literary executor Vladimir Chertkov, they set up a British branch of the Free Age Press, a small publishing business devoted to the production of cheap English-language editions of Tolstoy's works in which no copyright would be claimed. Unexpurgated Russian editions of Tolstoy's works were also printed and smuggled back into Russia. In a strongroom

in the cellar, under 24-hour guard, Tolstoy's manuscripts were carefully maintained. A disused waterworks in nearby Iford Lane was converted into a printing works and fitted with Russian type, Russian compositors, printing machines, machinists, imposing tables, stereotyping plant, wire-stitching machines, guillotines for cutting paper and all the other necessary plant of a small printing and paper-binding factory. Tolstoy's novels were subject to heavy censorship in Russia following his intervention on behalf of the Dukhobors, a persecuted religious sect who shared many of Tolstoy's precepts – chastity, abstinence from alcohol and tobacco, the pooling of all goods and property, co-operation and non-resistance to evil. In keeping with the latter they refused to bear arms in the Russian army and, as a consequence, were subjected to a number of atrocities from Cossack troops.

In December 1896 Tolstoy had written a manifesto *Pomigite!* (*Give Help!*) on their behalf, which was signed by a number of influential literary figures including Count Chertkov. A copy was sent to Tsar Nicholas II, who responded by banishing Tolstoy to his estates at Yasnaya Polyana and exiling Chertkov to the Baltic Provinces. However, following intercession by his mother Yelizaveta Ivanovna, née Countess Chernyshova-Kruglikova, a former member of the Tsarist Court and already in exile in Bournemouth for her Baptist convictions, Count Chertkov was allowed to go into 'permanent exile' in England. Chertkov already knew England well. His mother had been a follower of the English evangelist Lord Radstock and was related by marriage to Count P. A. Shulatov, the Russian Ambassador to Britain between 1874 and 1879. At Tuckton House, Chertkov gathered around him a number of experienced publicists and revolutionaries drawn from across the Russian Empire including a young Latvian bookbinder and translator, Alexander Sirnis, and a Fleet Street sub-editor, Theodore Rothstein, then working on A. G. Gardiner's *Daily News* and C. P. Scott's *Manchester Guardian*. Rothstein would become Lenin's first secret agent in Britain.

Gertrude, a young widow,[53] and a supporter of the infant Labour Party, visited the Russian colony at Tuckton House regularly, becoming the community's cobbler. She fell in love with Alexander Sirnis and married him in 1909. They worked together on Tolstoy's manuscripts, translating his *Diaries* and other works. While the dominant philosophy of Tuckton

House was Tolstoyan, a number of visitors and workers on the translations embraced Marxism and other revolutionary doctrines. This was the case of Pyotr Kropotkin, philosopher and anarchist, and Sirnis's fellow Latvian, Jacob Peters, who gained notoriety in 1912 for his connections with Latvian anarchists involved in the Houndsditch Murders and the Siege of Sydney Street in London. After the Russian Revolution of October 1917, Jacob Peters became deputy chairman of the CHEKA (the predecessor of the NKVD) and the loyal executioner of chairman Felix Dzerzhinsky. These three men – Jacob Peters, Alexander Sirnis (both Latvians) and Theodore Rothstein (Lithuanian) – formed the coterie around which the early, post-revolutionary, Bolshevik intelligence service in Britain was formed. All three belonged to the Communist Working Men's Club and Institute in Charlotte Street, London, and were admirers of the Bolsheviks. Jacob Peters and Alexander Sirnis belonged to the 'Bolshevik section of the Russian Social Democratic Labour Party, Social Democracy of Lettland, London Branch'; while Rothstein was a member of the Russian Social Democratic Labour Party (Bolshevik) since its foundation in 1902.

All three were members of the British Socialist Party (BSP), a Marxist body which, until 1916, was led by an eccentric top-hatted stockbroker and Sussex county cricketer, Henry Hyndman. On the outbreak of the First World War, the BSP split between supporters and opponents of the war. The pro-war faction, led by Henry Hyndman, called on the workers to 'join up', while Theodore Rothstein, who had been prominent in organising the anti-war section in the build up to the war, took a leading role in the activities of the anti-Hyndmanites. When other members of the BSP's National Executive began appearing alongside recruiting sergeants, Rothstein resigned his membership of the party in protest. To avoid arrest and internment as an alien under the newly-enacted Defence of the Realm Act, Rothstein applied for, and secured, employment with British intelligence as a reader of the foreign press in MI7(d). According to Security Intelligence Middle East (SIME), he was also allegedly working for Turkish intelligence. He had been approached by them in 1908 while working alongside the Liberal-Radical anti-imperialist campaigner and Arabist, Wilfrid Scawen Blunt (a kinsman of the future Soviet spy, Anthony Blunt) in an organisation called the British-Egypt Association set up by Blunt to protest against Britain's illegal occupation of Egypt. Rothstein now began using

his knowledge of European affairs, and of the British and European labour and socialist movements gleaned from his work for MI7(d), to contribute informative articles to the BSP's newspaper, *The Call*. In order to hide his identity he wrote under two pseudonyms, John Bryan and W.A.M.M.[54]

Following the Russian Revolution and the Bolshevik seizure of power in October 1917, Rothstein offered his services as an unofficial go-between for the Bolshevik leader, Vladimir Ilyich Lenin, and the then British Prime Minister, David Lloyd George. At the time Rothstein was working on the Labour Party's Advisory Committee on International Questions with the then junior Foreign Office civil servant, Rex Leeper, and Virginia Woolf's husband, Leonard. Together with Leeper and Maxim Litvinov, a Russian political émigré and Bolshevik who had been in Britain since the beginning of the war, he made arrangements for a colleague of Leeper's, Robert Bruce Lockhart, to travel to Russia as a British envoy with ciphers. Maxim Litvinov was granted similar privileges in Britain. Rothstein now used his position inside MI7(d) to provide Gertrude Sirnis's husband, Alexander, with up-to-date news on the Russian Revolution. Alexander Sirnis at this time was struggling to keep the left-wing press alive in Britain, thwarting attempts by the authorities to close it down. In 1916 he had resigned from the BSP and joined the more militant Socialist Labour Party (SLP) based principally in Glasgow, where its paper *The Socialist* was published. Here, in 1918, the British Special Branch pied their type needed for publishing articles and speeches by Lenin, busting the printing presses in the process, so Sirnis quickly arranged for scarce paper and parts to be despatched to Glasgow from Chertkov's Russian printing press in Iford Lane.

Rothstein, in co-ordinating the response to the Russian Revolution of the more extreme elements of the British left was now well-placed to oversee intelligence work on behalf of Lenin's government inside the British labour movement. Whilst doing so he also ensured that a backchannel of communication was kept open between the British and Bolshevik governments, in the guise of the Lockhart-Litvinov agreement. However, Bruce Lockhart was arrested in July 1918, and expelled from Russia for his part in a botched attempt to overthrow the Bolshevik government (the so-called 'Lockhart Plot'). The British authorities retaliated by arresting Litvinov and depositing him in Brixton gaol before deporting him in November, so Rothstein found himself in sole charge of Bolshevik affairs in Britain.

At the time there was a split in the British Cabinet between those, led by Lloyd George, who favoured negotiations with the Bolsheviks with a view to signing a trade agreement and some form of formal recognition of the regime; and those, most notably Winston Churchill and George Curzon, who were vehemently opposed to anything associated with Bolshevism. Rothstein found himself squeezed between the two factions and his status in Britain was far from secure. He had been denied British nationality in 1910 for writing a book, *Egypt's Ruin*, highly critical of British rule in Egypt and, as his MI5 file shows, steps were now taken to arrange his deportation. MI5 had raised the question of Rothstein's continued employment by the intelligence services as early as 25 May 1917 when, following publication of Lenin's *April Theses* calling for the overthrow of the Provisional Government and Russia's withdrawal from the 'imperialist war', they regarded him as a security threat. The head of MI7, Lieutenant-Colonel Wake, however, retorted that Rothstein was 'a very valuable man' and that he would be 'very averse' to part with him, although he would 'do so without demur' if it was considered absolutely necessary. He spoke of his concern 'that if Rothstein was dismissed from MI7 he would immediately be snapped up by Count Gleichen, ex-head of Section E (Austrian and Turkish) of the Intelligence Department at the Foreign Office and a leading figure in Lloyd George's personal Special Intelligence Bureau. Count Gleichen', he observed, 'had already borrowed Rothstein's services on one occasion and envies MI7 the possession of them.'[55] By June, however, sterner voices were warning the intelligence services about Rothstein's activities, among them the Liberal MP Sir Donald Maclean, the father of the future Cambridge spy Donald Maclean, who wrote to MI5 expressing his concern about Rothstein's connections with the socialist movement in London. The veteran socialist leader, Henry Hyndman warned that Rothstein was 'hand in glove with Lenin'. The Russian scholar in the Foreign Office, Dr Seton Watson also raised his objections to Rothstein's continued employment describing him 'as a completely unreliable person who should on no account have access to confidential documents.'[56]

The Foreign Office, however, continued to view the matter differently. When Rothstein was arrested by the Metropolitan London police and held 'on a ship lying in the Pool just below London Bridge awaiting deportation', he was successful 'in getting a letter to Lloyd George smuggled out.'

Lloyd George apparently gave immediate orders to the police to release the Russian 'ambassador'.[57] The Foreign Office believed that if Rothstein was 'sent back forcibly to Russia' he would prove a most 'dangerous opponent' of the British Government. Rex Leeper argued that it would be far more sensible to keep a watchful eye on Rothstein in England, than to deport him: 'owing to his very real ability, doctrinaire though he is, and his intimate knowledge of this country, extending over many years, he would be a dangerous opponent to us and of great assistance to the Soviet Government. On this ground I think his deportation inadvisable.'[58]

Leeper, who was then working under Sir William Tyrell, Permanent Under Secretary at the Foreign Office, on the Reconstruction of Eastern Europe, believed that a softly, softly approach to Rothstein would prove more effective. He suggested to Tyrell that he should approach Rothstein privately and warn him that any further activity on behalf of the Soviet Government would result in his expulsion. His advice was accepted. Lenin also took steps to protect Rothstein by adding his name to the Russian Trade Delegation when it arrived in London on 27 May 1918 to conduct negotiations with Lloyd George. At that time, Rothstein was also overseeing the complex and fractious negotiations underway to form a united Communist Party in Britain as disparate left-wing parties and socialist societies had openly come out in support of the Bolshevik Revolution. The recently formed Communist International (Comintern), in order to increase the pressure on European governments to stop the Allied War of Intervention and support of the Whites in the Russian Civil War, now embarked upon an aggressive policy of communist unity amongst the various left-wing groups in Europe.

The creation of the Comintern in March 1919 had encouraged the formation of overseas communist parties, splitting the western labour movement along reformist and revolutionary lines in the process. Those who opposed the creation of the Comintern now called for the resurrection of the 'collapsed' Second International, leading to a fierce conflict between the two International bodies.[59] In Britain, both sides regarded control over the editorial policy of the labour movement's main newspaper the *Daily Herald* as essential to their cause. Yet despite its growing importance the paper was in serious financial difficulties and, by the end of the year, it was confronted with a near embargo on supplies from British paper merchants

and was on the verge of closure. In order to overcome these difficulties Francis Meynell, a director of the paper, and future Lawn Road Flats *aficionado*, approached Rothstein privately and requested his help in securing the *Daily Herald*'s future. Rothstein introduced him to members of the recently arrived Soviet Trade Delegation, whose members included the CHEKA agent Nikolai Klishko, at a luncheon party at Frascati's restaurant in London. Meynell raised the question of a subsidy for the *Daily Herald* and thus began Meynell's brief career as a secret agent.

Arrangements were now put in place for Meynell to visit Litvinov in Copenhagen on behalf of Litvinov's English born wife Ivy (née Low) who had recently been refused permission by the British authorities to travel abroad. Meynell, the son of the poet Alice Meynell, recorded the lighter side of these events in his entertaining autobiography *My Lives* published in 1971. A *bon vivant* who would later play an important part in the culinary activities of Lawn Road Flat's Isobar, he played his part wonderfully, making arrangements for his sister Viola, who was a close friend of Litvinov's wife, to visit her and collect a special gift: a spotted necktie containing a secret note from Rothstein. Once in his possession, Meynell was to deliver it personally to Litvinov in Copenhagen:

> I said, 'Here, dear Maxim, is a present from Ivy,' and gave him a carefully parcelled new tie in which was sewn a note from Rothstein, who was substituting for Litvinoff in London. Maxim thanked me with an understanding glance and went into his bed-room. In a few minutes he returned, wearing the new tie. When we were seated, and chatting, the door open all the time, he said, 'You English, are great pipe smokers. Here is some Russian tobacco to try and he tossed me a tobacco pouch. I knew that he knew that I never smoked a pipe, so I guessed that the pouch contained an answer to Rothstein. It did – a practical one; for when I got back to my hotel I opened the pouch and found two strings of pearls.[60]

Meynell made a number of such trips to Litvinov in Copenhagen, each time transporting jewels back to Rothstein for sale on London's black market. During one 'jewel-trip' he smuggled two strings of pearls buried in a jar of Danish butter, on another he posted a large and expensive box of chocolate creams, each containing a pearl or diamond, to his friend the

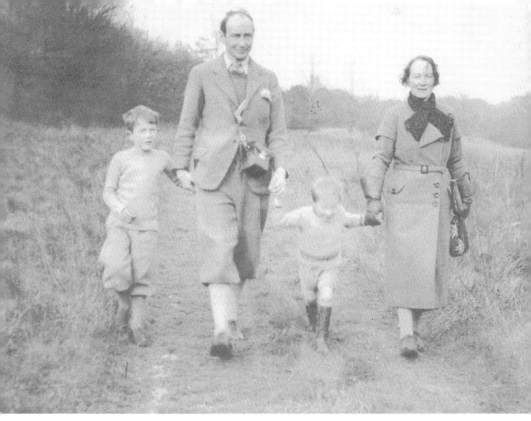

1 *(above)* Jack and Molly Pritchard with their children Jonathan and Jeremy.

2 *(right)* Wells Coates.

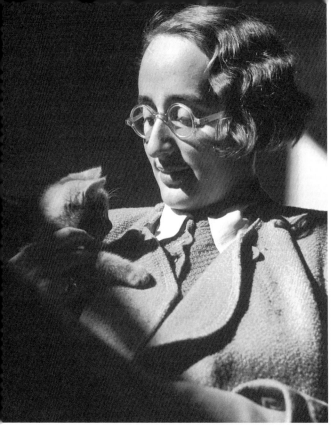

3 (left) Edith Tudor-Hart.

4 (below) Lawn Road Flats under construction.

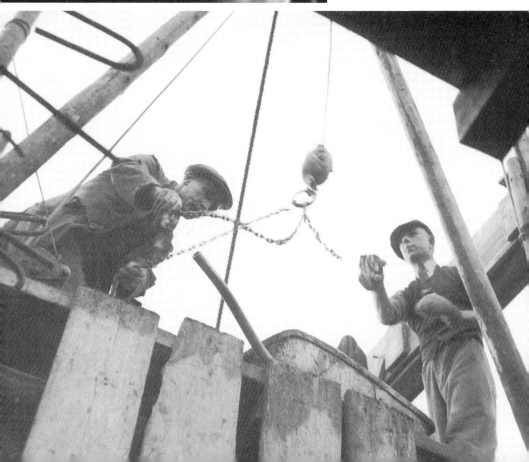

5 *(right)* Lawn Road Flats under construction, lunch break.

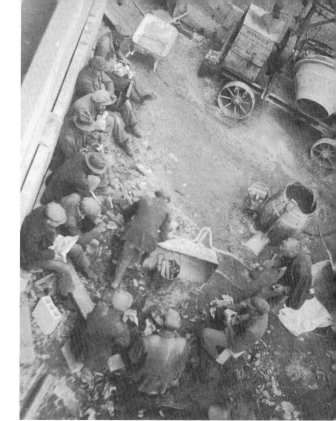

6 *(below)* The rear of the Flats under construction.

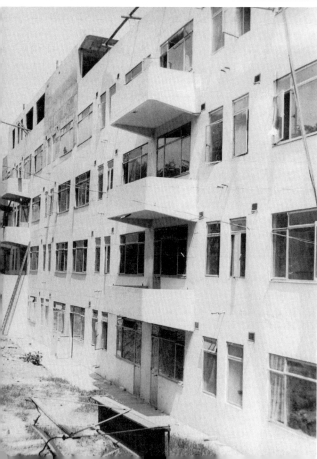

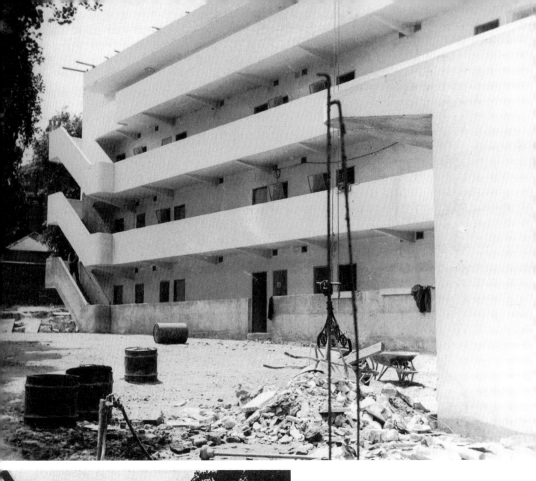

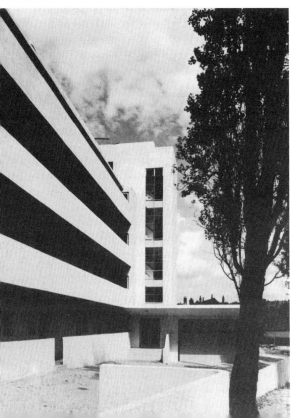

7 *(opposite above)* Lawn Road Flats under construction front.

8 *(opposite below)* Completion.

9 *(right)* Thelma Cazalet M.P. declares the Lawn Road Flats open by breaking a beer bottle over its side. Wells Coates architect on right behind Cazalet. Jack on the left wearing a trilby, Molly by his side.

10 *(below)* Lawn Road Flats opening ceremony

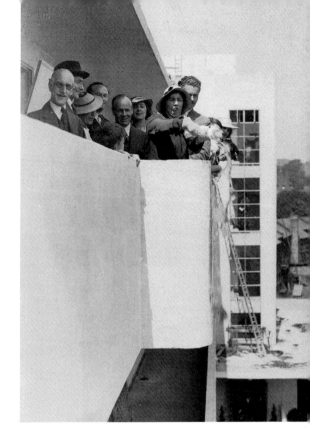

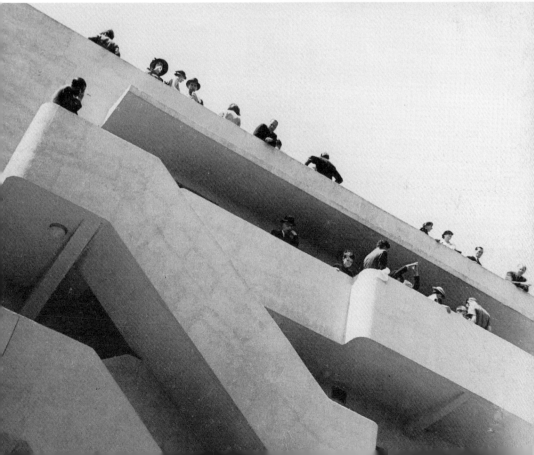

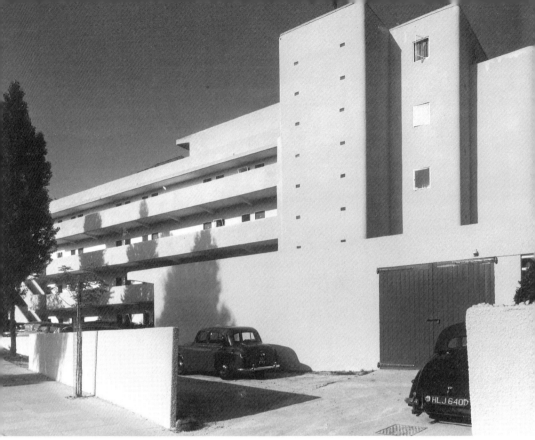

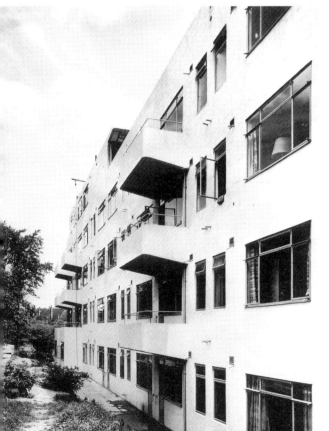

11 *(above)* Lawn Road Flats.

12 *(left)* Lawn Road Flats (rear)

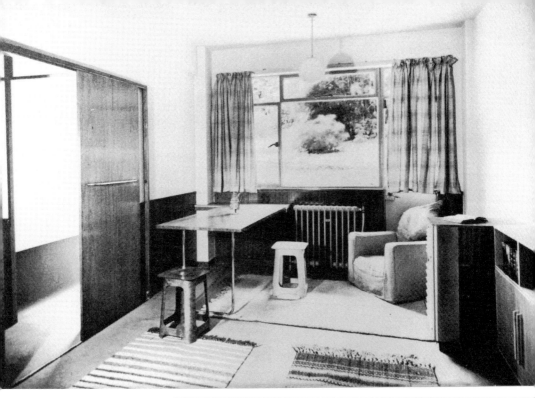

13 *(above)* Interior, Ground Floor Flat.

14 *(right)* Interior, minimalist kitchen.

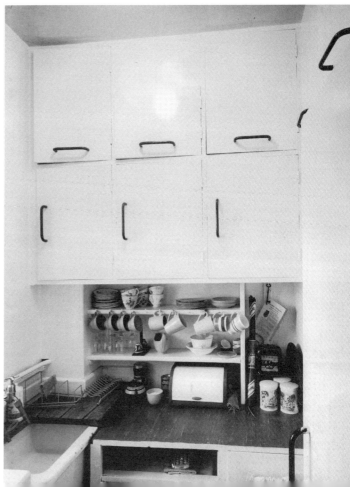

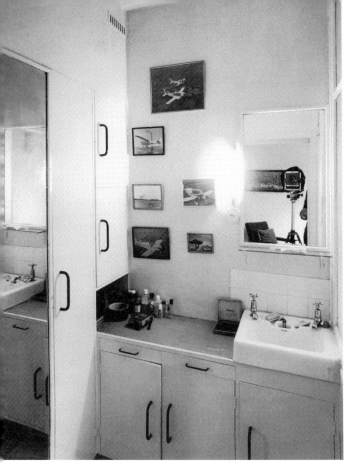

15 *(left)* Interior, minimalist bathroom and dressing room.

16 *(below)* Interior, living room ground floor.

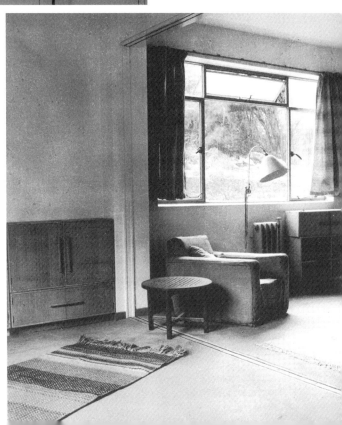

philosopher and future broadcaster, Cyril Joad. (A fellow *bon vivant* and raconteur, Joad later had a walk-on part in the history of Lawn Road Flats and Soviet espionage in Britain. A good companion and close friend of Jack Pritchard's who nominated him for membership of the Savile Club during the Second World War, Joad was in all respects *cavendo tutus.*[61]) Once back in London, Francis Meynell was taken to Scotland Yard and searched but nothing was found. Two days later he and his wife recovered their chocolates from Joad and 'spent a sickly hour sucking the chocolates and so retrieving the jewels.'[62]

Unfortunately, despite these elaborate precautions, the Bolsheviks' diplomatic codes had been successfully broken by the Government's Code and Cypher School, allowing Sir Basil Thomson to closely monitor Meynell and Rothstein's activities. It was now only a matter of time before the authorities closed down the Rothstein network. On 28 May 1920, Nikolai Klishko, assistant to Leonid Krassin, the head of the Russian Trade Delegation, was summoned to Scotland Yard to attend an interview with Basil Thomson and there it was made clear to him that Rothstein's career as a secret agent in London was all but over. He was 'advised to cut off relations with Mr Rothstein until we settle about him. He has for a long time been interfering in politics here. We do not think it important enough to take any action, but there comes a time when it may be expedient to act. After all, he is a Russian.'[63]

Klishko, who was apparently visibly unsettled by this encounter, immediately made contact with Meynell and asked him to take possession of a number of platinum bars for the Russian Trade Delegation. He was helped by a passing policeman:

> 'There is danger,' he [Klishko] told me, 'that we shall be expelled. We have here a large quantity of platinum. We do not want to take it with us. Will you guard it for us till our return?' I agreed, and struggled down the stairs with a barely portable suitcase in each hand. In the street I hailed a taxi. The first suitcase went safely in. When I lifted the second its handle came off and several wrapped bars of platinum fell on the pavement. A policeman helped me lift them on to the taxi's floor. 'Heavy, ain't they?' he said.[64]

Rothstein was less fortunate. Basil Thompson's agents followed him to a

converted Pullman car at Tophill, Lake Windermere, where he was known to be co-ordinating the secret negotiations for the formation of a Communist Party in Great Britain.[65]

There were then three main socialist groups competing for control of the nascent British communist movement: the British Socialist Party (BSP), the Socialist Labour Party (SLP) and Sylvia Pankhurst's Workers' Socialist Federation (WSF). In 1919 Rothstein was still a well-known political figure in the BSP and he was able to lead it into the Communist Party of Great Britain without too many problems. In October 1919, following a ballot of members on the question of affiliation to Comintern, 98 branches voted in favour with four branches voting against. The SLP and Pankhurst's WSF, however, would not join a Communist Party dominated by the BSP because of the BSP's insistence that the Communist Party should seek affiliation to the British Labour Party, and fully participate in parliamentary politics. To overcome their opposition, Rothstein approached both parties and told them that he was Lenin's 'official' representative in Britain. Quoting from Lenin's 1919 pamphlet *Left-Wing Communism: An Infantile Disorder*, he pointed out that Lenin fully supported the BSP's position on affiliation to the Labour Party and began to channel some of the money earmarked for Meynell's *Daily Herald* to an 'unofficial' group inside the SLP hoping to force through a change of policy. However, he had no success whatever with Sylvia Pankhurst who, according to Special Branch reports on the negotiations, claimed she, not Rothstein, was the authentic voice of Leninism in Britain:

> It is believed that when Litvinoff left for Russia he appointed Theodore Rothstein to represent him, but Rothstein had a competitor in Sylvia Pankhurst, whose restless activity appears to have impressed the continental Bolsheviks to such effect that she was invited to attend the International Congress in Moscow at the beginning of 1919, an invitation that she would gladly have accepted if she could.[66]

Lenin was called upon to adjudicate and ruled in favour of the formation of two communist parties in Britain one working inside parliament and the other outside. Sylvia Pankhurst remained unmoved. A British Cabinet Report on 'Revolutionaries and the Need for Legislation', dated 2 February 1920, remarked that 'Sylvia Pankhurst distrusts Rothstein'

while 'Rothstein has a contempt for Sylvia Pankhurst's intelligence and discretion. But the real division is between those who favour using the Communist Party in Parliamentary elections and those who, like Sylvia Pankhurst, will have nothing to do with Parliament at all. Lenin has been kept accurately informed of these differences, and in a letter to an English supporter, which was quoted in one of my recent reports, he says that he would favour a Communist Party in Parliament (for the conversion of the other Parties) and a Communist Party outside working in collaboration with it.'[67] Defiant, Sylvia Pankhurst journeyed to Moscow in July 1920 to remonstrate with Lenin and to complain to him about Rothstein's behaviour. She was forthright and made her point with some force. As a consequence, Rothstein began to fret and in August decided to travel to Moscow to report to Lenin first hand on the progress being made towards Communist Unity in Britain. Basil Thomson could barely disguise his pleasure:

> Rothstein's recall to Moscow is connected with Miss Pankhurst's presence in that city. She claims that Rothstein has appropriated for his personal use money given him for propaganda and that he has mismanaged propaganda in this country.[68]

It was an opportunity too good to miss and, as soon as Rothstein left the country in August, Thomson persuaded the Home Office to act: 'Orders have been issued that Rothstein shall be refused leave to land if he should return to this country.'[69] Lenin, fearful that such 'a dirty trick' was intended, rushed off a letter on 15 July to Rothstein telling him that he was to remain where he was.[70] The letter missed him, and as soon as he was out of the country the government declared him *persona non grata* and he was refused the right of re-entry. The following month Sylvia Pankhurst's WSF, the 'unofficial' SLP, the BSP, the ILP (Left-Wing), and the South Wales Socialist Society all joined together to form the Communist Party of Great Britain (CPGB). One of their first acts was to apply for affiliation to the Labour Party, which was turned down. The CPGB then developed more or less along the lines advocated by Lenin in his letter to an English comrade and two communist organizations came into being, the one 'open', reformist in character and revolutionary in sentiment; the other 'secret', an underground organization created for clandestine activities and for the purposes of espionage.

*

Soviet espionage in Britain during the 1920s owed much to the groundwork carried out by Theodore Rothstein in the immediate post-revolutionary period. After his expulsion in 1920, many of his activities were taken over by his son Andrew who, like Francis Meynell and Cyril Joad, would resurface in Lawn Road Flats. Well-educated and a raconteur, his name appears in the records of the Lawn Road Flat's Half Hundred Club, a members-only dining club, and on a list of previous tenants to be invited to the Flats' twenty-first birthday party in 1955. During the Second World War he was linked with Flats 16 and 8, although there is no proof that he actually lived there.[71] A founder member of the CPGB, a Marxist intellectual who had taken an active part in the soldiers' strikes of 1919, Andrew Rothstein remained an influential member throughout the history of the CPGB, spanning the years 1920–1991. A Brackenbury scholar and graduate of Balliol College, Oxford, he was, according to his MI5 file, the 'leader of the Communist set at Oxford and an extremely active propagator of intellectual Bolshevism'. In 1920 he visited his father in Moscow, along with two of his Oxford undergraduate friends, and caused something of a sensation when he claimed to be 'primarily responsible for the preparation of the list of persons to be shot in England when the Red revolution dawned'. When asked by another diner how he selected persons for inclusion on this list, a note in his MI5 file states that he was unable to 'give any understandable answer'.[72]

Communism at Oxford University between 1917 and 1920 centred upon Balliol which housed a number of leading Marxist intellectuals, though not all fully paid up members of the CPGB, who over time made their way to Lawn Road Flats. Among them was the historian of the British labour movement and founder of *The Good Food Guide*, Raymond Postgate, whose wife Daisy was a daughter of Labour leader George Lansbury. Postgate's sister Margaret married the labour historian and leading Guild Socialist, G. D. H. Cole. Vere Gordon Childe, the pre-historian and secretary of the Oxford University Socialist Society (then under the presidency of G. D. H. Cole) and also Agatha Christie's bridge partner during the Second World War, was an active Oxford communist. All five were close friends and maintained frequent contact with Andrew Rothstein

who, back from his visit to Moscow, promoted himself to the helm of the underground Communist Party in Britain.

In 1920 Andrew Rothstein was attached to the Russian Trade Delegation and was given responsibility for targeting naval and military secrets as well as conducting propaganda among the Armed Forces. He managed the Trade Delegation's Information Bureau (the forerunner of the Russian news agency TASS), serving as the main link between the Soviet government and the CPGB. In 1924 he was appointed London Correspondent of a new press agency, the Russian Telegraph Agency (ROSTA), and was admitted to the inner circle of the Russian-British section of the communist 'underground' movement. Working closely with the Soviet Embassy and the Russian Trade Delegation, the CPGB's underground section also had responsibility for the quarterly transmission of Russian money from the Soviet Embassy to the CPGB and affiliated organizations. This arrived at the Soviet Embassy in the form of American currency by diplomatic bag. In 1925, using the alias C. M. Roebuck, Rothstein was appointed to the CPGB's Central Executive Committee and served as the 'connecting link between Soviet institutions in Britain and the CPGB'.[73] In July 1926 he left TASS to take up employment as London correspondent of 'Trud' (the organ of the Russian TUC) and *Pravda*. At the end of the year he was back in Moscow attending the Plenum of the Executive Committee of the Communist International and was in great demand. In December 1927 he went to Brussels to take part in a meeting of the League Against Imperialism, and in the summer of 1928 he attended the Sixth Congress of the Communist International in Moscow. He remained on the Central Executive Committee of the CPGB until 1927. After the collapse of the General Strike in 1926, the true extent of Soviet espionage in Britain was laid bare following the ARCOS raid of 13 May 1927 on the premises of the Russian Trade Delegation, and Rothstein's influence was then curtailed by a purge of communists from the official labour movement including the Labour Party.[74]

This purge was made all the easier by changes taking place inside the CPGB itself as a result of instructions issued by Comintern. The Ninth Conference of the CPGB had passed a resolution calling for a campaign to bring down the elected Conservative government and its replacement by a Labour government. The new government would then pursue a working

class programme under the control of the labour movement. No sooner had this conference finished, however, than a telegram arrived from the president of Comintern, Nikolai Bukharin, informing the Executive Committee of the CPGB that the attitude of the communist parties to their respective social democratic parties was being reviewed. The following year the Sixth World Congress of Comintern adopted the divisive policy of 'Class against Class', whereby all social democratic parties were to be condemned as 'social fascist'. The CPGB was ordered to withdraw its support for the Labour Party at elections and was told to stop seeking affiliation. Andrew Rothstein, and other members of the National Executive Committee, expressed their dismay. Arguing that the British Labour Party was not yet a social democratic party in the accepted meaning of the term they quoted from Lenin's *Left-Wing Communism: An Infantile Disorder* to support their claim that affiliation to the Labour Party gave them a direct link to the masses. Comintern would not budge and in 1929, following the May General Election and the return of Ramsay MacDonald's minority Labour Government, Andrew Rothstein was summoned to Berlin by the executive committee to explain the CPGB's continued support for a policy of 'class collaboration' as opposed to 'class against class'. At the Eleventh National Congress of the CPGB, along with other leading members of the Party, he was dismissed from the National Executive Committee on account of alleged 'right' deviationism. The Central Committee of the CPGB even went so far as to conclude that he was a 'danger' to the British Party and 'placed him at the disposal of the Russian Communist party'. In January 1930 he left England to work with his father in Moscow where he remained until May 1931. He was only allowed to return to England after difficult and protracted negotiations between Moscow and the executive committee of the CPGB. His principal opponent was his fellow Oxford graduate, Rajani Palme Dutt, who reasoned that by sending Andrew Rothstein to Moscow the leadership had given the impression that they considered him dangerous; if they were to recall him they would only give the impression that they were too weak to do without him. Nevertheless, Rothstein was allowed to return to London where he took up employment under Jacob Janson in the construction and shipbuilding department of the All-Russian Co-operative Society, ARCOS, and joined the Islington branch of the Communist Party. Correspondence with his father at this time showed

that he was dissatisfied with this position and that he thought his abilities were being wasted.

From 1930 Theodore Rothstein ran the Press Section of the Soviet Foreign Office, and in August 1932 the head of the TASS agency in Moscow, Doletsky, was issued with new instructions to see that Andrew Rothstein was returned to his former employment as head of the TASS offices in London. In this capacity he travelled to Europe on a number of occasions. He went to Geneva in connection with the Disarmament Conferences of June and December 1932 and May 1934, and he also represented TASS in the Saar region while the plebiscite to determine its status was being carried out in December 1934. At the Party's National Congress in 1935 he was again elected to the Executive Committee of the CPGB.

Andrew Rothstein made a number of visits to Moscow between November and December 1933, and June and September 1935. He was also an executive member of the Friends of the Soviet Union and the editor of *Russia Today*. In 1934 he recruited the eldest daughter of Gertrude Sirnis, Melita Norwood, a secretary working at the British Non-Ferrous Metals Research Association in Paddington to the NKVD at a meeting of the Friends of the Soviet Union. At that time Andrew Rothstein had responsibility for Scientific and Technical Intelligence (S&T) gathering in Britain, and had been observed 'making mysterious motor car drives to Cambridge and other neighbouring towns' with the Soviet Ambassador Ivan Maisky to meet with the Russian scientist Peter Kapitza, then working on a plant for the dilution of helium at the University of Cambridge Cavendish Laboratories.[75]

<div align="center">*</div>

It was Gertrude Sirnis's youngest daughter, Gerty, who introduced the espionage talents of the Kuczynski family to Lawn Road. In 1933 Gerty was studying law at the London School of Economics and was a member of the student-staff communist group. There, in September 1933, she met the German communist, Robert (René) Kuczynski, a statistician who had resigned his post at a Berlin Library on the grounds of being an anti-Nazi. For his own safety he had moved to Geneva carrying out honorary work for the League of Nations before enrolling at the LSE on a six-week course of study. In October he successfully applied for an 'extension of

stay in the UK' and told Gerty that he had been forced to flee Germany, leaving his wife and two of his five daughters in Berlin where their lives were in danger. He had made arrangements for them to come to London but needed to find them suitable accommodation as quickly as possible. Gerty's mother, who was then working with the British Committee for the Relief of the Victims of Fascism, arranged for the Kuczynskis to move into 12 Lawn Road, Hampstead, directly opposite the construction site that was then the Lawn Road Flats.

On Christmas Eve 1933 Robert Kuczynski's wife, Berta, arrived in England on a one-month visit. Her resident permit was duly extended and on 5 January 1934 she went back to Berlin to collect her daughters. Seven weeks' later she returned to London with Sabine, aged fifteen, and Renate, aged twelve. Their passports and identity documents had been marked with the *'auswanderer'* (emigrant) stamp, and on 31 July their permits were extended to the 23 October 1935. After a brief stay at 44 Park Hill, NW London, they moved to 12 Lawn Road where another daughter Brigitte, who had recently been awarded a PhD by the University of Basle in Switzerland, joined them on 22 September 1935. A fourth daughter, Barbara arrived the following year and on 12 October 1936 she was granted permission to work as a Clerical Research Assistant at the London School of Economics. She was informed that she could 'remain in the UK for an indefinite period' and on 30 October this privilege was extended to the rest of the Kuczynski family.[76] On 11 November 1936 'Bow Street reported the registration' of Robert and Berta Kuczynski's son, Jurgen, who had first arrived in the UK on 21 January 1936. All the members of this highly-educated and gifted German-Polish-Jewish family were involved with the British and German communist parties and worked at some point for the Soviet military intelligence body, the GRU.

Arnold Deutsch, Kim Philby and Austro-Marxism

T HE Comintern agent Arnold Deutsch was an Austrian Jew who had travelled to London from Vienna in May 1934. His instructions from Moscow Centre were 'to cultivate young radical high-fliers from leading British universities before they entered the corridors of power'.[1] In 1936, with his wife Josefine, a trained NKVD wireless operator, he moved into No. 7 Lawn Road Flats, a furnished studio flat on the ground floor at the monthly rate of £4 4s, to be paid weekly. Deutsch's flat was only two doors from the Soviet agent Brigitte Kuczynski, a German Jew, who lived in Flat 4 with her Scottish husband A. G. Lewis, a member of the CPGB. Gertrude Sirnis, who knew the Pritchards through her work with the Quakers, had made the arrangements for Brigitte to move into Lawn Road Flats in 1934.

Brigitte Kuczynski, or Bridget Lewis as she now was, and Arnold Deutsch worked for different Soviet intelligence agencies – the GRU and OMS respectively – and came from very different Marxist traditions. The German Communist Party, the KPD, was very much in the Stalinist mould and in thrall to the Soviet-dominated Third International; whereas the Austrian Communist Party, the OKP, was still strongly influenced by the 'revisionist' ideologies of the pre-war Second International and the Austro-Marxism of Otto Braun. While Brigitte Kuczynski followed the *diktats* of the Stalinist KPD, Deutsch's Marxism explored broader Austrian intellectual currents including Freudian theories of psychoanalysis and the influential sexual liberation 'sexpol' politics of Wilhelm Reich.

Arguably, the Cambridge-educated spy, Kim Philby, and possibly other members of the group that formed the Cambridge Spies, were influenced more by the preambles of Austro-Marxism than the precepts of Marxist-Leninism that dominated the Third International. There can be little doubt that Deutsch, as pointed out by the official historian of MI5, Professor

Christopher Andrew, was an outstanding academic and certainly appealed to Philby and Philby's vanity; and no doubt his support for, and involvement with, 'the guru of the better orgasm', Wilhelm Reich would have endeared him to the Cambridge Five (whose sexploits have been well documented), to say nothing of the Lawn Road Flats' sexually-athletic residents. But there was always a more serious side to this and Philby's intellectual development arguably owes more to Deutsch's Austro-Marxism and the attempts by the Austrian psychiatrist and communist Wilhelm Reich to wed Freud with Marx, than to Stalinism. To fully understand Philby's conversion to communism, as well as the impact of Reich on the 'sexploits' of more than one Lawn Road resident, an examination of Reich's career would be a useful starting point.

Wilhelm Reich was born into a Jewish family on 24 March 1897 at Dobrzcynica, Galicia in the Austrian Empire. His father, 'no longer a faithful Jew, had become assimilated', he 'spoke only German with his children and his wife', and he 'did not give his children a Jewish education'.[2] Soon after Wilhelm's birth the family moved to the Ukrainian part of Austria, to Jujinetz in the Bukovina where his mother committed suicide in 1911. Reich was ridden with guilt over her death believing that he had played a part by revealing to his father her love affair with one of his tutors. To compound his guilt his father died shortly afterwards, in 1914, from tuberculosis.

During the First World War Reich was an officer in the Austrian Army, and saw action on the Italian front. His social conscience was not very well developed, and he 'took the war in his stride' without bothering much about the rights and wrongs of the conflict. 'I was up to that time,' he wrote, 'certainly no rebel.'[3] At the end of the war he went to Vienna where he first matriculated at the Faculty of Law, University of Vienna but, 'dissatisfied with the dryness of his studies, their remoteness from human affairs', he switched, 'even before the end of the first semester, to the Faculty of Medicine'. As a war veteran 'he was given the privilege of working at a faster pace than the general medical student, and was able to compress six years of medical studies into four … In 1919 a fellow student invited him to attend a lecture on psychoanalysis. The subject matter was said to have impressed him so much 'that he soon decided to devote his life to psychiatry. He brought such enthusiasm, energy and interest to the then fairly new and revolutionary concepts of psychoanalysis that he

was allowed to join the Vienna Psychoanalytic Society as an undergraduate medical student, a rather unusual distinction.'[4] He was awarded his medical degree from the University of Vienna in 1922 and soon afterwards joined the Austrian Social Democratic Party.

Psychoanalysis in Vienna was then dominated by Sigmund Freud and Reich began working in Freud's Psychoanalytic Polyclinic, established in Vienna in 1922, as its first clinical assistant. This brought him into contact with Vienna's working-class population and, in 1924, he began to study the social causation of mental illness, embarking on an intellectual crusade to reconcile Marxian and Freudian concepts.[5] In 1927 he published *Die Funktion des Orgasmus (The Function of the Orgasm)* in which he put forward the theory that sexual energy is perpetually being built up in the body and needs release through orgasm, an act which involves the total body. If the natural release of sexual energy is inhibited for any reason, stasis of the energy sets in, giving rise to all kinds of neurotic mechanisms. Release of the dammed-up energy is the therapeutic goal, the function of the orgasm, since it establishes the natural flow of energy and eliminates the neurosis.[6]

In 1928, following his appointment as vice-director of the Vienna Psychoanalytic Polyclinic, Reich resigned from the Social Democratic Workers Party of Austria (SDAPO) and joined the Austrian Communist Party. Along with four psychoanalytic colleagues and three obstetricians he set up the Sozialistische Gesellschaft für Sexualberatung und Sexualforschung (Socialist Society for Sex Consultation and Sexological Research) and redoubled his efforts to reconcile Marxist theory and psychoanalysis, publishing *Dialektischer Materialismus und Psychoanalyse* (Dialectic Materialism and Psychoanalysis) in the Moscow periodical *Pod Svaminien Marxisma*, No. 718, 1929. An excerpt appeared in the Viennese journal *Almanach der Pyschoanalyse* in 1930 under the title 'Die Dialektik im Seelischen' (Dialectics and Psychology). In January 1929 the Socialist Society for Sex Consultation and Sexological Research opened its first sex hygiene clinics for workers and employees (*Sexualberatung – Klinik für Arbeiter und Angestellte*) in Vienna, providing free information on birth control, child rearing, and sex education for children and adolescents.

Highly critical of bourgeois morality and laws, Reich drew inspiration from the Soviet Union, writing enthusiastically about the work of Vera Schmidt and the early Soviet experiments in mental hygiene. His articles

on the liberalization of laws in the Soviet Union on marriage, divorce, abortion, birth control, child development, child upbringing, juvenile delinquency and homosexuality became required reading for Cambridge and Oxford undergraduates who were beginning to describe themselves openly as radical, socialist or Marxist. Other sections of Britain's intelligentsia, most notably Bertrand and Dora Russell, as well as Norman Haire's lesser-known ES.LWSR were also inspired by Reich. Here was a philosophy of 'love' – 'sexpol' – that caught the modern mood of the times and swept the enthusiastic advocates of 'free love', radical free schools, nursery education and progressive child development along with it in a manner that anticipated the 'make love, not war' generation of 1960s America.

Reich's Vienna, the cradle of Austro-Marxism, encouraged a general belief that culture, including sexual liberation, had a leading role to play in the 'class struggle', finding expression in Reich's efforts to marry Marx with Freud.[7] What Reich didn't foresee, however, was the destruction of Austro-Marxism by Austrian Fascism and the suppression of both the Austrian Marxist and psychoanalytical movements. The seeds of their destruction were sown in Berlin where Reich had established the German Association for Proletarian Sexual Politics in 1930.

In Berlin, Reich lost little time in offending Nazi ideology by campaigning for the abolition of laws against abortion and homosexuality, and for the dissemination of birth control information. Many in the German psychoanalytical movement were uneasy, expressing their fears that they had little chance of surviving the rise of Fascism if they became associated with communism.[8] The German Psychoanalytical Society asked Reich to resign his membership of the German Communist Party (KPD) several times, but he always refused. The problem was finally solved in 1933 when the KPD accused him of diverting the attention of the masses away from the 'class struggle' and towards mental health and sexual hygiene campaigns, and expelled him from its ranks. His hopes of reconciling Marx with Freud now over, he moved to New York in 1939.[9]

Hitler's triumph over democracy in Germany set in motion a trail of events that led to the brutal suppression of Austro-Marxism in March 1934 by the Austrian Chancellor, Engelbert Dollfuss. Its final moments were witnessed by Kim Philby, by now a confirmed Marxist, who was in Vienna

working for Willi Münzenberg's International Workers' Relief Fund. He was also working as a courier for the underground Austrian Communist Party, at some risk to his life. In Vienna he was on good terms with the *New York Times* Central European correspondent, G. E. R. Gedye, whose eyewitness accounts of the Fascist destruction of democracy in Austria and Czechoslovakia were later published by Victor Gollancz's Left Book Club under the title *Fallen Bastions*. Gedye described the Fascist takeover of Austria in dramatic terms tracing the 'death of liberty' back to the terms of the loan agreement concluded between the League of Nations and the Austrian government of Ignaz Siepel, a Catholic priest and leader of the Christian Social Party, in 1922.

At the end of the First World War, with the threat of revolution spreading into Central Europe from communist Russia, Austro-Marxism and the left wing of the SDAPO had controlled Austrian politics under the charismatic leadership of Otto Braun. Believing in an orderly and peaceful transition from capitalism to socialism, SDAPO, under Braun's leadership, had set about introducing a number of social welfare reforms that they hoped would undermine the appeal of Soviet communism among Vienna's working class. These reforms, which included state unemployment assistance, the eight-hour day and statutory holidays, were quite advanced for their day. The owners of large factories were instructed to increase the number of their employees by 20 per cent, and to take on one war invalid for every twenty employees.[10] In Vienna the socialist-led city government embarked upon a public building programme that was widely acclaimed. The Karl-Marx Hof, the Arbeiterheim in Ottakring, and the garden city block of Sandleiten had, Gedye wrote in a despatch to the *New York Times*, given 'to the great masses of my fellow-beings something of the good things in life which I demanded for myself – clean homes, sunshine, pure air, a glimpse of green from at least some of their windows, decent sanitation and simple opportunities of personal cleanliness, a corner of safety from traffic for the children to play in, medical attention in cases of emergency. And all this not as charity for which the recipient had to show humble and respectful gratitude, but as something which it was the recognised duty of the community to provide, even at the cost of a little less superabundant luxury and unconsumable wealth for the small class of the very rich.'[11]

Vienna's welfare programme, however, provoked a conservative back-lash. A retired Austrian general told Gedye: "'One day we are going to stop that business in Vienna by fair means or foul. Parquet floors and shower-baths for workers, indeed – you might as well put Persian carpets in a pigsty and feed the sow on caviar.'"[12] The Catholic-Fascist paramilitary organisation, the Heimwehr, created in 1923 by the Christian Social govern-ment of Ignaz Siepel, took it upon itself to do just that.[13] The Heimwehr's creation owed much to the terms of the League of Nations' Protocol for the Reconstruction of Austria, agreed in October 1922, which had virtu-ally handed over the country's economy to the Western powers. Cuts were demanded in public expenditure, and deficit reduction was demanded as part of the deal. SDAPO's welfare reforms were revoked, mass unemploy-ment led to widespread disturbances, and a 'council of war' was convened at SDAPO's 1922 congress. It was agreed to 'unleash a struggle animated by the highest idealism', against the terms of the loan laid down by the League of Nations.[14]

Alarmed by these developments, the Christian Social Party supported the formation of the Heimwehr while SDAPO set up its own armed secu-rity organisation, the Republikanischer Schutzbund (Republican Defence League). The Austrian Communist Party, not to be undone, formed the Red Brigades. Armed clashes were inevitable.

As Austria drifted towards civil war, the courts openly sided with the Heimwehr. Following the acquittal of three of their members who had shot and killed an invalid and a child at a Social Democratic meeting in the Burgenland village of Schattendorf, a spontaneous general strike spread across Vienna on 14 July 1927. Tens of thousands of strikers marched into the city centre, set fire to the Palace of Justice, by then seen as a symbol of class oppression, and fought pitched battles with the heavily armed police. There were 86 deaths and 1,100 injuries. Extensive clashes between workers and police continued late into the night. Fearing outright civil war, SDAPO's leadership refused to arm the strikers and the balance of physical force on the streets shifted in favour of the Heimwehr.[15] The situation for both the Austrian left and right deteriorated further in April 1932 when the National Socialist German Workers' Party (NSDAP – The Nazi Party) arrived on the political scene splitting the Austrian Fascist movement into two factions. Victories for the Nazis in city and parish council elections

on 24 April were evidence of a significant shift in right-wing opinion away from the Christian Social Party. SDAPO, which had increased its share of the vote, immediately called for the dissolution of parliament, and the beleaguered Chancellor, Dr Karl Buresch, was forced to resign in favour of his Minister of Agriculture, Engelbert Dollfuss. Ten days later, Dollfuss announced a rabidly anti-Socialist cabinet consisting of the Clerical Party, the Farmers' Party and the Heimwehr. The Social-Democrats, by far the largest party in parliament, were ignored.

On 6 March 1933, the day following the Reichstag fire in Berlin, Dollfuss ended parliamentary government in Austria. Squeezed, as he believed Austria to be between the demands of Berlin and the aspirations of Moscow, he embarked upon a war on two fronts. He declared the Austrian Communist Party to be illegal and arrested its leaders while bringing thousands of armed Heimwehr to Vienna to intimidate the Social Democrats and to guard against a putsch by the Nazi Party. Four thousand Heimwehr were billeted at the Ministry of Agriculture and two thousand at the Military Club. Nazi violence followed in the Graben and the Karntnerstrasse with brown-shirted youths shouting the slogans 'Heil Hitler' and 'Perish Juda'. In the working-class suburbs, Nazi and Socialist supporters fought pitched battles.[16] The police president of Vienna, Dr Franz Brandl, a prominent Nazi, ordered the police to surround the Ministry of Agriculture, telling the Heimwehr: 'If you do not clear out, we shoot'. The Heimwehr surrendered and the next day Dr Brandl was dismissed from his post. Nazi-inspired violence intensified. In June, the attempted murder by the Nazis of the Austro-fascist, Dr Richard Steidle, a founder member of the Heimwehr was the signal for a full-scale terrorist campaign. On 12 June the first Nazi murder of a Jew took place. A bomb thrown from a passing motor car into a Jewish jeweller's shop in Vienna killed one and injured many others. Intent on destabilizing the country further, a number of bomb-throwing incidents, orchestrated by the Nazis, followed. Dollfuss acted quickly: he outlawed the Nazi Party in Austria and arrested and imprisoned over a thousand Nazi leaders, including eighty-one provincial mayors. Nazi terrorism continued with a growing number of attacks on the Heimwehr and Jews; SDAPO called on Dollfuss to restore democracy and to open a common front against the Nazis, an appeal which fell on deaf ears. In a speech delivered to a parade of Heimwehr on the Vienna Trotting Race-

course on 11 September 1933, Dollfuss triumphantly announced the 'death of liberty' in Austria: 'The old Parliament with its leaders and members is gone – never to return. The Liberal-Capitalist economic system is gone – never to return. Socialist influence is dead – for ever. I announce the death of Parliament.'[17]

There remained only the 'big clean up' of SDAPO and those members of the Austrian Communist Party still at liberty.[18] This got underway in February 1934 when police and detectives raided the workers' club in Linz in search of Republican Defence Corps' arms. Shooting broke out and massed artillery fire was used to dislodge the workers holed up in the club's cellars. A socialist plan for a general strike went into action, with strikers barricading their homes and defending their districts with fire-arms. 'The one-sided battle lasted four days and a thousand people were killed. Two of the biggest blocks of workers' flats, the Karl Marx Hof and the Goethe Hof, were destroyed by Heimwehr artillery fire.'[19] Fortunately, most of the defenders managed to clamber down into the sewers from the interior of the building and escape. 'For long afterwards', the *New York Times* correspondent Gedye reported, 'the sewers were the refuge of the defeated Socialists, even badly wounded men were kept here for weeks, being moved from time to time when danger of arrest arose, and tended by devoted doctors, mostly Jewish, at the risk of their careers.'[20] Government reprisals were savage. Nine socialists were clumsily hanged, strung up and allowed to strangle to death in the courtyard of the Supreme Court. One day a young Englishman whom Gedye knew, came to his flat and demanded a suit of clothes to enable a wounded socialist to get out of the country. 'I opened my wardrobe to select something. When he saw several suits hanging there he cried: "Good God, man – one suit, and you have seven! I must have five – I have six wounded friends in the sewers in danger of the gallows." What could I say? He took the suits.'[21] That young Englishman was Kim Philby, and from that day onward he was committed to the communist cause. The next day Gedye reported how he 'stood by the howitzers as they poured their last shells into the Karl Marx Hof, and saw the white flag go up as its little handful of defenders – not more than five hundred men, cornered finally at last – were driven out by the Heim-wehr, holding their hands above their strained faces, which showed white beneath the grime of battle.'[22]

Harold Laski's 'Salute to the Viennese Martyrs', published in the *Daily Herald* on 17 February 1934, compared the Vienna uprising to the Paris Commune of 1870 and the Russian Revolution of 1905. *L'Humanité*, the paper of the French Communist Party, accused the Austrian socialist leaders of having brought on the debacle by putting 'their faith in bourgeois democracy and bourgeois governments' instead of 'accepting a united front with the communists'. The OKP itself, 'a negligible quantity' before the Fascist onslaught, 'increased its strength tenfold among the embittered masses'. On 24 February 1934, in Vienna Town Hall, Philby married his communist girlfriend, Litzi Friedmann to save her from the gallows:

> It was a quiet, hurried ceremony. Litzi looking back over the years and over two subsequent marriages remembers it: 'The police were hunting down active Communists and I found out that they were after me. One way I could avoid arrest was to marry Kim, get a British passport and leave the country. This is what I did. I wouldn't exactly call it a marriage of convenience. I suppose it was partly that and partly love. We left Austria together and went to stay in England.'[23]

Three months later Philby was recruited into the Soviet intelligence service by Arnold Deutsch on a park bench in London's Regent's Park. Deutsch told him, 'We need people who could penetrate into the bourgeois institutions. Penetrate them for us!'[24]

<p style="text-align:center">*</p>

Broadly speaking, Soviet foreign intelligence-gathering between 1920 and 1934 was split between the Comintern's OMS (International Liaisons Department), the Foreign Department of the OGPU (the predecessor of the NKVD established in 1934), and thirdly, the Fourth Department of the general staff, the GRU. At the beginning of the 1930s the heads of the three organisations – General Jan Karlovich Berzin, Artur Khristyanovich Artuzov and Iosif Aronovich Pyatnitsky – agreed a strategy of agent penetration as a means of gathering foreign intelligence. This strategy pitched Soviet intelligence into the forefront of the intelligence-gathering organizations operating inside Europe and America during the inter-war period. It was set up in Britain by Austrian and German Communist Party members who were living in exile in London following the suppression

of the workers' movement in Austria and Germany in 1933 and 1934. The Lawn Road Flats, Lawn Road itself and the neighbouring streets was its base. It was Jack Pritchard's lover Beatrix Tudor-Hart who innocently began the process by introducing Pritchard to her friend, fellow communist and future sister-in-law, Edith Tudor-Hart, née Suschitzky.

Edith had recently returned to London following her marriage to Alexander Tudor-Hart in Vienna in August 1933. He had gone to Vienna in response to her appeals for help when her life appeared to be threatened.

While she was in Vienna, Edith's activities had been closely monitored by MI5 and Section V of MI6 (the counter-intelligence arm of MI6, set up in 1931 under Valentine Vivian to liaise with MI5 on matters of counter-espionage). One of her first acts on arriving there in 1931, according to her MI5 file, was to write to Alexander asking him 'to obtain from Communist Party Headquarters in London a certificate to the effect that she [had] worked in the party as "E. White"' and had been 'deported for that reason'. She asked for the certificate to be sealed and sent by registered post, 'so that the English police should not come across it'.[25] In mid-1931 she again wrote to Alexander Tudor-Hart at his apartment in 5c Westbourne Terrace, Paddington, informing him 'that she had found employment with the Austrian Communist Party and had been appointed the official photographer for Austria to the Moscow "Press Cliche" (sic)'.[26] The Security Service's report noted that she had 'obtained this appointment through the good offices of the manager of TASS in Vienna, Herr Ebel, who had 'loaned her a first class camera for her work'.[27] On 14 April 1931 Alexander Tudor-Hart received 'a panicky letter' beginning with the words 'the camera is found', informing him that its loss had made her 'sick inside in spite of its recovery later'.[28] On 22 June she wrote a further letter (this time in German) of a more personal nature expressing her love for him and gratitude for all that he had done for her:

> Writer sees clearly that it will be better for all when she can satisfactorily be loosed from the connection with the addressee and yet is it really so? He has laid the foundation stone of her pol. [political] education and she is so much bound to him, that everyone else has lost their appeal for her – but perhaps not quite so much as before, it is in any case not impossible for writer to find another intelli-

gent and loving comrade – but there are few whom one can love. How does addressee feel about it? Does he sleep sometimes with the ex-wife? He need not tell her. They must both grasp the fact that marriage between them is impossible, and that also, it would not work out; and the separation is natural. Will addressee tell writer what the p. is doing? and how he is and the Analysis. Has he a char-woman, or is he living in the pigsty as he was in Gloucester Terrace ... Here follows more about their 'connection', and the eternal triangle point of view ... Writer then asks after ROSA and THOMAS, and whether MAURICE (?) is still living with addressee? Does addressee find out much in the P.A.? Writer sends kisses and the signature is very doubtful.[29]

The signature was unmistakably Edith's, and the letter was filed in both Alexander and Edith Tudor-Hart's Personal Files held by MI5. An MI5 file entry in 1951 also claimed that between 1932 and 1933 Edith had been working for Russian intelligence in Italy with Arpad Haas, 'a Hungarian communist of long standing with an espionage record'.[30] In May 1933 Edith had been arrested getting into a taxi outside the Goethe bookshop in Vienna's ninth district and 'interrogated'. She admitted to being a press photographer and was visiting the bookshop on an errand. A man, whom she had met in a café some months before, and whose name and descrip-tion she had quite forgotten, had asked her to deliver a number of sealed letters to the Goethe bookshop in aid of the charitable refugee organisa-tion, the Rote Hilfe.[31] The bookshop, in fact, was a drop for the Austrian Communist Party in Vienna which then existed under conditions of semi-legality. The letters from the mystery man were found to contain 'mimeo-graphed requests to provincial cells for detailed reports of their situation and called for heightened political activity'.[32] Edith spent several weeks in prison before being released for lack of evidence and married Alexander in a hurry in August. Before the couple left for London in August 1933, they were recruited by Arnold Deutsch to work for Soviet intelligence and 'were given the joint codename of Strela ('Arrow').[33]

Soon after her arrival in London, Edith was commissioned by Jack Pritchard to take photographs of the Lawn Road Flats, then under construction. He also introduced her to the editor of the BBC journal

The Listener, R. S. Lambert, who began publishing her work from late 1933 onwards.[34]A professional photographer, Edith had published photo essays in *Der Kuckuk* and had established strong ties with the worker-photography movement. She opened studios at 158a Haverstock Hill on the corner of Haverstock Hill and Upper Park Road, adjacent to the Haverstock Hill Arms and Lawn Road, and in 1934 took the official photos of the opening and launch of Lawn Road Flats. The following year she introduced Deutsch to the Pritchards and helped him and his wife, Josefine, move into Lawn Road Flats and accompanied Philby on his first meeting with the OMS agent on a park bench in London's Regent's Park.

*

In some respects Deutsch had come home. The Lawn Road Flats had set out to achieve in London what had been derided in Berlin and destroyed in Vienna. One of the main purposes of the Isokon building had been to showcase continental achievements in working-class housing and, from the start of the project, this had been uppermost in Pritchard's mind. They provided the perfect camouflage for those Soviet spies who, like Arnold Deutsch and Brigitte Kuzcynski, were highly-educated, gifted individuals who lacked neither charm nor sophistication.

Brigitte Kuczynski, whom MI5 described as a schoolteacher of the Montessori sort, had moved into Lawn Road Flats following her marriage to Anthony Gordon Lewis at Hampstead Registrar Office on 4 July 1936. She was twenty-six and Anthony Lewis was twenty-three. Shortly afterwards, MI5 began taking an interest in her activities in support of the Republicans during the Spanish Civil War. Her husband, who was then working for the BBC's Listener Research Section in the Home Intelligence Department of the BBC's Public Relations Division, was also listed as being of interest. His position at the BBC would certainly have recommended him to the Soviets. The British Broadcasting Company, later the British Broadcasting Corporation (BBC), had gone on air in November 1922 and was an early target for Soviet intelligence. The Cambridge University graduate Guy Burgess, recruited to Soviet intelligence by Arnold Deutsch in 1937 and one of the Cambridge Five, worked as a BBC correspondent between 1936 and 1944. His left-wing sympathies had been light-heart-

edly dismissed by the Cambridge historian, George Trevelyan in his letter dated 5 December 1935 supporting Burgess's application:

> I believe a young friend of mine, Guy Burgess, late a scholar of Trinity, is applying for a post in the B.B.C. He was in the running for a Fellowship in History, but decided (correctly I think) that his bent was for the great world – politics, journalism, etc. etc. – and not academic. He is a first rate man, and I advise you if you can to try him. He has passed through the communist measles that so many of our clever young men go through, and is well out of it. There is nothing second rate about him and I think he would prove a great addition to your staff.[35]

The Soviet intelligence service that recruited Burgess and the Cambridge spies relied on two types of spy for its work with recruits: 'legals' and 'illegals'. 'Legal' agents were, as the name suggests, resident in the host country legally and enjoyed diplomatic immunity, holding official postings at Soviet embassies or legations; 'illegals' did not have diplomatic status and were more vulnerable to detection. During his time in the Isokon building, Deutsch served under the Hungarian 'illegal', Teodor Maly, who would eventually be shot by his 'colleagues', accused of being a German or Polish spy. Maly also ran a spy ring inside the Woolwich Arsenal and advised Deutsch on the handling of the Cambridge spies. Both men had strong OMS ties and also worked for the OGPU. The other German-speaking communist agent living in the Isokon building, Brigitte Kuczynski (Bridget Lewis), on the other hand, was a GRU agent and was probably unknown to Maly.

Intense rivalry existed between the GRU and the OGPU. Both were organized as quite separate espionage networks, each with its own controlling 'Centre' in Moscow. They 'recruited agents separately and secretly and each was required to protect its own patch', and were, apparently, 'forbidden to consult each other without permission from the top intelligence authority in Moscow, the State Defence Committee. While they did not share agents or raw intelligence, information of special interest to each other could be shared through the State Defence Committee without sources being revealed.'[36] This would have meant that the two Soviet spies in the Isokon building, Arnold Deutsch and Bridget Lewis, would have had

little or no operational contact with one another while living in Lawn Road Flats. This situation was most bizarre. Both spies were German-speaking communists, albeit from different Marxist traditions; both were Jewish refugees from Fascism and lived barely a handshake apart in the same block of *avant garde* flats as a number of left-wing intellectuals, sharing mutual friends and associates; and yet both were presumably unaware of each other's intelligence work, and of the fact that they were working for rival Soviet intelligence organizations. This would have dramatic consequences in respect of the GRU's suspicions concerning Kim Philby in 1937 and Arnold Deutsch and Teodor Maly's recall to Moscow in 1938, at a time when Stalin's purge of his secret service was decimating the Soviet Union's intelligence personnel.

In January 1936 the 'illegal' Teodor Maly had received instructions from Moscow Centre to travel to London in order to take control of a leading spy in the British Foreign Office, the cypher clerk, John Henry King, who hitherto had been controlled from Holland by a Dutch artist Henri Christiaan (Hans) Pieck. (In 1936 The Hague in Holland and the French capital, Paris, were the points of entry for Soviet 'illegals' to Britain.) Maly's initial contact was Bryan Goold-Verschoyle, a young Irish communist who had been living at 9 Lawn Road since November 1935 with his girlfriend, Charlotte Moos, a Jewish-Communist refugee from Nazi Germany.

At that time Goold-Verschoyle was under MI5 surveillance. His file described him as 'a public schoolboy type', 'highly-strung', 'a nervous individual' and 'the least suitable person' for the world of spies.[37] He had arrived in England from his native Donegal in 1929 to take up work with the English Electric Company in Stafford as an apprentice engineer. He had joined the CPGB in 1931, and had made an immediate impression. Two years later he was appointed organizer of the Stafford Communist Party and Special Branch put him under surveillance. Their watcher described him as 'a reticent young man who spent most of his spare time reading Russian and Communist literature'.[38] In July 1933 he made the first of many trips to Soviet Russia to visit his brother Hamilton Neil Stuart Goold-Verschoyle who had been an active communist in Ireland during the civil war years of 1922–1923, and had gone to Moscow in 1930 to work as a translator. There, Hamilton met and married a Russian woman Olga Ivanovna, a NKVD agent. While in Moscow Bryan Goold-Verschoyle took

up employment as an electrician in a Moscow factory, and began courting a friend of Olga's, Irina Adler, who was also a NKVD agent. Olga introduced him to two men wearing the dark green uniforms of the NKVD who impressed upon him the secret nature of their meeting. They told him that permission to reside in the Soviet Union could not be given yet and that he was to return to Britain, resign his 'open' membership of the CPGB, move to the Kings Cross area of London and take up pre-arranged employment with the BBC. This he did. One year later, however, having heard nothing from the Russians he compromised his 'sleeper' status by giving up his BBC job and returning to Moscow. He hadn't been there long when he was again visited by two people in dark green uniforms. They reprimanded him for having come back to Moscow without permission, and instructed him to leave for London at once, which he did reluctantly. At the end of May 1935, however, Goold-Verschoyle again chose to ignore NKVD instructions and made his way back to Moscow. This time he was immediately confronted by two NKVD agents who told him never to return to Russia without permission because he had made himself quite useless by these journeys to and from Moscow. 'They hadn't been able to make use of him in London because there wasn't, as yet, any "organization" in place in England. But if he needed something it wasn't necessary to travel to Moscow, there was a contact address in Paris he should use. He was to forget about Moscow altogether for the immediate future.'[39]

Back in London in 1935 Goold-Verschoyle made arrangements with Charlotte Moos to move into a flat in 9 Lawn Road opposite the community of spies already in existence in the Isokon building. In August of that year, a Special Branch detective who had been tailing them for some time noted that they were socializing with people who were suspected of underground communist activity:

> These persons have been seen recently in the flat occupied by Mrs. Edith Tudor Hart at 158a Haverstock Hill, N.W.3. They are also believed to be friendly with a Dr. Bone who formerly resided at 9 Lawn Road and who associated with someone residing at 4 Lawn Road.[40]

Other residents at 158a Haverstock Hill who were of interest to Special Branch and MI5 were Elfriede Neuhaus and Johanna Baruch SB301/

CSC/303 (Special Branch file), and Miss M. G. Steward SB 301/MP/9305 (Special Branch file).

Goold-Verschoyle, working from his flat next door to the Kuczynski family living in Lawn Road and the spies directly opposite in the Isokon building,[41] was to serve as the initial contact between Teodor Maly and John Henry King. This proved a fatal mistake.

At the end of January 1936, Goold-Verschoyle's application to train as a wireless operator in Moscow was approved by Moscow Centre and on 18 February he left Lawn Road for the Soviet Union. Charlotte Moos accompanied him to the station where she later recalled a strange incident took place: 'When we sat in the train talking an old man (white beard) came to the train window and asked B. whether he would post a picture of Edward VIII for him in Paris and handed the picture, rolled in a big roll, into the compartment. I felt this to be very strange, but B. laughed at me. This was about the time when Edward VIII became King.' Soviet intelligence moved in mysterious ways. Goold-Verschoyle travelled to Moscow via Paris where he met with Henri Christiaan Pieck, telling him that contact with Teodor Maly should be arranged through his Lawn Road address.[42]

On arrival in Moscow, Goold-Verschoyle was initially treated very well and was put up in a very elegant room in the Hotel Moskva. Three months later, however, Charlotte Moos arrived, unannounced on an Intourist visa, and the Russians showed their displeasure. He was turned out of the Hotel Moskva and put into an empty hall in the Hotel Metropole where there was nothing but two beds, a table and a microphone. He became ill and since his room didn't have any windows Charlotte moved him into her room in the Novaya Moskovskaya. He was still ill with fever, when a 'superior person, who spoke German' called and insisted that Charlotte leave the room. He 'then shouted with Bryan so furiously that the hotel resounded'. When she was readmitted, she was told that she 'had no right to be there, that Bryan had no right to have her come and change his room etc'. A few months later Goold-Verschoyle was posted to Germany, and Charlotte was told that she would either have to stay in Russia on her own or leave. On 18 October 1937 she arrived back at 9 Lawn Road. Some days later she received a telephone call from Goold-Verschoyle in Paris letting her know that he was on his way to Spain 'to fight against Fascism'.[43] That was to be

the last time they spoke together. Suspected of Trotskyism, he was lured on board a Soviet ship and transported to Odessa before, according to the Soviet defector Walter Krivitsky, being shot on 12 April 1937 in a Moscow dungeon dubbed the 'shooting gallery'.[44]

While Maly was handling Goold-Verschoyle and liaising with him through his address at 9 Lawn Road, he had also been working closely with Deutsch in the Isokon building opposite, helping to set up Kim Philby's early career as a Soviet intelligence agent. It was an operation that, despite its success, led to the recall of both men to Moscow and, in Maly's case, given his involvement with Goold-Verschoyle, to his execution as a German spy. Philby's first instructions had been to distance himself from the left and establish a cover as a pro-German with Nazi sympathies. He did this with characteristic efficiency, joining the Anglo-German Fellowship and writing for an Anglo-German magazine set up to promote Anglo-German trade. Quite quickly he acquired little-known information about unofficial business and financial contracts between England and Nazi Germany and was introduced to the German Ambassador to England, Joachim von Ribbentrop. Following Ribbentrop's appointment as minister of foreign affairs, the two men met frequently in Berlin.[45] Maly sent a dispatch to Moscow Centre speaking highly of Philby's achievements:

> He returned just a few days ago from Berlin, where he was taken around for two weeks as a foreign VIP. They showed him 'achievements' and the 'new spirit'. He saw people from the Ministry of Propaganda and people from Ribbentrop's bureau. Talks touched on future work, the magazine, and related technical questions.
>
> The magazine will begin publication only in October [1935]. I am sending you the July issue of *Geopolitik* with his article. The first goal we set ourselves with 'Sohnchen' [Philby's code name] – making him into a major journalist – has been met, since he is editor of a magazine. Undoubtedly, this work has strengthened his ties with Germany and local Germanophiles, and will give him new ties. The future will show which of these ties we will use and in which way. Let us not forget that he is hindered in developing those ties and turning business relations into personal ones by the fact that his wife is Jewish.[46]

Philby's career as a journalist on the Anglo-German society's magazine,

however, came to an abrupt end later that year when he was dismissed from his post following a takeover over of the magazine by purely German interests. Maly and Deutsch then made arrangements for him to go to Spain as an independent journalist and to cover the conflict from the Franco side.[47] He left for Spain on 3 February 1936.

Maly reported Philby's every step to Moscow Centre: 'Sohnchen left for ...', 'Sohnchen should be in Lisbon today ...', 'Sohnchen is headed for the meeting point ...', 'In the next mail I hope to be able to tell you something ...'[48] Unfortunately, and inexplicably, as Philby was not their spy, the GRU had come to the conclusion that Philby was 'a German spy in England'.[49] This was incredible; these suspicions were raised at a time when Deutsch and Maly were controlling Philby from 9 Lawn Road and the Isokon building opposite, and coincided with the appearance of a GRU network centred upon the Kuczynskis resident in 10 Lawn Road and the self-same Isokon building opposite that housed Deutsch. On 23 April 1937 Maly, according to the Russian author Genrikh Borovik,[50] reported to the Centre 'that his colleagues in intelligence in London (he may have meant Soviet military intelligence, the GRU) were suddenly interested in Kim Philby'.[51] Presumably unaware of Philby's ties with Deutsch, Maly, OMS and the OGPU, the GRU (if it was the GRU) now threatened not only the continued existence of the Cambridge Five as Soviet agents but also the security of both Deutsch and Maly.

The year 1937 was the year that the purges and the 'terror' in the Soviet Union reached its apogee, and those agents, like Deutsch and Maly, who had transferred their allegiances from the Comintern's OMS to the OGPU, were now regarded with suspicion by their colleagues in the newly-formed NKVD.[52] Was the GRU taking advantage of an opportunity and making a play for dominance in London? And what did the GRU agent Brigitte Kuczynski (Bridget Lewis), a fellow Lawn Road Flats resident, know about these developments, if anything, and the suspicions falling upon her OGPU/NKVD comrades? She was soon recruiting GRU agents from the Lawn Road Flats, presumably, unbeknown to the OGPU/NKVD agents there. How much intrigue can one building harbour?

Maly and Deutsch, either unaware or dismissive of the dangers threatening them, now set about creating a parallel agent network to the one run from Lawn Road and the Isokon building, inside the Woolwich Arsenal

centred upon a leading British communist, Percy Glading. Glading was regarded as a natural choice to run the network. As a one-time member of the executive committee of the CPGB, he remained highly placed in the Communist Party with extensive contacts among sympathizers inside the British Admiralty and the War Office. His 'conversion' to communism and early militancy enabled him to recruit a number of working-class spies employed inside key munitions factories and other leading industrial complexes. Both Deutsch and Maly saw him as a highly-valuable intelligence source. However, Glading's private life and his belief in his own prowess as a secret agent made him difficult to control, and his botched handling of the spy network operating inside the Woolwich Arsenal contributed to Moscow Centre's decision to recall Deutsch and Maly in 1937 and 1938 respectively, damaging, if not completely destroying, the parallel OGPU/NKVD network working from the Isokon building in the process.

In February 1937 Glading received specific instructions from Maly to remove secret documents from the Woolwich Arsenal and arrange for them to be photographed overnight and returned the following morning. He contacted a secretary working at Communist Party headquarters, taking her into his confidence and asking her to rent a flat that could be used as a safe house for his activities. Glading would pay the rent, telephone bill and any other incidental expenses. He told her to have three sets of keys cut promising to warn her before anyone came to the flat. Unfortunately, the secretary in question, Olga Gray, was an MI5 penetration agent working inside Communist Party's headquarters in King Street. Before making arrangements to take over a flat at 82 Holland Road in North London at an agreed rent of £100 per annum, Olga Gray contacted her MI5 controller, Maxwell Knight.

On the night of 21 April 1937 Glading arrived at the flat with Maly whom he introduced as 'Mr Peters,' and stopped for about three-quarters of an hour. Nothing of any importance passed between them and Olga Gray concluded that Mr Peters had come solely to check on her suitability for the task. She met him on a number of separate occasions and built up an interesting profile of him, which she passed on to Maxwell Knight. She described him as a fidgety man whose manner, bearing and demeanour were somewhat striking:

From Miss 'X' [Olga Gray[53]]:

Description: Aged about 45; very tall, about 6'4"; medium build, heavy enough not to look lanky; very dark hair; thinning along left and right partings; rather small eyes, dark possibly grey, rather heavy lids; straight nose but rather heavy; rather wide mouth, short upper lip, dark moustache slightly cleft chin; typical shiny grey complexion of some Russians and Germans; teeth gold filled in front; hands with very long fingers, flat nails, strums with fingers on chair arm etc.; dressed in black suit, black shoes, dark tie. Spoke English very well, but slowly. Noticeable accent, but English correct. Has difficulty with 'w's, tries not to pronounce as 'v' but not very successful.[54]

From Olga Gray's description of Mr Peters, Maxwell Knight had very little difficulty identifying him as Teodor Maly. On 29 April Glading again visited Olga Gray, and told her of another man in connection with their work: 'a small man and rather bumptious in manner'. 'Glading,' Gray said, 'dislikes him personally but he has to tolerate him for business reasons.'[55] This man was identified as Arnold Deutsch, Maly's principal agent inside Lawn Road Flats.

On 20 May Glading informed Olga Gray that he had a special job for her that would require her learning 'from another comrade something about photography', and that she would receive 'instruction in the photographing of documents with a miniature camera'. These documents, he informed her, would be "borrowed" ones that would be delivered one evening and collected the next. She was to take and develop these photographs but she was not to print them. On average there would be some photographing to be done about once a week from papers and drawings of a very secret nature. On 11 June Glading called again, this time late at night. He was drunk and obviously very anxious. He made two significant remarks. One was, 'I am doing hardly any work for the Party now – it is mostly for the other people'. The second was he had seen six of his "people" that evening.[56] Glading didn't know it at the time but a number of worrying episodes had recently threatened both the Woolwich Arsenal and Lawn Road networks. Earlier that month Arnold Deutsch had gone abroad to report that Edith Tudor-Hart had lost a diary along with a folder containing a list of his expenses, including payment to his agents, which

he had entrusted to her for safekeeping. As soon as Moscow Centre got wind of this missing folder they immediately closed down the Lawn Road Flats network and ordered Arnold Deutsch to leave England. He had been abroad for three weeks when Edith Tudor-Hart, 'desperately searching her apartment for one last time, found the ill-fated folder tucked underneath the cushions of her sofa and rushed to tell Maly, who reported the good news to the Centre.'[57] These events must have taken place in June 1937 as Maly had received instructions that month to travel to Paris to arrange the murder of a defector, Ignace Reiss. He never returned. His ill-fated dealings with Goold-Verschoyle in Lawn Road; his OMS/OGPU background at a time when the GRU and NKVD were taking control of the Comintern; and his handling of Philby in Spain, culminating in his strong objection to Philby being used in a bizarre plot to assassinate General Franco, all led to his execution as a German spy in 1938.

Deutsch, on the other hand, managed to return to London on at least a couple of occasions. The first time was towards the end of July before being 'recalled to Moscow in September 1937 in Maly's wake'. He did manage 'to get back to London for ten days in December to put his leaderless agents 'on ice', but by 1938 he was no longer operative.[58] His 'curriculum vitae' written on 15 December 1938 for his NKVD interrogators bears all the hallmarks of an OMS/OGPU agent distancing himself from his Comintern past in order to stay alive:

> In December 1928, comrades Koplenig and KONRAD, at that time Secretary of the Austrian Communist Youth Organization, recommended me for work in the underground organization of the Department for International Relations of the Comintern in Vienna. This was underground liaison and courier work. In October 1931, because of the bad work of some of the members of our apparatus, we were discovered.
>
> In January 1932 I was summoned to Moscow. Up to May I remained without work. Then I was sent on a temporary assignment to Greece, Palestine and Syria. In August of that year I returned to Moscow and I was told that I had been sacked and would work in a factory.
>
> The Head of the Department for International Relations was Abramov. Something about my attitude to Abramov, who later turned out to be

an enemy of the people. I once said something to a colleague which implied criticism of Abramov's work. This colleague told Abramov about this and the latter forced me to write a statement to the effect that I would never again criticise his organization. Abramov sent one of his creatures, a certain 'Willy' to Vienna, with whom I and certain other members of the Department did not get on because he tried to introduce an anti-party, bureaucratic spirit into our organization. When 'Willy' later returned to Moscow, I believe he encouraged Abramov in his dislike of me. I heard recently that 'Willy' was arrested a year ago by our security people.

When comrade Georg Mueller heard that I had been sacked from the Department of International Relations, he offered me work in our department. Mueller was at that time already working in the department and I knew him from the time of his work in the Vienna organization. I was also recommended by comrade Urdan, at present Head of Department in the People's Commissariat for Heavy Industry.[59]

Igor Damaskin, a retired senior officer of the KGB's First Chief Directorate who was granted special access to the KGB's archive in Moscow in 1991, summed up Deutsch's London career in his book on Kitty Harris, the controller and lover of the Cambridge spy, Donald Maclean:

Arnold Deutsch's London legacy was the recruitment of more than twenty agents, most of them first class. When he returned to Moscow, he somehow managed to escape the fate of the majority of his colleagues, probably because none of them had denounced him, but he was sidelined for several months and was clearly under suspicion, grimly illustrated by a memo his immediate superior wrote to their section head Dekanozov asking for funds to pay for Deutsch to take Russian lessons. Dekanozov scribbled on the memo: 'Comrade Sten'kin! Don't waste your time. STEFAN [Deutsch] needs to be thoroughly vetted, not sent off to learn languages.'[60]

Deutsch was fired from the NKVD and went to work at the Institute of World Economy and World Politics at the Academy of Sciences. When war broke out, the new NKVD leadership decided to send him to Latin America as an illegal. After two failed attempts to get him there via the

South Atlantic, one of which got him as far as Bombay, 'he sailed for America on 4 November 1942 on the tanker *Donbass*, the same ship which had carried Kitty [Harris] from Vladivostok to San Francisco. Deutsch was listed as a member of the forty-nine-man crew when it set off by the Arctic route from Novaya Zemlya. The ship was attacked by the Luftwaffe on 5 November and again two days later; after reporting a further attack, its radio went off the air and the *Donbass* was presumed to have sunk with the loss of all hands.[61]

The Isobar, Half Hundred Club and the Arrival of Sonya

O N 29 September 1937 the occupants of Lawn Road Flats received a letter from Jack Pritchard informing them of his decision 'to form a club for the tenants of the flats and their friends'. He had 'been fortunate', he wrote, 'in securing the services of T. A. Layton of the Book Wine Restaurant and Cheddar Roast to manage it.'[1] A prominent figure in the restaurant world and highly regarded in the wine trade for his 'revolutionary practice of delivering carefully selected parcels of fine wine, from Bordeaux and Burgundy, to his customers throughout London,' Tommy Layton brought reasonably-priced good wine to the tables of the middle classes. One of the most knowledgeable people in London when it came to cheese and wine he moved into Flat 7 in order to run the Isobar, the name chosen for the club room built into the basement of the Isokon building that same year.

The Isobar was designed by Marcel Breuer, the last of the Bauhaus trio then living in the Flats; Walter Gropius and Moholy-Nagy having left for America in the spring of 1937.[2] Breuer furnished the Isobar's restaurant with some of his best known pieces of Isokon experimental furniture, including the dining chairs and tables, stools, nesting and occasional tables, and the short chair. Prototypes were illustrated in the *avant garde* publication *Circle: An International Survey of Constructive Art* in 1937, where Beuer explained: 'the plywood is not used merely as a panel or as a plane surface borne by separate structural members; it performs two functions at one and the same time – it bears weight and forms its own planes'.[3]

The restaurant soon established a fine reputation with Philip Harben, the future BBC television chef and cookery writer, presiding over the kitchen. Although Harben was not Britain's first celebrity chef – that distinction must go to Marcel Boulestin, creator of the Boulestin omelette

in 1937 – he was not, as one writer has taken pains to point out, 'a fraud, like Fanny Craddock, who followed him on the television screen, or a mere entertainer, like so many later television cooks.'[4] Philip Harben was, in fact, an accomplished actor in his own right having previously worked with John Grierson on the documentary film *Drifters* in 1929. He was also an acclaimed fashion photographer who had worked in the Paris studios of Egidio Scaioni[5].

One of the Isobar club's many attractions was a copious supply of what today would be called real ale, noted in the letter of invitation sent to Cyril Joad by Tommy Layton: 'I am proposing to supply interesting Beer which is coming from various counties in England and which will be changed frequently during the year.'[6] Rare beers of high quality were racked, among them the threatened Rowsham Ale, which, since the recent demolition of the Crown at Aylesbury, could only be found in the homes of the Vale of Aylesbury farmers. Described by Dr Ronald Hargreaves, a Harley Street doctor who served on the Isobar's Wine Committee, as 'a sharp, clean beer which raised a terrific appetite', Rowsham Ale was one of the few remaining ales to be brewed by 'one-man' brewers in Britain.[7] To assuage another English virtue – the obsession with the weather – the Isobar's General Committee also co-opted Molly Pritchard on to the Weather Committee to provide 'the most up-to-date information on Weather conditions as given by the Air ministry.'[8] Membership was open to 'the tenants of the Lawn Road Flats, their friends and residents in Hampstead.'

An important objective of the Isobar club was to make 'available for reading and discussion contemporary periodicals' including 'all the more important foreign newspapers.'[9] These included delivery on a daily basis of *The Times, Daily Worker, Manchester Guardian, L'Action Française* and *L'Humanité; Gringore, L'Illustration, New Yorker* and *Time* were delivered to the club weekly, *Vogue* arrived fortnightly, and the *Architectural Review* each month. On Sundays members could read the *Sunday Times, News of the World* and *Reynold's News.*

To be admitted as a member, every candidate had to be proposed in writing, on a form specially designed for the club, by one existing member and seconded by another.[10] The club, however, failed financially and, after an informal farewell dinner for Marcel Breuer at the Isobar in December 1937, Tommy Layton left to set up Layton Wine Merchants.[11] In the New

Year of 1938 Jack and Molly Pritchard invited Philip Harben and his wife Kathie to move into Flat 7 and to take over the management of the Isobar. Under their stewardship the club became more political and embraced a number of popular left-wing causes. In May 1938 the Isobar offered a 'week of Spanish food, the proceeds to go to Spanish Medical Aid'.[12] Spanish dishes were on the menu with special 'technical culinary aid and/or advice from an expert in Spanish food'. A special dinner was held to raise money for the Hampstead Spanish Relief Committee whose members included zoologist, Julian Huxley; sculptor, Henry Moore; art critic, Herbert Read; and the poet, Louis MacNiece. The dinner was held in the Pritchards' flat on 25 May and cost 7s 6d [38p] per head including wine. It 'was a great success and the Spanish cooking admirable'; altogether £6 9s 4d [£6.47] was raised.[13] A letter of appreciation was sent to Señor Salsoma of the España restaurant in Wardour Street, thanking him 'most cordially for all the help you have given us'.[14] In October that year a 'bowl of rice' dinner was held for the China Campaign Committee and invitations were sent to Professor R. H. Tawney, Megan Lloyd George MP, the veteran trade unionist, Ben Tillett, Professor Harold Laski and the left-wing lawyer, D. N. Pritt. The dinner itself consisted 'of a plain bowl of rice and a simple vegetable dish flavoured with meat juices, the idea being to reproduce as exactly as possible the typical meal of the Chinese peasant'.[15] To add to its authenticity the catering was undertaken by Young's Chinese Restaurant from Soho's Wardour Street.

The Isobar's first birthday party was held on Thursday 10 November 1938. The invitation card, which entitled you to a free drink, stated that:

> THE ISOBAR is now a year old. It started with a membership limit of 250, and already the Committee have had to increase this so that waiting candidates can be admitted. There will be oysters at 2s. [10p] per dozen, a birthday cake, and the Darts Match versus Mr. Bob Wilson's team at 9pm. PLEASE LET US KNOW IF YOU ARE WILLING TO BE INCLUDED IN THE TEAM. In addition to the usual 2s. 6d. [13p] dinner there will be a specially good 3s. 6d. [18p] dinner.[16]

Forthcoming attractions would include an exhibition of the paintings of Leslie Hurry, and an exhibition of Czechoslovakian architecture. Another

oyster feast was held on 23 November and a claret tasting dinner early in December. On that occasion, four clarets were compared and voted on, with the chosen one to be added to the club list and sold at about 9s 6d [48p] a bottle. The wine was to be served from decanters and a prize offered to all those who could decide 'which claret is which'. The entry price was 5s [25p] per head inclusive; reservations were deemed essential.[17] In addition to these attractions the Isobar played host to the Half Hundred Club, 'a poor man's food and wine society' founded by Philip Harben and Raymond Postgate. Its name was derived from the fact that the club had 'twenty-five members each of whom could bring one guest, hence the half-hundred'. The laudable aim of the club was to combine 'good dining with economy':

> The Club shall be known as the half hundred, and shall consist of not more than 25 members, each of whom shall have the right to bring one guest.
>
> The object of the Club is to combine good and imaginative dining with economy.
>
> Members must be proposed, seconded, thirded and fourthed by existing members. No member may propose or second his or her wife or husband and no candidate shall be proposed who has not previously attended at least two dinners as a guest. Members must be elected by a majority of the Club, and the members proposing a candidate must certify him or her to be seriously and intelligently interested in food and drink and to possess no religious, political or other taboos or unsociable characteristics which may impede conversation.
>
> Ten dinners shall be held yearly, the cost of which shall not exceed £1 per head for food, wine and service, and failure to attend six per annum except owing to force majeur shall entail loss of membership.
>
> Every dinner shall be supervised and planned by a member and where possible cooked by him; every member accepts the obligation of directing such a dinner; and members shall be selected for this duty by rotation. ... The director shall preside at the dinner and shall deliver to the secretary not less than ten days beforehand a blurb of the meal, to be circulated to the members.[18]

The 'First Dinner of the Club' was held in the Pritchards' Flat on 19 January 1939. Its director was Philip Harben, and ten days before the event he circulated to club members the following 'blurb of the meal':

Item 1 This cooling and this verdant stream
 Of Florence is indeed the very cream.

 [Crème Florentine]

Item 2 Now see! What hirsute speed! Such swiftness rare
 Deserves a monument in earthenware.

 [Terrine of Hare and Olives both accompanied by
 Manzanilla fino sherry]

Item 3 Alas for thy proud manhood, farmyard sire,
 Bereft, that we may eat thee, of desire.
 Let Carolina give thee one last feed
 Before appeasing the Half-Hundred's greed.
 Let all thy wives unwed bemoan thy fate,
 Then welcome Spain-anointed, to our plate!
 To honour thee we'll add the elfins' seat
 And lay long Winter garlands at thy feet.

 [Norfolk capons roasted in Espagnole sauce with
 mushrooms stuffed with risotto, and braised celery.
 The wine selected to accompany this course was a
 Langoa-Barton 1921 (Ile cru. St Julien)]

Item 4 Thou famed disturber of the Two Beginners,
 Pray guard from strife the viands now within us.[19]

 [Cox's orange pippins and walnuts with Marsala wine
 followed by coffee.]

Both the Half Hundred Club and the Isobar had got off to a deservingly promising start. On 29 October 1938 Jack Pritchard wrote to Montgomery Belgion, a member of the Isobar's Wine Committee, suggesting that, owing to the 'almost unique reputation in London for interesting food and wine at low prices', each member of the club should introduce 'a new member to enjoy the excellence of his [Philip Harben's] gastronomic creations!'[20] This led to an influx of new members, among them the painter Ben Nicholson

and a former Soviet agent and foreign editor of the *Daily Herald*, William Norman Ewer.

The Half Hundred Club carried on in lively vein. On 1 November 1938 members tucked in to *Queue de bison, Noix de nilgaut* and *Coeur de filet de bison roti* at the Zoological Gardens, Regent's Park, with the kind permission of Dr Julian Huxley, with Raymond Postgate anointing *de Xeres 'La Ina', Maçon* as the chosen wine. Attempts by Postgate to induce members to dine on the 'Brighton Belle' in July 1939, however, proved unsuccessful, despite the attractive nature of the Pullman Car Company's offer:

Dear Mr. Postgate,

With reference to your letter of the 17th March, I am afraid it has taken some time to get a figure from the Southern Railway, but I am glad to be able to tell you that they have now quoted a special reduced fare of 5/9d [30p] for a third class return ticket between London and Brighton.

My idea is that you should go down by the 7.00 p.m. 'Brighton Belle' from Victoria, commencing dinner at about 7.10 p.m. You need not hurry over the meal because if you have not finished on arrival at Brighton at 8.00 p.m. you can carry on and finish the dinner while the train is still in Brighton Station. The return trip of the same train is 9.25 p.m. from Brighton, due Victoria at 10.25 p.m.

We are prepared to waive our supplementary charge of 1/- [5p], doing this as a special case, because we think you can get us some quite useful publicity.

Could you let me have some idea of what figure you are prepared to go to for the cost of the meal, plus wines? Could we work on something, say 12/- [60p] per head, so that the total cost per member would come to about 18/- [90p]? If you will name your price, then I will set about getting some ideas in regard to menus, and I hope between us we will strike something that will appeal to your Society.

I myself think there is a good deal of novelty about the whole thing, and if you decide to carry it out, I promise we will do everything in first class style.[21]

Unfortunately, the journey never took place; members found them-

selves reminding Raymond Postgate that 'few of us possess all that money. After all we are, by our articles of association, poor people; and few of us can afford the fare to Brighton in order to come back again.'[22] 'A Special Asparagus Supper', served in the Isobar after the London Music Festival's staging of Handel's 'Music for The Royal Fireworks', accompanied by a Grand Firework Display by C. T. Brock and Co. on Saturday 20 May 1939, proved more appealing. On 22 May 1939, Francis Meynell wrote to Jack Pritchard congratulating him 'on the Fireworks occasion at the Isobar. It was enormously enjoyed by all my party.'[23]

*

The genteel cultural pleasures of the Isobar and the Half Hundred Club, indeed of the Lawn Road Flats itself, happily exuded 'a bourgeois smugness' that seemed to belie its left-wing sensibilities. This was a fact noted at the time by Alexander Foote, a car mechanic who had fought in Spain with the International Brigade, recruited by the Soviet agent Brigitte Kuczynski (Bridget Lewis) to the GRU in the Flats in October 1938:

> It was an autumn day in October, 1938. The leaves were still on the trees linking that pleasant road in St. John's Wood,[24] and there was still something of summer in the air as I walked toward the house[25] with the green door – the door of the flat where I was to be recruited into the Russian Secret Service ... I pressed the bell and walked in. '... You will proceed to Geneva. There you will be contacted and further instructions will be given you.' The voice of my *vis-à-vis* was quiet and matter of fact, and the whole atmosphere of the flat was of complete middle class respectability. Nothing could have been more incongruous than the contrast between this epitome of bourgeois smugness and the work that was transacted in its midst.[26]

In the Isokon building, class conflict and class consciousness seemed a world away, although class distinction was not:

> I learned nothing much more from the respectable housewife with a slight foreign accent who interviewed me. Her name I never knew for certain, though I have my own ideas on the subject. She was certainly friendly with, if not actually related to, my contact and spymaster,

or rather spymistress, in Switzerland. I do not suppose that I was in the house more than ten minutes. I was dealt with by the lady of the house in as brisk and impersonal a way as she would have used to engage a housemaid.[27]

Foote's contact in Switzerland was indeed related to Brigitte Kuczynski. Ursula Kuczynski, codenamed Sonya, who had been sent to Switzerland by the GRU to establish a small group of anti-Fascist activists 'prepared for illegal, dangerous work inside Germany', was Brigitte's sister.[28]Sonya had specifically requested that her recruits be drawn from members of the British Battalion of the International Brigade who had been trained in sabotage techniques. Sonya's tradecraft was excellent; Englishmen, she urged, were very well-suited for the task that lay ahead:

> It was not unusual for the odd well-to-do Englishman to travel the world and settle for a while wherever he happened to feel like it, and if he felt inspired to choose Germany, then this was not at all out of keeping with the continental image of the eccentric Englishman. Centre agreed to my plan, but reiterated what I already knew: no contact with the British party. I kept to that.[29]

This was not strictly true. When Sonya arrived in England in late 1938 she approached the Austrian communist, Fred Uhlmann, a veteran of the Spanish Civil War, and asked him to recommend two English recruits for a Russian Intelligence Service sabotage group. Uhlmann approached the National Organiser of the CPGB, Dave Springhall (real name, Douglas), a prominent figure in the International Brigades British Battalion who recommended Foote. Uhlmann then interviewed Foote and dangled before him the prospect of a 'secret and dangerous' job abroad. His biographical details were passed to Sonya who signalled them to Moscow Centre who in turn approved the recruitment, advising her to contact Foote before she departed for Geneva. Foote, however, had been taken ill and the proposed meeting never took place. Contact was again made between Foote and Uhlmann at Communist Party headquarters in King Street. Uhlmann gave him the telephone number of Brigitte Kuczynski, then living in Lawn Road Flats who invited him to lunch in the Isobar where he was struck by the incongruity of his surroundings and the call to proletarian revolution. MI5

later believed that Foote had a brief affair with Brigitte Kuczynski before leaving for Geneva. The meeting, therefore, lasted longer than ten minutes and was less matter-of-fact than Foote later claimed. She told him that he had been given an assignment in Germany and issued him with a £10 note along with instructions on where to meet Sonya in Geneva. That meeting took place at the end of October 1938 and was remarkable for its bizarre amateur elaboration of introductory identification marks:

> Wear a white scarf and carry a leather belt in your hand Sonya will be carrying an orange in one hand and a shopping net containing a green parcel in the other.[30]

When they met, Foote was struck by Sonya's calm demeanour. He was told to take lodgings in Munich, study German, and to 'keep his eyes and ears open'. If possible, he was to 'establish connections with the Messerschmitt aeroplane factory.'[31]She asked him if he knew of others in Britain who would be willing to undertake anti-Nazi work and he suggested a rather quiet young man, Leon Charles Beurton, who had served alongside him in Spain.

In the spring of 1939 Len Beurton found himself sitting down to lunch in the Isobar with Brigitte Kuczynski at Lawn Road Flats. After receiving the customary £10 note, he, too, was given instructions on how to make contact with Sonya. The meeting took place in Switzerland outside the Uniprix shop in Vevey and, apparently, it was love at first sight:

> I met Len for the first time in January or February 1939 ... He was then twenty-five years old, had thick brown hair, eyebrows that met and clear hazel eyes. He was lean and athletic, strong and muscular. Half shy, half-aggressive, he gave the impression of boyish immaturity. Len was seven years younger than I was. Unlike Jim [Foote], he was not interested in material things and, again in contrast to Jim, he was extremely sensitive. When I told him that he had been chosen for dangerous work in Germany his face lit up ... Len was to settle in Frankfurt am Main and to make contact with personnel at the I. G. Farben chemical works.[32]

Foote and Beurton often travelled from Germany to Switzerland, rendezvous with Sonya in Geneva, and receive instructions in elemen-

tary sabotage techniques. She would often ask them for a list of suitable targets in Germany, and on one occasion Foote, half-jokingly, suggested Adolf Hitler. He told her of a time when he, along with Len, had dined at Hitler's favourite restaurant in the hope of catching a glimpse of the famous Führer. As luck would have it Hitler turned up:

> 'We didn't have to give the salute because we were British subjects, but we stood up like the rest!' At the moment of Hitler's entrance into the main restaurant BEURTON, who was facing him standing, put his hand inside his jacket to take out his cigarette case, but in appearance as though he were going to draw a revolver. F said his heart was in his mouth and he thought that he and BEURTON would be shot down by Hitler's escort. However nothing whatever happened and F commented to Sonya that if there was all this feeling against Hitler it was a wonder no-one tried to bump him off considering the lack of precautions taken on these informal occasions. He had pointed out, for example, that it would have been easy to put a bomb in a suitcase beneath the coats and hats which hung on the partition wall separating Hitler from the main restaurant. Then, said Foote, what did Sonya do but turn on me and say, what an excellent idea![33]

The Second World War may well have been avoided if Foote and Beurton had taken Ursula Kuczynski's advice and carried out their 'excellent idea'.

<p style="text-align:center">*</p>

For Ursula's sister Brigitte the outbreak of war on 1 September 1939 brought to a close that 'bourgeois smugness' that Foote had noted on his visit to the Flats in 1938, and introduced an austerity into the lives of the Isokon building's residents that made Julian Huxleys' Half Hundred Club dinner at Regent's Park Zoological Gardens seem a world away. London Zoo began destroying some of its inhabitants, causing much stress to keepers and veterinary surgeons alike. One vet reported 'that it took a tremendous effort to kill a monkey – it feels something like murder'.[34] Huxley 'decided to destroy the whole collection of poisonous and constrictor snakes, and this operation, too, felt "something like murder" to keepers who had lived with reptiles for twenty-five years. Chloroform was the lethal agent; it was also used on the black widow spiders'.[35] Elephants and pandas were moved

to Whipsnade while other animals were given a suspended sentence of death. 'A direct hit on the aquarium would have released 200,000 gallons of water, so the decision was taken to drain it. Of the occupants some were eaten, some were moved to new homes, some were bottled for museums and some, like the manatees, were shot. The aquarium then became a storehouse for paper and newsprint. During alerts six keepers armed with service rifles took up position in the Zoo grounds ready to kill any large carnivores which might be liberated by bombing.'[36] Winston Churchill's acquaintance in the Isokon building, the Right-Honourable Gathorne-Hardy, told his friend and future Lawn Road Flats' tenant, the BBC producer Lance Sieveking, that Churchill was initially horrified:

> At the beginning of the Second World War, Churchill asked Professor Julian Huxley what was going to be done about the larger and fiercer animals in the Zoo.
> HUXLEY: Well … I think we shall probably shoot them. That might be wisest, as if bombs fall on the Zoo, some of the animals might escape.
> CHURCHILL (*protests*): *Shoot them?* Surely not! Just think of it! – bombs exploding, anti-aircraft guns thundering, houses collapsing, churches burning, aeroplanes crashing, and above the shrieks of the terror-stricken crowds and the howls of the dying are heard the ROARS of lions and tigers! (*He pauses and then adds thoughtfully*) A pity to shoot them …[37]

Gathorne-Hardy's confidant, Lance Sieveking was one of a number of BBC employees living in the Isokon building during the Second World War; others included Edith-Tudor Hart's close friend Trevor Blewitt who, in 1944, had responsibility on Foreign Affairs in the BBC's Home Talks Department, and Brigitte Kuczynski's husband Anthony Gordon Lewis who worked for the BBC's Listener Research Department. Sieveking, a cousin of the poet Gerard Manley Hopkins and a godson of writer G. K. Chesterton, was arguably the most gifted producer to work at the BBC during the 1920s and 30s.[38] His career with the BBC began in the early 1920s when he was appointed assistant to the BBC's Director of Education and handed responsibility for 'public relations (wining and dining distin-guished public figures to win their goodwill …)' and 'editing news bulle-

tins, and organizing topical talks'. He was responsible for the first outside broadcast to be aired, and in 1927 changed the face of football commentary forever by designing an eight-squared drawing to cover the entire playing area. Radio commentators were now able to give listeners a much better idea of where the ball was and what was happening on the pitch, giving rise to that most hackneyed of football phrases 'back to square one'.[39] Sieveking went on to adapt numerous classics for radio drama including C. S. Lewis's *Chronicles of Narnia* and to produce the first British television play, *The Man with the Flower in his Mouth*, based on Luigi Pirandello's short play, *L'uomo dal fiore in bocca* (1923). Broadcast by the BBC on 14 July 1930 the play was 'received enthusiastically by the Press'.[40] Lionel Fielding, who shared an office with Sieveking at the BBC, gave this description of him in his book *The Natural Bent*:

> Lance lived somewhere among the rolling clouds of his vivid and sometimes erratic imagination, and occasionally from these clouds there fell a shower of brilliant ideas. His impact on broadcasting, though it cannot be measured by any statistical standards, was considerable. He was in the forefront of all experiments and afraid of nothing. He was a stimulant. It is always dangerous to say that any one person is or was responsible for an innovation, but it seems to me, that it was Lance who fathered the first experiment in Baird's television – right back in 1930 at Savoy Hill – which took the form of a play, *The Man with a Flower in his Mouth*. It was jagged and hazy, but it gave us, even then, an idea of what television was bound to be. And with his play *Kaleidoscope* – at about the same time – he started the use of multiple studios with a 'panel' to control and 'mix' them.[41]

Fielding was less happy with Sieveking 'as a stable companion' describing him as 'unpredictable and often irritating':

> He would always arrive at work in the morning (late) and bending over his table towards me would say something like this: 'Have you *ever*, my dear Lionel, have you *ever* walked down a long *long* passage, with a mirror, a *huge great* mirror, at the end of it, and walked slowly slowly *slowly* until you got up to that *huge great* mirror and looked into it, and seen ...' and here his voice rose to a shout, 'NOTHING!!!!'

And I would say, 'Oh really, Lance at this time of the morning, do for God's sake shut up!' And Sheila Wynn-Williams, our admirable and charming secretary, would giggle in the background.[42]

Sieveking's sense of humour, however, had a purpose. He 'invented and had printed and framed a notice which stood beside the microphone: "If you *sneeze* or *rustle papers*, you will DEAFEN THOUSANDS!!!!"'[43] This may have caused 'great alarm and despondency among talkers' but it did prevent the broadcast of unexpected and unwelcome noises. Fielding, after difficult negotiations, managed to get these notices taken down; a rare triumph over Lance Sieveking but one that he would be forced to regret: '... on one occasion a policeman who was broadcasting for me about his duties, and whom I had carefully rehearsed, had a last minute idea (which he did not communicate to me) that it would be fun to blow his whistle: he did so, and the whole BBC went off the air for several hours.'[44]

The BBC Listener Research Department (LRD) was a valuable source of open intelligence on British morale leading up to and during the Second World War. Conceived in the mid-1930s[45] when the BBC was experiencing 'one of its periodic phases of being in bad odour with much of the popular press', particularly with the powerful *Daily Mail*'s radio correspondent Collie Knox for whom the BBC could do nothing right,[46] the LRD fed information directly to the Ministry of Information (MOI), the 'Ministry of Morale'.[47]It conducted a number of surveys that gave an insight into the listening habits of the British public. Over the winter of 1937–1938, for example, LRD sent out a single-sheet questionnaire to a random sample of 3,000 households from the list of wireless licence-holders, asking at what times of day they 'listened to the radio, and information about what kinds of programme they liked at particular times of day and night. Questionnaires were returned from 44 per cent of households, the first national survey of listening habits – and by extension, living habits – of its kind.'[48]Not surprisingly, the findings 'demonstrated a pattern of daytime listening that peaked between 1 and 2 pm, then again between 5 and 6 pm. The overwhelming majority of respondents preferred light music in the middle of the day, with variety, plays and talks in the later afternoon, and the audience remained steady in the evenings till around 10.00 pm (later on Saturday nights) after which time it rapidly faded.' A second survey,

conducted the following summer confirmed that 'age, class and family size were sharp discriminators of taste: broadly, the younger or the more working-class the respondent, and the larger his or her family size, the more likely they were to prefer variety and light music and the less talks, discussions and classical music.'[49]

The precise contribution from Anthony Gordon Lewis is unknown, but as he also worked for the British Institute of Public Opinion (BIPO), the first British public opinion agency set up in 1937 to conduct polls for the *News Chronicle*, an offshoot of the American Gallup organisation, he would have had access to a broad range of opinions on a number of important issues. Moreover, in the early stages of the war BIPO undertook subcontracted work for LRD and the information collected by them was also used by the MOI. According to one historian of LRD the research undertaken by the BBC concentrated upon the 'sociological' rather than the 'statistical' and was 'very much in the mainstream of social research in Britain in the late 1930s'.[50]

Anthony Gordon Lewis's work complemented the work of another Lawn Road Flats resident, Charles Madge. Madge, along with the conservationist Tom Harrison and the documentary film-maker Humphrey Jennings, had set up Mass Observation in 1937 to study British society using some of the tools of anthropology. Madge, who was also a member of PEP, worked closely with Jack Pritchard and decided to move to Lawn Road Flats in 1942, remaining there for the next two years.

Certainly, there was substantial interest in morale, public opinion and the role of broadcasting during the war among the Flats' residents providing valuable access to open source intelligence for the Kuczynski family and other interested persons. Flat 7 had, in fact, been given over to the production of a weekly bulletin, *Comparative Broadcasts*, published between 1 December 1939 and 16 March 1940.[51] The purpose of this bulletin was to examine how various national broadcasts handled contentious subjects, with as many broadcasts as possible being covered by listeners in the Flats 'including American, British German, French German, German English, Italian, Italian English, Italian French, Russian, Russian English, Russian French, and Russian German'.[52] An interested group of private members of the Isobar would tune in to broadcasts, select 'one or two subjects a

week' for publication with the intention of showing 'how different countries came up with entirely different interpretations' of the same event.[53]

Comparative Broadcasts drew on a pool of talent from inside the Flats. Its first editor, L. W. Desbrow, a Lawn Road Flats' resident, was an accomplished academic. He had been President of the Students' Union at the London School of Economics between 1936 and 1938 and Honorary Secretary of the National Union of Students between 1938 and 1939, and lectured in Economics at the City of London College. During the war he worked for the LCC, and collaborated with the Hungarian diplomat Paul de Hevesy in the production of a book on economic planning, and he also took a keen interest in the work of PEP. [54] In January 1940 he was succeeded as editor by the architect Robert Furneaux Jordan, the driving force behind the Architects' Czech Relief Fund. Expert advice was given to both editors by Vyvyan Adams, Conservative MP for Leeds West, and John Parker, Labour MP for Romford and general secretary of the Fabian Society.

Jack Pritchard had become acquainted with Vyvyan Adams following the rejection by British Foreign Secretary, Anthony Eden, of the Soviet Union's call for Collective Security in a BBC wireless debate on foreign policy, broadcast by the BBC on 24 February 1936. A small group of Liberal and Conservative MPs clustered around Winston Churchill, including Vyvyan Adams, now joined with the left wing of the Labour Party in support of Collective Security. However, in order to be effective, Collective Security relied upon the Western Powers – Britain, France, and the United States – to demonstrate unequivocally that in any future confrontation they were prepared to join forces with the Soviet Union against Germany. Britain would not commit to such a course and on 25 February 1936, after listening to Anthony Eden's broadcast, Jack Pritchard wrote to Vyvyan Adams asking him 'what an ordinary individual like myself can do to assist in persuading others of the importance of Collective Security and the importance of doing something about it quickly'.[55] He followed this up on 4 March with a letter to John Strachey, a former Labour MP who had recently joined the Communist Party, advising him that he [Strachey] would 'probably be of more use' to the campaign for Collective Security 'a little further to the right'.[56] 'There is in Hampstead,' he continued, 'a very large middle-class vote, and it seems that the right type of person

would be (for lack of a better term) Intelligentsia Labour. By adopting the labour ticket he would automatically get the orthodox Labour vote, and by being an "intelligent gentleman" he would stand a reasonable chance of getting not only the present Liberals but a great many of the old-fashioned Liberals as well, especially if he stood on a sort of Labour-PEP policy ... having done that the time would then come to go further left.'[57]

Pritchard now embarked on a campaign of letter writing in favour of Collective Security. He wrote first to Gerald Barry, editor of the *News Chronicle*, a founder member of PEP and a close friend asking him why there was not more support in his paper for the policy of Collective Security: 'What has happened to the *News Chronicle*?' he asked '– no more Collective Security – no more crusading for the League. Unless we fight hard now for Collective Security it will be a dream of the past. The risk of war now as a result of a firm stand against treaty breaking is small compared with the risk of over toleration of alleged past injustices. ... It is sad to see the *News Chronicle* and the *Daily Herald* having so much toleration for Nazi Germany, whose leader even now says that he will not be "dragged before international tribunals". Anyway I would prefer a war now when Germany's air force is a bit out of date and her supplies of materials so low rather than wait for her to be better equipped. There must be heavy risks for the Collective Peace system – including a resort to arms.'[58]

In 1938 he wrote separately to Vyvyan Adams and George Balfour, Conservative MP for Hampstead, at the House of Commons, calling on them to take a firm stand against appeasement, and appealing to Balfour as a concerned property owner, to oppose a proposed loan to Italy.[59] To make his point he quoted the Bishop of Chelmsford in both letters:

Dear Sir,

As a very considerable property owner in Hampstead I must write and tell you what anxiety Mr. Chamberlain's present policy is causing me, as I do not wish to have my property destroyed by a war which will be the inevitable outcome of this policy if it is continued.

I think the Bishop of Chelmsford described the present situation very well when he said yesterday:

'Massacres like those of the general population of Guernica and the women and children of Barcelona have no parallel in past history.

'A civilisation which can give birth to the shameful persecution of the Jews, the spraying of mustard gas upon Abyssinian villages, the lying and dishonesty which makes a mock of treaties and agreements, is a civilisation not worth preserving.

'No doubt, for instance, a loan to Italy would buy off Italian aggression for a while, but apart from the shame of such a thing – for it would mean that this country was paying the bill for the rape of Abyssinia and the murder of the women and children of Barcelona – such a policy would ultimately fail.

'A blackmailer can never be bought off.'[60]

On 26 September 1938, four days before the signing of the Munich Agreement which paved the way for the dismemberment and subsequent disappearance of Czechoslovakia, Jack Pritchard wrote to George Balfour again expressing his dismay at the crisis facing Britain, and calling on Balfour to help 'stop this degeneration into a gangster Europe'. He was adamant 'had we stood up to the bullies of Europe firmly and honestly at the beginning, over Abyssinia, over Spain and over Czechoslovakia, this present appalling crisis would not be upon us.'[61] Appealing to Balfour, the businessman, to uphold the sanctity of contracts and to condemn the dismemberment of Czechoslovakia, Pritchard opined that 'perhaps a very long way away' the USSR might begin to move 'in the direction of sanity':

> I think you will agree that there is not much to choose between Russia and Germany, but I think you will also agree that the present regime in Germany must come to a dead end, whereas Russia does seem to point ultimately, although perhaps a very long way away, in the direction of sanity, and therefore it is best for them from the long view and the present immediate position, to go into consultation with them and the French with a view to making a strong and determined effort to stop the breaking of contracts. What business man will bow under a threat of blackmail such as the one which Germany is putting up?[62]

Following the Munich Agreement Anthony Eden, who had resigned as Foreign Secretary in February that year, shifted his stance on Collective Security and condemned Prime Minister Chamberlain's policy of appease-

ment, moving Jack Pritchard to write to the *Sunday Times* in support of Eden's *volte face*, and calling for a policy of Collective Security through the League of Nations. The letter criticised the *Sunday Times* for expressing the view that 'in the circumstances Mr Chamberlain had done the only possible thing' and pointed out that the anti-appeasers' criticism was based not solely on Mr Chamberlain's policy at Munich, but stretched back to his opposition to sanctions in 1935 at the height of the Abyssinian Crisis when he was Chancellor of the Exchequer:

> Many Conservatives will remember that it was Mr. Chamberlain himself who made a speech in Birmingham at the time of the application of sanctions against Italy, when he said that sanctions were 'midsummer madness'. Had the British Government used the same energy and determination in the application of sanctions and in persuading France to work with us, as they used in carrying out their policy of appeasement, we should not find ourselves in our present position of relative isolation with small countries both doubting our word, and ability to carry out our promises.[63]

On 23 May 1939 Jack Pritchard sent a letter to the editor of the *Daily Telegraph* expressing the view that 'the fear of Communism is greater than pride in our Empire or faith in the principles of democracy',[64] there is a 'general feeling', he wrote, 'that the Prime Minister does not treat Parliament in a sufficiently courteous and democratic manner. He is always facing it with the accomplished fact. What is the use of voting for a Member of Parliament if he has no chance of making himself heard till the deed is done?'[65]

The following month Pritchard wrote to *The Times* newspaper again expressing his outrage at the loss of Britain's imperial prestige following the Japanese blockade of the British settlements in the north China treaty port of Tientsin, blaming the crisis on the appeasement policies of the Government. 'The Dictators', he wrote, 'seem to be right in saying that we have lost our old stamina and courage, and that had a similar incident occurred fifty years ago, we would have taken a very much more drastic action than we appear to be doing now'. The recent experiences of Abyssinia, Spain and Munich were mentioned with the warning that 'it is necessary to act fairly and judiciously, but also with exceeding swiftness.'

'Prospective allies,' he concluded, 'will not feel very reassured that we will come to their help sufficiently quickly if we are so dilatory over our own affairs.'[66]

The Japanese blockade of Tientsin followed the refusal of the British authorities to hand over four Chinese nationals suspected of the assassination of the manager of the Japanese-owned Federal Reserve Bank of North China who had taken refuge in the British concession. The blockade led to a major diplomatic crisis between Britain and the United States, with the US making it known that they were not prepared to risk war with Japan for purely British interests. Included in Japanese demands were instructions to hand over all the silver reserves belonging to the Chinese government held in British banks and the ending of anti-Japanese radio broadcasts from anywhere in the British Empire. Not surprisingly these demands were rejected and after three months of negotiations the Japanese backed down from their more extreme demands, (namely, the demand to turn over all Chinese silver held by British banks to Japanese banks) while Britain gave up the four accused, who were executed.

The Tientsin blockade served to highlight British weakness in Asia, both militarily and diplomatically, following Britain's failure to persuade the United States to take a stronger position in the region in its support.[67] This episode took place three months after the final destruction of Czechoslovakia; Britain's seeming impotence in both Europe and Asia convinced Stalin that the British Empire was feeble and incapable of facing down the determined aggression of the dictators. It was, arguably, a contributing factor in nudging him towards his 'deadly embrace' with Hitler. The Nazi-Soviet Pact signed on 23 August 1939, leading to the Nazi and Soviet invasions and division of Poland, paved the way for the Second World War.

*

British communists, and the majority of those who regarded themselves as left wing or 'progressive', including Jack Pritchard, were dismayed. German communists living in exile in London, including the Kuczynski GRU network in and around the Lawn Road Flats, were also horrified. With the outbreak of the Russo-Finnish War on 30 November 1939, however, their views changed. There was a general acceptance of the Moscow line among communists; but not among the majority of 'progressives', among

them Jack Pritchard. On 4 December he wrote to the Finnish architect
and designer Hugo Alvar Henrik Aalto, expressing his total horror at what
was happening to Finland and offering him accommodation in Lawn Road
Flats.[68]Reactions to the invasion of Finland and the war broadcasts of the
Russian, Finnish and German stations filled the first issue of the Flats'
Comparative Broadcasts, which appeared on 1 December 1939 only hours
after news of the invasion was broadcast from Russia; its front page carrying
a brief, but interesting, article on Russian and German radio silence and
special 'announcements'. This was in contrast to up-to-date Finnish broad-
casts in English three times a day on four different wavelengths:

> At 5 a.m. on Nov. 30th Soviet troops crossed the Finnish fron-
> tier. The Russian radio kept complete silence on these operations
> throughout the day, even up to the final news bulletin and it was not
> until 47 minutes after midnight (i.e. 9.47 p.m. G.M.T.) that a special
> announcement of the invasion was made.
>
> At the very moment when the Russian radio was broadcasting the
> news in Russian, the Finns, on a very close wavelength, were broad-
> casting categorical denials of the Russian accusations.
>
> The German radio kept silent on the matter until 22.00 (i.e. 9 p.m.
> G.M.T.) when a brief announcement was made at the end of the
> news bulletin.
>
> The Finnish radio has announced that from to-day onwards 3 broad-
> casts in English will be made daily: at 8 a.m. on 19.75 m. and 31.58
> m. and at 9.40 and 11.40 on the above wavelengths and on 335.3 m.
> and 1807.2 m.[69]

The following week's bulletin reported that Russian broadcasts were 'less
full of news than might have been expected', and had opted to broadcast
a large number of resolutions as opposed to war news: 'The broadcasting
of resolutions from Communist Party, Trade Union and factory meetings',
had 'always been a feature of Russian broadcast programmes', and 'the
coming together of the anniversary of the foundation of the Constitution
in 1936 and the assassination of M. Kiroff in 1934' had been seized upon
to continue that trend.

Resolutions 'in connection with the war and the forthcoming elec-
tions to the local soviets', were dominating Russian radio programmes.[70]

One such resolution, expressing the view that the war in Finland would 'be written indelibly in the book of the history of the liberation of the working class', sent greetings to the new People's Government of Finland and quoted from *The Times* newspaper of 1919 to justify the invasion: 'Finland is the key to Petrograd, Petrograd is the key to Moscow.' This simple statement was broadcast alongside a declaration that 'the present incident will bring peace and security to Finland and Russia … the Russian last word on the subject.'[71] Finnish stations, on the other hand, broadcasting in Russian at 2 am on 3 December, called on all 'Red soldiers not to fight against Finland.' They too recruited Comrade History, pointing out that on 15 May 1917 Lenin had made a declaration in favour of the freedom of Finland. They also quoted Stalin, reminding the world that the policy of the Soviet Union was to defend small nations fighting for their independence. An interview with a Red Air Force officer who, not wanting to fight in Finland, had dropped his bombs in a lake and parachuted to safety, was also broadcast. The interview was translated into English, French and German with one slight but significant alteration in the German broadcast. The pilot had 'asked his interviewer if he could be provided with French and English novels in Russian, in the German broadcast the words "French and English novels" were replaced by the words "Foreign novels".'[72] The broadcast concluded with an appeal to the "true followers of Lenin" not to fight against Finland.[73]

Broadcasts from Madrid, Budapest and Rome were all, unsurprisingly, 'strongly sympathetic to the Finns'. Rome called for a united front against Bolshevism and reported that all 'the countries of South America are calling for an anti-Bolshevik block'. 'Only President Roosevelt', it was claimed, remains 'unwilling to take energetic steps against the U.S.S.R.' Berlin's response was ambivalent; restrained by the terms of the 1939 Nazi-Soviet pact, German broadcasters simply began airing the Russian communiqués from the beginning of the war without any comment at all, and only 'began later to broadcast the Finnish communiqués as well.'[74]

All this would have undoubtedly interested the Kuczynskis. *Comparative Broadcasts* had built up good contacts inside the BBC and the MOI through Vyvyan Adams' wife, Mary who worked for both organisations. *Comparative Broadcasts'* report on the BBC Overseas Service's monthly review of Nazi propaganda would have been of particular interest; the

December edition quite cleverly comparing 'the German story of the sinking of a cruiser of the London class with the story of Alice and the White Queen'. These stories of the sinking of British ships, *Comparative Broadcasts* suggested, were made up to convince the German public that Germany was dominating the seas and to glean news of shipping movements from the denial of such losses by the British Admiralty. It was also explained that German black propaganda was using deception techniques to spread false anti-German rumours in neutral countries allowing Germany to discredit genuine British claims by denying these false rumours. Several apparent mistakes were made by the German broadcasters, particularly the broadcasting of the wrong news to the wrong places. Of interest would have been the German broadcast claiming that Sir Walter Monckton had 'resigned from the Bureau of Censorship because Mr. Churchill was furious at a leakage of news about the damage to H.M.S. Belfast'.[75]

The following week's edition of *Comparative Broadcasts* concentrated on the global wireless propaganda war, and the BBC Overseas Service's inability to combat sophisticated Italian anti-British propaganda broadcast in Arabic. The BBC's habit of broadcasting in English, and the greater number of German, Soviet and Italian stations on the wavelengths, meant that Britain was in danger of ceding ground in the propaganda war:

On December 10th the BBC broadcast a lively survey of their foreign broadcast service and its effect in the places to which it is directed. The survey was very impressive and gave the English listener a comprehensive idea of how the BBC Overseas Service carries on its broadcasts in 15 languages.

Since we strive to be comparative, we must point out that in the war of wireless propaganda Britain has always been, and is still, very much behind the other great powers. Two years ago Britain was virtually the only great country broadcasting only in her own language. Not until January, 1938, after the Italians had started their anti-British propaganda in Arabic, did the BBC start their first foreign language service, in this case for the 40 millions of Arabs. It was during the September crisis, 1938 that the BBC spoke for the first time to the people of a European country in their own language.

Whenever you turn the knob of your wireless on medium or short waves you find that nearly every second station you get is a German one. While on the outbreak of war the BBC closed down the majority of British stations and has kept them closed, the Germans have opened new stations. Only a fortnight ago the Sender Bremen[76] started to broadcast. This station is especially used for anti-British propaganda. Last Sunday Bremen broadcast for the first time a news bulletin in Gaelic! In addition to the nine daily news bulletins in English broadcast from Hamburg and Bremen there are numerous short-wave stations providing 24 hour services exclusively and respectively for the USA, Latin America, Africa and the Far East.

The USSR broadcasts from 24 stations (including their new station in Lvov) and even Italy uses 18, including 12 short-wave stations.... If the BBC wants to continue to broadcast to the world it will have to bring more stations into operation.[77]

Comparative Broadcasts hammered home the point in its next issue, pointing out that the BBC had been slow to respond to a war being conducted on three fronts: military, economic and propaganda. When the BBC broadcast in German, the editor complained, it invariably sounded as if scripts were drafted in English and then translated into German. 'We still feel that <u>Germans</u> are treated to British propaganda against <u>Germany</u> and not to <u>German</u> propaganda against <u>Hitlerism</u>.' Moreover the BBC was only putting out one programme and many listeners were tuning into German stations to listen to music, a situation that Germany was not slow to exploit by 'sandwiching their propaganda between large slices of entertainment.' In the Balkans the Germans were also successfully putting out 'very clever imitations of British programmes "twisted" to German purpose.' 'This,' the bulletin commented, 'opens up a marvellous vista of doubts and suspicions. If the war goes on we may soon be wondering whether any programme comes from where it claims to come from.'[78]

Comparative Broadcasts folded in March 1940 but during its short history its reports on the propaganda war were to the point. While Britain's own black radio department, Electra House (EH), had been set up on the outbreak of war in the stables at Woburn Abbey, the ancestral home of the Duke of Bedford, it wasn't until after the German invasion of

France in May 1940 that EH began using an anti-Nazi German civil servant to broadcast subversive propaganda to Germany. Reporting on the radio propaganda war being fought behind the scenes between the Soviet Union and Nazi Germany, *Comparative Broadcasts* threw interesting light on the fragile nature of the Nazi-Soviet Pact in the early stages of the European democracies war against Hitler. By giving considerable column space to the Comintern's condemnation of Nazi Germany, and Hitler's half-hearted attempts to whitewash Stalin's attack on Finland, the publication drew attention to an ongoing cold war between the two dictators. On 5 January *Comparative Broadcasts* carried a report on 'Hitler, Stalin and the BBC.' and what it dubbed the 'switching of the war', which called on the BBC to clarify its position in respect of communism – either the Soviet Union is the bitter enemy of Nazism; or Stalin and Hitler are working in harmony?

> For home consumption [the BBC's] line has been for a long time that Hitler and Stalin are two sides of the same medal and that both have, eventually, got to be disposed of (even if there is a certain reticence as to who is to do the disposing). This point of view is, of course, still being maintained, but it ill accords with the BBC's current broadcasts to Germany where the 'Communist International' is freely quoted in its violent language against the Nazi regime.

To make its point the bulletin quoted from a Comintern announcement denouncing German imperialism that had been included in a recent BBC broadcast to Germany:

> 'By means of this war German imperialism is continuing the policy of the conquest of foreign countries, of subjugating foreign peoples. At every stage of development the policy of the German imperialists in practice gives the lie to their words. German Nazism described its goal as wanting to restore the honour of the German people, the equal status of Germany. But in reality it brought down upon the German people the disgrace of concentration camps, of mass murders, of butchery of Jews, of barbarism ...
> 'German Nazism is concerned solely with conquering foreign countries, subjugating foreign peoples, building up by robbery a world empire for the German capitalists and procuring gigantic super-

profits for them. The German people are being driven to slaughter, not for Danzig and not for Germany, but for the greedy desires of the German capitalists to exploit and plunder not only the German workers and toilers but also the workers and toilers of other countries and continents.'

The BBC 'cannot have it both ways', the bulletin declared, 'either Communism is the bitter foe of Nazism (as the Germans are told) or Stalin and Hitler are hand in glove (as the British are told). Which?'[79] The following week, quoting from Lewis Carroll's *Through The Looking Glass*, *Comparative Broadcasts* noted that the '"switching the war" game gets curiouser and curiouser and if the Germans are out to whitewash Stalin they have an odd way of doing it. This week German broadcasts have quoted French journalists extensively to the effect that the real front, for the Allies, is in Murmansk and later perhaps on the Indian frontier.'[80] The French, too, it seemed, were 'switching the war'.

On 19 January *Comparative Broadcasts* reported 'a communiqué from the Leningrad High Command denying, among other things, that 'the Russians were seeking the aid of German military instructors', dismissing such reports in the foreign press as 'borne of the "animal fear of a Soviet-German military bloc"'. However, since the signing of the Nazi-Soviet Pact on 23 August 1939 such 'animal fear', as the Russians were well aware, was a reality that did much to explain why Britain and France were so anxious to set the two dictators at one another's throats.

The final edition of *Comparative Broadcasts* ended, as it had begun, with the Russo-Finnish War devoting its columns to the peace agreement between those two countries and the almost total news blackout imposed by Moscow and the BBC on the signing of the treaty shortly after midnight on 12 March 1940.[81] The observation that 'very few people in England' could have 'learnt the sensational news ... on their wireless sets,'[82] contained veiled criticism of the BBC. The fact that the BBC maintained 'that there was still confusion and nothing definite could be said', while 'the peace treaty in correct detail was coming off the Fleet Street presses', gave rise to the clumsily put but, nevertheless, pointed question: 'Does the BBC have to wait for someone or something before it can speak which the newspapers do not have to wait for?' All through that night 'Russian music

filled in the hours until 3.15 am (Moscow Time) when the peace terms were given to the world – to a jubilant Russia, a rejoicing Wilhelmstrasse, a weary Finland and a pained Whitehall and Quai d'Orsay.'[83] The peace treaty, a disaster for British military aspirations in the Gulf of Finland as *Comparative Broadcasts* was quick to point out, was unwelcome news and Fleet Street, not the government-controlled BBC, was the bearer of bad news:

> When Moscow did finally speak fully on the Peace treaty she limited herself to remarking that Leningrad and Murmansk have been secured and that the Gulf of Finland could now be made impregnable against aggression. She declared the inviolability of Finnish independence, wished Finland a good future, and regretted that England had ever brought pressure to bear on the Mannerheim Government to resist the 'moderate proposals' of last autumn.[84]

Berlin made as much capital out of the agreement as possible stressing, 'as she was bound to do, British and French hypocrisy in having once again led a small nation on to expect help and then betrayed them at the last minute. Hans Fritsche [host of a popular German radio programme, "Hans Fritsche Speaks"] in one of his skilful broadcasts made the most of the situation in its bearing on the Near East and the Balkans. What, he remarked, were British promises and guarantees worth to Turkey and Rumania now?'[85] Such thoughts were no doubt shared by the leader of the German Communist Party in exile in Britain, Jurgen Kuczynski who, following a number of speeches in support of the Nazi-Soviet Pact, had been interned on 20 January 1940 by the Aliens Tribunal on the evidence 'that this alien is a communist, and/or working in sympathy with that movement.'[86] On his release he moved into Lawn Road Flats.

The Plot Thickens: Jurgen Kuczynski, Agatha Christie and Colletts Bookshop

T HE Munich agreement of September had been arrived at without the participation of the Soviet Union, and encouraged Stalin to conclude that Britain and France were leaving Germany a free hand against the USSR. Stalin faced with a 'dagger pointing east towards the heart of the Soviet Union', accordingly revised his policies towards the West. On 23 August 1939, two days after the collapse of military talks between the USSR, France and Great Britain, Stalin signed the Nazi-Soviet Pact. This momentous act demanded an unprecedented intellectual leap on the part of the world communist movement, from one of outright opposition to Fascism, to one of open opposition to western imperialism. The following day Moscow Centre began withdrawing its agents from Germany and severed radio links with German nationals working for Soviet intelligence inside the Third Reich; while the NKVD in Russia began handing German communists who had taken refuge in the USSR to the Gestapo. The German Communist Party issued a statement on 25 August:

> The German working people, and especially the German workers, must support the peace policy of the Soviet Union, must place themselves at the side of all peoples which are oppressed and threatened by the Nazis, and must now take up the fight as never before to ensure that peace pacts in the spirit of the pact which has just been concluded between the Soviet Union and Germany are also made with Poland and Romania, with France and England, and with all peoples which have reason to feel themselves threatened by Hitler's policy of aggression ...[1]

The reverberations shook not only the communist movement but also those Fascists committed to the destruction of communism. A good

number of SA men, veterans of many a street fight with the communists, were said to be dismayed:

> Voices were heard that it was about time that *Mein Kampf* was taken out of the bookshops since Hitler was now doing the exact opposite of what he had written.... The next morning the garden of the Brown House was reportedly littered with badges discarded by disillusioned Party members.[2]

For both Hitler and Stalin it was no easy task to convince their followers that the pact was a necessary expedient. On 7 September Stalin told the Bulgarian communist Georgi Dimitrov, general secretary of the Comintern, what he expected of foreign Communist parties. 'They should denounce their governments' war plans as imperialistic and reduce anti-Fascist propaganda.' Four days later the Communist Party of the United States declared the war to be a conflict between 'imperialist' nations. On 14 September a broadcast from Soviet Russia announced that the war was an 'imperialist' one, and a 'predatory' conflict pursued by two aggressor nations.[3] On 18 September the general secretary of the CPGB, Harry Pollitt, published a pamphlet entitled *How to Win the War*. On the very same day he received a Moscow press telegram with instructions that the war must be opposed. Under considerable pressure to conform to the new line he handed responsibilities to a secretariat – a *troika* – made up of the editor of the Party's theoretical journal *Labour Monthly*, Rajani Palme Dutt, the new editor of the *Daily Worker*, William Rust, and Douglas Springhall, the party's National Organiser.[4] At this point the *troika* began to anticipate hostilities, as opposed to an alliance developing between Great Britain and the Soviet Union. Two days later, in accordance with a secret protocol of the Nazi-Soviet pact, Russian troops crossed the eastern frontier of Poland and took up pre-arranged positions. On 29 September, the same day as Warsaw fell, a further German-Soviet treaty was signed, the 'German-Soviet Boundary and Friendship Treaty', defining in detail the limits of their respective occupations of Polish territory. In a joint declaration, issued on that date, the two governments claimed that they had 'definitively settled the problems arising from the collapse of the Polish State and have thereby created a sure foundation for a lasting peace in Eastern Europe'. Britain and France were called upon to recognise the boundary changes and a joint declara-

tion issued that it would be in the interests of all nations to stop the war. A few days later the Communist International declared:

> The present war is an imperialist and unjust war for which the bourgeoisie of all the belligerent states bear equal responsibility. In no country can the working class or the Communist parties support the war. The bourgeoisie is not conducting war against fascism as Chamberlain and the leaders of the Labour Party pretend. War is carried on between two groups of imperialist countries for world domination.[5]

On 11 October the CPGB announced that, in view of differences of opinion on the nature of the war, Harry Pollitt had offered his resignation as general secretary of the Party. There can be little doubt that Pollitt, along with a majority of the Western and Central European Communist Parties, was wrong-footed by Stalin's new strategy. Nevertheless, within a fortnight the leader of the KPD in exile, Dr Jurgen Kuczynski had succeeded in bringing most exiled German communists into line.

A leading member of the KPD since July 1930, Jurgen Kuczynski was an influential figure among those members of the German Communist Party exiled in Britain. A high-ranking communist official, he had met with the leader of the German Communist Party, Walter Ulbricht in 1935,[6] who entrusted him with securing the entire funds of the KPD ('a very important sum'), instructing him to smuggle them out of Germany and deposit them in the Dutch bank, Rotterdamsche Bankvereeniging. In order to avoid British war laws it was decided that the money should not be brought into Britain, but instead invested on the American stock market.[7] Kuczynski arrived in Britain with his Alsatian-born wife, Margueritte, on 21 January 1936, staying a few days with his parents in Lawn Road before journeying to the continent. His activities were already well known to British intelligence and his movements were very closely monitored while he remained in England. MI5 had opened a file on the Kuczynski family in 1928, based on information from MI6 agents working inside Germany. 'The file was at first simply a KAEOT – "Keep an Eye on Them" – commonly known as a K file.'[8] On 6 June 1934 MI5 reported that Jurgen Kuczynski had written to W. H. Williams of the Communist Party-dominated Labour Research Department in London, requesting 'their British Imperialism Series' and

'other books for review in the journal he edited *Finanzpolitische Korrespondenz*'.[9] On 24 June, a memo (CX/6561/V) was sent to the head of the newly created Section V (counter-intelligence) branch of MI6, Colonel Valentine Vivian,[10] mentioning 'Jurgen KUCZYNSKI, Berlin, in a list of functionaries of the Communist Central Organisations',[11] and detailing his links with British left-wing publishers and labour movement activists. In January 1934 MI5 reported the closure of the *Finanzpolitische Korrespondenz* because Kuczynski was a non-Aryan and 'was not allowed to continue as editor'.[12]

Jurgen Kuczynski returned to London on 29 July 1936 and stayed again with his parents at 12 Lawn Road before moving to nearby Upper Park Road where he set about co-ordinating the activities of the KPD in Britain. He was by no means, *persona non grata* in Britain, and was employed by the British government as an economic statistician specializing on Germany. Among his contacts were a number of left-wing members of the British Labour Party including the future Minister of Education, Ellen Wilkinson MP, who was closely involved with Willi Munzenberg's World Congress Against War; John Strachey and his wife Celia, both of whom were members of the CPGB; the Labour politician, Aneurin Bevan MP; future poet laureate Cecil Day-Lewis; and the East End of London domiciled painter and poet Lilian Bowes-Lyon, a cousin of Elizabeth Bowes-Lyon (consort of King George VI and later the Queen Mother). Jurgen Kuczynski, a highly-respected academic who often dined on high table at various Oxford and Cambridge colleges, had influential friends in the top echelons of British society.[13] He was also 'probably identical with the KUCHINSKI @ KARO who on 25.3.37' was reported by MI5 to be 'in touch with members of the Soviet Embassy in London'.[14] However, at the time this was not deemed to be of great significance, and on 7 October 1938 MI5 informed the Home Office 'that there would be no objection to KUCYNSKI's permanent residence in the UK'.[15]

Following the signing of the Nazi-Soviet Pact, Jurgen Kuczynski was said to be 'flabbergasted', according to an MI5 agent placed inside the London-based KPD. Identified only as Hess, the agent had spoken with 'Jurgen soon after the news of the signing of the German-Russian Pact' and had reported to his controller that Jurgen had seemed mortified, 'and quite unable to account for it'. About a fortnight later, however, an MI5

report claimed that 'he had perfectly definite views on the matter, and these were the official views of the Communist Party which, Hess suggests, had by that time been made known to Jurgen'.[16] As a result, Kuczynski began openly to condemn the war as an expression of Anglo-American imperialism dressed up as a defence of democracy and freedom, and began calling for acts of 'sabotage, strikes etc., in important war industries' in both Britain and Germany. He was then editing the KPD English language newspaper *Inside Nazi Germany*, which took the line that Germany was on the brink of revolution, and that British workers consequently had 'no need to prosecute the war energetically'. He was also working closely with the German Freedom Station, broadcasting the same views to Germany. As his statements became increasingly bellicose, anti-British, and pro-Stalin, MI5 began monitoring his activities more closely and on 23 November 1939 a Home Office Warrant (HOW) was granted allowing MI5 to intercept mail sent to his address at 36 Upper Park Road, NW3. On 20 January 1940 he was interned by the Aliens Tribunal on the evidence that he was an alien and a communist:

> H.O. file K.4790 re Jurgen Kuczynski.
> 20.1.40. Interned. Met. Police Tribunal No. 11.
> Reasons: I think that this alien is a communist, and/or working in sympathy with that movement.[17]

An appeal was immediately launched for his release and a well-organised campaign was got underway on his behalf by the defence lawyer in the Woolwich Arsenal case, D. N. Pritt, who on 22 January sent a letter to the Home Office questioning the grounds on which Jurgen Kuczynski had been interned. The cousin of the then Queen, Lilian H. Bowes-Lyon, and the president of the National Union of Railwaymen, John Marchbank, wrote separately to the Home Office calling for his release. Further letters in support of Pritt's appeal were received from among others the National Federation of Building Trade Operatives and the Conservative MP, Vyvyan Adams. Following further interventions on his behalf by the 'Red Dean' of Canterbury, Hewlett Johnson, and the Marxist academic Harold Laski, he was released from Warner's Camp, Seaton, Devon on 25 April on the grounds that membership of the KPD was not sufficient grounds for internment. On his release he moved into No. 6 Lawn Road Flats. Unable

to prevent his release, MI5 and Lieutenant-Colonel Valentine Vivian of MI6's counter-intelligence division, having accepted the inevitable, transferred the Home Office Warrant to Lawn Road Flats on 16 March 1940.[18]

After his release Jurgen Kuczynski wasted little time before resuming his former activities and stepped up his anti-British propaganda. MI5 described him as 'a typical panic maker who, uninvited, explained to all and sundry that Great Britain would lose the war'.[19] In June 1940, M/S, an MI5 agent working inside the German émigré community, sent in a report on two suspected hostile intelligence agents, Walter and Ernst Loewenheim (recently interned under suspicion of military espionage for Germany and Russia), warning against their connection with the Thames Engineering Co., and the access this gave them to large industrial firms. Drawing attention to the Loewenheim's connection with three prominent German communists in London – Hans Kahle, Professor A. Meusl and Jurgen Kuczynski – M/S concluded by referring 'to a report sent in to M.K. [Maxwell Knight] last September or October, in which it was stated that MEUSL, KAHLE & KUCZYNSKI were interested in a concern which had contacts with large industrial firms, and that they were thus in a position to obtain a lot of information which should not have been allowed to come their way'.[20] During Jurgen Kuczynski's period of internment Professor A. Meusl was described by MI5 as being 'the Chief of the Communist Party, a very dangerous man capable of committing every crime', while Hans Kahle, 'known as the famous "HANS", was referred to as the 'leader of the OGPU in Madrid and [while] in Berlin the leader of the "Workers' Radio", a sub-section of the German Communist Party'[21] who, along with Jurgen Kuczynski, had been 'running a G.P.U. espionage system at Bloomsbury House, the refugee centre in London.'[22]

On 8 May 1940 an MI5 memo stamped SECRET and initialled by MJEB/ SFM was sent to Lieutenant-Colonel V. Vivian of SIS informing him that according to information received from an agent referred to as OTTEN, 'Mrs. Margueritte KUCZINSKI *(sic)* [has] instructed the Bank of London and South America, Lima, to transfer certain securities from the holdings of the Rotterdamsche Bankvereeniging to those of the National City Bank of New York.' 'We should be most grateful,' the memo concluded, 'for any comments that you may be able to make regarding the control by KUCZYNSKI of K.P.D. money.'[23]A second secret memo again addressed

to Vivian of MI6, reiterated the importance of getting 'something further regarding KUCZYNSKI's control of K.P.D. money', and relaying important information regarding the Kuczynski's change of address: 'He has taken a new flat, the address of which he does not disclose. His wife answers telephone enquiries but gives no information about her husband. KUCZYNSKI apparently boasts that he has very influential supporters mostly 'people of the intelligentsia around the "New Statesman".'[24]

<p style="text-align:center">*</p>

With the fall of France in June 1940 Hitler ordered the German Air Force to draw up plans for a Blitz offensive against London and other British cities. On 1 August 1940 he signed Directive No. 17, intensifying the air and sea war against Britain as the basis for her 'final subjugation'. An invasion of the British Isles – Operation Sealion – was planned for mid-September. The actual offensive began on 13 August when German fighters appeared over southern England intent on sweeping the Royal Air Force from the skies. On 17 August, however, following a disastrous night for the Luftwaffe, Hitler was forced to accept that the 'battle for the skies' had been lost, and changed his air strategy accordingly. He had originally intended to unleash massive terror bombing of London as a prelude to Operation Sealion. He now brought that terror campaign forward. On 24 August a large number of German aircraft bombed London; the British replied with air raids on Berlin. From 7 September to the middle of November, night bombing became the norm. Kuczynski's supporters among the 'intelligentsia around the *New Statesman*' now joined the Communist Party's campaign for a 'bomb-proof shelter for all'.

Launched in 1938 with the publication of Professor J. B. S. Haldane's book *A.R.P.* by the Left Book Club, a 'bomb-proof shelter for all' drew attention to the appalling lack of shelters in London and other major British cities for people who were not wealthy. In his review of the book, John Strachey wrote that 'Professor Haldane has shown us that we can have full protection, though only by a scheme on a great scale such as it is idle to suppose that the Government will undertake unless an enormously strong public demand is generated. For my part, I can only say that full protection is what I demand for my wife, my two children, and myself, and that nothing less will do.'[25] Ferro-concrete buildings and buildings with

a steel frame were described in the book as being 'far harder to destroy' than brick buildings.[26] As a consequence, Lawn Road Flats came to be considered as 'one of the very safest buildings in the whole of London.' With air warfare against British civilians only months away, the residents of Lawn Road Flats had begun to prepare their own defences with Jurgen Kuczynski's sister, Bridget Lewis, taking a leading role.[27] As early as 1938 an executive committee had been formed by residents to decide on what needed to be done in the event of war. A questionnaire was distributed among residents to gauge the Flats' level of preparedness. Among the questions asked were: 'are you willing in principle to share the expense if necessary of sandbags and/or other structural defence measures up to a limit of, say, 10/- per head?' 'Have you made all necessary arrangements for the complete blacking out of all your windows as advised in the A.R.P. Handbook, not forgetting kitchen and bathroom windows? Special paper can be supplied from this office.' An itinerary of useful goods to have with you in case of an air raid was also included. In the event of tenants using the club room during an attack they were advised to bring with them a hot water bottle, bucket, toilet paper, cotton wool (for ears), blankets, and an electric torch.[28]

The 1938 residents' executive committee was made up of Mr Geddes (chairman), Mrs Bridget Lewis, Paul Reilly, Hans Goldschmidt, Egon Riss and Philip Harben. Mr Geddes 'was given the task of buying the necessary sandbags and raising the necessary money from the tenants',[29] while the Isobar was made ready by securing the following items for use in the club room: 'Bleaching powder, Gramophone, Gramophone needles, Gramophone records, Playing cards, Spillikins, Brandy for medicinal purposes, Primuses, Paraffin, Methylated Spirit, Matches, Food, Water, Tea etc. all to be easily available, Candles, Strong cord, Adhesive tape, First Aid, Rubber truncheons, Disinfectant, and a Battery wireless set.' Each tenant was also supplied with adhesive tape, black paper, black distemper and a reserve store of the fuel coke.[30]

*

The weather in the opening weeks of the war in September 1939 was hot and sultry and life in the capital was characterized very much by the encouraging slogan 'business as usual'. On a sunny Saturday in the first week of

the war the painter, Kenneth Rowntree, and his newly qualified architect wife Diana (née Buckley) held their 'wedding reception on the timber deck outside the Isobar'. Philip Harben cooked the wedding luncheon and, as Diana Rowntree later recalled, 'the fowl he boiled for us was the first of so very many gastronomic treats I have failed to appreciate, but this did nothing to lessen the total contentment of the occasion and its setting. The wedding had been secular, our clothes were informal, and there was nowhere in the world I would rather have been that day.'[31]

In September 1939 the Flats would have been well above the income level of a 24-year-old painter and a newly qualified architect. It was the onset of the Blitz in September 1940 that finally admitted the Rowntrees 'to the heady, rational joys of Lawn Road Flats.'[32]

On 16 September 1940 Jack Pritchard wrote to an old family friend, the American historian Allyn Forbes, with news that 'the raids on London are getting quite hot at times.'[33] Jack's wife Molly and two sons, Jonathan and Jeremy, along with his daughter, Jennifer Tudor-Hart, had recently been evacuated to America and were staying with Forbes and his family. With nightly air raids on London, Pritchard had included a letter for Molly to be handed over in the event of his death:

> If I get bumped off by a bomb, I should hate to feel that Molly was told by a telegram and nothing else. I have, therefore, decided to write a letter to her which should only be given to her in the event of my being killed. This letter is enclosed and I should be glad if you would keep it for me.
>
> I am telling George Cooks, my brother Fleetwood, and my secretary Joan Walton that you have this letter and that if you hear from any of these people asking you to hand the letter to Molly, I should be glad if you would do so.
>
> This sounds rather melodramatic and the chances, of course, are infinitesimal, but I feel that it is only right and proper that I should take this precaution, however small the risk may be.[34]

The risk was not small. On 8 September 1940 the blast from a nearby bomb had broken the windows of a top floor flat, frightening away its occupants and making way for the Rowntrees who were offered residency, without service, for £1.10.0 [£1.50] a week, which suited a £4.0.0. wage

packet. On another night half a dozen houses at the end of Lawn Road disappeared. However, with the Isobar 'beginning to be full almost every night',[35] there was a sense of hedonism among tenants helping them to cope with the pressures of wartime. In a further letter to Allyn Forbes Pritchard wrote: 'In many ways life goes on here just the same; indeed in my flats the Club is bright and full and sometimes we dance and are gay. Apart from the once when all our windows were blown in we have not been seriously inconvenienced'.[36] The Rowntrees expressed their satisfaction. A true machine for living, Lawn Road Flats gave them the opportunity to experience first hand the founding 'principles' of architectural modernism:

> After five years of developing a functional design philosophy at the drawing board, and by the dialect of the AA [Architects Association] studios, to find oneself living in a flat designed according to those principles was indeed to come home. No. 31 Lawn Road Flats performed entirely to our satisfaction, as Kenneth's studio by day, as a hospitable dining room by night, finally as bedroom luxuriously accoutred with 6'0" long bath, spacious built in dressing table and the dressing room I still remember with affection.[37]

Life in the Flats during wartime was incredibly social, here tenants and visitors to the Isobar enjoyed what Walter Gropius would later describe as 'an exciting housing laboratory, both socially and technically'. Diana and Kenneth Rowntree had indeed 'come home':

> We only used the restaurant for special occasions, but the bar itself we frequented as much for the intoxicating cool of the intellects gathered there as of the beverages. While J. C. Pritchard was building his formidable palate I was painstakingly acquiring the taste for draught beer. This pure twentieth century existence lasted less than a year. With the onset of our first born we moved into the country away from the bombs.[38]

<div align="center">*</div>

The bombs might well have caused the Rowntrees' departure, but they also heralded the arrival in the Flats of England's most famous crime writer, Agatha Christie. In 1941 at the height of the Blitz, Agatha Christie,

along with her husband Max Mallowan, moved into Flat 20, a far cry from 'Greenway', her country estate in Devon where she had been preparing a salad when Chamberlain announced that Britain was now at war with Germany:

> And so we were back in wartime.... The first war came with a shock of incomprehension, as something unheard of, impossible, something that had never happened in living memory, that never would happen. This war was different.... One expected to hear that London was bombed that first night. London was not bombed. I think everyone was trying to ring up everyone else.[39]

Agatha Christie had acquired Greenway in October 1938. A classic Georgian House built around 1780, it stood in thirty acres of woodland on the banks of the River Dart. As with all the houses she owned there was a sense of timelessness, of endless space, of extensive gardens, orchards, conservatories, tennis courts and croquet lawns. Such surroundings would provide the backdrop to many of Agatha Christie's later stories of easeful middle-class lives shockingly disrupted by murder;[40] an environment far removed from the imposingly modernist Isokon building in Lawn Road, Hampstead, where she wrote a number of her books and plays including *The Body in the Library, Five Little Pigs, The Moving Finger, Sparkling Cyanide* and her only spy novel, *N or M?*

All the rooms at Greenway were elegant and spacious. On one side of a wide pillared porch was an airy morning-room giving on to a drawing-room with a curved window and steps out to the garden. There were five main rooms on the first floor, a study, a dressing-room for herself and another for her husband the Arabist and archaeologist, Max Mallowan. The fourth room, at the front of the house, was the bedroom she shared with Max, with her large bed in the middle of the room and Max's smaller one at her side. Such elegance and space contrasted sharply with the unit dwellings of the Lawn Road Flats. The Isokon building would prove a mysterious interlude in the life of Agatha Christie, in many respects as much of a mystery as her notorious disappearance in 1926. As one of her biographers pointed out – the story of Agatha Christie centres upon romantic houses, and the questionable claim that she 'loved houses almost

more than she loved people'.[41] In the Isokon building these two love affairs came together in equal measure.

In mid-1940 Agatha and Max had left Greenway for a flat in Half Moon Street, Mayfair, before moving into a service flat in Park Place, off St James's Street. Their arrival in London had coincided with a series of air raids and Half Moon Street had been somewhat off-putting owing to 'the fact that the house in question stood up like a tooth – the houses on either side of it were missing. They had apparently been hit by a bomb about ten days before, and for that reason the flat was available for rent, its owners having cleared out quickly'.[42] Within a week the Mallowans had moved into Park Place, a rather expensive service flat that was now slightly down-at-heel. We 'lived there for some little time', she later recalled, 'with noisy sessions of bombs going off all around us. I was particularly sorry for the waiters, who had to serve meals in the evening and then take themselves home through the air raids'.[43]

Agatha Christie also owned an elegant London town house on Camden Hill at 48 Sheffield Terrace composed of large, amply proportioned rooms that had been let out to tenants. During the height of the Blitz the tenants vacated the house and the Mallowans re-occupied it. There, with 'bombs all round us whistling down', Agatha Christie underwent training in Air Raid Precautions until, in March 1941, with things in Sheffield Terrace 'very unsafe', they moved into the comparative safety of the Lawn Road Flats.[44] It was a building that made a lasting impression upon her: 'Coming up the street the flats looked just like a giant liner which <u>ought</u> to have had a couple of funnels, and then you went up the stairs and through the door of one's flat and there were the trees tapping on the window'.[45]

The Mallowans had been introduced to Jack Pritchard, the Isobar, and the Isokon building by an old friend, the Egyptologist, Professor Stephen Glanville, who was then working for RAF intelligence and living in Flat 2. Professor Glanville was Agatha Christie's long-standing tutelary genius who had made a number of suggestions for *Death on the Nile* and had helped her with the plot of her play set in Ancient Egypt, *Akhnaton*. Agatha was fascinated by Egypt and its history, and in Glanville she recognised the perfect Captain Arthur Hastings to her own Hercule Poirot. In the ancient Egyptian religions she admitted to finding something sinister – 'a strange mixture of human and animal in the deities', and an emphasis on death

and the rituals surrounding it which she found reassuring in wartime – the 'comfortable structure', as she called it, of the "old gods".[46] Glanville had visited the ancient Egyptian sites in 1922, including the newly discovered tomb of Tutankhamun. In 1923 he had been a member of the Egypt Exploration Society's archaeological expedition to Tell el-Amarna where he had studied hieroglyphics under F. L. Griffith. On his return to London in 1924 Glanville had worked as assistant (later assistant keeper, 1930–1933) in the department of Egyptian and Assyrian antiquities at the British Museum, where he began cataloguing the museum's demotic papyri.[47] In 1933 he was appointed reader in Egyptology at University College, London, and Edwards Professor of Egypt there in 1935.[48] Although his work at the Air Ministry dominated his wartime activities, he was able to finish editing *The Legacy of Egypt*, which was published by the Clarendon Press in 1942.

The Mallowans' decision to move to London in 1940 had been a result of Max's appointment as honorary secretary to the Anglo-Turkish Relief Committee. This had been established by the archaeologist and founder of the British School of Archaeology at Ankara, Professor Garston, following the total devastation of the town of Erzincan in Eastern Turkey by an earthquake. When the committee had completed its work, Professor Garston found Max a job with the Directorate of Allied and Foreign Liaison, part of the Intelligence Branch of the RAF, where he was given responsibility for integrating the Czech Air Force with the RAF. Max found himself working alongside his old colleague, Stephen Glanville, who introduced him to Jack Pritchard and the intimacy of the Isobar. 'My first year at the Air Ministry,' he wrote, 'was eventful, exciting and often amusing. Agatha and I lived at Lawn Road Flats in Hampstead.'[49] The Mallowans 'spent a contented year together at 22 Lawn Road Flats, from where Agatha went off to University College Hospital to work as a dispenser three and a half days a week and alternate Saturdays, and Max to the Air Ministry.'[50] Their London wartime interlude came to an end in 1942 when the RAF's Directorate of Allied and Foreign Liaison was asked to supply two officers to go to the Middle East to set up a corresponding branch of the Directorate in Cairo. Max, who had knowledge of Arabic, volunteered his services and, after promotion to the rank of Squadron Leader, joined the headquarters of the RAF in the Middle East. This was the first time in ten years that the couple had been separated and, to overcome her loneliness, Agatha Christie wrote prodigiously.

The Flats and the Isobar also offered her interesting company by way of consolation. 'Lawn Road Flats was a good place to be,' she later recalled, 'since Max had to be away. They were kindly people there. There was also a small restaurant, with an informal and happy atmosphere. Outside my bedroom window, which was on the second floor, a bank ran along behind the flats planted with trees and shrubs. Exactly opposite my window was a big, white, double cherry-tree which came to a great pyramidal point. The effect of the bank was much like that in the second act of Barrie's *Dear Brutus*, when they turn to the window and find that Lob's wood has come right up to the window-panes. The cherry-tree was especially welcome. It was one of the things in spring that cheered me every morning when I woke.'[51]

On summer evenings Agatha Christie would take her meal in the little garden by the side of the Flats or dine in the Isobar restaurant. She was looking after a friend's Sealyham Terrier called James, and would often walk the dog on Hampstead Heath, barely ten minutes away, before taking him with her to work. 'They were very good to me at University College Hospital: they let me bring him to the dispensary,' she wrote. 'James behaved impeccably. He laid his white sausage-like body out under the shelves of bottles and remained there, occasionally accepting kind attentions from the charwoman when she was cleaning.'

Life in wartime London was 'not so much like a nightmare', she would later recall, 'as something that had been always going on, had *always* been there. It had become, in fact, natural to expect that you yourself might be killed, that you would hear of deaths of friends. Broken windows, bombs, land-mines, and in due course flying-bombs and rockets – all these things would go on, not as something extraordinary, but as perfectly natural. After three years of war, they were an everyday happening. You could not really envisage a time where there would not be a war any more.'[52]

Occasionally Agatha would go and stay with the actor Francis Sullivan who had played Hercule Poirot in the 1930 production of her stage play *Black Coffee*, at his house in Haslemere, which boasted Spanish chestnut woods all around it.[53] On returning to Lawn Road Flats the reality of London and the Blitz would quickly reassert itself: 'I would be back again in Lawn Road, my face covered with a pillow as a protection against flying glass, and on a chair by my side, my two most precious possessions: my

fur coat, and my hot-water-bottle – a rubber hot-water-bottle, something at that time quite irreplaceable. Thus I was ready for all emergencies.'[54]

One of those emergencies was Stephen Glanville who seemed always 'to be falling in love with unsuitable women', and went to Agatha Christie for 'sensible advice'. When the war became too much for Agatha she would seek solace in her flat and 'lie back in that funny chair here which looks so peculiar and is really very comfortable, close my eyes and say "Now, where shall I go with Max?" Often it is Leptis Magna … or Delphi, or up the mound at Nineveh.'[55] Reclining on the Breuer Long Chair, memories of archaeological digs with her husband were no doubt comforting. She may also have recalled funnier moments like the time when a fellow Lawn Road Flats' resident, the architect and goldsmith Louis Osman, 'a man with huge charm and an energetic outlook on life', borrowed a pair of her knickers.[56]

*

Louis Osman lived in No. 5 Lawn Road Flats between 1937 and 1940 and left an account describing how novel many of the features of the Isokon building actually were, and just how difficult it was for tenants to accustom themselves to such new-fangled features as the sliding door: 'Wells Coates reinforced concrete; all the doors slid: no hinges, so if you pushed too hard they went slap through the wall into the garden.'[57] The walls were 'very thin' and must have been hell for his neighbours on account of the fact that Osman was a keen amateur musician and often practised his flute.[58] His adventure when he borrowed Agatha Christie's knickers took place just before he moved into the Flats in 1937.

In 1935 Max Mallowan had led an archaeological dig in Syria with Sir Leonard and Katherine Woolley, and had taken Agatha along with him. The British Museum and the British School of Archaeology were offering a prize to the 'foremost architectural student' of the day to join Max's expedition, and in 1936 Osman won it. He travelled on the Venice Simplon-Orient-Express through France, Milan, Venice and Constantinople, spending time in each place before joining the expedition at the headwater of the Euphrates, just south of the Turkish border. The following year he was chosen again although this time he was to travel much of the way with Sir Leonard Woolley and his wife. In his excitement he forgot to pack his swimming trunks[59] and so one hot day in Syria Agatha Christie kindly lent

him a pair of her knickers so that he could enjoy a swim with the group; much to their amusement, they became transparent when wet.[60]

Agatha Christie based the characters and plot for her novel *Murder in Mesopotamia* 'on many of her observations from this expedition'.[61] It is tempting to draw a similar conclusion from her stay in the Isokon building: 'I had decided to write two books at once, since one of the difficulties of writing a book is that it suddenly goes stale on you. Then you have to put it by, and do other things – but I had no other things to do. I had no wish to sit and brood. I believed that if I wrote two books, and alternated the writing of them, it would keep me fresh at the task. One was *The Body in the Library*, which I had been thinking of writing for some time, and the other one was *N or M?*, a spy story, which was in a way a continuation of the second book of mine, *The Secret Adversary*, featuring Tommy and Tuppence. Now with a grown-up son and daughter, Tommy and Tuppence were bored by finding that nobody wanted them in wartime. However, they made a splendid come-back as a middle-aged pair, and tracked down spies with all their old enthusiasm.'[62]

N or M? is quite remarkable for displaying the author's considerable knowledge of intelligence tradecraft and Fifth Column activity in Britain during the Second World War. What Agatha Christie would have made of Jurgen and Brigitte Kuczynski, supposing that they would have met in the very sociable atmosphere of the Isobar – 'full every evening and humming with conversation ... gay and cultured, with dances and Beethoven alternately'[63] – is intriguing to say the least. There is a telling passage in *N or M?* that certainly suggests that Christie may well have enjoyed more than one conversation with a member of the Kuczynski family or one of the many German refugees staying in the Flats. This is more than likely. On the 23 October 2013 I received an interesting letter from a Mr. Ron Heisler who described himself as being `partly Jewish' and `for a long time an active member of the Labour Party of an independent Marxist kind.' In a previous letter (dated 5 July 2013) Eisler had mentioned a friend of his, the antiquarian bookseller, Louis Bondy, who had been a Lawn Road Flats resident during the Second World War. Bondy was on close terms with the Kuczynski family who he knew both professionally and socially. For a while they all enjoyed the wartime hospitality of the Lawn Road Flats and Bondy later recalled dining in the Isobar with Agatha Christie and

the Daily Express cartoonist, David Low, also a Lawn Road Flats resident. Christie was an extremely intelligent woman; she was ideally placed to pick up on the very interesting conversations taking place in the intimate atmosphere of the Isobar during wartime, as this extract from N or M? would suggest:

> 'You've read in the newspapers of the Fifth Column? You know, roughly at any rate, just what that term implies. '
>
> Tommy murmured:
>
> 'The enemy within.'
>
> 'Exactly. This war, Beresford, started in an optimistic spirit. Oh, I don't mean the people who really knew – we've known all along what we were up against – the efficiency of the enemy, his aerial strength, his deadly determination, and the co-ordination of his well-planned war machine. I mean the people as whole. The good-hearted, muddle-headed democratic fellow who believes what he wants to believe – that Germany will crack up, that she's on the verge of revolution, that her weapons of war are made of tin and that her men are so underfed that they'll fall down if they try to march – all that sort of stuff. Wishful thinking as the saying goes.'[64]

At precisely the same time that Agatha Christie was formulating these words MI5 agents inside the exiled KPD community in London were quoting Jurgen Kuczynski as saying exactly the same thing. His defence of the Nazi-Soviet pact as a bulwark against British capitalism's dominance of a Europe in thrall to the New York Stock Exchange may well have been a topic of conversation in the Isobar:

> The Stalinist Treaty policy with Germany is, according to KUCZYNSKI, the only way of insuring a new and free Germany for the future. Europe must be prevented, above all, from coming under an English domination. In the same way it must be seen that Europe does not fall completely under the influence of the New York Stock Exchange. It is the duty of every revolutionary socialist to fight against the dictatorship of the financial magnates not excluding those who hide under the cloak of democracy.[65]

*

Fears for the future direction of post-war Europe were exploited by Jurgen Kuczynski to gain support among communists for the Nazi-Soviet pact. The threat to Europe posed by the New York Stock Exchange made it easier to sell the pact to disgruntled communists as part of an anti-capitalist offensive, even if it did mean accommodation with Fascism. In this respect a number of wealthy backers of the CPGB played an important part in publicizing the anti-capitalist agenda of the left in the early phases of the war. One important person in the CPGB's propaganda war against anglo-saxon capitalism was the heiress to Reckitt's Blue and Starch Company and the Colman's Mustard fortune,[66] Eva Collett Reckitt.[67] Regarded by MI5 as the 'milch cow' of the CPGB, she had first come to their attention in 1928 in connection with Soviet agent and future Half Hundred Club member, William Norman Ewer and his Federated Press of America (FPA), when a Home Office Warrant was issued against her address at 9 Old Square, Lincoln's Inn. The warrant stated: 'This woman is believed to be acting as a cover for an espionage organisation known to be working in this country on behalf of a foreign power.'[68]

Co-owner of Colletts political bookshop in Charing Cross Road, a major outlet for socialist and communist literature in Britain, Eva Reckitt moved into No. 22 Lawn Road Flats on 10 October 1940. She then moved into Flat 20 a few weeks later before vacating it for Agatha Christie at the end of February 1941, moving into Flat 1 on the ground floor next door to Agatha Christies's close friend, Stephen Glanville. How well she got on with Christie and Glanville is not recorded but, given her contacts with the publishing world, there must have been mutual curiosity, if not attraction. Eva Reckitt was undoubtedly a very interesting woman. She had been carded by MI5 for over a decade and a Home Office Warrant was maintained on her three addresses at Lawn Road Flats. In the 1940s, while she was living in the Flats she was linked with John Wilkinson, a scientist employed on secret work for the Chemical Warfare Department.[69] Harry Pollitt, the general secretary of the CPGB was also known to visit her at Lawn Road Flats. An intercepted phone call to Eva Reckitt's flat (Primrose 2315) noted: 'Harry then suggested that he called in at her place on the way to the office on Monday morning at 9.30. He asked the way, and Eva said turn left from Belsize Park Station and then first left again saying that was Lawnlode [*sic*] and she was on the ground floor, number 1.'[70]

MI5 also took an interest in Collett's bookshop; it had been opened in 1913 by Francis Henderson, a publisher and pamphleteer, described by Eva Reckitt as a 'wonderful chap with a red tie who looked like a bad-tempered Lenin, and never paid his bills'.[71]After Henderson's death in 1931 the shop had been taken over by his son who failed to keep it going, and Eva Reckitt had bought the premises in 1933 for £617. Weekly takings during the first six months of trading averaged £38 15s 4d, and the net loss over this first period of trading was £194 1s 0d. It was undoubtedly Eva Reckitt's inheritance that kept the bookshop afloat. She became both chairman and managing director, inviting onto the original board two leading figures from the communist and socialist worlds – Jack Pritchard's long-standing friend from the University of Cambridge, the economist and Soviet agent spotter, Maurice Dobb, and the Labour MP and leader of the shop workers' union USDAW, John Jagger. Her friend and fellow communist, Olive Parsons was also a board member. Eva Reckitt received much encouragement and advice from a number of prominent left-leaning figures from the world of publishing, among them Victor Gollancz, Sir Stanley Unwin, W. G. Taylor of Dent's and Francis Meynell. In Christmas week 1934 the shop posted a net profit of £9.00, and in the same week a Colletts bookshop opened in Glasgow followed by a Manchester bookshop in April 1935 and a Cardiff bookshop in October 1936. Eva had joined the CPGB in 1934, and was one of the few members of the Communist Party to pay supertax.

The impact of Colletts bookshop on the British reading public was quite substantial; its opening coincided with 'the beginning of a great surge in popular reading of a radical kind'.[72] The introduction of Penguin books by Allen Lane in 1935, and the establishment of the Left Book Club in 1936 'were enthusiastically welcomed by Eva Reckitt and her fellow-directors, and their bookshops became important centres for both sales and promotion'.[73] She continually sought to reach out to new audiences for book-buying, running two-penny libraries, publishing booklets, and arranging with publishers for the printing of special cheap editions. 'One innovation organised by the Manchester and Cardiff bookshops was a circulating library-cum-travelling bookshop. It had become common in the 1930s for tricycles fitted with containers on their front wheel to travel round built-up areas selling ice-cream, pies or lunch packets, and carrying a sign "Stop Me and Buy One". The Colletts' Manchester van was run along

similar lines, with its sign reading "Stop Me and Read One". A Colletts' van accompanied the Scottish contingent on the 1936 Hunger March, and the Cardiff shop sponsored a special marchers' song publishing an illustrated pamphlet on the South Wales march in the same year. The shops were often vandalised during Fascist demonstrations; all to no avail as any publicity was good publicity.'[74]

Agatha Christie, whose disappearance in 1926 helped turn *The Murder of Roger Ackroyd* into a bestseller, knew this only too well. What she made of the richest woman in the Lawn Road Flats is not known, nor her wartime opinions of communism or anti-Semitism. She had been resident in the flats four months when in the middle of May 1941 Hitler, in need of an alternative strategy to force Britain out of the war, once more turned to Fascism's main ideological purpose, the destruction of 'Jewish Bolshevism'. A true 'lightening war' against the Soviet Union, he believed, would remove any remaining hopes Churchill entertained that Britain's salvation lay with Russia's entry into the war. Furthermore, a decisive victory against the Soviet Union would serve a double purpose. It would not only deprive Britain of the Soviet Union as a future ally, but once Russia had been delivered a knock out blow, his Japanese ally would be free to move against the British Empire in the Far East diverting America's attention to the Pacific.[75] From May 1941 and the invasion of the Soviet Union by German troops on 22 June 1941, air raids on Britain declined in number and intensity as Hitler prepared to tear up the Nazi-Soviet pact that had hitherto kept Stalin neutral.

Refugees, The Kuczynski Network, Churchill and Operation Barbarossa

Ever since the departure of Gropius, Breuer and Moholy-Nagy for the United States in 1937, Jack Pritchard had continued to provide accommodation for refugees from Fascism by letting them occupy empty flats between lets, free of charge. His efforts on their behalf were tireless; making introductions, securing employment and, once the war had begun, writing to the chairman of the tribunal in support of their applications for exemption from internment as 'enemy aliens'. Those refugees who were fortunate enough to enjoy the hospitality of Lawn Road Flats were, like the Kuczynskis, in the main, highly-educated left-wing Jews. One such refugee, Dr Kurt Rothfels, a judge in Germany, had fled in the clothes he stood up in; Pritchard went to great lengths to help him settle in England. On 12 January 1939 he wrote to a solicitor friend of his, Fredrick Graham Maw, a director of Isokon, asking him to spare Dr Rothfels 'a few minutes' to see what could be done for him. 'I understand,' he wrote, 'that it is doubtful if his legal qualities will be of much use here, but he has turned out to be an exceedingly nice man, clearly reliable, trust-worthy, and I understand that he is prepared to do anything.'[1] He also wrote to Robert Furneaux Jordan, President of the Architects' Czech Refugee Relief Fund, with a similar request.

By now Jack Pritchard was working closely with a number of refugee organisations including that of the former Prime Minister, Lord Baldwin's Fund for Refugees. He first approached Lord Baldwin in January 1939 outlining the services of Lawn Road Flats and asking for his advice in vetting future tenants. Pritchard discussed the feasibility of extending the Lawn Road Flats' scheme to other 'larger blocks of flats':

Dear Sir,

We are attempting to help the refugees from Germany and Czech-oslovakia by putting what furnished service flats we can in our block at their disposal, and feeding them etc. for £1, a head. Unfortunately we cannot look after them entirely for nothing, much as we would like to do so. We have at present a Dr. Rothfels from Germany, who has a flat, and two Czecho students who are sharing another flat. These people are only temporary, and we would be very grateful if you could tell us what organization we should approach which would help us to go into the bona fides of any fresh people who may need our help, and also advise us if there is anything more we can do.

We understand that your publicity people were interested in getting our plan publicized so that other and larger blocks of flats could carry out our idea, our projected meeting, however, did not materialise.[2]

Other bodies expressing an interest in Pritchard's scheme were the Asso-ciated Press of Great Britain (APGB) who had written to Philip Harben on 2 January 1938 agreeing to participate 'in your scheme of providing free flats and full board to refugees'. They sent round a press photographer to take pictures hoping to generate further support by circulating photos of the Flats in 'the London and provincial newspapers'.[3] This prompted Austrian Self-Aid to write to Gerald Barry's *News Chronicle* about 'a very needy case who would very much need hospitality' asking for accommo-dation in Lawn Road Flats.[4] The Society of Friends (Quakers) German Emergency Committee and the British Committee for Refugees from Czechoslovakia also made good use of the Flats.[5]

The Architects' Czech Refugee Relief Fund introduced Jack Pritchard to the Viennese architect Egon Riss, a 'very good fellow' who 'would, I am sure, fit in with the club at Lawn Road'.[6] He was warmly welcomed by the Isobar and moved into Flat 8 on 20 February 1939. His brother Erwin followed him in June 1939, moving into Lawn Road Flats straight from a concentration camp in Germany. The fortunes of the two brothers would differ quite dramatically. On the outbreak of war the British authorities granted Egon permission to remain in the Flats while Erwin was interned

as an enemy alien, despite Jack Pritchard writing to the commissioner of the Metropolitan Police on his behalf.

Jack Pritchard also wrote to the chairman of the tribunal protesting against the internment of Hans Goldschmidt, a long-standing tenant of the Flats, and Michael Rachlis, a Russian-Jewish architect who had moved to Germany in 1913 at the age of 29 and had lived in the Flats between 1935 and 1936. Again, the fortunes of both men took very different paths.

Pritchard described Goldschmidt as 'a strong political opponent of Hitler' who had 'definitely worked in organisations against him'. His claim for refugee status as a German-Jew, however, was not accepted and Pritchard had some difficulty in making a case for him. He pleaded that, although Goldschmidt was not a Jew, 'according to the Nazi definition', he believed him to be 'of sound Jewish extraction'.[7] Pritchard's letter in support of Michael Rachlis, by contrast, described him as an architect who had been excluded from his profession in Germany 'owing to his being a Jew'. A tenant of the Flats for almost a year between 1935 and 1936, Michael Rachlis, Pritchard wrote, had 'already done some useful architectural work in this country, and I am sure he would be an asset to us' when released.[8] Almost a year later, on 8 October 1940, Pritchard received a letter from the Foreign Office, telling him that Michael Rachlis had been released from internment on 20 August while Hans Goldschmidt had been transported to Australia on 10 July as a prisoner of war; his place of capture being listed as the 'Lawn Road Flats'.[9]

At the beginning of the war Jack Pritchard had taken employment as an assistant censor in the Censorship Division of the Ministry of Information (MOI). The contract shows the appointment was temporary and could be terminated by one month's writing on either side and carried no right to permanent appointment or promotion.[10] Nevertheless, on 14 May 1940 Pritchard protested that he had not been upgraded to Censor, and the MOI responded in rather an ungracious manner. 'Promotions', the Ministry explained, 'are considered by boards who consider all candidates for promotion in the light of reports made by D.C.C's [Deputy Chief Censors] and those who are considered to be the best are recommended. If therefore you are passed over, it would only be because after most careful consideration you were not considered as suitable for promotion as those

recommended. There is no question of a "black mark" or error that you may have committed."[11]

Pritchard now became very critical of the Ministry's work. In 1940 the MOI was undergoing a radical shake-up that saw the responsibility for censorship and news lost to a newly created Press and Censorship Bureau under the directorship of Sir Walter Monckton. On 28 September 1940 Pritchard wrote complaining that he [Monckton] had personally intervened to stop publication of an Associated Press and a British United Press message that Pritchard had not referred to the censor. That message, 'stating that in an American paper someone had given his opinion that Hitler was about to "drench London in poison gas",' had been stopped by Monckton who felt that the content of the message, 'particularly if it was to be used by the BBC, ought to be qualified.'[12] Pritchard argued that those responsible for overseeing what information the British public should receive during wartime should not fight shy of the dangers; they should be preparing the British people to face a gas attack:

> Little pieces of unofficial information and foreign correspondents' rumours stating that gas is imminent helps the people to be prepared; in much the same way as the W.O. keeps us on our toes by talking and encouraging talk of imminent invasion.[13]

There was a danger, he argued, that an ill-informed British public, if caught by surprise, would be 'irritated with the authorities … and an irritated British public' would not be 'conducive to working and winning the war'.[14] On security grounds, too, there was the danger that, by suppressing such stories, the Germans would think that the British population was afraid of gas. Moreover, if the Germans believed that the British authorities were afraid of how the public might react to a gas attack then they would be all the more likely to launch such an attack. By publishing the message in its entirety, on the other hand, it would not only show that 'we don't care a damn' but also 'that we will hit back harder'. It would also demonstrate that the British population was 'psychologically prepared against the alarms of gas' and is therefore 'less likely to panic and get in the way of the military'.[15] Monckton was surprisingly acquiescent: 'I should be all against hiding from the British public the likelihood of German gas attacks in the near future', he wrote in his reply.[16]

Despite the welcome nature of Monckton's reply, Pritchard resigned from the MOI on Thursday 10 October 1940, to take up a position with the Ministry of Supply as a temporary statistical officer. This entailed signing the Official Secrets Act and an agreement that 'confidential matters' were not to be discussed with 'anyone outside the Office'.[17] Unquestionably, Pritchard would have followed these instructions to the letter; however, with Lawn Road Flats now accommodating a number of high-ranking civil servants, 'careless talk' was not beyond the boundaries of possibility. At this time, four senior government officials had recently moved into the Isokon building. These included Pritchard's elder brother, Fleetwood, then working as the Director of Public Relations to the Minister of Transport; Hugh Weeks, the Director of Central Statistics at the Ministry of Supply; Mr S. Cooke, the assistant to the secretary of Arthur Greenwood's Cabinet Committees on Reconstruction; and Lionel Elvin a principal in the Finance Division of the Air Ministry. Moreover, with Jurgen Kuczynski now working for the British government as a statistician specialising in German matters, while also operating as an undercover GRU agent, the possibilities for picking up important information in casual conversation in the Isobar were certainly there. The Kuczynski network inside Lawn Road Flats was undoubtedly active and, with the arrival in Britain of Jurgen and Brigitte's sister, Ursula, from Switzerland in January 1941, it was poised to become one of the most damaging spy networks ever to work against British interests.

<p style="text-align:center">*</p>

In Switzerland, Ursula Kuczynski (Sonya) had been a leading agent in the 'Rote Drei', one of the main Soviet espionage networks providing intelligence from Nazi Germany and occupied Europe. The Rote Drei, or 'Red Three' was named after its three main radio transmitters, under the overall leadership of Sándor Radó, a Hungarian émigré, communist and geographer. It was one of three independent espionage networks (also the Schulze-Boysen/Harnack group in Berlin and the Trepper group in Germany, France and Belgium) which were known collectively as the 'Die Rote Kapelle' (Red Orchestra) by Abwehr, the German intelligence agency. The 'musicians' or 'pianists' of the Red Orchestra were the radio operators who sent encoded messages to Moscow, their transmitters were their

'pianos', and their supervisors were their 'conductors'. The main 'conductor' was the Polish Jew, Leopold Trepper, alias Jean Gilbert, 'known within the network as *Le grand chef*.'[18]

At Lawn Road Flats, Brigitte Kuczynski had recruited Alexander Foote and Len Beurton for Rote Drei in 1938. Her sister, Ursula (Sonya), then ran them as valuable agents inside Nazi Germany.

With war imminent, Moscow Centre had sent instructions to Sonya to divorce her German husband, Rudolf Hamburger, in order to enter into a pro-forma marriage with an Englishman and obtain a British passport.[19] Len Beurton and Alexander Foote were recalled from Germany and she was expected to marry the elder of the two, Alexander Foote. He, however, declined the offer and suggested that she should marry Beurton instead. Moscow Centre agreed and Sonya reassured Beurton that she could be relied upon to divorce him once their marriage was no longer necessary. The couple married on 23 February 1940, the birthday of the Red Army. The marriage lasted for forty years.

In the late autumn of 1940, Moscow Centre gave Sonya instructions to move to England, alone if necessary; Beurton, as a former member of the International Brigade could not travel through Spain 'and had to stay in Geneva until we could find a different route for him. England could only be reached by the most improbable detours. At that time just one narrow road was open in France. This crossed the region "governed" by the Nazi puppet, General Pétain, and led to the Spanish border. From there the route lay through Spain and Portugal. From Lisbon it was supposed to be possible to reach England by plane or ship.'[20]

Sonya arrived in England with her two children, Michael and Janine, on 4 January 1941 staying initially with her father, who was then living at 78 Woodstock Road, Oxford, before moving to the Oxfordshire village of Glympton. Her husband, Len Beurton followed her in 1942. Foote, who had been training to take over Sonya's responsibilities since June 1940, now assumed her duties in Switzerland under the supervision of the Hungarian communist Sándor Radó, supplying Moscow with a stream of intelligence direct from the German High Command. Until the end of 1943, the Rote Drei sent thousands of radio messages detailing information on the Nazi war machine to Moscow Centre.[21] Before leaving Geneva, Sonya instructed Foote to transmit the following message to Moscow:

Wake Arms. Epping 1 & 15. G.M.T.3. ... place suggested by Ursula BEURTON (SONYA) for rendez-vous with the Russians on 1st and 15th of each month at 3 p.m. G.M.T. on arrival in UK in 1941.[22]

It was clear from this message that Sonya was being sent to England to take charge of a specific GRU 'mission'.[23] The exact nature of this 'mission' has never been ascertained and has led to many claims and counter-claims as to its true nature, not least that she was sent to control a penetration agent, a mole burrowed deep inside the security service, MI5. There has been much speculation as to the identity of this mole with the former Director-General of MI5, Sir Roger Hollis, being the foremost suspect. The evidence, however, is at best circumstantial and relies heavily upon four unproven assertions.

Firstly, it is said that Roger Hollis had been in Shanghai at the same time as Sonya before 1936 and was known to be friendly with the journalist, and American communist and GRU agent, Agnes Smedley who was then working closely with Sonya and Richard Sorge. Between them they had recruited Hollis to the GRU while he was in China.

Secondly, in 1940 MI5 had moved its headquarters from Wandsworth Prison to Blenheim Palace, Woodstock, Oxfordshire. Sonya had been sent to live locally by the GRU, firstly to Summertown, Oxford, and later Glympton, Oxon so that she could easily access her agent in MI5.

Thirdly, soon after her arrival, Sonya and the GRU took full responsibility for running the atomic spies in Britain, including Klaus Fuchs, Alan Nunn May, Bruno Pontecorvo and Melita Norwood. Information, identifying two of these spies (Fuchs and Nunn May), was received in 1946 from a Russian defector, Igor Gouzenko, a cypher clerk at the Soviet Embassy in Ottawa, Canada, but Hollis only arrested Alan Nunn May. Klaus Fuchs, recruited by Jurgen Kuczynski to the GRU in London, had already been cleared by Hollis on six occasions, permitting him to work on the atomic bomb project at the Los Alamos laboratories in the US and at Harwell in Britain. The information that Gouzenko passed to Hollis identifying Fuchs as a possible Soviet agent was deliberately ignored, it has been claimed.

Fourthly, when the noose seemed to be tightening around the Kuczynskis' necks, and their involvement in Soviet espionage became apparent, the two most important agents of the Kuczynski network, Sonya and

Jurgen, were tipped off and allowed to escape to East Berlin, which was then under Soviet control.[24]

While there are more aspects to this case than these four assertions, it remains unproven that Sonya was dispatched to Britain in December 1940 to control a mole inside MI5 headquarters at Woodstock.[25]

According to Foote, Sonya had been sent to the UK because her cover had been blown in Geneva and her security compromised. Her maid, Olga Muth, apparently loyal to Sonya's first husband, Rudolf Hamburger, disapproved of Sonya's forthcoming marriage to Len Beurton, and denounced her to the British Consulate in Geneva, stating that the marriage was one of convenience.[26]Foote's claim is further supported by the seizure of wireless material from Sonya's farmhouse in Switzerland by the police, as MI6 reported:

> In the autumn 1939 they [Sonya and her first husband Rudolf Hamburger] travelled to Lausanne and later went on to Caux near Montreaux, where Ursula finally decided to part from her husband who went back to China. One day they were visited by two Englishmen who had allegedly fought with the International Brigade in Spain, one of them being 'Lennard BOURTON' (or Leonard BURTON) whom Ursula was shortly to marry. The two men lived elsewhere, but visited them daily and busied themselves in the house with electrical apparatus which MUTH now realises was Morse equipment. One day these two men were surprised and denounced by a Swiss woman while Ursula was in Geneva, as a result of which a strange man went to Ursula's room and told MUTH not to get herself mixed up in the affair; on the same day a police official came to make enquiries about the wireless apparatus which he wished to confiscate. On entering this room into which MUTH had been forbidden to go, she saw amongst other apparatus, a frame composed of wires, and though she did not know its purpose, she feels sure that it was a wireless transmitter. The stranger who had a Finnish passport and spoke with a Berlin dialect, was arrested and MUTH heard no more of him.
>
> Before these activities were brought to an end, Ursula regularly got up at 2 a.m. and locked herself in this room which was so curtained that not a gleam of light was visible from outside. Another man

(name unknown) stayed with the BEURTONS for two days, who from what he said, had certainly come from Moscow and who intended to return there direct.[27]

By the time of Sonya's arrival in Britain in 1941 three Kuczynskis and their spouses, as well as her uncle, Hermann Deutsch, were either living in or connected with Lawn Road Flats. The list of residents or frequent visitors to the Flats that had at some time or other been linked with Soviet intelligence was remarkable. In all, a total of 32 individuals suspected of Soviet espionage in Britain during the 1930s and 1940s either lived or visited the Lawn Road Flats or Lawn Road itself.[28]This network was both potentially useful and harmful.

*

Not all the Kuczynski family welcomed Sonya's arrival. Her brother, Jurgen was known to be 'angry about Sonya's return to Britain. He believed that her presence there as a Russian agent might compromise the rest of the Kuczynski family in their political work.'[29] Jurgen was then busy writing 'economic reports [presumably on Germany] for Russia'; these were 'open' reports which were taken to the Russian Embassy personally by Jurgen. According to Alexander Foote, in a later interview with MI5 officers, Jurgen often expressed amazement that 'he was not followed by the British authorities on these visits.'[30] Certainly, Jurgen had good cause to question the wisdom of his sister's posting to Britain, particularly as she was said to be 'very much disturbed' by the Nazi-Soviet Pact while he was doing his best to persuade comrades of its anti-imperialist and anti-capitalist purpose.[31] Nevertheless, he had little choice but to acquiesce in the decision particularly as the necessary arrangements to send Sonya to Britain seem to have been conducted through his wife, Margueritte, and their uncle, Hermann Deutsch, who was helping Margueritte launder German Communist Party money through a Miss Marie Ginsberg in Geneva.[32] Marie Ginsberg was also asked to secure Sonya a Bolivian or Brazilian passport 'in case anything went wrong' with her marriage to Len Beurton. She did this through a diplomat in Berne to whom she paid 3,000 francs 'with the agreement of the Centre.'[33]

On 26 November 1939 Sonya had written to Margueritte from Switzer-

land letting her know of her intended 'mission' to England: 'Except knitting (which is not my strong side) one is not allowed to do much here.'[34] Sonya's espionage operations against Germany had been called to a halt after the signing of the Nazi-Soviet Pact. However, she did remain in wireless telegraphy (W/T) communication with Moscow Centre and, on Moscow's orders, undertook the training of both Foote and Beurton as W/T operators. She told Margueritte: '… reading an appeal for getting ready for blood transmission, I answered. They examined me, and found that I have very useful blood, it can serve all different blood groups.'[35] 'Blood transmission' was the code used for the transference of wireless operators from one country ('blood group') to another. Her wireless transmitter, which before the war had been used solely for the traffic of her own network, was now to be put at the disposal of other networks i.e. different blood groups. This 'blood transmission' would effectively pave the way for the GRU's takeover over of the Comintern's intelligence apparatus, and its control over the intelligence personnel who had been recruited to the anti-Fascist activities of Comintern during the period of the Popular Front. This explains Sonya's importance and the Centre's decision to transfer her to Britain.

The GRU's takeover of Comintern was the culmination of a long-standing strategy that had impacted badly on Teodor Maly and Arnold Deutsch in 1937, following Philby's recruitment in 1934. The Kuczynskis were instrumental in completing this process in the aftermath of the Nazi-Soviet pact when the Soviet Union's intelligence services encountered difficulties bringing OGPU/NKVD recruited agents, linked to the OMS, into line with Stalin's departure from the anti-Fascist agenda of the Comintern. In 1947 the MI5 agent M. F. Serpell produced an insightful document describing this process and how it was initiated and managed by the Kuczynskis. Serpell's analysis gives a very informative account of the Kuczynski family's engagement with both the Comintern and pre-war Soviet intelligence:

> From this rapid and rather superficial account of the KUCZYNSKI family context there emerges a picture of two circles: the first a circle of Comintern activity and the second of Soviet espionage.… Ursula BEURTON [SONYA] appears to represent a point at which these two circles overlapped before the war … it seems likely that the overlap in

Switzerland was considerably extended during the war, and it may be found that war-time necessities brought about the superimposition of the second circle on the first in many places.... Jurgen KUCZYNSKI and his wife represent an important segment of the first circle and it is likely that they had a considerable knowledge of the second.[36]

Before her arrival in England Sonya had been placed on the Central Security War Black List by MI5 and on arrival she had been monitored very closely.[37] A note in her file dated 6.12.40 showed that she was 'picked up' by watchers as soon as she landed in Liverpool: 'As spoken; we cannot refuse to allow this family to come here now, but I am anxious to keep a close eye on them when they do arrive. Could you please arrange for the wife to be put on the Black List, and ask the S.C.O. [Security Control Officer] to notify us when she arrives (by telephone), giving us her destination, description, and the part of the train on which she is travelling. I will then arrange for her to be picked up.'[38] If her mission had been Hollis, or the control of a senior mole burrowed deep inside MI5, then she had got off to a very bad start. Circumstances beyond her control changed the picture dramatically, and took some of the pressure off her; at four o'clock on the morning of 22 June 1941, German troops invaded the Soviet Union.

The invasion apparently took Stalin completely by surprise, despite the fact that he had been given advance warning from Great Britain, from Sándor Radó in Switzerland, and one of the GRU's 'great illegals' in Japan, Richard Sorge. Fearing a disinformation campaign aimed at embroiling him in a conflict with Hitler and the destruction of the Nazi-Soviet Pact, Stalin simply refused to believe the intelligence reports arriving on his desk. Only a few days earlier the TASS correspondent in Britain, Andrew Rothstein, 'had issued a statement maintaining that rumours, then current, of a coming German attack were without foundation' and were another example of the 'anti-Soviet dreams' of the British ruling class.[39]

The failure of the Soviet side to prepare for an invasion meant the German attack was a rapid success. The scale of the invasion was immense: more than three million German troops invaded the Soviet Union's territory along an 1,800-mile front; facing the invading armies on the western frontiers of the USSR were nearly three million Soviet soldiers, backed by a number of tanks now estimated to have been as many as 14–15,000

(almost 2,000 of them the most modern designs), more than 34,000 artillery pieces and 8–9,000 fighter-planes. The scale of the conflict on Russia's front, as Ian Kershaw so dramatically commented in his biography of Adolf Hitler, 'almost defies the imagination'.[40]

Winston Churchill, who had once remarked that if he had to choose between communism and Fascism then he would not choose communism, broadcast to the nation at 9 pm. His comments not merely surprised many on the left, but changed the whole complexion of the war effort.

> At 4 o'clock this morning Hitler attacked and invaded Russia. All his usual formalities of perfidy were observed with scrupulous technique. A non-aggression treaty had been solemnly signed and was in force between the two countries. No complaint had been made by Germany of its non-fulfillment. Under its cloak of false confidence the German armies drew up in immense strength along a line which stretched from the White Sea to the Black Sea and their air fleets and armoured divisions slowly and methodically took up their stations.
>
> No one has been a more consistent opponent of Communism than I have for the last twenty-five years. I will unsay no words that I've spoken about it. But all this fades away before the spectacle which is now unfolding.
>
> Any man or State who fights against Nazism will have our aid. Any man or State who marches with Hitler is our foe.... It follows, therefore, that we shall give whatever help we can to Russia and to the Russian people. We shall appeal to all our friends and Allies in every part of the world to take the same course and pursue it as we shall, faithfully and steadfastly to the end.
>
> The Russian danger is therefore our danger and the danger of the United States just as the cause of any Russian fighting for his hearth and home is the cause of free men and free peoples in every quarter of the globe.[41]

Churchill's broadcast re-united communists and progressives in a manner reminiscent of the Popular Front in 1936 and 1938, including that section of the Conservative Party that had opposed Chamberlain's policy of appeasement. The Soviet invasions of Poland and Finland were forgiven and a unity of purpose – the defeat of Fascism – regained. The CPGB

found itself invited to play an active role in industrial relations, boosting war production, and condemning sabotage and strike action as harmful of the war effort. The communist MP for the Scottish mining constituency of Fife, William Gallacher, stood up in the House of Commons and said that he was 'agreeably surprised' by Churchill's broadcast. On 26 June he released a press statement saying that the Communist Party would support the government in any steps it took to collaborate with the Soviet Union. A manifesto under the title 'People's Victory over Fascism' was issued on 4 July and declared that 'the war was now a just war'. Harry Pollitt was restored to the leadership of the Party.

<div align="center">*</div>

Margaret Cole, the wife of socialist historian G. D. H. Cole, wrote to the TASS correspondent in Britain, Andrew Rothstein, suggesting a Russian dinner to be held at Lawn Road Flat's Isobar on 20 August. Rothstein replied enthusiastically, promising to bring along a representative from the Soviet Embassy.[42] The Isobar was then under new management. Robert Braun, a Swiss national, had arrived from Paris in March 1940 to take over the running of the club from Philip Harben who had joined the RAF. Braun, a devotee of the Isobar's history, aimed to repeat Harben's week of Spanish food for Spanish Medical Aid and the 'bowl of rice dinner' for the China Campaign Committee that had graced the tables of the Isobar in 1938.

Andrew Rothstein's connections with Lawn Road Flats are difficult to discern. A founder member of the CPGB with links to Soviet intelligence dating back to the time his father Theodore Rothstein was Lenin's first secret agent in Britain,[43] the evidence linking Andrew Rothstein with the Flats is, literally, marginal. In the margins of a list of tenants to be invited to the twenty-first birthday party of Lawn Road Flats in 1955, Rothstein's name appears, scribbled in pencil, as 'Rothstein TASS – (No. 16 & 8) during war? School of Oriental Languages'.[44] The letter from Margaret Cole to Jack Pritchard mentioning the forthcoming Russian dinner is dated Sunday, 9 August (no year given), and the relevant section reads as follows:

> Could you be very kind and give two messages for me. To Fleetwood, say that I still am hoping to come up and have an official (lunch!)

interview with him and will let him know when I can get up, and to Robert,[45] tell him I spoke to Andrew Rothstein, who thinks he might be able to bring along a Councillor from the Soviet Embassy if he is going ahead with the Russian party. Robert could drop a line to Rothstein, or ring him up Tass Agency, Reuter's building, Fleet Street, Central 1937, but naturally they are rather busy and can't make plans very far ahead. I shall try and come up for it, was it August 20th he suggested?[46]

The date was correct. The architect and industrial designer Professor Dick Russell had sent a letter to Jack Pritchard on 11 August with apologies that he couldn't dine with him on Wednesday 13 August but that he would meet him the following Wednesday at the Russian party. The dinner was very much an occasion for the Isobar, particularly as a number of left-leaning journalists – Francis Meynell, William Norman Ewer and Cyril Joad – were all members. Andrew Rothstein, as TASS correspondent, had been much in demand since the beginning of the war and his appearance at the Isobar, along with a diplomat from the Russian Embassy, would have been regarded as something of a coup. Given the left-wing inclinations of many of the Flats' residents and the number of German-speaking communists living there who were suspected of having links with the Soviet intelligence service, MI5's surveillance of Rothstein at this time is of some interest.

During the early part of the war, despite the Nazi-Soviet pact, Andrew Rothstein had been regarded by the MOI as 'somewhat of a pet'. The Foreign Office News Department was 'also said to like him more than certain Yankee rough-necks'.[47] After Wing Commander Halliwell, the British Air Attaché at Moscow, had made arrangements for him to pass the night at anti-aircraft batteries – 'making him for a time famous here [London]' – he was in much demand.[48] Towards the end of 1940, however, the Foreign Office started a bitter campaign against him as part of their reprisals against the Soviet Union for its treatment of British and American journalists in Moscow. Its protests against what it regarded as the privileged treatment of German and Italian correspondents working in Moscow while British and American journalists were subject to petty restrictions, were ignored. In response the Foreign Office embarked on

a strategy of making life in London intolerable for Rothstein in order to force concessions from the Russian censors:

> Germans and the one Italian correspondent telephone their capitals freely from their own radiator-side, whereas British (and American) correspondents have to go to the Central Telegraph to do so.
>
> That, in my opinion, is a poor side issue: the local authorities are too afraid of Germans to tamper with their telephoning to Berlin. They would, even if we forced them to let us telephone abroad from our homes, find means of sabotaging the line, or tell us that it is not working, just as they already do when we try to get through from the Central Telegraph Office.
>
> Maisky [Soviet Ambassador to Britain] must be put on the defensive by a fact of reprisal against Tass (in which term I include their cable service to England, but above all their London correspondent) ... Andrew Rothstein (Tass correspondent) if adequately handled by the Ministry of Information and eventually sabotaged by the Special Branch, would [begin] to crack up nervously. He has been a Soviet agent (I seem to remember Joynson-Hicks named him as go-between in the transfer of Russian money to the Communist Party in England) for twenty years.... What I think might well get him down, if now suitably treated, is his unimaginative arrogance. He has been running round for twenty years convinced that as a natural British born subject, nicely clad and Oxford-instructed, he could, if he dared, do any mortal thing he liked.... When reprisals are taken against him, they ought to happen all together, blitz wise.'[49]

On 6 December 1940, the Foreign Office contacted MI5 requesting detailed information on Rothstein's communist activities in Britain. This request came from a member of the Cambridge spy-ring, Donald Maclean, now a Foreign Office official who had been recruited to the NKVD by Arnold Deutsch:

> The Department [Maclean's name has been scribbled above the word department in pencil] have asked me if I could get from you as soon as possible the record of Rothstein of the Tass Agency. In particular, I understand they want to know whether he has a British passport

and when he first came to this country. I should be very grateful for anything you can let me have.

(Sgd.) HENRY L d'A. Hopkinson.[50]

Maclean's request was handled by Roger Hollis who replied with very little up-to-date information on Rothstein other than that 'he is the son of Theodore Aronovitch ROTHSTEIN'. Hollis's memo also included the misleading information that while 'closely connected with the Communist Party since its foundation', having served 'on the Central Committee of the Party during the years 1927, 1928 and 1929', Andrew Rothstein had 'held no office in it for a number of years'. This was simply not true, as Hollis should have known, and in his closing remarks he made it quite clear that further enquiries would elicit little or no further information. 'At the moment,' he wrote, 'some of our more recent records of Andrew ROTHSTEIN are not readily available but I hope that this brief note will be sufficient. Will you let me know if there is any further point with which you would like me to deal and I will do my best, but I am afraid that it may not be possible to give you an immediate answer.'[51]

Hollis's reply was addressed to Henry L. d'a Hopkinson who had scribbled above Hollis's Oxford address – Box No. 500, G.P.O., Oxford – the words 'Mr. Maclean to see, please return', which clearly showed that Donald Maclean was involved in the Foreign Office's 'harrying' of Rothstein. Given what MI5 then knew about Andrew Rothstein (and of his father's activities) Hollis's note was not merely brief but, either by luck or judgment, withheld valuable information from Maclean. Early MI5 reports had identified Rothstein as being the 'leader of the Communist set at Oxford and an extremely active propagator of intellectual Bolshevism'. More recent reports showed that he was a 'directing influence on the policy of the British Communist Party' and 'had always acted as a connecting link between Soviet institutions in the United Kingdom and the Communist Party of Great Britain'.[52] The information Hollis did make available to the Foreign Office told them this. Rothstein, Hollis wrote, is 'in constant communication with the [British Communist] Party leaders and it could safely be said that he is a regular channel of communication between these leaders and the Soviet Embassy'.[53] Given that MI5 files also described another Lawn Road Flats' resident, Jurgen Kuczynski, as

'a regular channel of communication' between the Soviet embassy and the exiled leaders of the German Communist Party in London,[54] one can hazard the guess that on 20 August 1941, the night of the Isobar's Russian dinner, Lawn Road Flats played host to some very important Soviet agents.

*

The Lawn Road Flats, since its construction in 1934, had always attracted a number of admirers of the Soviet experiment, many of them members of the Half Hundred Club and the Isobar. Among this group was a leading trade unionist, William John Brown, general secretary of the Civil Service Clerical Association (CSCA). Brown had moved into Flat 26 in 1937 at the height of the controversial London busmen's strike of May 1937, in which he played a pivotal role.

The strike had begun on 1 May over working conditions; 26,000 London busmen were demanding shorter hours and an inquiry into busmen's stress brought about by bigger buses traveling at a 'dizzying' 30 mph instead of the more sedate 12 mph.[55] The industrial action coincided with the coronation of King George VI and the arrival of thousands of visitors to London for the event. Ernest Bevin, general secretary of the powerful Transport and General Workers' Union (TGWU), was conscious of the nation's patriotic mood and urged them to call off the strike.[56] His advice was rejected and the TGWU was forced to cede ground to the communist-dominated London Busmen's Rank and File Movement whose widely-read newspaper, *Busman's Punch*, was enjoying sales of 10,000 a month.[57] The TGWU countered by declaring the Rank and File Movement an 'illegal' organization, and ordered the strikers back to work. Three of the strikers' leaders were expelled from the union, Bert Papworth and Bill Jones who were members of the CPGB, and Bill Payne who claimed to be non-political.[58]

Following the collapse of the strike, Payne made an approach to William Brown asking for his help in launching a breakaway non-political union, the National Passenger Workers' Union (NPWU). Brown's advice was freely given and, in February 1938, he was installed as the new union's president, a post he combined with his CSCA duties. Initially successful, the NPWU made significant inroads into the TGWU's membership, reaching a peak of over 4,000 members before withering away after the war. The whole episode caused much bitterness between the TUC and CSCA with

Brown describing the TUC in July 1939 as 'about the most undemocratic and reactionary piece of machinery in Britain'.[59]

In Lawn Road Flats, Brown established a rapport with Jack Pritchard, but he was always a prickly character; his chagrin often provoked by the Isobar's expensive all-day breakfast menu:

Dear Mr. Pritchard,

I mentioned to you some time ago the major and minor sottises which I experienced in the Club. Here is another complaint, this time a formal one.

Last night I entertained my daughter, and I went into the Club and ordered bacon and eggs twice and a pot of tea for one.

The bill for this came to 5/3d [27p]!

Now one does not pay 5/3d – (or 5/-, allowing 3d for the tea) – for two plates of bacon and eggs anywhere outside the Berkeley Grill or the Ritz, and the bill was plainly ridiculous.

I complained about it, and was then told that the bill was arrived at in this way. First of all, there were overheads – so much for me, and somewhat more for my guest. Then there was added the price of the bacon and the eggs, and the total made up 5/3d.

Now, the short and simple point here is that no amount of manip-ulation of the bases of the calculation makes a half-a-crown [13p] the right price for a plate of bacon and eggs; nor is it any consolation to be told that one could eat some more if one wanted to, because one does not. I can get bacon and eggs in any restaurant in London for between 18d [9p] and 2/- [10p]. For 2/6d [13p] I can get a four course meal!

I declined to pay the bill because it was frankly ridiculous, and I am now writing to you about this incident and the Club generally. A half-crown either way does not make much difference to me person-ally, but what one does dislike intensely is the feeling of being done down.[60]

Brown, a frequent diner in the Isobar, also worked closely on the Lawn Road Flats Tenants' Committee for ARP with the German-born Soviet agent Brigitte Kuczynski; Jack had co-opted him on to the committee

following a 'frightful din' in Flat No. 38, and after one of Brown's many letters of formal complaint:

Dear Mr. Brown,

I have just heard about the frightful din that went on during a Dinner Party in No. 32. I should like to apologise for this noise. In agreeing to a member having a dinner party there, I inquired the nature of the party and found that it was a family affair to his mother and family. As his mother was already a grandmother, I rather assumed that it would be an elderly and quiet party, which would hardly be heard by anybody. It seems to have turned out to be one of the most rowdy affairs that one could possibly imagine. I have taken it up with the member and I have also made a note to make special inquiries before consenting to any private dinner party, as these must not be allowed to disturb the peace and quiet of any tenant. I trust you will not be disturbed again.

I was going to write to you in any case to ask whether you would agree to coming on the tenants' Committee for A.R.P. I was particularly impressed with the remarks you made to me some time ago, and as our local warden is wishing to come round and see us shortly I think it would be a good thing for all our sakes if we discussed this question very frankly and thoroughly together so that we know what we are going to do in a case of emergency. I expect you are frightfully busy with very much more important things, but if you can spare a few minutes, I should be grateful.[61]

In September 1941, Brown, no stranger to controversy, travelled to America on a five-month speaking tour of American factories for the MOI. He wasted no time in upsetting American trade unionists by claiming 'that the US war-effort was being sabotaged by inter-union rivalry'. The TUC, never an ardent fan of Brown, 'was forced to telegraph the American Federation of Labor to disclaim any responsibility for his comments'.[62] That same month, the German physicist Klaus Fuchs, a member of the German Communist Party and a naturalized British citizen, approached Jurgen Kuczynski offering to hand over secret information on Britain's atomic bomb programme.

17 *(right)* Interior.

18 *(below)* The Isokon Long Chair by Marcel Breuer.

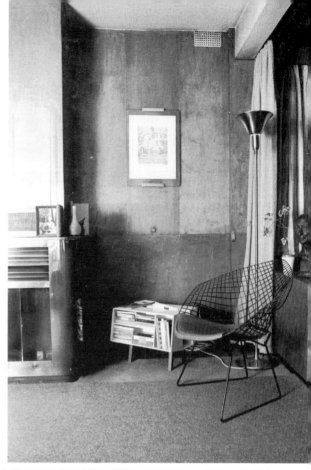

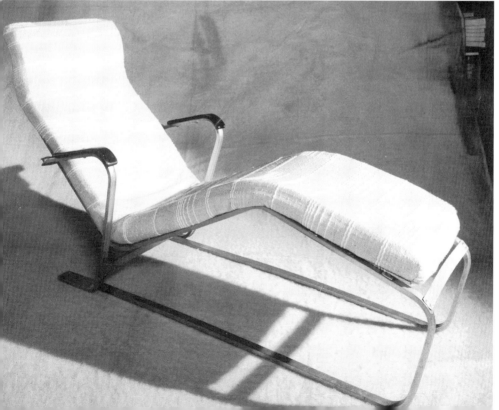

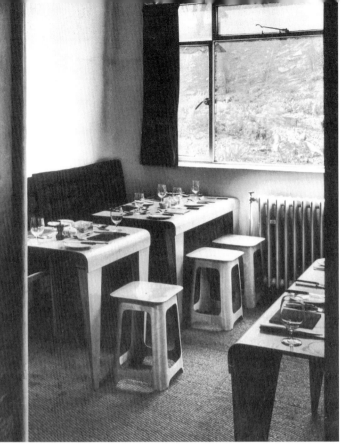

19 *(left)* Isobar restaurant. Furniture by Marcel Breuer.

20 *(below)* The Isobar complete with short chair by Marcel Breuer.

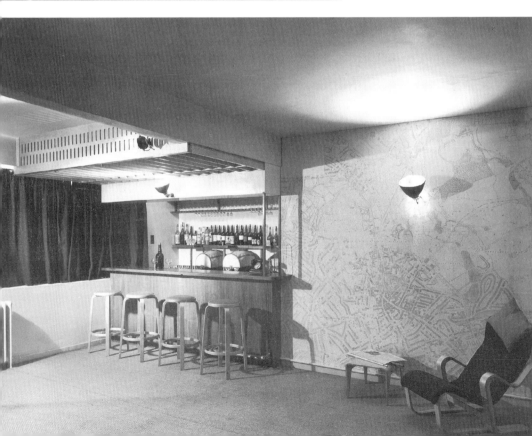

21 (right) Isokon Long Chair, Isobar garden restaurant.

22 (below) Isokon garden restaurant furniture by Marcel Breuer.

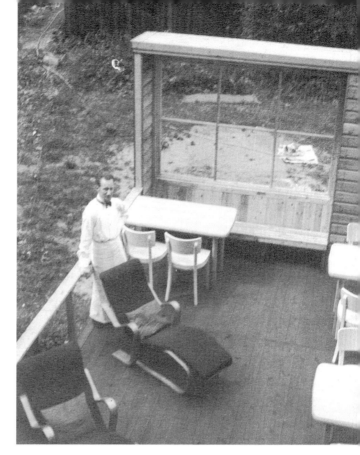

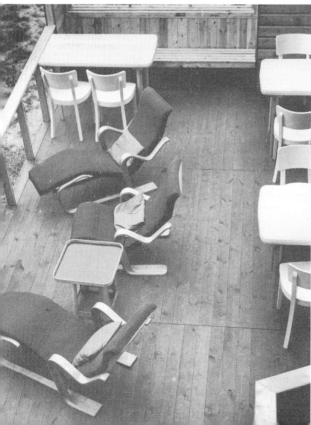

THE ISOBAR CLUB

in the Private Air-raid Shelter

of the

LAWN ROAD SERVICE FLATS

Lunch - 1/9 Dinner - 2/6

Fine Wines at reasonable prices

Luncheon Membership 2/6 per annum

Full Membership - - 7/6 per annum

23 *(above)* Invitation: The Isobar Club and Private Air-Raid shelter

24 *(left)* The Austrian Architect and designer Egon Riss building the Isokon Line. Second World War.

25 *(opposite above)* Jack and Molly Pritchard's Flat. Furniture by Marcel Breuer.

26 *(opposite below)* The Pritchard's Flat and roof garden.

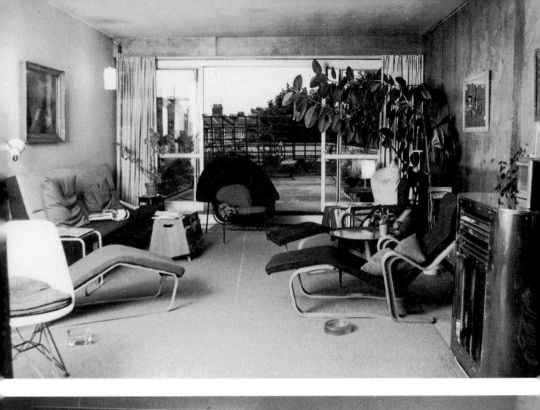
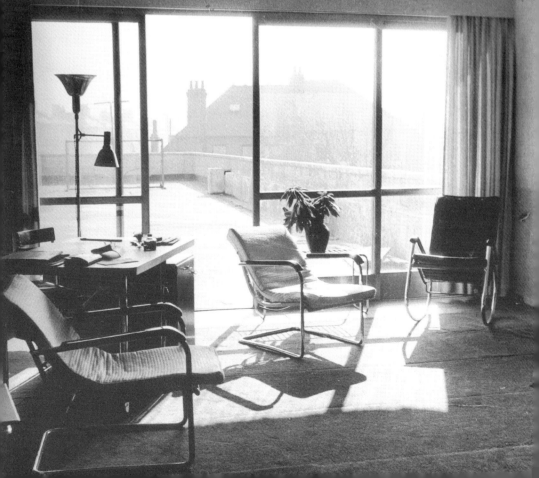

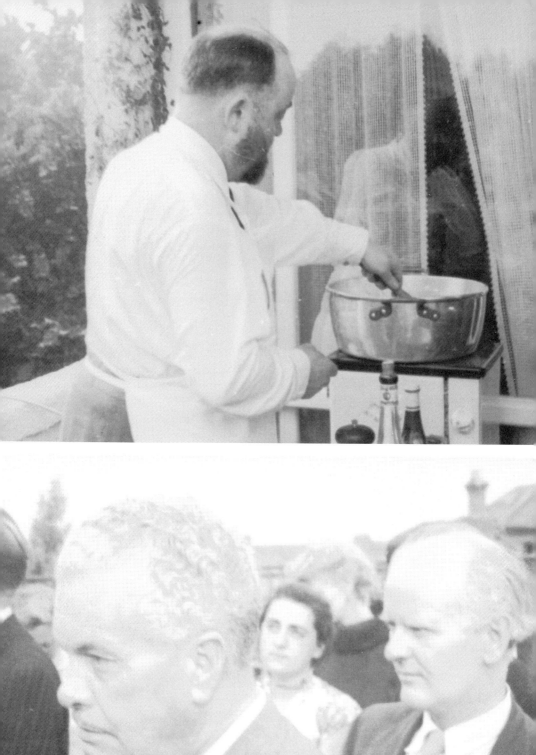

27 *(opposite top)* Philip Harben. Flats 21st birthday party.

28 *(opposite below)* Wells Coates and Jack Pritchard Lawn Road Flats 21st birthday party.

29 *(above)* Gordon Childe (Flats 21st birthday party).

30 *(right)* Walter and Ise Gropius. Marcel Breuer standing behind Ise's left shoulder.

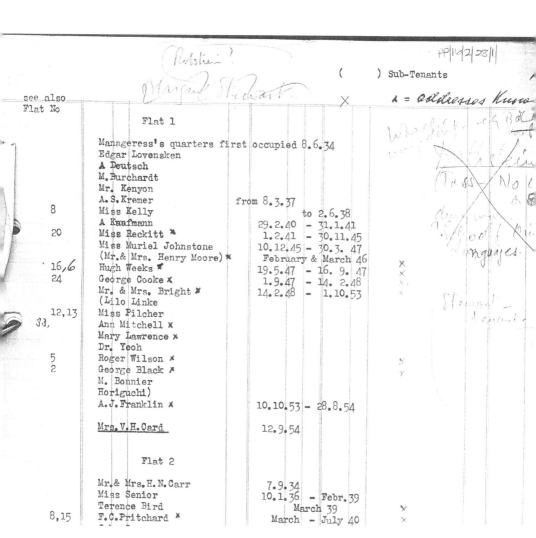

(Rothstein?)

Margaret Stewart

() Sub-Tenants

x

ℓ = Addresses Known

see also
Flat No

Flat 1

Manageress's quarters first occupied 8.6.34
Edgar Lovensken
A. Deutsch
M. Burchardt
Mr. Kenyon
A. S. Kremer from 8.3.37

8 Miss Kelly to 2.6.38
 A. Kaufmann 29.2.40 - 31.1.41
20 Miss Reckitt * 1.2.41 - 30.11.45
 Miss Muriel Johnstone 10.12.45 - 30.3. 47
 (Mr. & Mrs. Henry Moore) * February & March 46
16,6 Hugh Weeks * 19.5.47 - 16. 9. 47 x
24 George Cooke x 1.9.47 - 14. 2.48 x
 Mr. & Mrs. Bright * 14.2.48 - 1.10.53 x
 (Lilo Linke
12,13 Miss Pilcher
33, Ann Mitchell x
 Mary Lawrence x
 Dr. Yeoh
5 Roger Wilson x x
2 George Black x x
 M. Bonnier
 Horiguchi)
 A.J. Franklin x 10.10.53 - 28.8.54

 Mrs. V.H. Oard 12.9.54

Flat 2

 Mr. & Mrs. H. N. Carr 7.9.34
 Miss Senior 10.1.36 - Febr. 39 x
 Terence Bird March 39 x
8,15 F.C. Pritchard * March - July 40

31 List of Tenants: 'In the margin: "Who else moved out – eg Rothstein (Tass
No 16 & 8 during war. ? School of Oriental Languages."'

Klaus Fuchs, Rothstein once more, and Charles Brasch

Klaus Fuchs was an outstanding physicist and atomic scientist with degrees in mathematics and physics from the universities of Leipzig and Kiel. A committed communist, Fuchs had been a member of the German Communist Party (KPD) since 1932; he had once been badly beaten up by student Brownshirts at Kiel University and thrown into the nearby river. On 28 February 1933, the day following the Reichstag fire, a warrant was issued for his arrest and Fuchs went underground before fleeing to Paris and then to Britain. 'I was lucky,' Fuchs recalled years later, 'because on the morning after the burning of the Reichstag I left my home very early to catch a train to Berlin for a conference of our student organisation [KPD], and that is the only reason why I escaped arrest. I remember clearly when I opened the newspaper in the train I immediately realised the significance and I knew that the underground struggle had started. I took the badge of the hammer and sickle from my lapel which I had carried until that time.'[1] He was ordered abroad by the KPD, and told to concentrate on his studies in preparation for the new communist Germany that, they believed, would follow the collapse of the Hitler regime. 'I was sent out by the Party, they said that I must finish my studies because after the revolution in Germany people would be required with technical knowledge to take part in the building up of the Communist Germany.'[2] He arrived in England on 24 September 1933, practically penniless, and was more or less adopted by Professor Nevill Mott of the physics department at the University of Bristol who arranged for him to enroll at the university to work on the electron theory of metals. In October he became Professor Mott's research student and was awarded the degree of PhD in December 1936 for his thesis, 'The cohesive forces of copper and the elastic constants of monovalent metals'. He then enrolled at the University of Edinburgh

where in 1939 he gained the degree of DSc for a thesis on 'Some problems of condensation, quantum dynamics and the stability of the nuclei'.[3]

On the outbreak of the war, Fuchs's hitherto successful scientific career was brought to an abrupt halt. Although he had been recognised by the Tribunal for East Scotland as a refugee from Nazi oppression he was, nevertheless, interned on 12 May 1940 as part of the general internment of 'Enemy Aliens' in protected areas. An application for his release was made through the Royal Society and, on 11 January 1941, he was 'exempted by the Secretary of State from internment and from special restrictions applicable to enemy aliens'. In May 1941 he was invited to Birmingham University, then the centre of British atomic research, by the German scientist Rudolf Peierls to work on the gaseous diffusion process of separating uranium isotopes. The following month he signed the Official Secrets Act before starting work on Britain's secret atomic bomb project, code-named 'Tube Alloys', evaluating the critical size and efficiency of an atomic bomb. Following Germany's invasion of the Soviet Union, Fuchs contacted the head of the KPD in exile, Jurgen Kuczynski, and asked for his help in passing information he had gained from the project to the Russians. Kuczynski was close friends with the Soviet Ambassador in London, Ivan Maisky (no stranger to atomic espionage himself[4]) and arranged for him to introduce Fuchs to Simon Davidovich Kremer, a GRU officer at the London residency. Kremer and Fuchs, however, failed to get on,[5] and in the summer of 1942 Fuchs was passed to Jurgen's sister, Ursula, codenamed Sonya, who, since September 1941, had been receiving information from Melita Norwood on the 'X' metal (uranium). Sonya's network of spies included a close-knit group of émigré German communists, some of them family friends with a connection to Lawn Road Flats. It had been Melita Norwood's sister Gerty and her mother Gertrude who had initially introduced the Kuczynski family to Lawn Road Flats soon after their construction in 1934. The information provided by both Fuchs and Melita Norwood was important enough to keep the GRU abreast of research into atomic bomb design and the metallurgy of uranium metal, at a time when Stalin and the NKVD doubted the feasibility of a bomb.[6]

*

Jurgen Kuczynski, having successfully helped his sister, Sonya, establish her spy network in the months between February and October 1941, left Lawn Road Flats on 30 September 1941 for bigger premises in nearby Upper Park Road where he continued to co-ordinate the activities of German communists living in exile in Britain. Meanwhile, the spies and communists living in Lawn Road Flats now shifted their focus of attention. Eva Reckitt remained in Flat 1 but it is doubtful that she was still 'active' in Soviet intelligence. Anthony and Bridget Lewis (Brigitte Kuczynski) continued to pay rent on Flat 4 although they were no longer living there. Anthony Lewis had joined the RAF in December 1939 and was stationed in Bristol and Bridget Lewis had taken up a teaching post nearby. In 1942 the couple divorced and Bridget moved back to London to 62a Belsize Park Gardens while Anthony Lewis retained Flat 4. The movements of Andrew Rothstein in respect of Lawn Road Flats are difficult to establish. The registry between 1941 and 1945 for Flats 16 and 8 was kept blank, and surviving tenant records are incomplete. Rothstein's job as London's TASS correspondent was quite insecure and, at one time, he feared that he was in danger of being 'liquidated'. He was always under close MI5 scrutiny.

After the arrest of Douglas Frank Springhall, the National Organiser of the CPGB, on 17 June 1943 on charges of obtaining secret information from an Air Ministry employee and an army officer, a crime for which he received seven years hard labour, Rothstein's association with Springhall was examined. The general secretary of the CPGB, Harry Pollitt, outraged by evidence of Soviet espionage activity within the Party, distanced himself from Rothstein. The Springhall case not only weakened the standing of the CPGB in the country at large, but also questioned the patriotism of communists in Britain despite the British public's high regard for the Red Army. Intelligence provided by a secretary working at King Street, whom Rothstein had approached on Springhall's behalf on a matter of great secrecy, was brought to the attention of both Pollitt and MI5.

At this time Rothstein was living with his wife and two children at 39 Hillway, Highgate. If he was renting an apartment in Lawn Road Flats, he was undoubtedly keeping it very quiet. There was good reason for this, and may well have reflected his increasingly perilous position as head of London TASS. Following the Springhall case, Moscow, too, made several attempts to dampen Rothstein's activities; he was to be sent abroad and

Soviet personnel in Britain reshuffled. Three months before Springhall's arrest, the TASS correspondent in Shanghai, Vladimir Rogov, had been summoned urgently to Moscow and told to make arrangements to take over the management of TASS's London office from Rothstein, who was being transferred to Switzerland. Rothstein, however, knew nothing about this and was not informed of these developments until after Ivan Maisky's replacement as Soviet Ambassador to Britain by Igor Gusev in August 1943. One of the embassy officials then explained to Rothstein the new state of affairs: in view of the expected changes in the European war situation, the Soviet Union needed more representation in Europe. The Soviet Union had correspondents in only three cities: Stockholm, Ankara and Sofia. Rothstein had previously worked in Switzerland and he was therefore regarded as the most suitable candidate for such an assignment. He refused to leave London, however, and raised a number of objections: his earlier sources at the League of Nations were no longer available while the only valuable information to be gathered in Switzerland would come from émigré German businessmen or deserters. The TASS correspondent there, he reasoned, would need a full working knowledge of German and he didn't have that. He doubted, moreover, whether any foreigner could reach Switzerland under the conditions prevailing at the time.

Nevertheless, at the end of October, Gusev informed Rothstein that, while Moscow was aware of the difficulties involved, they had insisted that he was to proceed with his application to go to Switzerland. This he did. But in February 1944 his earlier objections were confirmed by the Swiss Legation, who informed him that while a TASS representative was acceptable, it was quite impossible for a correspondent to be sent to Switzerland under existing conditions. This, however, was not the end of the matter.

Following Maisky's departure from Britain, Moscow set about removing from positions of influence all those who had worked closely with him in London, including Rothstein, who was now instructed to apply for permission to go to Portugal.[7] At the end of March 1944 Rogov arrived in London eager to take up his new post as head of TASS in the UK. He asked how long had elapsed since Rothstein's departure and was told by an embarrassed staff that Rothstein had not left, nor had he received any 'official' instructions to leave. Rothstein immediately went to the Soviet Embassy and insisted that they contact Moscow and find out exactly what

was expected of him. Was he to resign his position as head of London TASS while waiting for the negotiations with Portugal to be finalized? Or was he to continue in his post? On 1 April 1944 he was summoned to the embassy to learn Moscow's reply and was told to hand over the management of TASS to Rogov immediately.

Towards the end of May, Rothstein learned that on account of the strained relations existing between Britain and Portugal, the Foreign Office had not approved his application to move to Lisbon. To complicate matters even further, in the middle of July the Swiss government backtracked on its earlier decision and granted him permission to enter Switzerland, provided he could overcome the difficulties of getting there. By this time, however, Moscow had decided to send him to Brazil. Bemused, Rothstein let them know that he regarded this proposal as ill-conceived and pointed out that he did not feel justified in dropping the Swiss negotiations at the eleventh hour. He cabled a list of his grievances to Moscow from the beginning of 1943, and suggested that he travel to Moscow to talk things over. His request was ignored. He didn't hear from Moscow again until September, by which time he had succeeded in securing a passage to Switzerland. A TASS correspondent was still urgently needed in Brazil, however, and he was told to accept this assignment. Dutifully, he submitted an application to the Brazilian Embassy only to receive a polite diplomatic refusal two months later, in November 1944.[8]

Undeterred, in January 1945 Moscow now suggested that he went to Brussels, an assignment Rothstein accepted with some enthusiasm, and he left for the Belgian capital in June 1945. By now, however, he had made up his mind to leave TASS as soon as the war was over, and MI5 noted his 'dismissal' from his position in September. According to their reports, however, he remained *persona grata* as far as Moscow was concerned, and in February 1946 was providing Moscow with material on the Indonesian Question. Later that year he retired from journalism altogether and took up a temporary teaching post at the London School of Slavonic Studies (UCL-LSSS). It was not a successful move. In 1948, following the appointment of Dr Bolsover as Director of UCL-LSSS, Rothstein's academic credentials were questioned. Dr Bolsover had previously worked as head of the Embassy Information Service in Moscow, and he was accused of victimizing Rothstein. The student body supported Rothstein and protests

were organized by the staff in his defence, leading to the local branch of the Association of University Teachers referring the matter to the national organisation. At the May 1950 meeting of the AUT in Swansea, a motion 'that the university should be asked to probe into the motives, conscious and unconscious, which had activated the university council in their victimization of Rothstein' was defeated and, despite further protest from the student body, Rothstein was dismissed from his post at the end of the summer term. He returned, somewhat reluctantly, to the world of journalism which had changed quite dramatically in his absence. In March 1951 he was complaining to Hymie Fagan at communist party headquarters that Johnny Campbell's editorship of the party paper, the *Daily Worker*, had turned it into a Fleet Street rag preferring to concentrate on 'the journalistic rather than the Propaganda angle'. From then on, he concentrated his energies on writing and published two useful books on Soviet history and Anglo-Soviet relations: *A History of the USSR* published in 1950 and *Peaceful Coexistence* published in 1955.[9] By now, the Cold War was well-established and Rothstein was no longer the doyen of left-leaning progressives operating on the fringes of the communist party. In June 1955 the final touches were being made for the Lawn Road Flats' twenty-first birthday party, and invitations were being sent out to past residents and friends of the Flats. When Rothstein's name cropped up it was politely put to one side and he was not invited, nor was Edith Tudor-Hart or any member of the Kuczynski family.

*

During the 1930s and the Second World War, Lawn Road Flats had accommodated, or played host to, a raft of intelligence agents working in some capacity or other for the Soviet Union: the controller of the Cambridge Five, Arnold Deutsch; the Kuczynski family; Rothstein; Eva Collett Reckitt; Francis Meynell; and Cyril Joad, to name but a few. Among the Flats' fraternity, and no doubt unbeknown to any of these agents, was a gifted New Zealand poet, Charles Brasch, who worked at the British Government's Government Code and Cypher School at Bletchley Park. Brasch, as far as is known, was the only person in the Flats working for British intelligence during the Second World War. Max Mallowan (Agatha Christie's husband) and Stephen Glanville both worked for RAF intelligence, but Mallowan

was rarely at the Flats and Glanville was distracted by failed romances. Brigitte Kuczynski's husband, Anthony Lewis may have been working for the RAF but was strongly linked to those in Soviet Intelligence. Charles Brasch, therefore, cuts an interesting if somewhat isolated figure, the lone Kiwi in a concrete world of smoke and mirrors.

Born in Dunedin in 1909, the only son of a wealthy Jewish lawyer, the war had caught Brasch in Honolulu on holiday with his father. It was the first time the two men had met since 1932 and Brasch senior was entreating his son to return to New Zealand and join the family business. A member of the Hallenstein dynasty with access to the vast family fortune made in the Central Otago goldfields, Brasch senior promised his son a secure and prosperous future in New Zealand. Charles Brasch, however, 'temperamentally unsuited to the commercial world', and 'determined, despite family disapproval, to become a poet'[10] was drawn to England, where he had spent ten of the previous twelve years. Between 1927 and 1930 he had studied Modern History at St John's College, Oxford and, after only two years in New Zealand, had returned to England where he knew other New Zealanders making a reputation for themselves in the literary world – among them Geoffrey Cox of the *News Chronicle* and the writer John Mulgan then employed by the Clarendon Press. In Honolulu, Brasch decided to return to England, arriving at the beginning of November 1939 on a steamer from New York:

> EUROPE PRESENTED a quite unexpected face when I reached it again at the beginning of November. Ireland had not been drawn into the war yet [it never was], so that its peaceful air was not surprising. Southampton Water next morning was grey, with flashes of sunlight over autumn trees. There were camouflaged buildings, grey ships. The boat train ran as usual, porters and taxis as usual at Waterloo.[11]

London, on Brasch's arrival, was empty (it was Saturday afternoon), 'with few cars about; windows were boarded over here and there, sandbags piled about two feet high against fronts of buildings, to protect cellars. Strips of brown paper were pasted across window-panes to prevent splintering if they were shattered; glass lights above doors were papered over completely so that no light should show at night. Notices said "To Air Raid Shelter". King Charles at Charing Cross was entirely covered over, but the

[statue of the] King at Cockspur Street remained unprotected.'[12] Brasch found accommodation in Flat 15 the Isokon building, 'one small oblong room with kitchen and bathroom.'[13] His description of the Flats having a 'Brave New World' air about it:

> The grey concrete building was set back from the street so that cars could park in front; each flat on each of the four floors opened onto a balcony corridor on that side. The street was fairly quiet, the window looked behind onto a back of tangled hawthorn, one straight poplar (*sei gegrüßt!*), a few small cherry trees, and a young silver birch; pigeons, sparrows, a blackbird singing. The room soon came to feel to me as if no one had ever lived in it before, a kind of glass case, or a pigeon-hole; life could never mark it; it would be suitable for a creature produced in a test-tube … but it was extremely convenient, and with books, a few pictures, colour, gradually it came to seem mine.[14]

It was in the Isokon building that Brasch, ironically, discovered New Zealand, not England as he had hoped. He began writing poems about his native land, 'the best', he claimed, 'he had yet written…. They were unexpected; in them I discovered the New Zealand I knew and did not know.'[15] Three of the poems were published in John Lehmann's *Penguin New Writing*, a considerable achievement. On one occasion Lehmann invited Brasch to visit him at the Hogarth Press in Mecklenburgh Square where he questioned him about writers in New Zealand for an article to be published in the *New Statesman*. Once back in the Flats Brasch immediately picked up John Mulgan's New Zealand novel *Man Alone*. 'I had to read on until I finished it in the small hours. The description of the escape, round Ruapehu, over the Rangipo Desert, through the Kaimanawas, was quite enthralling. The book was by far the best of its kind … ; the style carried one on, although it would only do for that kind of novel. John like so many of us was haunted by the country, its physical nature: the heavy dark bush, the mountains, the fern country. And he was haunted by the sense of man's exile in the world of the Truce – man homeless, without guidance, without allegiance. He replied to my letter about the book from Northern Ireland: he was in the army.'[16]

London had recently been spared enemy bombing. The first air-raid warning since the outbreak of war in September sounded a week after the

fall of France. It was the first Brasch had heard, 'a rising and falling shriek or moan of the sirens, piercing and chilling, like the howling of wolves; it seemed the death wail of civilization. Bombing of London was expected day by day.... The papers seemed to grow emptier and emptier, the B.B.C. news was half taken up with accounts of air battles, like recitals of a menu, and its soothing correct voices read out the communiqués that last night's air-raids did no *material* damage; bombs fell on open fields: few casualties, etc., until I came to doubt all such reports and felt that we were being spoon-fed, like the French.'[17] People began sleeping in the Isobar, in the basement of the Flats; 'sometimes', Brasch wrote, 'I went down myself.'[18]

The weather in September 1940 was exceptionally hot. On the second Saturday of the month the air-raid warning siren sounded and, before long, 'through the clear hot day came the soft thud of bombs and the quicker guns, both far off, but intense, long-continued. Across Regent's Park', Brasch recalled in his autobiography, 'we could see black puffs in the sky and a large number of planes flying very high; then, to the east, a great column of thick smoke rising in pale puffs and standing high into the air.... With darkness came a great red glow in the sky to south-east, like nothing I had ever seen except a New Zealand bush fire in the distance. Everywhere as I went home by Camden Town to Lawn Road people were speculating – Woolwich Arsenal? The docks? The nine o'clock news said only the docks had been attacked. The glow was still there after midnight. Next night again the clouds reflected the glow from the fires. Another raid started; the noise was sometimes quite near. About midnight I went down to sleep in the bar, with several other people. It was noisy outside, but I slept, woke at three, slept again, then woke in a crashing of glass, which fell all round and on the rug I had ducked under. I was unscratched.'[19] Heavy raids continued throughout the month and into October, their impact dramatically recorded by the official war artist and sculptor, Henry Moore, then resident in the Lawn Road Flats; his drawings of sleeping figures in underground shelters ably capturing the tense atmosphere of the Blitz. Among the London underground stations he recorded in ink, wax and watercolour were nearby Belsize Park and Hampstead, both very deep and crowded each night.

Brasch was called up for medical examination in February 1941 and was told that he was not medically fit for active service owing to 'slight

emphysema of one lung'. He was given a card that said 'Grade 3', and informed that it was unlikely that he would be called upon for active service. Two possible jobs, however, immediately presented themselves. Walking between Berkhamsted and Tring with his friend Colin Roberts 'by way of Marlin's Chapel (Marlin is Merlin: old worn ruins beautifully grown with elms and other trees, which seemed a fitting magician's haunt)', Colin told him that he was 'doing intelligence work for the Foreign Office' at nearby Bletchley Park. The unit was understaffed and Colin suggested that Brasch should write to them requesting work. After a brief period as a paid firefighter in Finchley Road, Brasch was appointed a junior assistant at the Foreign Office at the beginning of July 1941 and began working as a translator in the Italian section at Bletchley Park, 'an ugly Victorian country mansion of red brick'.[20]

> There was a small permanent staff and a large one of people recruited from the universities and elsewhere. The office work had some interest; it was soothing, often boring, and when one learned the routine, mostly predictable. I improved and extended my sketchy Italian, making a number of ludicrous mistranslations in the course of it. Later, I was called on to learn Rumanian, in which half the words were of Latin origin, and the rest a bizarre mixture of Slavonic, Hungarian, Albanian, Greek, Turkish; all I remember of it now is the beautiful word for an oak wood, *dumbrava*, and *Noroc!* which you say when someone sneezes, meaning 'good health'.[21]

The head of the small Italian section at Bletchley Park was Frank Hammond who Brasch thought 'might have passed at first sight as following any one of half-a-dozen occupations, according to the way he dressed – as a bank clerk or small businessman or minor civil servant, as an assistant in a men's wear department or a grocer's shop, as a detective, a courier, even a spy, as a school-teacher, a customs official. He would be lost in a crowd at once. He looked almost anonymous. It was easy to work for so cool and considerate a man'.[22]

Brasch shared his living quarters with Colin Roberts at Soulbury, a very small village a few miles away with only one inn called The Boot where they got to know a young historian, John Prestwich, who had been seconded from the army to Bletchley Park. He told them 'stories about the

G.O.C of his command, a new-broom general called Montgomery who had novel ideas of training. Prestwich thought him able, ruthless, autocratic, and decidedly dangerous, possibly with political ambitions.'[23] Such men aroused their suspicions, and Montgomery was viewed in much the same light as 'the despicable Mosley with his ruffian blackshirts, the Irish O'Duffy and his blue-shirts. To illustrate Montgomery's methods Prestwich told them 'of an occasion when he was meeting his officers informally in their mess, walking among them followed by a few aides. Happening to notice a fat major, Montgomery came up, stopped a few feet off, looked him coldly up and down without a word, and moved on, the officers parting to make way for him. When he had walked some little distance Montgomery stopped again and turned round, and pausing as he fixed his eyes on the major exclaimed with all his force, loudly and savagely with measured deliberation, "I – HATE – FAT – MAJORS!"'[24]

Brasch described his time at Bletchley Park as Kafkaesque. 'The administration seemed to be modelled on that of Kafka's Castle. Shadowy obstacles opposed with intangible reasons whatever needed doing; one fenced in a fantastic atmosphere of ghosts.'[25] Overall, the climate was one of mutual suspicion with no clear leadership, Byzantine in aspect, and drowning in abstruse official language:

> Rumours blew up and died away, moves were predicted, fixed, contradicted, so that we often worked quite uncertain what might happen to us next week. One wit declared that it only needed a few eunuchs about for the place to resemble the Byzantine court in the last stages of the Eastern Empire. The Park was said to be the only establishment in the country that did not cheer Churchill when he visited it: he was received in watchful silence. Perhaps he had the Park in mind when he issued his edict about simplifying official language; I recall a not untypical office circular referring to 'the incidence of unavailability of personnel.'[26]

Little wonder, then, that on 21 October 1941 four of the leading codebreakers at Bletchley Park wrote an urgent letter to the Prime Minister, Winston Churchill, complaining of 'incidences of unavailability'. 'Some weeks ago', the letter remarked, 'you paid us the honour of a visit, and we believe that you regard our work as important. You will have seen that,

thanks largely to the energy and foresight of Commander Travis, we have been well supplied with the 'bombes'[27] for the breaking of the German Enigma codes. We think, however, that you ought to know that this work is being held up, and in some cases is not being done at all, principally because we cannot get sufficient staff to deal with it.' The codebreakers listed four 'bottlenecks' that were causing them the acutest 'anxiety' before pleading with Churchill to take action: '… if we are to do our job as well as it could and should be done it is absolutely vital that our wants, small as they are, should be promptly attended to. We have felt that we should be failing in out duty if we did not draw your attention to the facts and to the effects which they are having on our work, unless immediate action is taken.'[28] Churchill's response was immediate. On 22 October he sent a minute to General Ismay stamped 'ACTION THIS DAY. <u>Secret. In a Locked Box …</u> Make sure they have all they want on extreme priority and report to me that this has been done.'[29]

Brasch, however, did not get the opportunity to welcome the changes brought about by Churchill's memo. Before the year was out, the Italian and Rumanian translators were attached to the Ministries of Economic Warfare and War Transport and moved to Berkeley Street and offices in Park Lane, Mayfair. They were all required to join the Home Guard, and exercise in nearby Green Park. For a time, Brasch lived in a small room overlooking Hampstead Heath before moving into No. 23 Lawn Road Flats on Saturday 13 June 1943, at a monthly rental of £16.9.0.

No. 23 was one of the larger flats and had not only been completely redecorated but also came with a new bed and black-out blinds; its single room had big windows on two sides and he could now put a friend up overnight.[30] Lawn Road itself, and particularly the trees in front of the Flats, worked on his imagination, transporting him back to New Zealand: 'Along the street in front of the building stood a row of Lombardy poplars. When losing their leaves they distilled a strange haunting scent that every time I passed took me back to New Zealand, to that thicket of old and young poplars growing in dazzling light on the wide shingle bed beside the Arrow River where it flows out of its gorge above Arrowtown: leaves there on the young saplings grew enormous as shields and their scent in autumn was rich and penetrating.'[31]

While living in the Flats, Brasch became friendly with the two managers,

Helen Kapp and Lena Neumann. Helen Kapp was an art historian of about Brasch's age, and the younger sister of the painter and draughtsman, Edmond Kapp (himself a previous tenant). During the war she worked for the Committee for the Encouragement of Music and the Arts (CEMA), 'that timidly named fosterling of war that would become the Arts Council'. Lecturing and arranging exhibitions for CEMA, Helen Kapp went on to enjoy a successful career in arts administration, succeeding Eric West-brook as director of the Wakefield Art Gallery before becoming the first director of the Abbot Hall Art Gallery in Kendal, the Lake District. During air raids, Brasch recalls, the two of them would sit in either his or her flat reading Jane Austen. He described her as a 'strong-minded active practical woman bubbling with hearty energy – energy spoke from her black curls nodding like a plume, her large brown eyes and even her prominent teeth; laughter blew out of her in short gusts'.[32] An accomplished artist in her own right, being Slade and Paris trained; she painted a striking portrait of Brasch 'in rather acid pinkish colours'.[33] For a while she worked at the Flats but her practical skills left Pritchard lost for words: 'Helen Kapp was for a short time manageress here. As a personality she was splendid. From the point of view of administration and accounts she was ...'.[34]

Lena Neumann, who replaced Helen Kapp, was just as vivacious: 'an older woman, a charming cultivated Viennese' from a musical and literary family with some connection with the press. 'Large and gentle, with beau-tiful tender eyes, firm in a dignified quiet way,' she helped Brasch revive his German by reading the whole of *Faust* with him in her Flat. A close friend of Sigmund Freud's daughter Anna, who lived close by in Mares-field Gardens, she and her brother later translated Freud's letters.[35] Her musical background was appreciated by Brasch who had a habit of inviting a troupe of Indian musicians, in England as medical students, to play their instruments in his Flat. The music added to the Flats' Bohemian air; Bhupen Mukerjee, a Bengali, played the sarode, while most of the others came from Madras:

> Bhupen and others occasionally brought their instruments to play at Lawn Road, where I now had enough space to ask friends to hear them. I got to love this music, a close and subtle tapestry of sound that did not impose itself peremptorily like most western music, but

stole on the senses in such a way that its rhythms called up colour and even scent; it suggested a more unified way of life than we know, sense and spirit as aspects one of the other.[36]

As the war dragged on Brasch felt more and more strongly that he would return to New Zealand once it was over. 'The thought of living there,' he wrote, 'haunted me, part vision, part nightmare, so insistently that I knew it would be impossible for me not to try, if the world allowed; yet I was afraid of becoming prey there to a more claustrophobic despair than I had ever known in England. I argued with myself continually, and often with friends, the reasons for returning.'[37] In 1942 Denis Glover, a fellow New Zealander – 'poet, craftsman, wit, and devil-may-care roist-erer' – arrived in England to join the Navy. Over the next two years, while on leave he stayed with Brasch at Lawn Road Flats.

Glover had written a number of well-received poems. In 1933 he had been the inspiration behind the Caxton Press in Christchurch showcasing contemporary New Zealand writers, and presenting their work in a dynamic modern typographical design. Brasch's pen portrait of Glover, as the 'man of action' fighting endlessly with the poet in the inner self, was true to the mark: 'He could not bear to let his boxing and drinking and sailing friends think he was soft or soft-headed or impractical; nor did he want his literary friends to take him solely as a literary man.' Of 'middle height, strongly built and solid, inclining to plumpness, with straight brownish short-cut hair, a ruddy complexion, the cauliflower right ear that boxing gave him, and a deceptively boyish air he was never to lose, ... he was always the same' when he appeared on leave at the Flats:

> Like a whale surfacing he blew, rolled about uncouthly, churned up the sea; it took him a day or two to settle down ... he was thirty already, not in his first youth, and underneath his impregnable front thought, imagination and feeling worked in him unceasingly. Life on a destroyer in wartime in cramped quarters and under extreme strain tested everyone to the limit. While still an ordinary seaman, Dennis spent five months on the destroyer *Onslaught*, based on Scapa Flow; he had been with convoys going to Russia, at Murmansk, in Iceland, and within 600 miles of the North Pole. All the time his ship was in danger from German submarines and from attack by air, often under

bombing for hours on end, all round him planes blowing up, ships foundering, men wounded and drowning; this in midwinter cold and stormy seas in those icy latitudes.[38]

On leave, Glover displayed 'a Chestertonian affectation about the bluff English virtues of beer' – 'the mere whiff of a pint of beer seemed enough to glaze his eye and loosen his tongue' – 'he got tight', 'far sooner than most people'. On leave, 'battered after terrible experiences at sea ... he had to go on a real blind, to forget completely for a while'. Occasionally returning to Lawn Road Flats to sleep off his intake he would astonish Brasch by 'his ability, when absolutely stoned, so that he could hardly stand upright, or walk straight, or get out an intelligible word, to rouse himself from stupor, find his way through the black-out in the small hours to Liverpool Street or Waterloo, and so get back to his ship on time'.[39] At the Lawn Road Flats they discussed endlessly the possibility of initiating a New Zealand literary review after the war that would be 'distinctly of New Zealand without being parochial':

> We talked over the prospect again and again, at all times of day and night, even while Denis lay soaking and talking in the bath, a large pink almost hairless octopus, and I moved the few steps between kitchen and bathroom to get breakfast and keep the conversation going. We sat for hours at my small round table, an old ash table scrubbed almost white by long use, its rough surface showing prominently the rings of the tree; outside the window a tangle of hawthorn straggled up the grassy bank.[40]

Their grandiose plans for New Zealand literature, however, were soon interrupted by rumours of a second front and the invasion of France. '... the long-awaited D-day; a windy morning of blue sky, white cloud and dramatic shadows, that soon turned grey and coldish although it was midsummer. Low-flying planes made a great roar at intervals throughout the night and day. Denis Glover, in command of a landing craft, crossed the channel with the invasion fleet, as he described not long after in his [book] *D Day*.'[41] The end of the war, however, seemed to recede as the Germans launched their last attacks on London. Raids by pilotless aircraft, the drones of the Second World War, V1s carrying high explosive bombs

that went off when the plane crashed, caused havoc. This went on through June, July and August. Then they stopped using pilotless planes and began using instead 'a kind of rocket, fired from farther away and describing a very high trajectory, so that they descended almost vertically out of the blue giving no warning. These came to be known as V2s. Because they fell unannounced, and carried greater explosive force than the V1s, they seemed instruments of utterly capricious doom. Warnings usually lasted all through the hours of darkness; I woke often at the sound of the planes or the shock of explosions. Finally I slept through the sirens as I had not done since 1940, and dozed off almost at once after the crump of a bomb woke me.'[42]

No more rockets fell on London after March, the black-out finally ended, and the war in Europe was brought to an end on 8 May 1945. Brasch's description of the end of the war in London was both dramatic and intense; presenting the scenes in Piccadilly and Lawn Road that took place on 7 May, his sense of relief and foreboding is palpable:

> Piccadilly was crowded at noon and in the evening as never perhaps since the war began. It grew hot after a grey morning. At night singing could be heard at the bottom of Lawn Road, and a few crackers. At midnight a storm began. First thunder and lightning, at longish intervals and growing in intensity, until they reached their greatest violence about 3 a.m. After some time slow, half-reluctant rain began, and short gusts of wind, and finally, when the lightning and thunder were at their height, a great downpour of rain fell in a solid vertical wall for half-an-hour or more. The thunder shook the ground, the lightning broke in great sheets and sometimes in ripples that waved across the room. As the enormous rain diminished the thunder retreated, but then approached again for a while; the whole demonstration did not end until about four.... *The Times* next day mentioned that the war had begun with a storm on the night of 2–3 September 1939. So, between a storm and a storm ...[43]

One windy morning in Norfolk, Brasch 'felt the cold air fresh and clean on' his 'skin after London's fog and haze' and looked out over 'lines of fields bare and clean, even through rain; but the flattish country was smooth, too smooth, and [he] longed for the rougher fell of New Zealand'.[44] He

returned to New Zealand in late 1945 where from 1947 to 1966 he edited *Landfall* the journal he conceived in discussions with Denis Glover around the small round table in his Lawn Road Flat during wartime. The journal, despite drawing inspiration from the Isokon building, wartime London, and Glover's experience of the Royal Navy, was devoted to New Zealand's confident young writers: 'to try to make it international by inviting contributions from writers in other countries would be to make it fluffy.... No good writer from England or America would send his best work to an unknown journal at the end of the world, and indifferent work even by famous writers was not good enough. We needed the best work of New Zealand writers', he explained, 'to ensure the quality and character of the journal, to show that the country could stand on its own feet, and to build up a body of New Zealand work'.[45]

<p align="center">*</p>

Brasch's dramatic descriptions of the Blitz, his stay in Lawn Road Flats, and the final stages of the Second World War, takes attention away from his work for the secret world. This was a fact that he was fully aware of in his daily routine and in conversations with his fellow Foreign Office employee, Colin Roberts: 'In London Colin and I continued to work together. When he was transferred to another job, much more crucial and exacting, we still met constantly. At that time if we wanted to talk about our work we took care to walk in the middle of the street, where we could not easily be overheard'.[46]

The Lawn Road Flats, too, had prying ears, not that Brasch wasn't cautious. Since their opening in 1934, when the photographer Edith Tudor-Hart and Gertrude Sirnis first introduced the controller of the Cambridge spies, Arnold Deutsch, and the Kuczynskis to the Flats, Soviet spies and communist 'fellow-travellers' had sauntered freely on the communal walkways. They had dined regularly with fellow residents in the Isobar and had enjoyed membership of the predominantly left-wing Half Hundred Club. An undated pencil note in Jack Pritchard's handwriting in the Pritchard Papers headed 'To be invited to some flat parties', is a list of some very interesting people who would have been regarded as left wing in outlook. Among them the lawyer and Labour MP for Hammersmith North, D. N. Pritt, and his wife, Marie; G. D. H. Cole's wife, Margaret; Aylmer and Phyllis

Vallance from the *News Chronicle* and *New Statesman*;[47] James Bone, the London editor of the *Manchester Guardian*; S. R. Elliott from the liberal-radical newspaper, *Reynold's News*; R. S. Lambert of the *Listener*; Pearl Adam from the *Observer*; and the left-wing cartoonist J. F. Horrabin, a member of the Socialist League and the joint author of a book on the 1926 General Strike with Raymond Postgate and Ellen Wilkinson MP, and his wife, Winifred.

This list was, in all probability, compiled during the first three months of 1939 as one of those on the list, the founding editor of *The Listener* R. S. Lambert, emigrated to Canada in April 1939. At the top of Jack's list was his and Edith Tudor-Hart's close friend, the BBC's German specialist Trevor Blewitt,[48] who moved into Flat 23 with his wife, Phyllis in September 1942. While here, Trevor Blewitt came close to a nervous breakdown, and wrote many letters to the then secretary of the Lawn Road Flats, Lena Neumann, complaining of overwork at the BBC. Blewitt had created an impressive circle of advisers and contributors to programmes on international affairs and he was working under considerable pressure, skillfully managing several difficult egos, among them that of the Oxford historian, A. J. P. Taylor.

At the beginning of 1942, Taylor had written to the BBC asking to be considered for radio broadcasting. Taylor's letter was read by Trevor Blewitt who invited him to come to the BBC for an audition for the series 'The World at War – Your Questions Answered'. It went extremely well and in March 1942 Taylor made his first appearance for the BBC 'in a fifteen-minute slot on the forces network'.[49] Between 31 March and 23 June he appeared on the programme a further six times. He was then dropped, quite suddenly, and in a letter to Blewitt in early September Taylor appeared to blame the CPGB and his comments about the newspaper, the *Daily Worker*, aired on the radio, for his abrupt fall from grace:

> For some reason of their own the Communists are running a campaign against me in Oxford and are saying, among other things, that as a result of my answer about the *Daily Worker* I have been banned from the BBC. I assume that this is quite untrue, but I should like to be sure. If you find it embarrassing to answer I will write to the Controller, but I thought it too trivial to bother him with.[50]

Taylor had a checkered history in respect of the communist party. He had been a member of the CPGB while a student at Oriel College, Oxford, between 1924 and 1926 and had only broken with the party over what he considered to be its ineffective stand over the 1926 General Strike. He then became an ardent supporter of the Labour Party, and remained so for the rest of his life. Blewitt, too, had a communist background, a former member of the communist party he had written a series of articles for the *Daily Worker* on the persecution of communists in Poland before the Second World War. He remained on friendly terms with Edith Tudor-Hart and, during wartime, MI5 had kept open a Personal File on him. Taylor's belief that the communists were in a position to influence hiring at the BBC, while shared by many, was not the case, and they were never in a position to dictate to the BBC. Taylor's departure from the BBC came about 'because he was alarming some of the great and the good in the area of foreign policy'.[51]

Blewitt's reply to Taylor's letter about communists and the BBC did, however, go some way to allay his fears – telling him 'to keep in contact' (Taylor did not, however, return to radio broadcasting until October 1944).[52] By the time Blewitt's letter reached Taylor he had already joined the Political Warfare Executive (PWE) and was using that position to gain leverage with the BBC.

PWE had been set up in 1941 to conduct black propaganda and was to all intents and purposes a secret body and all employees, including Taylor, were required to sign the Official Secrets Act.[53] Situated on the ground floor of Bush House, the BBC's headquarters, the post gave Taylor an opportunity to work his many BBC contacts on a regular basis, including Trevor Blewitt, whom he now pushed to get him on the Brains Trust.[54] First broadcast on 1 January 1941, the Brains Trust was a very popular wartime programme, and appealed greatly to Taylor.[55] Questions of varying kinds were put to three personalities – originally a regular team that included the philosopher (and connoisseur of the Isobar), Cyril Joad; the zoologist and Half Hundred Club member, Julian Huxley; and Commander Archibald Bruce Campbell – who could talk about practically anything. It went out on Tuesday nights and in early 1945 it was attracting 30 per cent of the listening public each week. Taylor first appeared on the programme on 23 January 1945 but, 'feeling his performance was

disappointing', wrote to Blewitt for reassurance. Blewitt replied, 'I don't think you were dreary in the Brains Trust. Nor does Arnot Robertson[56] who sends you her greetings.'[57] Nevertheless, Taylor only made one more appearance on the programme.

The previous year Taylor had published an influential book, *The Course of German History*, which, he later claimed, 'set him up', 'perhaps undeservedly, as an Authority on Germany'. According to the historian Chris Wrigley, Taylor 'had been swift to press' the book on Blewitt, and Blewitt was soon referring to him as part of his 'German team'.[58] Taylor's first mainstream radio discussions were consequently on 'The Future of Germany', transmitted as three programmes on 13 and 20 October, and 1 December 1944.[59] BBC officials, including Blewitt, were impressed by Taylor's 'abilities to argue a case strongly', although as the war drew to a close they were becoming 'increasingly anxious about his pro-Soviet views on foreign policy'.[60]

In May 1945 Blewitt set up a radio debate between the philosopher Bertrand Russell and the respected Marxist scientist, J. B. S. Haldane on 'Should the scientist be the servant of the State?' The debate was a lively one and a note from Lynda Pranger[61] to the writer and historian Gerald Brenan, quoting Bertrand Russell's views on the Haldane debate, pointed to a new consensus on the USSR inside the BBC. It was sent two days before the German surrender on 7 May 1945 and reflected a sea change among progressive intellectuals, both inside the BBC and academia, now that the war with Nazi Germany was all but over. 'BR [Bertrand Russell] is glad Brenan approved of BR's debate with Haldane', Pranger wrote, and passed on Russell's comments: '... I was afraid I had been too tame ... I don't think they will let me talk on politics. Now that the Germans are finished I think it important to be anti-Russian; but if this is to be done effectively we must be genuinely democratic, and not suggest to the world that the only alternative to Moscow is governments of semi-repentant Fascists. A Labour Government will be far more effective than Churchill in this way.... The source of all evil is Sparta as idealized in Plato and in Plutarch's *Life of Lycurgus*.'[62] It was a harbinger of things to come, and in many respects anticipated the course of Cold War broadcasting. When in February 1946 Taylor wrote to Blewitt setting out his views on Russia and asking to be

allowed to speak on Soviet affairs, he was not only going against the new wisdom, he was also gaining a reputation for himself as a maverick:

General argument would end: Bolshies too want peace and prosperity, not to conquer the world; they are hesitating whether to get it by spheres of influence or by co-operation. Therefore, we have to go on trying to co-operate. There wouldn't be anything I have not said before; but it would be in a more systematic form. The explanation of the internal conflicts of opinion in the Communist Party, or at least in the governing circles would be new for England. It would not be pro-Bolshevik except in the sense that I am always pro-Russia, i.e., I have no sympathy with anti-Russia hysteria and think that we should judge Soviet affairs with the same cordial, but friendly, detachment with which we judge American affairs.[63]

Blewitt who, it will be remembered, had once enjoyed close ties with the CPGB, now informed the BBC's Assistant Controller (Talks) that 'I do not wish to press the Russian topic', the 'Middle East *is* a good topic, but again Russia would come in'.[64] However, on 27 February 1946 Taylor was allowed to go ahead and air his views about the Soviet Union on the BBC Home Service's 'World Affairs: A Weekly Survey', one of eight appearances on that programme.[65] Despite further broadcasts on British and Russian foreign policy in the Middle East, Blewitt was uncomfortable with Taylor's barely disguised cynicism – 'in his tone of voice at the microphone' and 'in the tone' of his script – and decided to drop him from the series: 'Not so much because he is a cause of anxiety every time we put him on, but because I think his admirable qualities (courage, intellectual brilliance, if not profundity, ability to avoid the claptrap of the age, whether from Right or Left, vigour) are vitiated by a certain cynicism which is out of place in an objective and ultimately educational series for the ordinary listener'.[66] Taylor, apparently, was not told of Blewitt's concerns. In his autobiography he maintained that Blewitt had reassured him that he 'had a great future as a radio pundit' and he had no reason to disbelieve him.[67] 'Both of us', Taylor suggested, 'misjudged the contemporary situation. Soon after the end of the war there broke out that obsession with anti-Communism which came to be called the Cold War and I was on the wrong side'.[68]

Taylor's views on Russia were certainly heterodox. Although, as he was

eager to point out, he 'had not been a Communist since 1926 and had often enough taken an anti-Communist line in home politics', his sympathies were pro-Stalin because they were not pro-Hitler. These were sympathies that Blewitt, a Germanophile with left-wing views, could only encourage despite Taylor's indictment of German history in *The Course of German History*. He later claimed that he hadn't 'the slightest illusion about the tyranny and brutality of Stalin's regime' but that he 'had been convinced throughout the nineteen thirties that Soviet predominance in eastern Europe was the only alternative to Germany's and I preferred the Soviet one.' His 'dissent', however, went much further:

> I held with the great Lord Salisbury that cooperation with Russia was a wiser course than hostility and that Russia, whether Tsarist or Soviet, sought security, not world conquest.... At any rate I was dedicated to the cause of friendship and equality with Soviet Russia and preached the cause on the radio whenever I had an opportunity to do so. Little did I foresee the Cold War which has devastated my life.[69]

'In 1948, on Blewitt's prompting,' Taylor 'gave four talks on the contemporary situation, arguing that Great Britain should maintain the Balance of Power by cooperating with Soviet Russia against the American attempt to dominate the world. I did not allow,' Taylor wrote, 'for British financial dependence on the United States which compelled us to become American satellites from the time we accepted the American loan in 1946.'[70]

As a result of these talks Taylor found himself condemned in the House of Commons by the Deputy Prime Minister, Herbert Morrison, as 'anti-American, anti-British and not particularly competent'. 'I treasured this as high praise,' he wrote. 'The foreign office complained to the BBC which, after some feeble gestures of resistance, struck me off the Third programme.' Blewitt, who in 1946 had played it safe by blaming Taylor's demise on his cynicism, appeared to make no comment on what was little more than blatant government interference with the independence of the BBC. In 1948 Blewitt was under considerable emotional pressure and was possibly not in a position to intervene on Taylor's behalf. His wife, Phyllis, had died on 15 February 1948, aged 52. Her death certificate recorded that she had suffered from toxaemia of pregnancy in 1931 and that this had caused her premature death. Blewitt was unable to carry on without Phyllis and a year

later, on 31 March 1949, he gave up his apartment in Lawn Road Flats and took a room at a nearby lodging house in Rosslyn Hill where he took an overdose of sodium amytal and died on 10 April 1949.

Vere Gordon Childe

'T HE British prejudice against suicide is utterly irrational,' the occupant of No. 22 Lawn Road Flats, Vere Gordon Childe, wrote before taking his own life in 1957. Childe committed suicide in his native Australia, by hurling himself 1,000 feet to his death below Govetts Leap at Blackheath in the Blue Mountains, New South Wales, on 19 October 1957. 'To end his life deliberately,' he wrote, 'is in fact something that distinguishes *homo sapiens* from other animals even better than ceremonial burial of the dead.'[1] Many theories have been put forward to explain Childe's suicide not least his own fear that his intellectual powers were failing him. A pre-historian of great skill and reputation, his most popular book *What Happened in History* (published in 1942) has been described as 'probably the most widely read book ever written by an archaeologist.'[2] According to David Russell Harris, a former director of the Institute of Archaeology at University College London, Childe had a unique vision of evolution at a time when other archaeologists had only 'chronology charts.'[3]

A Marxist who never joined the Communist Party, Childe gained a reputation amongst his colleagues as the 'Red Professor'. Agatha Christie's husband, Max Mallowan described him as 'a man of brilliant intellectual capacity, whose writings were admired far beyond the archaeological circle. Gordon was a professed Marxist,' he wrote, 'and intellectually dedicated to the cause, but the Party was too clever ever to admit him intellectually: outside it he was an invaluable ally, from within he would have been a menace.'[4]

Australian archaeologist, communist and one-time bridge partner of Agatha Christie, Childe had first moved into Flat 18 on 9 September 1946 (he moved into Flat 22 in 1949, because it was bigger). The invitation to his house-warming party revealed a puckish sense of humour: 'A Childeish professor invites you to inspect its new nursery and such prehistoric liquors as survive on Thursday, October 3rd at 6 p.m.'[5] Agatha Christie

enjoyed his company; the two were excellent card players and next-door neighbours. An 'extraordinary man', the ugliest I have ever met,' Mallowan wrote, 'indeed painful to look at: his blue nose, like that of Cyrano de Bergerac, conditioned his nature, and had he not been the victim of polio which disfigured him in his youth he might well have conformed normally to the society in which he lived; but archaeology would have been the poorer without him. His Marxist concepts, his economic outlook, were a stimulus to archaeological thinking, and all prehistorians with proper concepts of food gathering and food production owe a debt to his work.'[6]

In December 1946 the Isokon building had received a dubious honour when it became the outright winner of the 'Ugliest Building in London' competition run by the highly-respected publication *Horizon*. 'No English journal,' according to New Zealand poet, Charles Brasch, 'had presented more lively, often brilliant work' or had been so 'continuously stimulating' as Cyril Connolly's journal *Horizon*.[7] The prize was hardly welcome. The Lawn Road Flats had emerged from the war largely unscathed; but the building, desperately in need of a face-lift, had been painted a dark choco-late colour. This was 'unattractive', as the architect and past tenant, Walter Gropius, freely admitted in a letter to the editor of *Horizon* defending the Isokon building. 'But,' he continued, 'this cannot veil the basic soundness of this handsome building of which I thought London could be proud.'[8]

The Flats' architect, Wells Coates, blamed Jack Pritchard for the poor state of the building and reminded him of the 'many serious knocks re LRF' he had experienced 'since the day it was opened by a ceremony on the roof: when Miss Cazalet was instructed to make a speech which gave nearly all the credit for the ideas behind the building to Molly ("Dr. Rose-mary Pritchard") and I was rather offhandedly referred to as "Mr. Russell Coates" ... I realize,' he continued, 'that, what with the blitz, the war, the lack of licenses, etc. things are difficult to arrange at the moment, but I hope that as soon as you can manage it, the building will be restored properly: there are many things to be done. I was shocked and surprised, when, recently, I visited you there again, not only to see the state it has been allowed to achieve, but also that you had unsatisfactorily done some patching up: probably due to difficulties with licenses, etc. but more importantly because whoever you employed did not know what to do.' Most shocking was the colour. 'It is clear,' Coates concluded, 'that the deci-

sion to use a dark chocolate colour is wrong: I hope you will, during the next year, be able to do something about this.'[9] Jack Pritchard wrote to Cyril Connolly complaining about the attack on what he considered 'to be one of the best jobs that Wells Coates has ever done.'[10] Connolly's reply probed Pritchard's sense of humour:

> The spirit of the competition is to be found in the report of the results in the December, 1946, Number and in the form of the competition itself as set out in previous Numbers, but, for your information I can add that it was more joke than anything else.[11]

Pritchard was never reconciled. But if he had taken umbrage unduly he certainly didn't lack a sense of humour. A very different competition had also been held in the Isobar where contestants were asked to send in definitions of <u>High Dudgeon</u>, <u>Huff</u> and <u>Umbrage</u>. Jack would have smiled at the entry that read, 'Umbrage is like an umbrella only it saves face and not clothing.' Gordon Childe's poetic entry may also have produced a wry chuckle:

> Beneath the shadow of his beetling brows,
> stiff Umbrage glares, roused by some fancied slight
> Huff simply sulks, and flounces off,
> his temper ruffled by the merest trifle,
> But Dudgeon stalks away, his held high,
> his unrequited merit to defend.[12]

Childe has been described as ' something of a 'loner' with 'many friends, but no intimates'. Never married, he 'had little contact with his family after he left home as a young man. His deeply-held belief in Marxist philosophy and his sometime naïve admiration for Soviet communism also set him apart from many of his colleagues.'[13] One of the contestants in the Isobar's competition probably had him in mind when sending in this definition of <u>High Dudgeon</u>: 'High Dudgeon is what Childe Harold wound up in when he didn't know where he was anyway.'[14]

A keen, but erratic motorist – he owned a V-8 coupe – Childe often combined motoring with dining at the Isobar. Known to enjoy good company, along with a bottle of wine, he frequently invited colleagues to join him there.[15] The Irish broadcaster, geologist and archaeologist, Dr

Frank Mitchell, in a speech to the 'Proceedings of the V. Gordon Childe Centennial Conference held at the Institute of Archaeology, University College of London, where Childe had been Director between 1946 and 1957, recalled one such memorable occasion:

> My chief recollection of Gordon is of his appalling driving; he was the second-worst driver I have ever been with, being only exceeded by another archaeologist, van Giffen of the Netherlands.
>
> After a meeting in the Institute – then in Regent's Park – Gordon invited me to dinner in his flat in north London. His car was a vast Ford V-8 coupe, with an enormous boot. When he opened this to put in his brief-case, it seemed to contain a large number of dirty shirts. We set off, and during our relatively short trip not only were our own lives, but those of several pedestrians, put at severe risk. I can still see a cripple we bore down on making a wild leap for the pavement.
>
> The block of flats where he lived was also remarkable. It was built in liner style, with the passages on the outside, just like the promenades on a ship. But I must say that once safely inside we had a very agreeable and relaxed meal, with much profitable conversation.[16]

Max Mallowan experienced a similar Childeish incident after dining at the Athenaeum: 'when we stepped into Pall Mall [Childe] found that his car was inconveniently parked between two others and that there wasn't enough room for him to manoeuvre it out easily so he proceeded to get in and treat it exactly like a steam engine. Instead of trying to find a gradual way out he simply shunted back and forth until he buffeted the two vehicles in front and behind enough to get them out of the way.'[17]

The Russians weren't overly-impressed by Childe's Marxism and admiration for Soviet archaeology; Professor Leo Klein of the Russian Academy of Sciences in St Petersburg, went so far as to liken it to a 'knight's romance ... which although based on mutual love, could not end happily.'[18] Regarded by most of his colleagues in the Soviet Union as a 'dangerous Marxist'[19] who insisted on treating Marxism as a way of thought, as opposed to a set of dogmas, he rejected the 'unilinear evolutionary scheme' of Soviet archaeologists, roughly based on Engels's *The Origin of the Family, Private Property and the State*, 'that societies at the same level of development, even if they were historically unrelated, would be fundamentally similar.'[20]

This put him at odds with the general drift of Soviet archaeology; he 'also objected to the rejection by Soviet archaeologists of diffusion and migration as factors promoting cultural change.'[21] Diffusionism – the belief 'that peoples from all parts of the world had an active role in the creation of a universal cultural heritage'[22] – formed the central argument of Childe's book *Scotland Before the Scots* published in 1946. In this work Childe probed the debate between diffusion and internal factors as explanations of cultural change, and admitted that diffusionists had paid insufficient attention to the latter while concluding that 'archeologists could never account for the Neolithic period without also accepting that, until domesticated plants and animals had been brought into Scotland from the south east, a food-producing economy could not have developed there.'[23]

<p style="text-align:center">*</p>

Scotland Before the Scots was based on excavations and research undertaken between 1927 and 1946 while Childe was First Abercromby Professor of Archaeology at the University of Edinburgh. He directed the excavation at Skara Brae on Orkney that led to the discovery of a complete Neolithic village where the buildings, tables, beds and cupboards were all built of stone because of the lack of trees on the island. Skara Brae and another Neolithic village at Rinyo, on the island of Rousay in the Orkneys were both 'recognized as classical illustrations of self-sufficient Neolithic communities.'[24] The excavations followed upon the discovery in 1936, by archaeologist Stuart Piggott, that there were 'similarities between Skara Brae pottery and the Grooved Ware of East Anglia.' Excavations at Rinyo in 1937 confirmed Piggott's thesis 'by producing further parallels to East Anglia shapes and motifs,'[25] and these discoveries supported Childe's diffusionist claims:

> The site had apparently been hastily abandoned by the inhabitants, and each single-roomed hut was just as the occupants had left it – a Pompeii of the Orkneys. The furniture consisted of stone beds once containing heather mattresses, shelves, dressers and water-tight small stone boxes or cists let into the floors. Fine necklaces and the bones of choice joints of meat were found in the sleeping places, where presumably such valuable belongings had been hidden by

their owners underneath the heather. Another very human touch was provided by a string of beads leading from the narrow doorway of a hut along a passageway; Childe suggested that a woman had broken her necklace in her haste to flee, leaving her treasured beads behind her as they fell. The linking passageways between the huts were paved and roofed, and the whole village had a common drainage system – evidence which provided fuel, in his [Childe's] explicitly Marxist *Scotland Before the Scots* of 1946, for Childe's theory that the inhabitants of Skara Brae considered themselves to be related members of a single great family or clan: 'With such a sociological structure there are neither ruling nor exploited classes and the land at least is communally owned. As long as the principal means of production – in this instance flocks and herds – are likewise held in common, we have 'primitive communism' in the Marxian sense; this does not preclude private property in articles individually made and used, such as tools and ornaments.'[26]

Childe enjoyed himself immensely at Skara Brae. A former student, Stewart Cruden, remembered that the 'Stromness landlady who looked after him during the epic days of Skara Brae commiserated with genuine solicitude on how the poor man never ate, too upset when he didn't find anything, too excited when he did'.[27] He published his work on Orkney as *Skara Brae* in 1931.

<p style="text-align:center">*</p>

In 1935 Childe made his first visit to the Soviet Union spending twelve days in Moscow and Leningrad attending a Persian Arts Congress where he was said to be very impressed by the central organization of museums and excavations made possible by the Soviet State.[28] Nevertheless, Childe made a point of enjoying all the comforts of the British Establishment and in 1937 he was elected to that select gentleman's club, the Athenaeum, where he insisted on reading the *Daily Worker*. Childe's commitment to Marxism as a philosophical system increased during the 1930s, and he argued strongly that archaeologists, by learning more about how cultures developed in the past, could contribute to the 'science of progress'. In this respect Childe 'was more successful than most archaeologists of the 1920s

in avoiding the racism that permeated the social sciences at that period'. Throughout the 1930s Childe 'ascribed positive moral and political value to diffusionism because it revealed the errors of Nazi racism' and because 'archaeologists outside Germany had to counteract the propagandistic uses that were being made of archaeology by the Nazi Party'.[29] For Childe, Egypt was the horror story of what happens when moribund social relations isolate a people from external contact – 'Four centuries after the Iron Age had opened in Greece we find the Egyptian smith still using the clumsy tools of the Bronze Age'.[30]

In his book *The Dawn of European Civilization*, published in 1925, Childe set out to challenge the racism of the German linguist Gustaf Kossinna, 'which attributed all human progress to the biological superiority of an Indo-European master race'. It was a seminal work that explored 'the prehistory of the whole of Europe during the Neolithic and Bronze Ages not as a mere chronicle of technological development but as a history of different peoples and their changing ways of life'.[31]

Although he never joined the Communist Party, Childe went to great lengths to cultivate his contacts with individual members of the Party, and attended Party functions. In 1944 he produced a booklet called *The Story of Tools* produced by the Cobbett Press for the Young Communist League and, in the spring of 1945, he was asked by the chairman of the Marx Memorial Library in Clerkenwell Green, Robin Page Arnot, 'to lecture at the Conway Hall after the annual march in commemoration of Marx's funeral'.[32] He visited the Soviet Union again in June 1945 with Julian Huxley as part of the British delegation to celebrate the jubilee of the Academy of Sciences. Childe, according to a note in his diary, dined at the Kremlin where he claimed to have spoken with Stalin.[33] Certainly Childe was inspired by this visit and 'returned from the conference with a strengthened conviction that in the future the original researcher in all branches of science would find Russian an essential language'.[34] He learnt to read Russian himself, 'and regarded the international exchange of scholarship as enormously important in bridging the gap between Russia and the West'.[35] The falling of an Iron Curtain across Europe was, he argued, 'a severe blow', a barrier to the 'natural scientists who from the days of Galileo and Newton to 1945 freely exchanged information and ideas by publication, correspondence and visits regardless of political frontiers'.[36]

Childe's closest friend throughout his life was the intellectual guru of the British Communist Party, Rajani Palme Dutt. In the 1950s, before Childe's return to Australia, they were working on a joint edition of Engels's *Origin of the Family, Private Property and the State*, in which Childe 'would add the archaeological notes to supplement the necessary limited information at that time available to Engels', and Dutt would write a political preface.[37] The work was never completed. Childe had first met Dutt in 1914 at the Oxford University Fabian Society along with the future wine connoisseur of the Isobar, Raymond Postgate. He became a frequent visitor to the Labour Research Department, the Fabian Society's think-tank, where he also met Postgate's closest friends and fellow labour historians, Margaret and G. D. H. Cole.[38] In 1916, while studying 'Greats' (Classics and Philosophy) and taking the University Diploma in Classical Archaeology at Queens to be followed by a B.Litt (he never completed the diploma but submitted a B.Litt thesis in 1919 on 'The Influence of Indo-Europeans in Prehistoric Greece') Childe moved into digs with Dutt who was studying at Balliol; a year later Dutt was expelled from the university 'for the propaganda of Marxism.'[39]

<p style="text-align:center">*</p>

Childe was born in Sydney, New South Wales, on 14 April 1892 to English parents. The son of a strict Anglican clergyman, his childhood was spent in the scenic Blue Mountains, sixty miles west of Sydney and eight miles from Govetts Leap, where in 1957 he would take his own life. He was educated privately, a solitary boy and adolescent, before being enrolled at Sydney Church of England Boys Grammar School, one of Australia's premier private schools. He attended the University of Sydney between 1911 and 1914 where he was awarded First Class Honours in Latin, Greek and Philosophy, a University Medal and a philosophy prize. He went to Oxford in 1914 on a Cooper Graduate Scholarship in Classics to study 'Greats'. He spent three happy years in England, and formed lasting friendships with Raymond and Daisy Postgate. He arrived back in Sydney in August 1917, a known pacifist who made no secret of his socialist views. This led to the Australian intelligence services placing him under surveillance and having his mail intercepted.[40]

Childe's first job in Australia was as a Latin teacher at the Marybor-

ough Grammar School in Queensland, an unenviable task that witnessed 'frequent disintegration of discipline and its restoration by drastic means'.[41] One former Maryborough schoolboy would recall: 'Whatever scholarship Childe brought with him was obliterated in the pandemonium that attended his classes. The climax came one day when a class all armed with peashooters launched a concerted attack on him.'[42] He was saved from further attacks by the University of Sydney when in November 1917 he was appointed senior resident tutor at St Andrew's College. At this time Childe was very active in the Australian Union of Democratic Control for the Avoidance of War (UDC), set up in June 1916 to thwart Australian Prime Minister Billy Hughes' attempts to introduce military conscription to Australia. The Australian branch of the UDC, like its English counterpart, advocated democratic control of foreign policy and the total abolition of conscription and compulsory military training; Childe was appointed its assistant secretary. In Easter 1918 the Third Inter-State Peace Conference, convened by the Australian UDC, was held at the Friends' Meeting House, Sydney. There were over 100 delegates from various peace groups, the Australian Labour Party, the Society of Friends, several trade unions, and a representative from revolutionary Russia, Peter Simonov, Soviet Consul-General for Australia (as yet unrecognized). Childe was billed as one of the speakers; he came to the platform and ended his speech by calling 'for the overthrow of the capitalist system'.[43] At the end of April the seditious nature of Childe's speech was brought to the attention of the Principal of St Andrew's College, Dr Harper, who asked for Childe's resignation, which was duly given on 1 June; the 1918 edition of St Andrew's College magazine commenting:

> Mr. Childe came to the College an entire stranger to us, and it speaks volumes for his personal worth that when he left us at the end of the first term he had won the respect and esteem of all the men. His scholarship was of the first order, and his tea and biscuits were second to none. His pipe was a thing of beauty and a joy for ever. He did not seek to be popular; he just became so. Owing to the fact that in this as yet intolerant world, it is not possible at a time of crisis to hold social and political views contrary to those in the majority, it became desirable, in the interests of the College, that Mr. Childe

leave us. He took the only proper course in the situation – that of voluntarily resigning – to the great regret of all those who knew him.[44]

In need of 'alternative employment Childe turned to the Catholic College of St John's', whose Rector was the Reverend M. J. O. Reilly, an Irish revolutionary, 'an opponent of conscription and a prominent name on the Intelligence Service list'.[45] Childe ended up in Brisbane working for the Workers' Educational Association before returning to New South Wales to become the private secretary to the leader of the Labour opposition, John Storey. On 14 April 1920 Storey became State Premier, forming a government with a precarious majority of one.[46] Childe was appointed a research officer and at the end of 1921 came to London to work as research and publicity officer for the NSW Agent-General, Sir Timothy Coghlan. He began his duties on 7 December 1921 but, as the Conservatives won the NSW elections on 20 December, his post was annulled and his contract terminated on 4 June 1922; disillusioned with Australian politics he decided to remain in London. The post had been 'an eye-opener for the young idealist', and after his dismissal he wrote his first book, *How Labour Governs*, 'a biting indictment of the corruption of labour politics in Australia'.[47] The book was favourably reviewed by Raymond Postgate in *The Plebs Magazine* in 1923 and Childe himself was invited to review for *The Plebs* the following year. It was an interesting journal, Marxist in sentiment, set up in 1907 by a miner from the Rhondda, Noah Ablett while a student of Ruskin College, Oxford.

Childe's first review was of fellow antipodean William Pember Reeve's book *State Experiments in Australia and New Zealand*, which had just been re-issued, the next was a book by J. K. Heydon on wage-slavery, and the third was a review of two books by W. J. Perry, *The Origin of Magic and Religion* and *The Growth of Civilization*. All three appeared in *The Plebs* in 1924.[48] In December 1917 Childe met 'the technical representative of the Oxford University Press', J. G. Crowther, 'a well-known popularizer of the history of science', at Leonard Woolf's 1917 Club, a socialist club in Gerrard Street founded to advance the aims of the October Revolution.[49] In his autobiography Crowther paid tribute to the 'modernity and quality

of Childe's mind', and the influence that Childe had on his own intellectual development:

> Childe had an understanding of technological and scientific factors in the evolution of man which made his view of prehistoric archaeology exceptionally interesting from the scientific point of view. I once asked him what was the social significance of his subject. He said that, for example, it showed that mankind had extraordinary powers of survival. There were moments in the hunting stage of mankind when a single comparatively small incident might have exterminated the human race. The dangers that man survived were repeated and very great. Frightful though modern dangers might appear, there had probably been many even worse in the prehistoric past, which man had survived. This was a reason why man could face the future with optimism and confidence. The modernity and quality of his mind and conceptions were very striking; I was much influenced by them.[50]

At the end of 1922 Childe attended a summer school organized by the Labour Research Department at Cloughton, near Scarborough. 'Here he spent two pleasant weeks playing tennis or walking during the day, with lectures in the evening.' He enjoyed the company of some leading left-wing intellectuals – Rajani Palme Dutt and his brother Clemens, Raymond Postgate, G. D. H. and Margaret Cole, Maurice Dobb and J. G. Crowther. George Bernard Shaw, H. N. Brailsford and Charles Trevelyan were among the guest speakers, Childe spoke on the Wobblies, the International Workers of the World (IWW).[51]

Shortly after his return from Scarborough 'Childe was invited to travel to Vienna, to examine and sort out some unpublished material in the Prehistoric Department of the Natural History Museum' staying at the house of the assistant director of the museum, Dr Mahr.[52] In 1925 he became librarian to the Royal Anthropological Institute before leaving for Edinburgh in September 1927 to become the first Abercromby Professor of Archaeology. In the summer of 1946 he moved to London to take up an appointment as director of the Institute of Archaeology and Professor of Prehistoric European Archaeology.[53] In Childe's day the Institute was housed in St John's Lodge on the Inner Circle, Regent's Park. The surroundings were spacious and 'lent themselves to informality in teaching and

many lecturers conducted their courses with open doors. The Institute was a relatively new enterprise and was still imbued with an exciting pioneering spirit; staff and students alike found it a happy and stimulating atmosphere in which to work.'[54] Professor Charles Thomas, a student of Childe's at this time, recalled that Childe 'used to demonstrate flint-knapping outside the old Institute, in the yard, using large chunks of flint and invariably cutting himself and spattering the gravel with (irregular) flakes and gores. He was persuaded, for these frequent and inept shows, to substitute a large potato and slice it with a knife from the kitchen, and VGC [Vere Gordon Childe] used to buy such potatoes from a Camden Town barrow when walking from Belsize Park in the a.m. The lead in was "Imagine this is a flint I'm holding in my hand ..." One day Uncle Gordon forgot to buy his jumbo spud, but this didn't deter him; choking with laughter, we had to stand there while he went through the motions, the opening comment being "Imagine that I'm holding a potato ..."'[55]

<p style="text-align:center">*</p>

Childe left hardly any trace of his own personality in his rooms in the Lawn Road Flats; 'there were no obviously personal pictures or ornaments and no books. There was on one shelf a small range of battered blue files – and these contained the sum of his incomparable knowledge of European prehistory. Most of his work that required reference to libraries he did in his book-lined room at the Institute.'[56] Childe was at the height of his intellectual powers, in March 1950 he was elected a fellow of the Zoological Society. 'When the periodical *Past and Present* was formed by Marxist historians in 1952 he joined the editorial board, he was also a member of the board of *The Modern Quarterly* in the early 1950s, later called *The Marxist Quarterly*. Not officially an organ of the CPGB it was so in reality. The chairman of the board was his long-standing friend R. P. Dutt and the board meetings took place in the Communist Party's headquarters in King Street. Dutt, who would refer to Stalin's errors in *Labour Monthly*, the communist journal he edited, as mere 'spots on the sun' which 'would only startle an inveterate Mithras-worshipper', was not to everyone's taste.[57] Following the Soviet invasion of Hungary in October 1956 the *New Statesman* 'published a famous letter signed by some leading British Communists or pro-Communists, dissociating themselves from

the Russian action. Childe did not sign this letter; he explained that to have done so would have given too much satisfaction to his life-long enemies.' Deeply upset by the Russian action 'he lost his faith in Soviet Communism, though not his faith in communism itself,' which remained his ideal.[58] Before his retirement from the Institute in the summer of 1956 Childe had become something of a celebrity in Britain appearing on the popular TV programme 'Animal, Vegetable, Mineral'.

On the eve of his retirement Childe's 'many ... friends asked him what his plans for retirement were. He replied that he wanted to go back to Australia, see his native land again, and visit his two surviving half-sisters and his old friends. He also stated unequivocally to several people on separate occasions that he intended to find a suitable cliff and jump off it. Recently he had visited an aged and learned friend and had been struck by his senility, and the reason he often gave for wanting to end his own life was that he had a horror of growing old and useless and ending his days with no one to look after him. He feared too that he had cancer and that his doctors were concealing the fact from him.'[59]

Childe now began sorting out his personal papers, donating a large proportion of his vast personal library to the Institute of Archaeology; the remainder was sold through the antiquarian booksellers Holleyman and Treacher in Brighton. In December 1956 he gave up his flat at the Lawn Road Flats, and travelled by air (the Suez Canal was closed) to spend the winter as the guest of the Indian government at a science congress. On his return to England he lived at the Athenaeum before sailing from England on 17 March 1957 on the Orient Line ship, the SS *Oronsay*, arriving in Sydney on 14 April, his 65th birthday. On the 19 October he jumped 1,000 feet to his death in the Blue Mountains. His suicide note was poignant:

> I have revisited my native land and found I like Australian society much less than European without believing I can do anything to better it; for I have lost faith in all my old ideals. But I have enormously enjoyed revisiting the haunts of my boyhood, above all the Blue Mountains. I have answered to my own satisfaction questions that intrigued me then. Now I have seen the Australian spring; I have smelt the boronia, watched snakes and lizards, listened to the 'locusts'. There is nothing more I want to do here; nothing I feel I

ought and could do. I hate the prospect of the summer, but I hate still more the fogs and snows of a British winter. Life ends best when one is happy and strong.[60]

The New Statesman, Ho Chi Minh and the End of an Era

Not long before his death Childe sent 'affectionate letters' to all his friends, including Agatha Christie.[1] The Mallowans stayed on as tenants at the Lawn Road Flats until June 1948 and remained close to Childe. As the director of the Institute of Archaeology, Childe was Max Mallowan's immediate boss and he helped Max secure the chair of Western Asiatic Archaeology. Mallowan undoubtedly liked Childe and in his autobiography made a number of favourable references to him; Agatha Christie, however, doesn't mention him at all.[2]

Max Mallowan had returned to England from Cairo in May 1945. As the war drew to its close Agatha Christie became 'completely unnerved' by the thought that her husband might have changed in his absence, or find her different, and in some panic she had rushed off to her daughter, Rosalind, in Wales for the weekend. On the Sunday evening she travelled back to London on 'one of those trains', she recalled in her autobiography, 'one had so often to endure in wartime, freezing cold, and of course when one got to Paddington there was no means of getting anywhere.'[3] She managed to board 'some complicated train' which despatched her at 'a station in Hampstead not too far away from the Lawn Road Flats', and from there she 'walked home' carrying her suitcase and some kippers wrapped in a brown paper parcel:

I got in, weary and cold, and started by turning on the gas, throwing off my coat and putting my suitcase down. I put the kippers in the frying pan. Then I heard the most peculiar clinking noise outside, and wondered what it could be. I went out on the balcony and I looked down the stairs. Up them came a figure burdened with every-thing imaginable – rather like the caricatures of Old Bill[4] in the first war – clanking things hung all over him. Perhaps the White Knight

might have been a good description of him. It seemed impossible that anyone could be hung over with so much. But there was no doubt who it was – it was my husband! Two minutes later I knew that all my fears that things might be different, that he would have changed, were baseless. This was Max! He might have left yesterday. He was back again. *We* were back again. A terrible smell of frying kippers came to our noses and we rushed into the flat.

'What on earth are you eating?' asked Max.

'Kippers,' I said. 'You had better have one.' Then we looked at each other. 'Max!' I said. 'You are two stone heavier.'

'Just about. And you haven't lost any weight yourself,' he added.
'It's because of all the potatoes,' I said. 'When you haven't meat and things like that, you eat too many potatoes and too much bread.'

So there we were. Four stone between us more than when we left. It seemed all wrong. It ought to have been the other way round.

'Living in the Fezzan desert *ought* to be very slimming,' I said. Max said that deserts were not at all slimming, because one had nothing else to do but sit and eat oily meats, and drink beer.

What a wonderful evening it was! We ate burnt kippers, and were happy.[5]

Max went back to the Air Ministry for a final six months, and the Admiralty derequisitioned their home 'Greenway' on Christmas Day.[6] 'There could not,' she recalled, 'have been a worse day for having to take over an abandoned house.'[7] They decided to remain at Lawn Road Flats and pay for the construction of a door linking Flats 16 and 17 to double their living space. In August they were still waiting for workmen to install their inter-connecting door, and decided to go to 'Greenway' until the two flats were ready. Rather like the painting of Lawn Road Flats in chocolate brown, however, the Mallowans' door became a contentious issue. On 14 August Pritchard wrote to Agatha Christie at 'Greenway' apologising for the delay:

Dear Mrs. Mallowan,
I am afraid your pessimistic view about proceedings in your Flat was correct.

The workmen are still there and it won't be possible for us to have it re-decorated by Monday next – even should V.J. Day not be celebrated this week.

I am sorry that the Flat won't be perfectly ready, but it definitely will be habitable when Professor Mallowan comes back.

As you suggested, we will decorate the Flat whenever you leave London for another week.

I hope you are having a good time.[8]

For the remainder of the year the Mallowans appear to have divided their time between Lawn Road Flats and 'Greenway'. On 15 October 1945 Pritchard wrote to Agatha Christie at 'Greenway' informing her of a telegram the manageress of the Flats had intercepted before it was posted through the letterbox of Flat 16. The telegram, he wrote, appears to have been steamed open more than once and has been wrongly addressed. He saw nothing wrong with reading the telegram himself:

Dear Mrs. Mallowan,

Emily happened to see the telegraph boy when he was just on the point of putting this telegram through the slot of your door. The envelope was open and seems to have gone through several kitchens before reaching its destination! I was rather interested to know whether it was the telegram which you were expecting last week so I read it and found, as you will see, that it is quite correctly addressed on the inside – whoever handled it at the Hampstead Post Office, however, has put the wrong address on the envelope. This seems to have been the reason for the delay and I think a good reason for complaining to the Hampstead Post Office.

Yours sincerely,

P.S. I hope that you will think this good detective work on my part!![9]

At the end of the year, a fortnight before the derequisitioning of 'Greenway', Agatha Christie sent Jack Pritchard a cheque for £16 2s 3d from 'Greenway' asking him to send their mail from 18 and 25 December to her daughter's address in Wales where they would be spending Christmas, and after that to 48 Swan Court as they were travelling abroad. She would be

back in Lawn Road Flats at the end of January on a longer tenancy, and would be furnishing their apartments with their own furniture:

Dear Mrs. Mallowan,

Thank you for your note received this morning, and for your cheque; receipt for which is enclosed. It will be nice to have you back at the end of this month, and we can of course make arrangements about taking our furniture out of your flat. We shall also be very pleased to make an arrangement with you for a longer tenancy.

I paid £1 2s. 7d for laundry received on December 4th and December 18th and I don't think I have made a mistake in charging it to you. If I have, would you kindly let me know?

Thank you for reminding me about the key. I will see that it is made before you come home.[10]

The Mallowans moved out of Lawn Road Flats on 1 June 1948. The previous October Agatha Christie informed Jack Pritchard she had found a bigger apartment and intended to leave the Flats. In the meantime, they were going abroad in January, and because it was unlikely that their new flat would be ready for them by the time they returned at the end of April, she would remain a Lawn Road Flats' tenant until June. If he agreed, she would sub-let the flat to friends – a Dr and Mrs Smith, Custodians of the British Museum – while they were away. She also 'agreed to pay for restoring the wall between Nos. 16 and 17 to its original state, and also for the redecoration of the two flats made necessary by this work.'[11]

With the departure of the Mallowans the wartime ethos of the Flats came to an end. Television, as opposed to radio broadcasting, began to dominate the post-war world and many of the residents, past and present, enjoyed a new-found celebrity. Philip Harben, who since 1942 had been compering a BBC wireless cooking programme, achieved nationwide fame between 1946 and 1951 presenting a BBC TV programme called *Cookery*. This was followed by *Cookery Lesson* with co-presenter Marguerite Patten and *What's Cooking* from 1956. In 1947 along with Raymond Postgate he briefly revived the Half Hundred Club (closed since 1940, the Isobar had remained open during the war) to help 'meet the challenge of shortages.'[12] In a letter to Philip Harben, Raymond Postgate set out the new terms of

membership taking into account post-war limitations on both food and wine: 'The revived club should have a similar object to the old, but modified to the extent that while previously the challenge was to produce fine meals within a low price range, it is now to produce them within the limits of certain shortages.... Because of the wine situation, the price would need to be varied to the extent say that £1 became the maximum per head.... Each member to put down £2 and always to be one dinner in credit. Any profits to be drunk at once. Food may be provided at home, at any restaurant, at the Isobar or in Mr. Harben's chain of *maisons tolerees*.'13

Harben was then credited with 'the first TV 'moment' when on live television he cracked an egg that was so bad he had to abandon the recipe while he and the studio crew broke into helpless laughter'. Harben had a brief career as a film star, appearing as himself in the 1953 movie *Meet Mr Lucifer* and in the 1955 Norman Wisdom film *Man of the Moment*. His celebrity status was further enhanced in *Separate Tables: Table Number Seven*, a play by Terence Rattigan, where two of the characters leave the table announcing they are off to watch 'dear Philip Harben'.

*

Philip Harben was not the only celebrity to emerge from the Flats; Gordon Childe, too, enjoyed his moment of fame. His appearances on 'Animal, Vegetable, Mineral' were, no doubt, 'a good means of bringing archaeology to the public' and he 'was delighted to be recognized in the street as a participant'.14 William Brown was also building a successful TV career appearing on *In The News* throughout the 1950s with A. J. P. Taylor, Robert Boothby MP and the journalist and politician Michael Foot. Graham Hutton, an economist, was in the chair and John Irwin the producer. 'Boothby', according to Taylor, 'was a left-wing Tory whose ideas, as learnt from Keynes, often carried him away from Toryism altogether. He would begin with an aggressively Tory statement and gradually retreat from it. Then Michael would say, 'He's coming round again. He agrees with us', and Bob would chime in, 'That's right.'15 The programme ran each Friday evening and 'achieved viewing figures as good as those of a variety show'.16

In The News undoubtedly brought its panel 'fame though of a limited kind.' There were only a few hundred thousand television sets throughout the country. 'Few middle-class people had them and certainly no intel-

lectuals. Most of the viewers came from the more prosperous, skilled working class – taxi drivers, artisans, waiters and such like. A landlord in the Midlands complained that his pub was empty on a Friday night because the miners had all gone home to watch *In The News*.[17] 'In this way,' A. J. P. Taylor continued in his autobiography, 'we acquired perhaps undeserved reputations as demagogues or People's Artists.' Taylor was hailed as the 'Plain Man's Historian', a description he 'did not disdain'.[18]

In 1951 Walter and Ise Gropius returned to the Flats to visit the Festival of Britain on the London South Bank. Gropius had lost none of his poise. In an interview with the *Observer* newspaper he compared the human mind with an umbrella – 'it functions best when open' – and praised the 'feeling of lightness and gaiety' that the festival had created. 'He was especially enthusiastic about the interior of the Festival Hall,' although about the outside he was more guarded. He did speak appreciatively of 'the wavy roof-line of the Thames-side restaurant' mimicking the 'rippling waters below'.[19]

The 1950s brought with them a new sort of tenant for Lawn Road Flats and a new source of irritation – wireless sets played at 'full strength'. In 1952 Percy Dickins of the *New Musical Express* began compiling a hit parade introducing record charts to a new generation of listeners (previously, a song's popularity was measured by the sales of sheet music). In November 1953 Frankie Laine's 'Answer Me' was number one despite the BBC banning the 'religious' version of this song – it had begun with the words 'Answer me, Lord above, Just what sin have I been guilty of?' – after receiving a number of complaints; Nat King Cole's more acceptable version 'Answer me, Oh my Love' became a hit sensation the following year. Before the BBC's ban, however, younger listeners reached for the volume knob. On Friday 23 November 1953, William Brown wrote to Lena Neumann, secretary of the Lawn Road Flats, complaining about the noise:

Dear Miss Neumann,

As you know, I am not given to grumbling and complaining, but we seem to have some new tenants in the flats whose wireless is really driving me to distraction. I do not know where they are but they seem to be somewhere below me and they keep their wireless on at what seems to be full strength.

I am under the unhappy necessity of having to earn my living and, as you know, I do it by writing. I cannot write with this appalling racket going on for most of the day.

My secretary, Miss Cormack, who comes to me to receive dictation from me, is similarly bothered by the racket of this particular wireless. If you can tell me who the tenants are, I will interview them myself but something must be done if we are to live in any sort of civilised fashion at all.[20]

He was not alone; the writer Charles Fenn wrote to William Brown four days later to tell him that his days, too, were being made 'intolerable by the radio beneath you'. He had also complained but to no avail. 'I've complained in vain to the occupant. I wrote to Fleetwood Pritchard but my letter has been ignored. What <u>are</u> we to do?'[21] Brown acted swiftly. That same day he wrote again to Lena Neumann enclosing Charles Fenn's letter and informing her that he, and Charles Fenn, had found a solution to their common problem:

Dear Miss Neumann,
I find that the annoying radio comes from Miss Jean Pritchard's flat.[22]

I got the enclosed this morning from Mr. Fenn and he and I went and had a word with Jean Pritchard which I hope will produce the desired effect.[23]

*

Charles Fenn was a retired American intelligence agent and the last of the Lawn Road Flats' gifted spies. In March 1945 in a café on Chin-Pi Street in Kunming, China, he had recruited one of the twentieth century's most famous revolutionaries, the Vietnamese leader Ho Chi Minh, into a US intelligence network controlled by the Office of Strategic Services (OSS), the forerunner of the CIA. During the Second World War, Fenn had been assigned to the Morale Operations branch of the OSS, and had worked on subverting the Japanese enemy through propaganda methods. Assigned to China-Burma-India (CBI), he found himself responding to four main theatres of war where competing nations pushed their own agendas and interpretations of the CBI conflict: the 'French and British striving to keep their Asian colonies; Americans opposing the Chinese Communists; and

Chinese nationalists fighting the growing Communist insurrection more fiercely than the Japanese invaders'; and the Vietnamese, under Ho, 'struggling for political freedom from the French'.[24]

The recruitment of Ho was undoubtedly a major achievement, and contributed to the successful American war effort in China-Burma-India. Fenn was awarded the US Soldier's Bronze Star Medal for Valor, and a citation from General William Donovan, the head of OSS, for his wartime service with OSS.[25] Fenn supplied Ho with radio equipment, a radio operator, arms and medical supplies in exchange for an agreement to fight their common enemy, Japan. In an interview given to *Parade* magazine in 1973 he told his interviewer, Lloyd Shearer, that he remembered 'asking Ho if his Viet-minh group was Communist', and was told by Ho that 'the French called all Vietnamese who wanted their independence, Communists. I told him something about our work,' Fenn continued, 'and asked if he would be interested in providing us with intelligence on Japanese movements. He said yes but that he had neither radios nor men who knew how to operate such sophisticated equipment. I told him that it could all be arranged and asked what he wanted in return. He said arms and medicines. We agreed to meet again.' In 1973, at the height of the Vietnam War, Fenn remained convinced that had President Truman and his Secretary of State, Dean Acheson, 'been more knowledgeable and farsighted, had they been more tolerant and open-minded with their one-time intelligence agent, Ho Chi Minh, and his nationalist-Communist background ... then the US might never have gotten so long and expensively bogged down in the tragic Vietnamese-quagmire'.[26]

In 1948 Fenn returned to London, where he had been born in 1907, and moved into Lawn Road Flats. While there he wrote plays for London's Little Theatre and several books on China including a biography of Ho Chi Minh and an account of his experiences with the OSS in CBI. He also worked for the BBC and helped produce the Emmy award-winning television documentary *Uncle Ho and Uncle Sam*. He 'later retired to Ireland where he lived in Schull, County Cork, managing a colourful bed and breakfast, the Standing Stone. For Fenn, it was a green and peaceful spot, far removed, both figuratively and geographically, from the war-torn Far East the author once knew'.[27]

<p style="text-align:center">*</p>

The 'nominated year of 1950' had 'passed without any public enquiry as to the obsolescence of the living places' known as the Lawn Road Flats. The Isokon building, like Charles Fenn among the Irish fishermen of Schull, County Cork, had settled down 'with decent dignity among the accepted inhabitants of Hampstead's lower slopes.'[28] To celebrate the occasion Jack Pritchard held a twenty-first birthday party at the Flats inviting residents past and present. Philip Harben prepared the food; Raymond Postgate selected the wine. Photographs taken at the party show a middle-aged Wells Coates and Jack Pritchard as well as a portly and obviously contented Philip Harben, a haunted Gordon Childe was also present. The RSVP from the industrial consultant Frederick Fyleman's secretary's secretary, is a priceless gem:

> Sir and Madam,
>
> Mr. Frederick Fyleman, the eminent Insultant, is extremely busy and has asked me to reply to your kind invitation for 14th July which he accepts, he says, with mingled feelings.
>
> He is somewhat surprised, however, that no mention has been made of free transport but takes it that his fee will cover this little matter. Rather to my surprise he prefers not to mention any stated sum as he is not as a rule backward in coming forward, so to speak, and says he prefers to leave it to your discretion.
>
> I have not made a copy of this letter so perhaps you will refrain from showing Mr. Fyleman this letter as it might do harm but not much, as all he pays me is 25/- a week including home comforts so what can the louse expect for that?
>
> On behalf of Mr. Fyleman, written by his secretary's secretary, Connie Winterbottom (Frosty)[29]

In many respects the Lawn Road Flats twenty-first birthday party was the 'last hurrah' for Jack Pritchard at the Flats, as they were sold in 1968 to the *New Statesman* and, given the Flat's past history, the intervening thirteen years were uneventful. The *New Statesman* paid £67,500 for a 90 per cent interest in the freehold of the Flats and the Isobar, which included the club's furniture and kitchen equipment, forming a subsidiary investment company, Lawn Road Flats Ltd, to manage the property. The minority owner was the building company Bovis – one of the directors of the *New*

Statesman, Neville Vincent, was also a Bovis director. The new company was formed on 31 December 1968 and a final glass of sherry was provided for tenants in the Pritchards' flat on 23 December where they were introduced to the new chairman of the company, Jeremy Potter. The sale was reported in a number of papers, including the *Hampstead and Highgate Express*, which mocked the 'New Statesman, protector of the pragmatic Left,' for 'unexpectedly entering "the lush and profitable pastures of the property market"'.

> 'There's nothing very startling about it,' Jack Morgan, secretary of the *New Statesman* and now secretary of the subsidiary company set up to run the flats, told a reporter from the *Express*, 'It's what you might call a run of the mill investment. We have others. We have simply decided to put some of our reserves into property.'[30]

The take-over, despite going ahead smoothly gave rise to 'a few murmurs from some tenants that their rents might go up'. The *New Statesman*, however, 'conscious that Hampstead provides probably the highest concentration of its readers in the country' ('I hope there are a good number among our tenants,' said Mr Morgan), proved itself to be 'an admirable landlord' and 'sensibly allayed any fears by sending out a letter saying that 'everything will continue as before'.[31] It was also agreed that Jack and Molly Pritchard would continue as tenants of Flat 32 for a period of up to five years paying the same fixed rent of £92.7.10 plus rates. Eight months later, however, the 'wonderful manageress' of the Flats, Renée Little, resigned her post and the management of the Flats and Isobar passed to George Knight & Partners, Estate Agents, on 1 August 1969. Both George Knight and his partner Kenneth Walker became members of the Isobar Club. Coincidental with this new arrangement, tenants were asked to make their own contracts direct with the Electricity Board.[32] The personal touch that the Flats had always provided ended abruptly with the departure of Renée Little, and the day to day running of the Flats was switched to the Estate Agents' office in Heath Street. Gone were the days when a tenant who had mislaid their key could be let in by the manageress. On 28 July Jack Pritchard received a standard letter sent to all tenants announcing the managerial take-over by George Knight and Partners:

... there may well be a number of unforeseen minor difficulties during the first weeks and we trust that you will bear with us until we have settled in. We have already met a number of residents socially at the Isobar and those of you whom we do not know we hope to meet during the first weeks of August.

In future, all matters concerning the Management of the flats will be dealt with from our office which is open from 9.30 a.m. to 6.30 p.m. Monday to Friday and from 9.30 a.m. to 1 p.m. on Saturday. Mr. Paul Eastwood will be responsible for attending to the day to day administration and from Monday to Friday will visit the flats each morning to attend to any problems which may have arisen.

...

Genuine emergencies such as fire or water penetration should be notified out of office hours to

	George Knight	Telephone 267–1371
or	Paul Eastwood	Telephone 435–8315
or	Kenneth Walker	Telephone 722–5360

We would mention that we do not regard loss of keys as an emergency. A list of locksmiths on 24 hour call is kept by the Police.[33]

And that was that. Very soon afterwards the Isobar was sadly closed down and converted into flats. The club 'had never been a profit making venture but with its disappearance the sense of community which had been such an important part of life in the Lawn Road Flats also vanished.'[34] In January 1972 estate agents George Knight and Partners negotiated on behalf of the *New Statesman* the sale of the Flats to Labour-controlled Camden Borough Council 'for what some might consider to be the bargain price of £157,500', 'considerably below the £200,000 figure' which it was thought that the Lawn Road Flats 'would fetch'.[35] 'After being the property of a left-wing political magazine for almost three years,' reported the *Hampstead & Highgate Express* on 4 February, 'they now belong to a left-wing council which, for the first time, will be able to offer its tenants furnished flats to live in.'[36] The sale was discussed at a noisy meeting of the Camden Borough Council on 10 February 1972 where it was agreed to go ahead with the purchase. The following points were made:

(1) The Council thanked the present owners for the way in which the negotiations had been conducted.

(2) That the Council was becoming, to an increasing extent, the only supplier of rented accommodation. Twenty-seven of the flats are furnished and the accommodation was well within the range of accommodation which the Council was entitled to purchase.

(3) That the Council would be able to offer furnished tenants a degree of security of tenure greater than the Government was prepared to provide by legislation.

(4) (from the Public gallery) That it was all very well for the Middle Classes.

 I cannot guarantee the accuracy of this report as proceedings were made virtually inaudible by continuous barracking from a member of the public who claimed to have been dispossessed by a Compulsory Purchase Order.[37]

It was a contentious sale. *Private Eye* accused the *New Statesman* of profiteering prompting the then board of the *New Statesman* to issue an injunction against *Private Eye* preventing them from repeating such allegations. Some of the Isokon furniture pieces that had adorned Lawn Road Flats and the Isobar, the work of Marcel Bureau, were donated to the Bethnal Green Museum while the Victoria and Albert Museum expressed an interest in obtaining the furniture in the Pritchards' flat – 'a historically important ensemble'.[38]

In 1973 Jack Pritchard moved to the house designed for him by his daughter Jennifer and her husband Colin Jones at 8 Angel Lane, Blythburgh, Suffolk. The following year the Ministry of Public Buildings and Works, the forerunner of English Heritage, designated Lawn Road Flats a Grade II building, defining it as a 'particularly important building of more than special interest'.[39] On 18 January 1975 Pritchard wrote to the town clerk and chief executive at The Town Hall, Euston Road, a Mr Wilson, complaining that he had not been consulted on the refurbishment of Lawn Road Flats then underway. 'There seems to be some misunderstanding,' he wrote, 'which I very much hope will be cleared up quickly. I believe that the aims for "Listed" buildings is to have them maintained, as nearly as possible, in their original condition. The Isokon Lawn Road Flats is a

"Listed" building. Re-painting has begun, and although I have repeatedly offered to give what guidance I can regarding maintenance in the widest sense of the word, we have never been consulted on any point although we are probably the only people still living that were closely concerned with its construction. So far the painting that has just started is not complete and consists of a hard white filler coat – certainly not the original colour. I ask that the final coat should not be put on until its colour has been agreed. The doors of course were never in the blue that they are at present. (They were painted by the previous owner, namely the *New Statesman*.)'[40]

Pritchard did not get his way. The following week he sent two rather angry letters to a Mr H.A. Hunt at the Housing Department upbraiding him for not adhering 'to the spirit of the Listed Buildings policy'[41] and for his downright pig-headedness: 'Anyway, I am told that you said that the original colour was pink – that is hardly true. It was off white, not unlike the attached.'[42] By 3 March Pritchard was exasperated: 'to describe the original colour as "pink" without any qualification was by no means correct.... Naturally I am glad the building now looks clean, but sad that simply because you did not consult in sufficient time, as I had so often suggested, we could now have had the building looking much as it was in 1934. I can't help wondering why you refuse to consult even your own Architect Department?'[43]

Blythburgh and the setting up of the Theta Club, a sailing club for children on the Norfolk Broads, now became the main preoccupation of both Jack and Molly Pritchard. The sailing club, 'following the rules of education they had learned from Bertrand Russell, arranged for the children to take the club over and operate it for themselves'.[44]

The Pritchards' marriage lasting 'more than 60 unconventional years' had given rise to 'much socialising and fairly Bohemian entertaining'.[45] Blythburgh, 'an exquisite small house' became an *entrepot* of interesting people, a place where one might meet 'artists, silversmiths, economists, sculptors, journalists, singers, brewers, dons, authors, a penniless refugee from southern Asia or the sister-in-law of an archbishop. Only two things were certain: good wine and good talk'.[46] The journalist, Fiona MacCarthy, wrote in the *Guardian* newspaper that 'Jack believed in the impulse principle of friendship. Three and a half minutes after he first met me, in a modern furniture store in Bromley, he had asked me to Suffolk for

the weekend. I was not the only one. On an average Saturday Jack would welcome warmly 20 or 30 people, mixing ages and sexes with a wonderful abandon, piling his guests all in together in the sauna. One evening I found myself lying alongside a stranger who turned out to be the naked Chairman of the Pru.'[47]

Molly's death in October 1985 was a blow to Jack from which he never really recovered; he died seven years' later. Jack had confided in Fiona MacCarthy that he 'disliked the thought of funerals' and 'that when he died his friends must assemble for a gigantic party, mirror image of the uninhibited assembly that had marked the death of Gropius'.[48] In her obituary for the *Guardian* published on 30 April 1992, three days after Jack's death, Fiona MacCarthy rounded off her article with the touching statement: 'What a party it will be.'[49]

On 5 May a letter from Charles Fenn appeared in the *Guardian* that caught the Jack Pritchard and Lawn Road Flats' experience perfectly, and deserves quoting in full:

> Fiona MacCarthy's obituary of Jack Pritchard (April 30) admirably reflects Jack's own effervescence, but perhaps I may add a personal note. The 12 years I lived in the Lawn Road Flats (1948–1960) were amongst the happiest of my life, largely because of the numinous haven offered. In 1935 Jack Pritchard, having found almost the last remaining acre of unspoiled wilderness in Belsize Park, inspirationally commissioned Wells Coates to design a block of flats. This building (Coates's first, he later admitted to his client) turned its back on the street and its face to the wilderness, so that the windows looked out upon what seemed open countryside.
>
> As in a well-constructed yacht, the flats offered *multum in parvo*, and at what seemed a very low rent. Breakfast, if required, was served to each flat. Cleaners (discreet friends to us all) serviced the flats daily: shoes were cleaned each morning by the porter, the attached club served meals and drinks at absurdly low prices. Close by were a tube station, a railway station, a bus depot, Hampstead Heath, and excellent second-hand bookshops and junk-shops.[50]

What more could Fenn have desired? In the 1980s the building fell into disrepair, and as a Grade 1 listed building it was placed on the English

Heritage 'at-risk' list.[51] In May 2001 Notting Hill Housing Group was chosen to purchase and restore the building and to make the flats available as affordable 'key worker' accommodation. The architect Wells Coates and his patrons Jack and Molly Pritchard would have warmly approved.

Epilogue

THE Isokon building, Lawn Road Flats, was an expression of British Modernism that found its hubris in 1960s brutish architecture, 'brave, bold and very British.'[1] Emerging from the architectural offices 'of the postwar British state between 1950 and the 1970s', brutalism has been described as 'an architecture of the welfare state'. Certainly, Jack Pritchard's early vision for the Flats as a model for working-class housing that wasn't Peabody, fitted this description, even if it did take the Conservative MP Thelma Cazalet to see its advantages for middle class professionals.

In recent years the British contribution to modernism has been neglected. In March 2013, however, the *Financial Times* reported on the scheme to refurbish Preston bus station – 'a supreme example of 1960s brutalist architecture' – in more appreciative terms:

> Built in 1969, it is marked by its grand size – the passenger area with 80 gates was designed to evoke an airport arrivals hall – ... five layers of sweeping, curved concrete.... Preston bus station, like so many brutalist buildings, is a monument to a bygone public realm, generous, sculptural, civic and genuinely public. Once they are gone, nothing like them will ever be built again.[2]

The article depicted Preston bus station as very much an organic concept, less raw concrete more dependent on the life-cycle of those travelling to and from Preston by bus. "'It's part of Preston," said Melissa, who declined to give her surname. "You won't find anyone who wants it knocked down. Most people have memories of here as well. I met my partner here when he asked for a light."'[3] The Lawn Road Flats, while less public, deserve similar attention. The atomic spy Melita Norwood, whose mother introduced the Kuczynskis to the Flats, gave her commitment to the welfare state as her motivation for spying for the Soviet Union in 1999 'I did what I did not to make money, but to help prevent the defeat of a new system which had, at great cost, given ordinary people food and fares which they could afford, given them education and a health service.'[4] This is not to

suggest that Britain's welfare state gave rise to Soviet espionage, and opponents of welfarism would be foolish to draw such a conclusion. However, the fact that Lawn Road Flats did occupy such a prominent place in the history of Soviet espionage in Britain does add another dimension to this broad notion of modernism as the architectural expression of the welfare state. Modernism was unquestionably the architecture of progressives; it had its economic and social origins in 1930s Political and Economic Planning and had a lineage going back to the Arts and Craft movement of William Morris at the end of the nineteenth century. A new architecture for its age, modernism provided an arena in which the ideological and cultural battles of the twentieth century could take place. The Lawn Road Flats building was unique in this instance because it hosted a 'brave, bold and very British' form of espionage; albeit one that would be perfected by Austrian and German communists.

In total there were no less than thirty-two agents or sub-agents connected to Soviet espionage associated with the Lawn Road Flats and Lawn Road. These included Brigitte Kuczynski, (Bridget Lewis) and her husband Anthony Gordon Lewis; Jurgen Kuczynski and his wife Margueritte; Barbara Kuczynski (Barbara Taylor), a schoolteacher who during the latter part of the war worked for the Ministry of Economic Warfare, and her husband Duncan Murnett Macrae Taylor, also known to be a member of the CPGB, and serving as an intelligence officer with the RAF;[5] Ursula Kuczynski (Sonya) who would, on occasion, visit her relatives in the Flats and surrounding streets; a Kuczynski uncle, Hermann Deutsch, who had been living in the Flats since their opening in 1934. Others linked in some way or other to the Flats and Soviet intelligence organisations included Trevor Blewitt, W.N. Ewer, Cyril Joad, Francis Meynell, Gertrude Sirnis and Melita Norwood, D. N. Pritt, Eva Collett Reckitt, Andrew Rothstein, and Beatrix and Edith Tudor-Hart. Past spies or others associated with Soviet intelligence who lived in the Flats included the controller of the 'Cambridge Five', Arnold Deutsch, and the architect, Maxwell Fry. In Lawn Road itself there were a number of spies and others linked to the Soviet secret services, among them Robert René Kuczynski and his wife Berta, the Hungarians Edith Bone and Teodor Maly, the Irish communist Bryan Goold-Verschoyle and his German lover Charlotte Moos. All this Soviet 'intelligence' activity took place in an atmosphere where German residents

were routinely investigated before being interned by the authorities. A fourth Kuczynski sister, Sabine, was married to Francis Loeffler, a prominent left-wing solicitor, a German communist who had become a British citizen, and a partner of Jack Gaster's firm of solicitors. Gaster had carried out the necessary paper work for Hilary Nussbaum to anglicize his name to Norwood shortly before his marriage to Melita Sirnis in 1934.

The artists and writers who lived in the Flats were also 'progressives' in the modernist sense: Walter Gropius, Marcel Breuer, Lázló Moholy-Nagy, Henry Moore, Adrian Stokes, Charles Brasch and Nicholas Monsarrat to mention but a few. Agatha Christie too made a contribution to the triumph of modernism; upsetting pre- and post-First World War literary conventions in her wartime novels written in the Lawn Road Flats. That her bridge partner was the Australian communist and pre-historian Gordon Childe would also suggest that there was more to Agatha Christie than retired vicars, cucumber sandwiches and the discovery of the body in the library. All these creative people associated with the Isokon building, however, were travelling players, if they can be so described, with walk on and off parts in the modernist drama that defined the Lawn Road Flats in the last century. Jack and Molly Pritchard, on the other hand, graced the stage to the very end.

Notes

Sources

Records held at the BBC Written Archive, Caversham, Berkshire

'BBC Internal Circulating Memo 5 December 1935' see also http://www.bbc.co.uk/archive/burgess/7701.shtml

Trevor Blewitt to AJPT, 13 February 1945, A. J. P. Taylor Radio File 1

AJPT to Trevor Blewitt, 14 February 1946, A. J. P. Taylor Radio File 1

Trevor Blewitt to Assistant Controller (Talks), 15 February 1946, A. J. P. Taylor Radio File 1

Memorandum by Trevor Blewitt 20 May 1946, A. J. P. Taylor Radio File 1

Listening Research. LR/67, Winter Listening Habits, 1938, BBC WAC R9/9/2

Listening Research. LR/71, Summer Listening Habits, 1939, BBC WAC R9/9/2

Records held at the Churchill Archives Centre, Churchill College, University of Cambridge

Belgion, Montgomery, *From Left to Right* (Unpublished autobiography n.d., The Papers of (Harold) Montgomery Belgion, GBR/0014/BLGN

Records held at McMaster University, Hamilton, Ontario, Canada

McMaster University Digital Archives Collection www.digitalcollections.mcmaster.ca. Bertrand Russell papers. Radio debate between the philosopher Bertrand Russell and Marxist scientist J. B. S. Haldane, 'Should the scientist be the servant of the State?'

Records held at the National Archives of England and Wales, Kew, London

CAB *Cabinet Reports*

CAB24/97 Revolutionaries and the Need for Legislation, 2 February 1920

CAB24/111 A Monthly Review of Revolutionary Movements in British Dominions, Overseas and Foreign Countries

FO *Foreign Office*

FO371/3347 Russia 1918.

FO371/24856

FO371/29521

KV2 *The Security Service: Personal (PF Series) Files*

KV2/573 Leonid Krassin

KV2/777 Peter Leonidovitch Kapitza

KV2/817 Bryan Goold-Verschoyle

KV2/1008–1009 Teodor Maly

KV2/1012–1014 Edith Tudor-Hart

KV2/1020–1023 Percy Eden Glading

KV2/1369–1375 Eva Collett Reckitt

KV2/1575–1584 Andrew and Theodore Rothstein

KV2/1611–1616 Alexander Foote

KV2/1871–1880 Jurgen and Margueritte Kuczynski

KV6 *The Security Service List (L Series) Files*

KV6/41–45 Ursula Kuczynski; Ruth Werner (Sonya)

Records held at The Archives Department, The University Library, University of East Anglia, Norwich

Gillies, Bridget, St John, Michael, and Sharp, Deirdre, *The Pritchard Papers: A Guide*, Archives Department, The University Library, University of East Anglia, Norwich © 1998

PP/1 – PP43 The Pritchard Papers compiled by Bridget Gillies, Michael St John and Deirdre Sharp

Records held at Wiener Library, London

Sigilla Veri, General Introduction. Testaments to the Holocaust: Series One. Archives of the Wiener Library, London

Records held at the *Institut für Zeitgeschichte*, University of Vienna

Edith Suschitzky. Police File MF A/270, ff 1355–1508

PROLOGUE

1 The original building was made up of 32 flats. Following the sale of the building to the *New Statesman* in 1968, the Isobar was converted into two extra flats.

2 Pritchard, Jack, *View From A Long Chair* (London: Routledge & Kegan Paul, 1984), p. 80.

3 The five Cambridge graduates Anthony Blunt, Guy Burgess, John Cairncross, Donald Maclean and Kim Philby who worked for Soviet intelligence from 1934 to 1963.

4 Andrew, Christopher and Mitrokhin, Vasili, *The Mitrokhin Archive* (London: Allen Lane, The Penguin Press, 1999), pp. 74–5.

CHAPTER 1
Hampstead Man Among 'The Modernists'

1 Monsarrat, Nicholas, *Life is a Four-Letter Word. Book One: Breaking In* (London: MacMillan, 1969), pp. 363–5.

2 Monsarrat, *Life*, pp. 363–5.

3 Monsarrat, *Life*, pp. 363–5.

4 Monsarrat, *Life*, pp. 284–7.

5 Monsarrat, *Life*, pp. 284–7.

6 Monsarrat, *Life*, p. 365.

7 Monsarrat, *Life*, p. 367.

8 Monsarrat, *Life*, p. 391.

9 Monsarrat, *Life*, p. 392.

10 Monsarrat, *Life*, p. 392.

11 'The Pritchard Papers: A Guide', compiled by Bridget Gillies, Michael St John and Deirdre Sharp, Archives Department, The University Library, University of East Anglia, Norwich, 1998, PP/16/2/14/3, hereafter PP.

12 PP/16/4/22/6.

13 www.open.edu –The Arts – Le Corbusier.

14 www.open.edu – The Arts – Le Corbusier.

15 Cohn, Laura, *The Door to a Secret Room. A Portrait of Wells Coates* (London: Lund Humphries, 1999), p. 135.

16 Cohn, *Secret Room*, p. 128.

17 Cohn, *Secret Room*, p. 129.

18 Cohn, *Secret Room*, p. 128.

19 www.open.edu – The Arts – CIAM (Congrès Internationaux d'Architecture Moderne (22/12/2009) p. 1.

20 Mackley, Alan, 'Isokon and Blythburgh', Blythburgh January 1995.

21 Pritchard, *View*, p. 27.

22 Pritchard, *View*, p. 27.

23 Pritchard, *View*, p. 27.

24 Pritchard, *View*, p. 27.

25 Pritchard, *View*, p. 29.

26 Pritchard, *View*, p. 29.

27 Pritchard, *View*, p. 29.

28 Pritchard, *View*, p. 29.

29 Pritchard, *View*, p. 29.

30 Pritchard, *View*, p. 29.

31 Pritchard, *View*, p. 29.

32 Pritchard, *View*, p. 38.

33 Pritchard, *View*, p. 38.

34 Pritchard, *View*, pp. 38–9.

35 Pritchard, *View*, p. 42.

36 Pritchard, *View*, pp. 29–30.

37 Wells Coates letter to Marion Grove, 30 March 1926, quoted in Contacuzino, Sherban, *Wells Coates: A Monograph* (London: Gordon Fraser, 1978); MacCarthy, Fiona, 'Introduction. Jack Pritchard and the Hampstead of the Thirties', Pritchard, *View*, p. 12.

38 http://designmuseum.org/design/wells-coates p. 1.

39 http://designmuseum.org/design/wells-coates p. 1.

40 cited http://www.embassycourt.org.uk.

41 'The double tragedy of architect Wells Coates' PP/23/4/4.

42 MacCarthy, Fiona, 'Introduction' Pritchard, *View*, p. 12.

43 http://www.embassycourt.org.uk.

44 *Congrés Internationaux d'Architecture Moderne.*

45 Cambridge University undergraduate examinations.

46 Howarth, T. E. B., *Cambridge Between Two Wars* (London: Collins, 1978), p. 119.

47 Howarth, *Cambridge*, pp. 119–20.

48 Howarth, *Cambridge*, p. 166; *Wikipedia, Raymond McGrath.*

49 PP/34/1/131.

50 PP/34/1/131.

51 Ozanne, Andrew, 'Frontiersman of the Heroic Age', *RIBAJ* September 1979, p. 410; PP/23.4/38.

52 Ozanne, 'Fontiersman'; PP/23/2/14.

53 `Memoranda Re Proposed Company' PP/23/2/14.

54 PP/23/2/14.

55 PP/23/2/14.

56 Blake, Peter, *Mies van der Rohe. Architecture and Structure* (Middlesex: Harmondsworth, Penguin Press, 1963), p. 15.

57 Blake, *Mies,* p. 29.

58 Blake, *Mies,* p. 43.

59 Blake, *Mies,* p. 45.

60 Blake, *Mies,* p. 38.

61 Pritchard, *View*, pp. 57–8.

62 Moore, James, *Gurdjieff and Mansfield*, (London: Routledge & Kegan Paul, 1980), p. 3.

63 Moore, *Gurdjieff*, p. 69.

64 'There is evidence to show that commissariats of free love have been established in several towns, and respectable women flogged for refusing to yield. Decree for nationalisation of women has been put in force, and several experiments made to nationalise children.' General Poole to the War Office, received 12 January 1919, published in the *Auckland Star,* 20 January 1919.

65 Beatrix Tudor-Hart PF41583; Norman Haire PF49764; see also V.A. Hyett, a school teacher of the Miss Jean Brodie type, V.A. Hyett PF41138. Their files, if they still exist, have not been released.

66 Guyon, René, *Sexual Freedom* (London: John Lane, 1939).

67 Guyon, René *Sexual Freedom*, Introduction by Norman Haire (London: John Lane, 1939).

68 Page, Bruce, Leitch, David, & Knightley, Phillip, *Philby. The Spy Who Betrayed A Generation* (London: Andre Deutsch, 1968), p.59; Gedye, G. E. R., *Fallen Bastions* (London: Gollancz, 1939).

69 Forbes, Duncan, 'Politics, photography and exile in the life of Edith Tudor-Hart (1908–1973)' unpublished paper n.d.

70 *Ibid.*

71 Hopkinson, Amanda, 'Hart, Edith Tudor (1908–1973)', *Oxford Dictionary of National Biography* (Oxford University Press, 2004).

72 Surviving records of her Bauhaus years show that she registered on the famous foundation course in late 1928 and was, unusually, still registered on it in 1930. She is not, however, recorded as a student in Walter Peterhans' photographic department (established in 1929), and there is no known surviving imagery from her stay in Dessau. She appears to have interrupted her studies in 1929 and was registered as a 'guest student' at some point later that year, possibly with Peterhans. Her brother, Wolfgang, states that she studied with Peterhans in his short biography *Edith Tudor Hart: The Eye of Conscience* (Essex: Dirk Nishen Publishing, 1987).

73 Forbes, 'Politics', p. 12; Suschitzky, Edith, 'A university of commercial art', *Commercial Art* (March 1931).

74 Burke, David, *The Spy Who Came In from The Co-op* (Woodbridge, Suffolk: Boydell, 2008), pp. 84–104.

75 TNA KV2/1012.

76 TNA KV2/1012/8a. Trevor Eaton Blewitt to Edith Tudor-Hart, postmark Warsaw dated 14.12.30.

77 Is this Harry Pollitt, General Secretary of the CPGB?

78 Is this also Harry?

79 TNA KV2/1012/5b. Copy of intercepted postcard from Maurice Dobb to A. E. Tudor-Hart.

80 Forbes, 'Politics', p. 12 and fn 47, p. 28; See also McLoughlin, Barry, Schafranek, H., and Szevera, W., *Aufbruch – Hoffnung – Endstation: Österreicherinnen und Österriecher in der Sowjetunion 1925–1945* (Wien: Verlag fur Gesellschaftskritik, 1997).

CHAPTER 2
National Planning for the Future

1 'Use of the word planning in the early 1930s', 2 December 1980, PEP Archive, LSE.

2 Grieve, Alastair, 'Introduction' *The Pritchard Papers: A Guide* (University of East Anglia, 1998).

3 Israel Sieff, President of PEP, chairman of Marks and Spencer 1964–67.

4 Pritchard, *View*, p. 64.

5 'Other odd supporters (in both senses)' of Beaverbrook's crusade were the writer Sir Arthur Conan Doyle; the author, poet and translator Lord Alfred Douglas (Bosie), better known as the intimate friend and lover of Irish satirist Oscar Wilde; the novelist Charles John Cutcliffe Hyne; the Irish athlete, poet, politician and well-known conversationalist, Oliver St John Gogarty, believed to be the inspiration behind Buck Mulligan in James Joyce's novel *Ulysses*; and Lady Houston – 'an uncompromising team'. (Taylor, A. J. P., *Beaverbrook* (London: Allen Lane, Penguin Press, 1974), p. 360.

6 Pinder John (ed.), *Fifty Years of Political and Economic Planning: Looking Forward, 1931–1981* (London: Heinemann, 1981), p. 6.

7 Nicholson, Max, 'A National Plan for Great Britain'. *Week-End Review*, 14 February 1931.

8 'A National Plan For Great Britain'. Supplement to the *Week-End Review*, 14 February 1931. PP/4/2/1.

9 PP/4/2/1.

10 'A National Plan For Great Britain'. Supplemen*t to the Week-End Review*, 14 February 1931.

11 'The Russian papers (presented), by high Soviet officials, are very disappointing. They show little distinction between fact and prophecy or hope, and little sense of critical standards of analysis. The impression is rather one of amazing naïveté than of any ulterior purpose'. *World Social Economic Planning*. (New York and The Hague: International Industrial Relations Institute, 1932 review by Frank H.

Knight, University of Chicago, *The American Economic Review* Vol. 23, No. 2 (June 1933), pp. 357–9. Published by the American Economic Association.)

12 'A National Plan for Great Britain.'

13 'A National Plan for Great Britain.'

14 Correspondence, Maurice Dobb to Jack Pritchard, 31 October 1931. PP/4/1/7.

15 Noel Hall quoted in Pinder (ed.), *Fifty Years*, p. 15.

16 Lindsay, Kenneth, 'PEP through the 1930s' in John Pinder (ed.), *Fifty Years,* p. 24.

17 Pritchard, *View*, p. 12.

18 Howarth, *Cambridge*, p. 137.

19 Max Nicholson, founder of the British Trust for Ornithology and of *Shopping Reports,* the first attempt to apply US *Consumer Reports* to Britain; the economists A. E. Blake and N. E. Smith; and Gerald Barry, editor of the *News Chronicle.*

20 Coates, Wells, 'Response To Tradition', *Architectural Review,* Nov. 1932.

21 PP/15/2/13/4/139.

22 F. S. Thomas to Jack Pritchard, 14 November 1931, PP/15/1/29/2.

23 Jack Pritchard to F. S. Thomas, 17 November 1931, PP/15/1/29/3.

24 Pritchard, *View*, p. 81.

25 PP/15/2/13/4/139, *New Statesman* negotiations.

26 PP/15/2/13/4/139.

27 PP/15/2/13/4/139.

28 PP/69.

29 Cohn, *Secret Room*, p. 127.

30 Pritchard, *View*, p. 83.

31 PP/2/13/4, Negotiations 1968–1969.

32 PP16/1/3/38; Cohn, *Secret Room*, p. 153.

33 Cohn, *Secret Room*, p. 157.

34 Cohn, *Secret Room*, p. 157.

35 Pritchard to Coates, 4 June 1934 PP/16/1/3/38; Cohn, *Secret Room*, p. 157.

36 Cohn, *Secret Room*, p. 157.

37 Peabody Trust (Peabody) – social housing provider founded in 1862 by the London-based American banker George Peabody.

38 PP/16/1/419, Jack Pritchard to Herbert Morrison, 4 April 1934.

39 PP/16/1/419.

40 PP16/2/23/1.

41 PP/16/2/23/1.

42 PP/16/2/23/1.

43 'Isokon Flats' Reprinted from the *Architectural Review,* 7 July 1955 PP/16/2/28/5/13.

44 Cohn, *Secret Door*, p. 157.

45 Cohn, *Secret Door*, p. 160.

46 Cohn, *Secret Door*, p. 160.

47 *From Left To Right* unpublished autobiography n.d. The Papers of (Harold) Montgomery Belgion. GBR/0014/BLGN, Churchill Archives Centre, Churchill College, University of Cambridge.

48 Wollheim, Richard, 'Stokes, Adrian Durham (1902–1972), writer and painter', *Oxford Dictionary of National Biography* http://www.oxforddnb.com.

49 Wollheim, 'Stokes'.

50 Wollheim, 'Stokes'.

51 Gropius to his mother, Namur, undated, believed to be August–September 1917, cited in Isaacs, Reginald, *Gropius* (London: Little, Brown and Company, 1991), p. 52.

52 Isaacs, *Gropius*, p. 56.

53 Isaacs, *Gropius*, p. 110.

54 Isaacs, *Gropius*, p. 112.

55 Gropius to Lily Hildebrandt, Weimar, undated, believed to be spring 1924 cited Isaacs, *Gropius*, pp. 112–13. Beyer had been an accountant at the Bauhaus; Zachmann was a master craftsman in the cabinet-making workshop from 1921 to 1922; and Schlemmer was a master craftsman in the wall-painting workshop.

56 'Obituary. Dr Walter Gropius. Influential modern architectural philosopher', *The Times*, 7 July 1969; PP/24/11/17.

57 'Obituary', *The Times*, 7 July 1969.

58 Ise Gropius to Jack Pritchard, 11/26/73 (sic) PP24/14/127.

59 'Obituary', *The Times*, 7 July 1969.

60 PP/24/1/2.

61 PP/24/1/2.

62 Walter Gropius to the President of the Reich Committee for the Fine Arts, Professor Honig, 18 January 1934, PP/24/1/2.

63 PP/24/1/2.

64 PP/24/1/2.

65 Walter Rathenau was a successful Jewish businessman, the founder of the firm Allgemeine-Elektrizitats-Gesellschaft (AEG), and Weimar German Foreign Minister before his assassination by two-right wing army officers on 24 June 1922 for his part in negotiating the Treaty of Rappallo, signed between Germany and the Soviet Union on 16 April 1922. Under the Treaty the two nations had agreed to cancel all financial claims against each other and to strengthen economic and military ties. It was somewhat ironic that Rathenau should have been killed for allegedly furthering Jewish interests when the Treaty enabled the German army, through secret agreements, to produce and perfect in the USSR a range of weapons then forbidden under the Treaty of Versailles. While the Treaty of Rapallo remained in place for ten years the resentment it caused in German right-wing circles meant that by associating Walter Gropius's name with that of Walter Rathenau's, Gropius's life was effectively put in danger.

66 PP/24/1/2.

67 PP/24/1/2.

68 *Sigilla Veri.* General Introduction. Testaments to the Holocaust: Series One. Archives of the Wiener Library, London.

69 Walter Gropius to Professor Honig, 27 March 1934, PP/24/1/5.

70 It was Shand, the grandfather of Camilla Parker Bowles, who began the process by which Gropius came to Britain. Shand's articles on Modern Architecture appeared in the *Architectural Review* from the late 1920s and he was a frequent contributor to a trade magazine *The Concrete Way*. He had also written a number of books on French wines and an interesting work on theatre and cinema-going in Britain with the albeit uninspiring title, *Modern Theatres and Cinemas*.

71 *Journal of the Royal Institute of British Architects*, 19 May 1934, pp. 679–94.

72 Elliott, David, 'Gropius in England: a documentation 1934–1937' (London: The Building Centre Trust, 1974), PP/24/15/87.

73 'The Volta Conference was the name given to each of the international conferences held in Italy by the Royal Academy of Science in Rome and funded by the Alessandro Volta Foundation. In the inter-war period, they covered a number of topics in science and humanities, alternating between the two.' Volta Conference, Wikipedia.

74 JPB 'Gropius. Unity in Diversity. A Building Centre Trust Exhibition, Whitworth Art Gallery, 25 May–22 June 1974'. PP/24/15/19.

75 Pritchard, *View*, p. 103.

CHAPTER 3
The Art of Espionage

1 See Barron, Stephanie, ed. *'Degenerate Art': The Fate of the Avant-Garde in Nazi Germany* (New York: Harry N. Abrams, Inc., 1991).

2 Gatje, Robert F. and Pei, I. M., *Marcel Breuer. A Memoir* (New York: The Monacelli Press, 2000), p. 14.

3 Gatje, *Breuer*, p. 14.

4 See Hochman, Elaine S., *Bauhaus: Crucible of Modernism* (New York: Fromm International Publishing Corp US, 1997).

5 PP/18/4/6.

6 Moholy-Nagy, Sibyl, *Moholy-Nagy: Experiment in Totality* (New York: Harper & Brothers, 1950), p. 8.

7 Kaplan, Louis, *László Moholy-Nagy.* (Durham and London: Duke University Press, 1995), p. 2.

8 Moholy-Nagy, Sibyl, *Experiment*, p. 1.

9 Moholy-Nagy, Sibyl, *Experiment*, p. 1.

10 Moholy-Nagy, Sibyl, *Experiment*, p. 1.

11 Hight, Eleanor M., *Picturing Modernism: Moholy-Nagy and Photography in Weimar Germany* (Cambridge, Massachusetts, MIT Press, 1995). 'Reminiscences of Jeno Nagy', an interview by Krisztina Passuth dated October 1975, in Passuth, Krisztina, *Moholy-Nagy* (London: Thames & Hudson, 1987), pp. 385–6.

12 21 March 1920 quoted in Moholy-Nagy, Sibyl, *Experiment*, pp. 14–15.

13 See Szabo, Julia, 'Ideas and Programmes: The Philosophical Background of the Hungarian Avant-Garde', in Passuth, Krisztina, Szabo, John and Julia, et al. *The*

Hungarian Avant-Garde: The Eight and the Activists, (London: Hayward Gallery and Arts Council of Great Britain, 1980), pp. 9–18.

14 Passuth, et al., *Avant-Garde*; Caton, Joseph Harris, *The Utopian Vision of Moholy-Nagy* (Essex: Bowker Publishing Company, 1984), p. 4.

15 Moholy-Nagy, Sibyl, *Experiment*, p. 17.

16 Moholy-Nagy, László, *The New Vision and Abstract of an Artist* (New York: Wittenborn, 1946), p. 70.

17 Moholy-Nagy, Sybil, *Experiment*, p. 15.

18 Moholy-Nagy, Sybil, *Experiment*, p. 13.

19 Moholy-Nagy, Sybil, *Experiment*, p. 19.

20 Moholy-Nagy, László, *New Vision*, p. 70.

21 Hight, Eleanor M., *Picturing Modernism. Moholy-Nagy and photography in Weimar Germany* (Cambridge, Massachusetts: MIT Press, 1995), pp. 21–34.

22 Hight, *Picturing*, p. 34. On the KURI group see Masbach, Steven A., 'Constructivism and Accommodation in the Hungarian avant-garde', *Art Journal* 49 (Spring 1990).

23 Hight, *Picturing*, p. 34.

24 Hight, *Picturing*, p. 36.

25 Caton, *Utopian*, p. 10.

26 Moholy-Nagy, Sybil, *Experiment*, p. 35.

27 He remained at the Bauhaus in Weimar until 1925 and after its move to Dessau that year until 1928, when Gropius resigned.

28 Moholy-Nagy, Sybil, *Experiment*, pp. 45–6.

29 Moholy-Nagy, Sybil, *Experiment*, pp. 45–6.

30 Moholy-Nagy, Sybil, *Experiment*, pp. 46–7.

31 Moholy-Nagy, Sybil, *Experiment*, p. 47.

32 Moholy-Nagy, Sybil, *Experiment*, p. 47.

33 Moholy, Nagy, Sybil, *Experiment*, p. 104.

34 Moholy-Nagy, Sybil, *Experiment*, p. 118.

35 The object of trubenising is to give permanent stiffness to a fabric, especially collars and shirt cuffs.

36 Moholy-Nagy, Sybil, *Experiment*, p. 119.

37 Moholy-Nagy, Sybil, *Experiment*, p. 120.

38 Moholy-Nagy, Sybil, *Experiment*, p. 120.

39 Moholy-Nagy, Sybil, *Experiment*, p. 120.

40 Moholy-Nagy, Sybil, *Experiment*, p. 120.

41 Moholy-Nagy, Sybil, *Experiment*, p. 125.

42 Moholy-Nagy, Sybil, *Experiment*, p. 126.

43 In Hungary, Korda was instrumental in setting up the first nationalised film industry in the world.

44 http://www.cobbles.com/simpp_archive/alexander-korda_biography.htm

45 The film can be viewed with a soundtrack on YouTube.com and without sound on dailymotion.com.

46 Moholy-Nagy, Sybil, *Experiment*, p. 129.

47 *Britannica Concise Encyclopaedia:* Erich Moritz von Hornbostel; hereafter BCE EvH.

48 The Smithsonian Institute in Washington D.C. was also carrying out this work. See Fewkes, J.W., 'On the Use of the Phonograph in the Study of the Language of American Indians', *Science* 15 (1890): 267–69, and Martland, Peter, *Recording History: The British Record Industry 1888–1931* (Maryland: Scarecrow Press, 2013).

49 Myers, Helen (ed.) *Ethnomusicology: An Introduction* (London: Norton, 1992) p. 117.

50 History of the Archives of Traditional Music, Indiana University Bloomington, http://www.indiana.edu/~libarchm/.

51 H. T. Burt, V. J. Reed, Miss E.E. Irvine, Francoise Howard.

52 *Blossom the Brave Balloon,* Herbert , E. F., illustrated by Philip Zec (London: F. Muller, 1941).

53 Gertrude Stedman first married Carl Alfred Brandt in 1905. They moved to Spain where Carl died in 1906.

54 'So whose were these initials? [Wolfgang Amadeus] Mozart! Father passionately loved classical German music'. Rothstein, Andrew, *Iz Vospominanii ob Otse (Recollections of Father)* in Al'tman, V.V., *Imperializm i borba rabochevo klassa: Pamyati Akademika F. A. Rotshteina* (Moscow, 1960), p. 51.

55 TNA Kew KV2/1575 Theodore Rothstein.

56 TNA Kew KV2/1575 Theodore Rothstein.

57 Woolf, Leonard, *Downhill All The Way: An Autobiography of the Years 1919–1939* (London: Harcourt Brace, Jovanovich, 1960), p. 27.

58 TNA Kew FO371/3347/179551, 29 October 1918.

59 The Second International (1889–1916) was the original Socialist International of workers' organizations that included both revolutionary and reformist political parties; its overall strategy was revisionist.

60 Meynell, Francis, *My Lives* (London: Bodley Head, 1971), p. 125.

61 'Safe through taking care', *Chambers Twentieth Century Dictionary.*

62 Meynell, *Lives*, p. 128.

63 TNA Kew KV2/573/64.

64 Meynell, *Lives*, p. 125.

65 'When in London he resides at his mother's house at 53 Whitehall Park, Highgate, but he also occupies a converted Pullman car at Tophill, Windermere. His son, a Brackenbury scholar at Balliol College, Oxford, assists him'. TNA Kew Cab 24/97/544.

66 TNA Kew Cab 24/97, p. 5.

67 TNA Kew Cab 24/97.

68 TNA Kew Cab 24/111.

69 TNA Kew Cab 24/111.

70 Lenin, V.I., *Collected Works* 4th edition Vol. 44 p. 403. An alternative version of these events is given by Andrew Rothstein who, in a letter to myself dated 13 August 1981, stated that his father returned to Moscow simply as a result of his own request. He asked to accompany Milyutin of the Russian Trading Delegation

who was returning 'to report on progress in the peace talks with Lloyd George
... TR specifically asked to be allowed to go, not having been back for 29 years.
In fact there is a letter from Lenin which missed him, pressing him not to go,
because the British Government might play some dirty trick on him!' Lenin's
letter to Theodore Rothstein dated 15 July 1920 reads: '... I am not against your
coming "to take a look" at Russia, but I am afraid that to quit Britain is harmful
for the work'.

71 PP/16/2/28/1 In a list of past tenants, Rothstein's name is written out twice.
 The following pencilled note appears in the margin: 'Who else moved out – eg
 Rothstein (TASS No. 16 & 8) during war. ? School of Oriental Languages.'

72 TNA Kew KV2/1576 Defence Security Intelligence Report (DSIR) Subject Andrew
 Rothstein, 23 May 1922; TNA Kew KV2/1576 M.I.5/B, 23 November 1920.

73 TNA Kew KV2/1576 Defence Security Intelligence Report (DSIR) Subject Andrew
 Rothstein, 23 May 1922; TNA Kew KV2/1576 M.I.5/B, 23 November 1920.

74 Despite the Communist Party's low membership figures – at the end of 1926 they
 had no more than 7,900 members – there were approximately 1,500 communists
 known to be active in the Labour Party itself. Until 1926 there had been nothing
 to stop individuals from becoming members of both the Labour Party and
 the CPGB, while trade unions could elect communists as delegates to Labour
 organizations and meetings. At the end of 1926 as many as 1,544 communists still
 belonged to the Labour Party as individuals, and another 242 were trade union
 delegates to Labour organizations. That year the leaders of the Labour Party,
 in accordance with a decision first adopted at the 1924 Labour Party Annual
 Conference, began to purge the communists from its ranks.

75 TNA Kew KV2/777/79A; 80A; 82.

76 TNA Kew KV2/1872; TNA Kew KV2/1871/74A.

CHAPTER 4
Arnold Deutsch, Kim Philby and Austro-Marxism

1 Andrew, Christopher and Mitrokhin, Vasili, *The Mitrokhin Archive: The KGB in
 Europe and the West* (London: Allen Lane, The Penguin Press, 1999), p. 75.

2 Reich, Ilse Ollendorff, *Wilhelm Reich, A Personal Biography* (London: St Martin's
 Press, 1969), p. 1.

3 Reich, *Biography*, p. 5.

4 Reich, *Biography*, pp. 6–7.

5 Reich, *Biography*, p. 10.

6 Reich, *Biography*, p. 15.

7 See Gruber, Helmut, *Red Vienna: Experiment in Working-Class Culture, 1919–34*
 (Oxford: Oxford University Press, 1991), p. 5.

8 See Rycroft, Charles, *Reich* (London: Fontana/Collins, 1971), p. 12.

9 Rycroft, *Reich*, p. 12.

10 Loew, Raimund 'The Politics of Austro-Marxism', *New Left Review* 118 (Nov.–
 Dec., 1979), p. 113.

11 Gedye, G. E. R., *Fallen Bastions* (London: Victor Gollancz, 1939), p. 131.

12 Gedye, *Fallen*, p. 112.

13 Gedye, *Fallen*, p. 112.

14 Loew, 'Austro-Marxism', pp. 39–40.

15 Loew, 'Austro-Marxism', pp. 40–41.

16 Gedye, *Fallen*, p. 85.

17 Gedye, *Fallen*, p. 89.

18 Gedye, *Fallen*, p. 89.

19 Page, Bruce, Leitch, David and Knightley, Phillip, *Philby: The Spy Who Betrayed a Generation* (London: Andre Deutsch, 1968), p. 62.

20 Gedye, *Fallen*, p. 114.

21 Gedye, *Fallen*, p. 114.

22 Gedye, *Fallen*, p. 114.

23 Cited Page, et al. *Philby*, p. 64.

24 Andrew and Mitrokhin, *Archive*, p. 76.

25 TNA Kew KV2/1604/181 Edith Tudor-Hart.

26 TNA Kew KV2/1604/181.

27 TNA Kew KV2/1604/181; see also TNA Kew KV2/1012/14a dated 8.7. 31 marked Secret 'the offices of the "TASS" Agency in that city are situated at No. 24, Bauernmarkt, Vienna I, Room 34, and are under the management of Herr EBEL. This man, is frequently seen in the company of a woman employed at "TASS", whose name is SUSCHITZKI.'

28 TNA Kew KV2/1604/181.

29 Personal File. See TNA Kew KV2/1012/45.

30 TNA Kew KV2/1012/45.

31 Forbes, Duncan 'Politics, Photography and Exile in the life of Edith Tudor-Hart (1908–1973)' unpublished paper p.2; see also Shulamith Behr, Marian Malet, eds *Arts in Exile in Britain, 1933–1945: Politics and Cultural Identity.* (Amsterdam: Rodopi, 2005); Edith Suschitzky's police reports, a microfilm copy of which is held by the Institut für Zeitgeschichte, the University of Vienna, MF A/270, ff. 1355–1508.

32 Forbes, 'Photography', p. 3.

33 Andrew and Mitrokhin, *Archive*, p. 76.

34 See *The Listener* 29 Nov., 13 Dec. 1933, 10 Jan., 16 May, 13 June 1934 and 2 January 1935.

35 BBC Archive, 'BBC Internal Circulating Memo 5 December 1935.' http://www.bbc.co.uk/archive/burgess/7701.shtml.

36 Pincher, Chapman, *Treachery. Betrayals, Blunders, and Cover-ups: Six Decades of Espionage Against America and Great Britain.* (New York: Random House, 2009), p. 15.

37 TNA Kew KV2/817.

38 TNA Kew KV2/817.

39 TNA Kew KV2/817.

40 TNA Kew KV2/817.

41 Robert and Berta Kuczynski and their daughters Barbara and Renate; their daughter Brigitte lived opposite in the Isokon building along with Arnold Deutsch.

42 TNA Kew KV2/817.

43 TNA Kew KV2/817.

44 An account of his kidnapping and transportation to Russia appeared in Walter Krivitsky's book *I Was Stalin's Agent*. (London: Hamish Hamilton, 1939).

45 Borovik, Genrikh, *The Philby Files: The Secret Life of the Master Spy – KGB Archives Revealed*, (London: Little Brown and Co., 1994), p. 57.

46 Quoted in Borovik, *Philby Files*, p. 58.

47 The idea of sending Philby to Spain did not come from the Centre but from Maly and Deutsch.

48 Borovik, *Philby Files*, p. 68.

49 Borovik, *Philby Files*, p. 69.

50 Borovik who interviewed Philby shortly before his death in 1988 was also granted access to Philby's KGB file prior to the collapse of the Soviet Union in 1991. Maly's reports are taken from Philby's KGB file.

51 Borovik, *Philby Files*, p. 69.

52 The OGPU was created in July 1923 and was incorporated in the NKVD in July 1934.

53 Olga Gray was referred to as 'Miss X' throughout Percy Glading's trial for spying.

54 TNA Kew KV2/1008.

55 TNA Kew KV2/1022.

56 TNA Kew KV2/1022.

57 Damaskin, Igor and Elliot, Geoffrey, *Kitty Harris: The Spy With Seventeen Names*, (London: St Ermin's Press, 2001), p. 150.

58 Andrew and Mitrokhin, *Archive*, p. 76; Damaskin and Elliot, *Harris*, p. 154.

59 West, Nigel & Tsarev, Oleg, *The Crown Jewels: The British Secrets at the Heart of the KGB Archives* (London: Harper Collins, 1998), pp. 105–6'; For Percy Glading and the Woolwich Arsenal case see Burke, *Spy*.

60 Damaskin and Elliot, *Harris*, p. 236.

61 Damaskin and Elliot, *Harris*, p. 236.

CHAPTER 5

The Isobar, Half Hundred Club and Sonya

1 PP/17/3/1/4. Tommy Layton was the founder of Laytons Wine Merchants Ltd., Wine Supplier in London. The Book Wine Restaurant and Cheddar Roast was Layton's first restaurant.

2 Gropius left England for America on 12 March 1937 where he had been appointed Senior Professor of Architecture at the Harvard Graduate School of Design;

Moholy-Nagy sailed for America on 1 July 1937 to take up his appointment as head of the New Bauhaus in Chicago.

3 Grieve, Alastair, Introduction, *The Pritchard Papers: a guide*, p. 2.

4 Levy, Paul 'Harben, Philip Hubert Kendal Jerrold (1906–1970)', *Oxford Dictionary of National Biography* Oxford University Press 2004–2009 http://www.oxforddnb.com/view/printable/60050.

5 Levy, 'Harben'.

6 PP/17/1/3/13.

7 PP/17/2/3/11.

8 PP17/1/1/2; PP17/1/2/9.

9 PP17/1/1/2;PP/17/1/3/13.

10 PP/17/1/1/2.

11 Breuer left to join Gropius and Moholy-Nagy in America.

12 PP/17/6/11.

13 PP/17/6/15.

14 PP/17/6/14.

15 PP/17/6/25.

16 PP/17/6/28.

17 PP/17/6/28.

18 PP/39/2/1/3.

19 PP/39/1/2/2.

20 PP17/1/3/85.

21 PP/39/1/36/1.

22 PP/39/1/36/12.

23 PP/8/43/1.

24 Writing in 1949 Foote did not tell all and the 'pleasant road in St John's Wood' was in fact in Lawn Road, and Brigitee Kuczynski lived in the Lawn Road Flats.

25 Ditto.

26 Foote, Alexander *Handbook for Spies* (London: Museum Press Limited, 1949), pp. 9–10.

27 Foote, *Handbook*, pp. 18–20.

28 Foote, *Handbook*, p. 189.

29 Foote, *Handbook*, p. 188.

30 TNA Kew KV2/1613.

31 TNA Kew KV2/1613.

32 Werner, Ruth, *Sonya's Report* (London: Chatto & Windus, 1991), p. 221.

33 TNA Kew KV6/41.

34 Turner, E.S., *The Phoney War on The Home Front* (London: Michael Joseph, 1961), p. 124.

35 Turner, *Phoney War*, p. 124.

36 Turner, *Phoney War*, pp. 124–5.

37 Sieveking, Lance, *The Eye of the Beholder* (London: Hulton Press, 1957), p. 140.

38 Siepmann, C.A. 'Sieveking, Lancelot de Giberne, (1896–1972), writer and radio and television producer', *Oxford Dictionary of National Biography*, (Oxford: Oxford University Press 2004). http://www.oxforddnb.com/view/printable/31683.

39 Siepmann, 'Sieveking'.

40 Briggs, Asa, *The BBC: The First Fifty Years* (Oxford: Oxford University Press, 1985), p. 158.

41 Fielden, Lionel, *The Natural Bent* (London: Andre Deutsch, 1960), p. 106.

42 Fielden, *Natural Bent*, p. 107.

43 Fielden, *Natural Bent*, p. 107.

44 Fielden, *Natural Bent*, p. 107.

45 'It was not until 1936 that the BBC began systematic research into its own audience, establishing a Listener Research Section in the Home Intelligence Department of its Public Relations Division. On the outbreak of war in 1939, the Listener Research Section was expanded and renamed the BBC Listener Research Department (LRD); in 1950 the LRD was rechristened the BBC Audience Research Department in deference to the growing importance of television.' BBC Audience research reports, Part 1: BBC Listener Research Department 1937–c1950. Nicholas, Siân, 'The good servant: the origins and development of BBC Listener Research 1936–1950', University of Wales, Aberystwyth.

46 Silvey, Robert *Who's Listening? The Story of BBC Audience Research* (London: Allen & Unwin Ltd., 1974), p. 13.

47 The Ministry of Information was set up to handle certain tasks – the release of official news; security censorship; publicity campaigns for government departments; and the maintenance of morale, particularly during the post-Dunkirk period when the Home Morale Emergency Committee was set up to counter the possible dangers of a breakdown in morale in the country at large.

48 BBC Audience research reports Part 1: BBC Listener Research Department 1937–c1950. Nicholas, Siân, 'The good servant: the origins and development of BBC Listener Research 1936–1950', University of Wales Aberystwyth, p. 5; LR/67, Winter Listening Habits, 1938, BBC WAC R9/9/2.

49 Nicholas, 'good servant', pp. 5–6; LR/71, Summer Listening Habits, 1939, BBC WAC R9/9/2.

50 Nicholas, 'good servant', pp. 5–6; LR/71, Summer Listening Habits, 1939, BBC WAC R9/9/2.

51 PP/5/1/121.

52 PP/5/1/121.

53 PP/5/1/125.

54 PP/12/1/14; de Hevesy, Paul, *World Wheat Planning and Economic Planning in General* (Oxford: Oxford University Press, 1940).

55 PP/5/1/5.

56 PP/5/1/30.

57 PP/5/1/30.

58 PP/5/1/32.

59 Balfour may be better known for the construction firm Balfour Beatty, which he founded in 1909.

60 PP/5/1/48; PP/5/1/48 Jack Pritchard to Vyvyan Adams, 22 March 1938.

61 PP/5/1/64.

62 PP/5/1/64.

63 PP/5/1/177.

64 PP/5/1/178.

65 PP/5/1/178.

66 PP/5/1/179.

67 Watt, Donald Cameron, *How War Came: The Immediate Origins of the Second World War* (New York: Pantheon Books, 1989), pp. 351–9.

68 PP/9/1/2.

69 'Reactions To The Invasion of Finland,' *Comparative Broadcasts* No. 1, 1 December 1939; PP/5/1/107.

70 *Comparative Broadcasts* No. 2, 8 December 1939; PP/5/1/108.

71 *Comparative Broadcasts* No. 2.

72 *Comparative Broadcasts* No. 2.

73 *Comparative Broadcasts* No. 2.

74 *Comparative Broadcasts* No. 2.

75 *Comparative Broadcasts* No. 2.

76 This was the famous voice of William Joyce, Lord Haw-Haw.

77 *Comparative Broadcasts* No. 3, 15 December 1939; PP/5/1/109.

78 *Comparative Broadcasts* No. 4.

79 PP/5/1/111.

80 PP/5/1/112.

81 PP/5/1/113. The only surviving editions of *Comparative Broadcasts* of which I am aware held in the Pritchard Papers at the University of East Anglia, they cover editions 1–11 and span the months 1 December 1939 to 16 March 1940.

82 'On Tuesday at midnight the BBC still denied that a decision had been made and even on Wednesday morning it merely reported that there was still confusion and nothing definite could be said.' *Comparative Broadcasts* 16 March 1940; PP/5/1/116.

83 PP/5/1/116.

84 PP/5/1/116.

85 PP/5/1/116

86 TNA Kew KV2/1871/68.

CHAPTER 6
The Plot Thickens: Agatha Christie

1 Merson, Allan, *Communist Resistance in Nazi Germany* (London: Lawrence & Wishart, 1985), p. 213.

2 Kershaw, Ian, *Hitler 1936–1945: Nemesis* (London: Allen Lane, The Penguin Press, 2000), p. 206.

3 Branson, Noreen, *History of The Communist Party of Great Britain 1927–1941* (London: Lawrence & Wishart, 1985), p. 256.

4 Beckett, Francis, *Enemy Within. The Rise and Fall of the British Communist Party* (London: John Murray, 1995), pp. 90–93.

5 Branson, *op cit* p. 268.

6 Walter Ulbricht, first head of the post-war communist DDR.

7 TNA Kew KV2/1872/87a.

8 Williams, Robert Chadwell, *Klaus Fuchs, Atom Spy* (Cambridge, Massachusetts and London: Harvard University Press, 1987), p. 25.

9 TNA Kew KV2/1871/74a.

10 'The clear division of responsibility established between the Security Service and SIS in 1931 improved the working relations between them. As part of the 1931 reorganization, SIS established a new Section V (counter-intelligence) under Valentine Vivian (later deputy chief of SIS), which liaised with MI5. Chistopher Andrew, *The Defence of the Realm* (London: Allen Lane, The Penguin Press, 2009), p. 135. MI6 agent reports arrived at the Foreign Office with the prefix CX.

11 TNA Kew KV2/1871/74a.

12 TNA Kew KV2/1871/74a.

13 *The Times*, 11 August 1997, Obituaries. Professor Jurgen Kuczinski; TNA Kew KV6/42.

14 TNA Kew KV2/1871/74a.

15 TNA Kew KV2/1871/74a.

16 TNA Kew KV2/1873/149a.

17 TNA Kew KV2/1871/68.

18 TNA Kew KV2/1871/71B.

19 TNA Kew KV2/1873/185.

20 TNA Kew KV2/1872/94b.

21 TNA Kew KV2/1872/81a.

22 TNA Kew KV2/1879/525A.

23 TNA Kew KV2/1872/85c.

24 TNA Kew KV2/1872/89a.

25 'John Strachey writes', The Camelot Press, Southampton (T.U.) 1938.

26 Haldane, J. R. S., *Air Raid Precautions (A. R. P.)* (London: Victor Gollancz, 1938), p. 33.

27 PP/16/3/1/7.

28 PP/16/3/1/7.

29 PP/17/1/2/13.

30 PP/17/1/2/15.

31 PP/16/4/34/1.

32 PP/16/4/34/1.

33 PP/2/C-F54, letter dated 16 September 1940.

34 PP/2/C-F/54.

35 PP/2/C-F/54.

36 PP/2/1/C-F/53.

37 PP/2/1/C-F/53.

38 PP/16/4/34/1.

39 Christie, Agatha, *An Autobiography* (London: Collins, 1977), p. 482.

40 Morgan, Janet, 'Christie [née Miller; other married name Mallowan] Dame Agatha Mary Clarissa (1890–1976), *Oxford Dictionary of National Biography* 2004–9 http://www.oxforddnb.com.

41 Morgan, Janet, 'Christie'; See also Morgan, Janet, *Agatha Christie. A Biography* (Glasgow: Collins, 1984).

42 Christie, Agatha, *An Autobiography*, pp. 485–6.

43 Christie, *Autobiography*, pp. 485–6.

44 Christie, *Autobiography*, p. 486.

45 PP/16/4/22/6.

46 Morgan, Janet, *Christie*, p. 212.

47 Simpson, R.S., 'Glanville, Stephen Ranulph Kingdon (1900–1956), Egyptologist *Oxford Dictionary of National Biography* (Oxford: OUP 2004–9); Glanville, Stephen, *Catalogue of Demotic Papyri in the British Museum* (1939–1955) (London: The British Museum, 1955).

48 Simpson, 'Glanville'; Glanville, Stephen, *Catalogue.*

49 Mallowan, Max, *Mallowan's Memoirs: Agatha and the Archaeologist* (London: HarperCollins, 1977), pp. 171–2.

50 McCall, Henrietta *The Life of Max Mallowan. Archaeology and Agatha Christie* (London: The British Museum Press, 2001), p. 137.

51 Christie, *Autobiography*, pp. 486–7; PP/16/4/22/6.

52 Christie, *Autobiography*, p. 487.

53 Christie, *Autobiography*, p. 489.

54 Christie, *Autobiography*, p. 490.

55 McCall, *Life*, p. 146.

56 Moore, Jenny, *Louis Osman (1914–1996): The Life and Work of an Architect and Goldsmith* (Devon: Halsgrove Press, 2006), p.16.

57 Moore, *Osman*, p. 14.

58 Moore, *Osman*, p. 14.

59 Moore, *Osman*, p. 18.

60 Moore, *Osman*, p. 19.

61 Moore, *Osman*, p. 19; see also McCall, *Life.*

62 Christie, *Autobiography*, p. 489.

63 PP/6/3/76.

64 Christie, Agatha, *N or M?* (London: HarperCollins, 1941, reprint 2010), pp. 10–11.

65 TNA Kew KV2/1872/128a.

66 Now part of Reckitt Benckiser Group plc.

67 Eva Reckitt had two brothers, Geoffrey, who was largely apolitical, and Maurice, a Christian Socialist and a leading Guild Socialist.

68 TNA Kew KV2/1371; TNA Kew KV2/1371/56B.

69 TNA Kew KV2/1369–1375.

70 TNA Kew KV2/1374/2.

71 Saville, John, 'Reckitt, Eva Collet (1890–1976) Communist Bookseller' in Bellamy, Joyce and Saville, John (eds), *Dictionary of Labour Biography* Vol. 9 (Macmillan 1993), p. 240.

72 Saville, 'Reckitt', p. 241.

73 Saville, 'Reckitt', p. 241.

74 Saville, 'Reckitt'.

75 See Ian Kershaw, *Nemesis*, p. 308.

CHAPTER 7
Refugees

1 PP/11/6/2.

2 PP/11/8/5 Letter dated 12 January 1939. No letter of reply in the Pritchard Papers, University of East Anglia.

3 PP/11/8/10.

4 PP/11/8/4.

5 PP/11/7/6; 'Germans and Austrians of almost every shade of religious and political outlook (many of them being persons of high professional standing), have found refuge from Nazi Dictatorship in Czechoslovakia. The German Government is now demanding that they should be handed over to the Gestapo. The situation is desperately urgent. These innocent persons must be saved from imprisonment or execution. They must be rescued immediately. The British Government are willing to grant the necessary visas to these refugees provided that their keep can be guaranteed in this country, pending future arrangements for emigration. A group of students and staff of the Architectural Association School have agreed to organise such assistance as they can, in co-operation with the British Committee for refugees from Czechoslovakia.' PP/11/5/2.

6 PP/11/5/8. Letter dated 7 February 1939.

7 PP/11/4/8.

8 PP/11/7/37.

9 PP/11/4/41.

10 PP/12/2/2.

11 PP/12/2/37.

12 PP/12/2/35.

13 PP/12/2/35; PP/12/2/54.

14 PP/12/2/35; PP/12/2/54.

15 PP/12/2/35; PP/12/2/54.

16 PP/12/2/54.

17 PP/12/2/50.

18 Andrew and Mitrokhin, *Archive*, p. 134.

19 Their marriage was by now a marriage of convenience, and at the beginning of 1939 Hamburger had left Switzerland for Marseilles to train as a radio operator for an assignment in China.

20 Werner, *Report*, p. 228.

21 The Rote Drei was arguably the Soviet Union's most important wartime agent network with access to sources inside Germany operating in Switzerland. See Andrew, Christopher and Gordievsky, Oleg *KGB: The Inside Story of its Foreign Relations from Lenin to Gorbachev.* (London: Hodder & Stoughton, 1990), p. 224.

22 TNA Kew KV6/43/234A.

23 A note on her MI5 file states: 'It is not clear why Ursula BEURTON left Switzerland as she did at the end of 1940 to proceed to this country, but on the evidence of FOOTE she did so with at least Russian concurrence and the possibility therefore cannot be excluded that she came here with a mission.' D.D.G. through B.1., B.1.b. 15.7.47 signed by J.H. Marriott.

24 At the time of Fuch's arrest, Jurgen Kuczynski was living in the American sector of Berlin. In June 1950 British intelligence asked the Americans to make him available for questioning. Somebody, presumably well-versed in the Fuchs and Kuczynski investigation, tipped him off. Before he could be questioned he had moved to Berlin-Weisensee in the Russian sector. Sonya visited him there some weeks later and remained in East Berlin. See Burke, *Spy*, p. 155.

25 For the Woodstock mole, i.e. Roger Hollis, see Pincher, Chapman, *Treachery*.

26 TNA Kew KV2/1611/63a.

27 TNA Kew KV6/44/261a.

28 See Epilogue pp. 269–71.

29 TNA Kew KV2/1611/63.

30 TNA Kew KV2/1611/63.

31 TNA Kew KV2/1611/63a.

32 TNA Kew KV2/1876/373b. Gist of translation of intercepted letter from Monty JACOBS, to Dr J. KUCZYNSKI dated 28.8.44., received 31.8.44. 'Writer has been asked by his friend Hermann DEUTSCH, who is suing a Miss Marie GINSBERG of Geneva in respect of certain important papers and shares entrusted to her, to ask addressee (Deutsch's nephew) for a witness statement. DEUTSCH had asked writer to interview addressee personally to make this request, but writer prefers to look upon this as a specimen of DEUTSCH's over-correctness, and is sure it needs no visit from him for addressee to do this small favour to a relative in great need. Should he be able to help addressee in any way, he is entirely at his disposal. The lawyer requires the statements in English, dated and with the place given, signed and in triplicate.' The letter bears all the hallmarks of a request for the release of funds. See also Marie Ginsberg's purchase of Sonya's 'Bolivian or Brazilian passport'.

33 TNA Kew KV2 1611/31B.

34 TNA Kew KV2/1611/54a [?].

35 TNA Kew KV2/1611/54a [?]; presumably both the GRU and NKVD.

36 TNA Kew KV2/1611/54a. It is interesting to note that the FBI in 1947 was saying the same things about the activities of the KPD Communist/Comintern/Russian Intelligence agent in the USA, Gerhardt Eisler.

37 Her husband Len Beurton was already on the Black List for his activities in Spain.

38 TNA Kew KV6/41.

39 Branson, *Communist Party*, p. 329.

40 Kershaw, Ian, *Hitler 1936–1945 Nemesis* (London: Allen Lane, The Penguin Press), p. 393.

41 *The Times*, 23 June 1941.

42 PP/2/1/unidentified/11; PP/8/57/5.

43 See Burke, *Spy*, Chapter 4.

44 PP/16/2/28/1.

45 Robert Braun, the new manager of the Isobar and Half Hundred Club.

46 PP/2/1/Unidentified/11.

47 TNA Kew FO/371/29521/39.

48 TNA Kew FO371/29521/39.

49 TNA Kew FO 371/29521/65655/39.

50 TNA Kew FO/371/24856/488.

51 TNA Kew FO/371/24856/488.

52 TNA Kew KV2/1580 Andrew Rothstein.

53 TNA Kew KV2/1580 Andrew Rothstein.

54 TNA Kew KV2/1611.

55 *Observer*, 2 January 2011.

56 Branson, *Communist Party*, p. 175.

57 Branson, *Communist Party*, p. 175.

58 Branson, *Communist Party*, p. 175.

59 Temple, Richard, 'BROWN, William John (1894–1960)', in Bellamy, Joyce & Saville, John (eds) *Dictionary of Labour Biography* Vol. X London: Macmillan Press, 2000), p. 33.

60 PP/16/4/32/2. Letter W. J. Brown to Jack Pritchard, 8 March 1940.

61 PP/16/4/32/2. Letter Jack Pritchard to W. J. Brown, 26 September 1938.

62 Temple, 'BROWN', p. 33.

CHAPTER 8
Klaus Fuchs, Rothstein and Charles Brasch

1 Williams, Robert Chadwell, *Klaus Fuchs, Atom Spy* (Cambridge, Massachusetts & London: Harvard University Press, 1987), p. 15.

2 Williams, *Fuchs*, p. 17.

3 Williams, *Fuchs*, p. 29.

4 Burke, *Spy*, p. 67.

5 'Kuczynski put him [Fuchs] in touch with Simon Davidovich Kremer, an officer at the GRU London residency, who irritated Fuchs by his insistence on taking long rides in London taxis, regularly doubling back in order to throw off anyone trying to tail them.' Andrew and Mitrokhin, *Archive*, p. 152. Contrary to recent claims Simon Davidovich Kremer was not a Lawn Road Flats' resident. The Kremer in question was A. S. Kremer Esq. (see illustration no. 36.) As far as I am aware no GRU agent ever used the title 'Esquire'. Given the title's original purpose – to bestow social rank upon the sons of noblemen and gentry above that of mere gentleman – it would have been extremely unlikely that Simon Davidovich Kremer, a Marxist, would have adopted the persona of an English gentleman. M. S. Kremer Esq., a Lawn Road Flats' resident, given to complaining about the condition of his wall (see PP/16/3/3/9), was not a secret agent. The confusion arises from M. S. Kremer having the same surname as S. D. Kremer. See Pearlman, Jill, 'The Spies Who Came into the Modernist Fold: The Covert Life in Hampstead's Lawn Road Flats', *Journal of the Society of Architectural Historians*, Sept. 2013.

6 Burke, *Spy*, pp. 126–9.

7 'Andrew Rothstein' TNA Kew KV2/1582/820b.

8 'Andrew Rothstein' TNA Kew KV2/1582/820b.

9 'Andrew Rothstein' TNA Kew KV2/1582/820b.

10 http://www.bookcouncil.org.nz/writers/braschcharles.html.

11 Brasch, Charles, *Indirections: A Memoir 1909–1947* (New Zealand: Oxford University Press, 1980), p. 350.

12 Brasch, *Indirections*, p. 350. The statue of the King at Cockspur Street is of George III who lost the American colonies, while Charles I who lost his head occupies the former site of the Eleanor Cross at Charing Cross. It is interesting to note which king was revered most and was deserving of protection during the Second World War.

13 Brasch, *Indirections*, p. 352.

14 Brasch, *Indirections*, p. 353.

15 Brasch, *Indirections*, p. 360.

16 Brasch, *Indirections*, p. 362.

17 Brasch, *Indirections*, p. 362.

18 Brasch, *Indirections*, p. 362.

19 Brasch, *Indirections*, pp. 364–5.

20 Brasch, *Indirections*, p. 372.

21 Brasch, *Indirections*, p. 372.

22 Brasch, *Indirections*, p. 372.

23 Brasch, *Indirections*, p. 373.

24 Brasch, *Indirections*, p. 373.

25 Brasch, *Indirections*, p. 373.

26 Brasch, *Indirections*, p. 374.

27 A 'bombe' was an electromechanical device used by British cryptologists to help decipher German enigma-machine-encrypted signals.

28 Letter from Cryptanalysts in Hut 6 and Hut 8, Bletchley Park, to the Prime minister, 21 October 1941 quoted in Smith, Michael & Erskine, Ralph (eds), *Action This Day: Bletchley Park from the breaking of the Enigma Code to The Birth of The Modern Computer* (London: Bantam Press, 2001), pp. ix–xii.

29 Smith & Erskine, *Action*, p. xiii.

30 PP/16/4/29/4; Brasch, *Indirections*, p. 377.

31 Brasch, *Indirections*, p. 377.

32 Brasch, *Indirections*, p. 377.

33 Brasch, *Indirections*, p. 377; Jack Pritchard PP/16/3/1/3.

34 Jack Pritchard PP/16/3/1/3.

35 Jack Pritchard PP/16/3/1/3.

36 Brasch, *Indirections*, p. 378.

37 Brasch, *Indirections*, p. 380.

38 Brasch, *Indirections*, pp. 385–6.

39 Brasch, *Indirections*, p. 387.

40 Brasch, *Indirections*, p. 388.

41 Brasch, *Indirections*, pp. 392–3.

42 Brasch, *Indirections*, p. 395.

43 Brasch, *Indirections*, pp. 397–8.

44 Brasch, *Indirections*, p. 405.

45 Brasch, *Indirections*, p. 390.

46 Brasch, *Indirections*, p. 32.

47 Aylmer Vallance had worked for the Black Propaganda arm of the Political Warfare Executive during the Second World War and had been a vocal supporter of the communist partisans in Yugoslavia naming one of his sons Tito after the revolutionary, Josip Broz Tito.

48 PP/16/2/23/1.

49 The precursor of the BBC Light Programme and later Radio 2.

50 Wrigley, Chris, *A. J. P. Taylor: Radical Historian of Europe* (London: I.B. Tauris, 2006), pp. 150–1.

51 Wrigley, *Radical Historian*, pp. 150–51.

52 Wrigley, *Radical Historian*, pp. 150–51. In December 1942 Blewitt had invited Taylor to London 'to discuss one or two ideas for programmes' but nothing came of this meeting.

53 Wrigley, *Radical Historian*, p. 151.

54 Wrigley, *Radical Historian*, p. 167; AJPT to Mr. Smith, 25 September 1943, and 10 February 1944 to Trevor Blewitt, BBC Archives.

55 Wrigley, *Radical Historian*, p. 167.

56 Writer and broadcaster, Eileen Arbuthnot Robinson.

57 Wrigley, *Radical Historian*, p. 167; see also Blewitt to AJPT, 13 February 1945, BBC Archives.

58 Wrigley, *Radical Historian*, p. 168.

59 Wrigley, *Radical Historian*, p. 168.

60 Wrigley, *Radical Historian*, p. 168.

61 Companion to Gerald Brenan, see also Gathorne-Hardy, Jonathan, *The Interior Castle: A Life of Gerald Brenan* (London: Sinclair-Stevenson, 1992).

62 McMaster University digital collections http://digitalcollections.mcmaster.ca. Bertrand Russell papers; 145253.

63 Wrigley, *Radical Historian*, p. 177.

64 Wrigley, *Radical Historian*, p. 177; see also AJPT to Trevor Blewitt, 14 February 1946; Trevor Blewitt to Assistant Controller (Talks), 15 February 1946. BBC Archives.

65 Wrigley, *Radical Historian*, p. 177.

66 Wrigley, *Radical Historian*, p. 178; see also Memorandum by Trevor Blewitt, 20 May 1946 BBC Archives.

67 A.J.P. Taylor, *A Personal History* (London: Coronet Books, 1983), p. 199.

68 Taylor, *Personal History*, p. 199.

69 Taylor, *Personal History*, p. 199.

70 Taylor, *Personal History*, p. 109.

CHAPTER 9
Vere Gordon Childe

1 Green, Sally, *Prehistorian: A Biography of V. Gordon Childe* (Bradford-on-Avon, Wiltshire: Moonraker Press, 1981), p. 154.

2 Harris, David R. (ed.), *The Archaeology of V. Gordon Childe, Contemporary Perspectives* (London: University College London, 1994), p. 20.

3 Harris (ed.), *Archaeology*, p. 4.

4 Mallowan, Max, *Mallowan's Memoirs* (New York: Dodd, Mead & Company, 1977), p. 234.

5 Green, *Prehistorian*, p. xvi.

6 Mallowan, *Memoirs*, p. 235.

7 Brasch, *Indirections*, p. 216.

8 Walter Gropius to The Editor, *Horizon*, 10 January 1947, PP/16/2/27/26.

9 Wells Coates to Jack Pritchard, 21 January 1947, PP/16/2/27/39.

10 PP/16/2/27/2.

11 PP/16/2/27/43.

12 PP/19/6/47.

13 PP/19/6/47.

14 PP/19/6/47.

15 Green, *Prehistorian*, p. 118.

16 Harris (ed.), *Archaeology*, p. 4.

17 Green, *Prehistorian*, p. 125.

18 Green, *Prehistorian*, p. viii.

19 Harris (ed.), *Archaeology*, p. 5: 'It was not until Stalinist intellectual orthodoxies began to be eroded in the post-war period that translations of some of Childe's works into Russian began to appear: *The Dawn of European Civilisation* in 1952 and *New Light on the Most Ancient East* in 1954.

20 Trigger, Bruce G., 'Childe's Relevance to the 1990s' in Harris (ed.), *Archaeology*, p. 18.

21 Trigger, 'Childe's Relevance', p. 19.

22 Trigger, 'Childe's Relevance', p. 12.

23 Trigger, 'Childe's Relevance', p. 19; see also Childe *Scotland Before the Scots* (London: Methuen, 1946), p. 24.

24 Green, *Prehistorian*, p. 70.

25 Green, *Prehistorian*, p. 70.

26 Green, *Prehistorian*, pp. 70–1.

27 Green, *Prehistorian*, p. 69.

28 Green, *Prehistorian*, p. 77.

29 Trigger, 'Childe's Relevance', pp. 11–12, 17.

30 Rowlands, Michael, 'Childe and the Archaeology of Freedom' in Harris (ed.), *Archaeology*, p. 48; Childe, V.G., 'Archaeological Ages as Technical Stages' in *Royal Anthropological Institute, Journal 77*, pp. 7–24.

31 Trigger, 'Childe's Relevance', p. 11.

32 Green, *Prehistorian*, p. 100.

33 'A tantalizing note in Childe's incomplete diary for the period records that he dined at the Kremlin during the visit, and suggests that he may have met Stalin on this occasion; unfortunately there is no confirmatory evidence that this meeting ever took place.' (Green, *Prehistorian*, p. 101).

34 Green, *Prehistorian*, p. 101.

35 Green, *Prehistorian*, p. 101.

36 Green, *Prehistorian*, p. 101; Childe, *The Prehistory of European Society* (Middlesex: Harmondsworth, Penguin Press, 1958) p. 173.

37 Dutt, R.P., 'The Pre-Historical Childe', *Times Literary Supplement* 1957, p. 539.

38 The national Fabian Society had set up a research department, which in 1918 became the Labour Research Department and later a Marxist body.

39 Green, *Prehistorian*, p. 21.

40 See Cain, Frank, *The Origins of Political Surveillance in Australia* (Sydney, Australia: Angus & Robertson, 1983); Ravetz, Alison, 'Notes on the work of V. Gordon Childe' (*The New Reasoner* 10 1959), pp. 56–66.

41 Green, *Prehistorian*, p. 26.

42 Green, *Prehistorian*, pp. 26–7.

43 Green, *Prehistorian*, p. 35.

44 *The St Andrew Magazine* 16 November 1918, no. 12.

45 Mulvaney, John, "Another University Man Gone Wrong": V. Gordon Childe 1892–1922' in Harris (ed.), *Archaeology*, p. 59.

46 Green, *Prehistory*, p. 35.

47 Green, *Prehistory*, pp. 38–40, p. xx.

48 Mulvaney, 'Another university man', p. 71.

49 Green, *Prehistory*, p. 43.

50 Crowther, J.G., *Fifty Years with Science* (London: Barrie & Jenkins, 1970), p. 20; cited Green, *Prehistory*, p. 42.

51 Green, *Prehistory*, pp. 43–4.

52 Green, *Prehistory*, p. 43.

53 'The London University Institute of Archaeology was founded in 1937, mainly through the efforts of Mortimer and Tessa Wheeler, and before 1946 depended largely on a voluntary staff of lecturers and research workers. Only after the war were funds provided for an adequate complement of lecturers and administrative officers.... From 1947 the Professor of Western Asiatic Archaeology was Max Mallowan and Mortimer Wheeler was Professor of Archaeology of the Roman Provinces.' Green, *Prehistory*, p. 110.

54 Green, *Prehistory*, p. 110.

55 'Postscript: three recollections of Childe the man' from Professor Charles Thomas, 26 February 1992 in Harris (ed.), *Archaeology*.

56 Green, *Prehistory*, p. 118.

57 See *Labour Monthly* May 1956; Green, *Prehistory*, p. 120.

58 Green, *Prehistory*, p. 120.

59 Green, *Prehistory*, p. 143.

60 Green, *Prehistory*, p. 154.

CHAPTER 10
The End of an Era

1 Max Mallowan, *Memoirs*, p. 235.

2 'In due course, with the backing of Professor Gordon Childe, I was appointed to be the first occupant of the Chair of Western Asiatic Archaeology at the Institute of Archaeology in the University of London.' Mallowan, *Memoirs*, p. 233.

3 Christie, *Autobiography*, p. 506.

4 Bruce Bairnsfather's cartoon character featured in his weekly 'Fragments from France' published in *The Bystander* magazine during the First World War.

5 Christie, *Autobiography*, p. 506.

6 Christie, *Autobiography*, p. 506.

7 Christie, *Autobiography*, pp. 507–9.

8 PP/16/4/22/6

9 PP/16/4/22/6, Jack Pritchard to Mrs Mallowan, 15/10/45.

10 PP/16/4/22/6, Jack Pritchard to Mrs Mallowan, 7/1/46.

11 PP/16/4/22/6, note dated 28/10/47.

12 PP/39/2/1/11.

13 PP/39/2/1/9.

14 Greene, *Prehistorian*, p. 125.

15 Taylor, *Personal History*, p. 195.

16 Taylor, *Personal History*, p. 196.

17 Taylor, *Personal History*, p. 196.

18 Taylor, *Personal History*, p. 196.

19 *Observer* 22 July 1951; PP/24/8/22.

20 PP/16/4/32/2.

21 PP/16/4/32/2.

22 Jack's niece.

23 PP/16/4/32/2.

24 McIntosh, Elizabeth, Foreword, in Fenn, Charles *At The Dragon's Gate: With The OSS in the Far East* (Annapolis, Maryland: Naval Institute Press, 2004), p. vii.

25 McIntosh, Foreword, p. vii.

26 *Parade*, March 18, 1973; PP/22/5/2/23.

27 McIntosh, Foreword, p. viii.

28 *The Architectural Review*, July 1955; PP/16/2/28/5/13.

29 PP/2/1/C-F/56.

30 *Hampstead and Highgate Express*, 21 February 1969; PP/15/2/13/4/44.

31 *Hampstead and Highgate Express*, 21 February 1969; PP/15/2/13/4/44

32 PP/15/2/13/4/145.

33 PP/15/2/13/4/146.

34 'Isokon' by Alaistair Grieve n.d. PP/18/4/12/36a.

35 *Hampstead and Highgate Express*, 4 February 1972; PP/15/2/13/5.

36 *Hampstead and Highgate Express*, 4 February 1972; PP/15/2/13/5.

37 PP/15/2/13/5.

38 PP/16/4/38/1.

39 En.wikipedia.org/wiki/isokon_building.

40 PP/15/2/13/5.

41 PP/15/2/13/5 Jack Pritchard to H.A. Hunt, January 27th, 1975.

42 PP/15/2/13/5 Jack Pritchard to H.A. Hunt, January 28th, 1975.

43 PP/15/2/13/5 Jack Pritchard to H.A. Hunt, March 3rd, 1975.

44 *Times*, 12 May 1992, Jack Pritchard Obituary; PP/1/7.

45 *Times*, 12 May 1992, Jack Pritchard Obituary; PP/1/7.

46 *Times*, 12 May 1992, Jack Pritchard Obituary; PP/1/7.

47 Fiona MacCarthy, 'Plywood Pritchard's progress: Obituary of Jack Pritchard *Guardian*, 30 April 1992.

48 Fiona MacCarthy, 'Plywood Pritchard's progress: Obituary of Jack Pritchard *Guardian*, 30 April 1992.

49 Fiona MacCarthy, 'Plywood Pritchard's progress: Obituary of Jack Pritchard *Guardian,* 30 April 1992.

50 *Guardian,* 5 May 1992, letter: Jack Pritchard Obituary; PP/1/7.

51 The Lawn Road Flats had been upgraded to Grade 1: buildings of exceptional interest in 2000.

EPILOGUE

1 *Financial Times,* 8 March 2013.

2 *Financial Times,* 8 March 2013.

3 *Financial Times,* 8 March 2013.

4 Burke, *Spy,* p. 8.

5 TNA Kew KV2/1611/63a.

Bibliography

Al'tman, V. V. (ed.), *Imperializm i borba rabochevo klassa: Pamyati Akademika F. A. Rotshteina* [Imperialism and the Struggle of the Working Class: Essays in Memory of Theodore Rothstein] (Moscow: Akademii Nauk, SSSR, 1960)

Ames, Eric, 'The Sound of Evolution', *Modernism/Modernity* Volume 10, No. 2, April 2003

Andrew, Christopher, *The Defence of the Realm. The Authorized History of MI5* (London: Allen Lane, 2009)

Andrew, Christopher and Gordievsky, Oleg, *KGB: The Inside Story of its Foreign Relations from Lenin to Gorbachev* (London: Hodder & Stoughton, 1990)

Andrew, Christopher and Mitrokhin, Vasili, *The Mitrokhin Archive: The KGB in Europe and the West* (London: Allen Lane, The Penguin Press, 1999)

Barron, Stephanie, (ed.), *'Degenerate Art': The Fate of the Avant-Garde in Nazi Germany* (New York: Harry N. Abrams. Inc., 1991)

Beckett, Francis, *Enemy Within: The Rise and Fall of the British Communist Party* (London: John Murray, 1995)

Blake, Peter, *Mies van der Rohe. Architecture and Structure* (Middlesex: Harmondsworth, Penguin Books, 1963)

Blake, Peter, *Le Corbusier. Architect and Form* (Middlesex: Harmondsworth, Penguin Books, 1963)

Blunt, Wilfrid Scawen, *My Diaries: Being a Personal Narrative of Events 1888– 1914: Part Two* (London: Martin Secker, 1919)

Borovik, Genrikh, *The Philby Files: The Secret Life of the Master Spy – KGB Archives Revealed* (London: Little Brown and Co., 1994)

Boyle, Andrew, *The Climate of Treason: Five Who Spied for Russia* (London: Hutchinson, 1979)

Branson, Noreen, *History of the Communist Party of Great Britain, 1927–41* (London: Lawrence & Wishart, 1985)

Brasch, Charles, *Indirections. A Memoir 1909–1947* (New Zealand: Oxford University Press, 1980)

Briggs, Asa, *The BBC: The First Fifty Years* (Oxford: Oxford University Press, 1983)

Brown, W. J., *So Far* (London: George Allen & Unwin, 1943)

Bullock, Alan, *Hitler: A Study in Tyranny* (Middlesex: Harmondsworth, Penguin Books, 1962)

Burke, David, *The Spy Who Came In From The Co-op. Melita Norwood and The Ending of Cold War Espionage* (Woodbridge, Suffolk: Boydell, 2008)

Cain, Frank, *The Origins of Political Surveillance in Australia* (Sydney, Australia: Angus & Robertson, Australia, 1983)

Caton, Joseph Harris, *The Utopian Vision of Moholy-Nagy* (Essex: Bowker Publishing Company, 1984)

Challinor, Raymond, *The Origins of British Bolshevism* (London: Croom Helm, 1977)

Childe, V. Gordon, *Scotland Before the Scots* (London: Methuen, 1946)

Childe, V. Gordon, *The Prehistory of European Society* (Middlesex: Harmondsworth, Penguin Books, 1958)

Christie, Agatha, *An Autobiography* (London: Collins, 1977)

Christie, Agatha, *N or M?* (London: HarperCollins, 1941)

Coates, Wells, 'Response To Tradition', *Architectural Review*, (November 1932)

Cohn, Laura, *The Door to a Secret Room. A Portrait of Wells Coates* (London: Lund Humphries, 1999)

Contacuzino, Sherban, *Wells Coates: A Monograph* (London: Gordon Fraser, 1978)

Crowther, J. G., *Fifty Years With Science* (London: Barrie & Jenkins, 1970)

Damaskin, Igor and Elliott, Geoffrey, *Kitty Harris: The Spy with Seventeen Names* (London: St Ermin's Press, 2001)

Elliott, David, 'Gropius in England: a documentation 1934–1937' (London: The Building Centre Trust, 1974)

Fenn, Charles, *At The Dragon's Gate. With The OSS In The Far East* (Annapolis, Maryland: Naval Institute Press, 2004)

Fielden, Lionel, *The Natural Bent* (London: Andre Deutsch, 1960)

Foote, Alexander, *Handbook for Spies* (London: Museum Press, 1949)

Forbes, Duncan, 'Hart, Edith Tudor (1908–1973)', *Oxford Dictionary of National Biography*: in association with the British Academy (Oxford: Oxford University Press, 2004)

Forbes, Duncan, 'Politics, photography and exile in the Life of Edith
 Tudor-Hart (1908–1973)', unpublished article, n.d.

Gathorne-Hardy, Jonathan, *The Interior Castle: A Life of Gerald Brennan*
 (London: Sinclair-Stevenson, 1992)

Gatje, Robert F. and Pei, I. M., *Marcel Breuer. A Memoir* (New York: The
 Monacelli Press, 2000)

Gedye, G. E. R., *Fallen Bastions* (London: Gollancz, 1939)

*Glavnoye Razvedyvatelnoye Upravleniye, Entsiklopediya Voennoi
 Razvedki Rossii* [Soviet Military Intelligence: Encyclopaedia of Russian
 Military Intelligence (Moscow, 2004)

Glees, Anthony: *The Secrets of the Service: British Intelligence and
 Communist Subversion 1939–1951* (London: Jonathan Cape, 1987)

Green, Sally, *Prehistorian: A Biography of V. Gordon Childe* (Bradford-
 on-Avon, Wiltshire: Moonraker Press, 1981)

Gruber, Helmut, *Red Vienna: Experiment in Working-Class Culture,
 1919–1934* (Oxford: Oxford University Press, 1991)

Guyon, Rene, *Sexual Freedom* (London: Bodley Head, 1939)

Haldane, J. R. S., *Air Raid Precautions (A. R .P)* (London: Victor
 Gollancz, 1938)

Harris, David R. (ed.), *The Archaeology of V. Gordon Childe:
 Contemporary Perspectives* (London: University College, London,
 1994)

Herbert, E. F., *Blossom The Brave Balloon* (London: F. Muller, 1941)

Hight, Eleanor M., *Picturing Modernism. Moholy-Nagy and Photography
 in Weimar Germany* (Cambridge, Massachusetts: MIT Press, 1995)

Hilton, Matthew, *Consumerism in Twentieth Century Britain. The Search
 for a Historical Movement* (Cambridge: Cambridge University Press,
 2003)

Hochman, Elaine S., *Bauhaus: Crucible of Modernism* (New York:
 Fromm International Publishing Corp US, 1977)

Howarth, T. E. B., *Cambridge Between Two Wars* (London: Collins, 1978)

Intelligence and Security Committee, *The Mitrokhin Inquiry Report*
 (London: The Stationery Office, June 2000)

Isaacs, Reginald, *Gropius* (London: Little, Brown and Company, 1991)

Kaplan, Louis, *Lázló Moholy-Nagy* (Durham and London: Duke
 University Press, 1955)

Kendall, Walter, *The Revolutionary Movement in Britain 1900–1921*
 (London: Weidenfeld & Nicholson, 1969)

Kershaw, Ian, *Hitler 1936–1945: Nemesis* (London: Allen Lane, The Penguin Press, 2000)

Klugmann, James, *History of the Communist Party of Great Britain* (London: Lawrence & (Wishart, 1969)

Krivitsky, Walter, *I Was Stalin's Agent* (London: Hamish Hamilton, 1939)

Lenin, V. I. *Collected Works,* vol. 51, *Letters July 1919–November 1920* (Moscow: Institute of Marxism-Leninism, 1965)

Levy, Paul, 'Harben, Philip Hubert Kendall Jerrold (1906–1970), *Oxford Dictionary of National Biography*: in association with the British Academy (Oxford: Oxford University Press 2004–2009)

Loew, Raimund, 'The Politics of Austro-Marxism', *New Left Review* 118 (Nov.–Dec. 1979)

MacCarthy, Fiona, 'Plywood Pritchard's Progress' *Guardian* 30 April 1992

Mackley, Alan, 'Isokon and Blythburgh', *Blythburgh* January 1995

Mallowan, Max, *Mallowan's Memoirs: Agatha and the Archaeologist* (New York: Dodd, Mead & Company, 1977)

Martland, Peter, *Recording History: The British Record Industry 1888–1931* (Maryland: Scarecrow Press, 2013)

Masbach, Steven A., 'Constructivism and Accommodation in the Hungarian Avant-Garde', *Art Journal* 49 (Spring, 1990)

McCall, Henrietta, *The Life of Max Mallowan. Archaeology and Agatha Christie* (London: The British Museum Press, 2001)

McLoughlin, Barry, Schafranek, H., and Szevera, W., *Aufbruch – Hoffnung – Endstation: Osterreicherinnen und Osterriecher in der Sowjetunion 1925–1945* (Wien: Verlag fur Gesellschaftskritik, 1997).

Merson, Allan, *Communist Resistance in Nazi Germany* (London: Lawrence & Wishart, 1985)

Meynell, Francis, *My Lives* (London: Bodley Head, 1971)

Moholy-Nagy, László, *The New Vision. Fundamentals of Design, Painting, Sculpture, Architecture* (New York City: W. W. Norton & Company, 1938)

Moholy-Nagy, László, *The New Vision and Abstract of an Artist* (New York: Wittenborn, 1946)

Moholy-Nagy, Sibyl, *Moholy-Nagy: Experiment in Totality* (New York: Harper & Brothers, 1950)

Monsarrat, Nicholas, *Life is a Four-Letter Word. Book One: Breaking In* (London: MacMillan, 1969)

Moore, James, *Gurdieff and Mansfield* (London: Routledge & Keegan Paul, 1980)

Moore, Jenny, *Louis Osman (1914–1996). The Life and Work of an Architect and Goldsmith* (Devon: Halsgrove Press, 2006)

Morgan, Janet, *Agatha Christie. A Biography* (Glasgow: Collins, 1984)

Morgan, Janet, 'Christie [née Miller; other married name Mallowan] Dame Agatha Mary Clarissa (1880–1976), *Oxford Dictionary of National Biography*: in association with the British Academy, (Oxford: Oxford University Press, 2004–2009)

Mulvaney, John, '"Another University Man Gone Wrong": V. Gordon Childe 1892–1922' in Harris (ed.), *Archaeology, p. 59.*

Myers, Helen (ed.), *Ethnomusicology: An Introduction* (London: Norton, 1992)

Nicholas, Sîan, 'The good servant: the origins and development of BBC Listener Research 1936–1950,' University of Wales Aberystwyth

Nicholson, Max, 'A National Plan for Great Britain', *Week-End Review*, February 1931

Ozanne, Andrew, 'Frontiersman of the Heroic Age', *RIBAJ* September 1979

Page, Bruce, Leitch, David and Knightley, Phillip, *Philby. The Spy Who Betrayed A Generation* (London: Andre Deutsch, 1968)

Palmier, Jean Michel, *Weimar in Exile: The Anti-Fascist Emigration in Europe and America* (London: Verso, 2006)

Passuth, Krisztina, *Moholy-Nagy* (London: Thames & Hudson, 1987)

Passuth, Krisztina, Szabo, John and Julia, et al., *The Hungarian Avant-Garde* (London: Hayward Gallery and Arts Council of Great Britain, 1980)

Pearlman, Jill, 'The Spies Who Came into the Modernist Fold: The Covert Life in Hampstead's Lawn Road Flats', Journal of the Society of Architectural Historians, Sept. 2013

Pelling, Henry, *The British Communist Party* (London: A & C Black, 1958)

Pincher, Chapman, *Treachery. Betrayals, Blunders, and Cover-ups: Six Decades of Espionage Against America and Great Britain.* (New York: Random House, 2009)

Pinder, John (ed.), *Fifty Years of Political and Economic Planning: Looking Forward, 1931–1981* (London: Heinemann, 1981)

Pritchard, Jack, *View From A Long Chair* (London: Routledge & Kegan Paul, 1984)

Ravetz, Alison, 'Notes on the work of V. Gordon Childe', The *New Reasoner* 10, 1959

Reich, Ilse Ollendorff, *Wilhelm Reich, A Personal Biography* (London: St Martin's Press, 1969)

Ritschel, Daniel, *The Politics of Planning. The Debate on Economic Planning in Britain in the 1930s* (Oxford: Oxford University Press, 1997)

Rycroft, Charles, *Reich* (London: Fontana/Collins, 1971)

Saville, John, 'Reckitt, Eva Collett (1890–1976) Communist Bookseller', in Bellamy, Joyce, and Saville, John, (eds), *Dictionary of Labour Biography* Volume 9 (London: Macmillan Press, 1993)

Siepmann, C.A., 'Sieveking, Lancelot de Giberne, (1896–1972) writer and radio and television producer', *Oxford Dictionary of National Biography*: in association with the British Academy (Oxford: Oxford University Press, 2004)

Sieveking, Lance, *The Eye of the Beholder* (London: Hulton Press, 1957)

Silvey, Robert, *Who's Listening? The Story of BBC Audience Research* (London: Geo. Allen & Unwin, 1974)

Simpson, R.S., 'Glanville, Stephen Ranulph Kingdon (1900 – 1956), Egyptologist', *Oxford Dictionary of National Biography*: in association with the British Academy (Oxford: Oxford University Press 2004 – 2009)

Slatter, John, (ed.), *From The Other Shore: Russian Political Emigrants in Britain, 1880–1917* (London: Frank Cass, 1984)

Smith, Michael and Erskine, Ralph (eds), *Action This Day: Bletchley Park from the breaking of the Enigma Code to the birth of the modern computer* (London: Bantam Press, 2001)

Suschitzky, Wolfgang, *Edith Tudor-Hart: The Eye of Conscience* (London: Dirk Nishen Publishing, 1987)

Taylor, A. J. P., *A Personal History* (London: Coronet Books, 1983)

Taylor, A. J. P., *Beaverbrook* (London: Allen Lane, The Penguin Press, 1974)

Temple, Richard, 'BROWN, William John (1884–1960)', in Bellamy, Joyce M. & Saville, John (eds), *Dictionary of Labour Biography* Vol. X (London: MacMillan Press, 2000)

Thompson, Willie, *The Good Old Cause: The British Communist Party 1920–1991* (London: Pluto Press, 1992)

Trigger, Bruce G., 'Childe's Relevance to the 1990s' in Harris, Archaeology.

Turner, E. S., *The Phoney War on the Home Front* (London: Michael Joseph, 1961)

Watt, Donald Cameron, *How War Came: The Immediate Origins of the Second World War* (New York: Pantheon Books, 1989)

Waugh, Alec, *The Loom of Youth* (London: Meuthen, 1984, 1917)

Werner, Ruth, *Sonya's Report* (London: Chatto & Windus, 1991)

West, Nigel & Tsarev, Oleg, *The Crown Jewels: The British Secrets at the Heart of the KGB Archives* (London: Harper Collins, 1998)

Williams, Robert Chadwell, *Klaus Fuchs, Atom Spy* (Cambridge, Massachusetts & London: Harvard University Press, 1987)

Wollheim, Richard, 'Stokes, Adrian Durham (1902–1972), writer and painter', (Oxford: Oxford Dictionary of National Biography in association with the British Academy, 2004–2009, http://www.oxforddnb.com

Woolf, Leonard, *Downhill All the Way: An Autobiography of the Years 1919–1939* (London: Harcourt Brace, Jovanovich, 1960)

Wrigley, Chris, *A. J. P. Taylor: Radical Historian of Europe* (London: I.B. Tauris, 2006)

Index

A National Plan for Great Britain 28–9

Aalto, Alvar 54, 125

Abraham, Otto 65

Adam, Pearl 188

Adams, Mary 126

Adams, Vyvyan 120–1, 136

Aliens Tribunal 131, 136

Andrew, Christopher, 1, 84
 Mitrokhin Archive 1, 3

Architects' Czech Refugee Relief Fund 152–3

ARCOS raid 79

Arts and Craft movement 19, 60, 224

Associated Press of Great Britain 153

Astor, W. W. 32

Austrian Communist Party (OKP) 83, 85, 87, 89–93

Austrian Self-Aid 153

Austro-Marxism 83–4, 86–7

Baldwin, Stanley 152

Balfour, George 121–2

Barman, Christian 32

Barry, Gerald 28, 32, 121, 153

Bauhaus 4, 20, 23, 43, 45–8, 51, 53–4, 58–61

Bayer, Herbert 60

Beacon Hill 21

Beaverbrook, Lord 27

Behrens, Peter 1, 46

Belgion, Montgomery 4, 41, 43, 110

Beurton, Leon Charles 114–15, 157, 159, 161

Bevan, Aneurin 135

Bevin, Ernest 67, 168

Blackett, Basil, Sir 27–8, 31

Bletchley Park, 176, 180–1

Blewitt, Trevor Eaton 24, 116, 188–93, 224

Blewitt, Phyllis 188, 192
 (see also Dobb, Phyllis)

Blunt, Anthony ix, 70

Blunt, Wilfrid Scawen 70

Blythburgh 220

Bolsover, George Henry 175

Bondy, Louis 147

Bone, Edith 97, 224

Bone, James 188

Boothby, Robert 212

Borgeaud 16

Borovik, Genrikh 100

Bovis 216–17

Bowes-Lyon, Elizabeth 135

Bowes-Lyon, Lilian H. 135–6

Brailsford, H. N. 204

Brains Trust 189–90

Brasch, Charles 4, 176–87, 195, 225

Braun, Otto 83, 87

Braun, Robert 164–5

Brenan, Gerald 190

Breuer, Marcel 4, 19, 43, 53–5, 60, 62, 65, 106–7, 152, 225
 (see also Isokon Long Chair)

British Broadcasting Corporation (BBC) 17, 67, 94, 116–19, 126–31, 179, 188–92, 213

British Committee for Refugees From Czechoslovakia 153

British Institute of Public Opinion
119
British Socialist party (BSP)
70–1, 76–7
Brown, E. A. 10
Brown, William John 168–70,
212–14
Bruce Lockhart, Robert 71
Brutalism 223
Bunbury, Henry Sir 28
Burgess, Guy ix, 94–5

Cairncross, John ix
Cambridge University Socialist
Society 13
Camden Borough Council
218–19
Campbell, Archibald Bruce 189
Campbell, Johnny 176
Cazalet, Thelma 37–8, 195, 223
Chagall, Marc 46
Chawner, W. Dr 13
Chermayeff, Serge 16, 17, 20, 34
Chertkov, Vladimir Count 3,
68–9
Childe, Vere Gordon xi, 3, 78,
194, 196–208, 212, 216, 225
Christie, Agatha x–xi, 1–3, 4, 8,
78, 141, 143–151, 194, 208–211,
225
 Akhnaton 143
 Black Coffee 145
 Death on the Nile 143
 Murder in Mesopotamia 147
 Murder on the Orient Express
 x, 1–2
 N or M? 3, 4, 147
 The Body in the Library 147
 The Murder of Roger Ackroyd
 8, 151
 The Secret Adversary 147
Churchill, Winston 67, 72, 116,
120, 127, 163, 181–2, 190

Coates, Harper Havelock 15
Coates, Sarah Agnes Wintemute
15
Coates, Wells Wintemute 1, 2,
10, 14, 16–18, 20, 22, 27, 32–7,
39–40, 43, 55, 58, 146, 195–6,
216, 221–2
Cohn, Laura 9, 35
Cole, G. D. H. 12, 78, 164, 187,
201, 204
Cole, Margaret (nee Postgate) 78,
164, 187, 201, 204
Collective Security 120–3
Communist International
(Comintern) 73, 76, 79–80,
129, 133–4, 161
(see also Third International)
Communist Party of Great Britain
(CPGB) 13, 67, 76–81, 83,
134–5, 149, 164, 167, 188–9
Communist Part of the United
States of America 133
Comparative Broadcasts 119–20,
125–31
*Congrès Internationaux
d'Architecture Moderne* (CIAM)
9, 16, 34, 61
Connolly, Cyril 195–6
Constructivism 58–9
Cooke, S. 156
Cowell, Henry 66
Cox, Geoffrey 177
Cresta Silks 10, 16
Cresswell, H. B. 35
Crowther, J. G. 203–4
Crysede Silks 9–10
Curzon, George 72

Dada 59
Damaskin, Igor 104
Day-Lewis, Cecil 135
De Cronin Hastings, H. 37–8
De Hevesy, Paul 120

De Stijl 19, 59
Desbrow, L. W. 120
Design and Industries Association
 (DIA) 10, 50
Deutsch, Arnold ix–x, 1–2, 65,
 68, 83–4, 91, 93–96, 99–105, 161,
 166, 224
Deutsch, Hermann 65, 160,
 224
Deutsch, Josefine 83, 94
Deutsch, Oscar 65
Deutscher Werkbund (German
 Association of Craftsmen) 18,
 19, 23, 43, 47, 60
Diffusionism 198, 200
Dimitrov, Georgi 133
Dobb, Maurice 13, 17, 24–5, 30,
 31, 150, 204
Dobb, Phyllis 24
 (*see also* Blewitt, Phyllis)
Dollfuss, Englebert 86, 89–90
Doyle, Arthur Conan, Sir 13
Dukhobors 69
Dutt, Rajani Palme 80, 133, 201,
 204–5
Dzerzhinsky, Felix 70

Eastwood, Paul 218
Ebert, Friedrich 44–5
Eden, Anthony 120, 122–3
Einstein, Albert 46
Electra House 128–9
Eliot, T. S. 41–3
Elliot, S. R. 188
Ellis, Clough Williams 27
Elmhirst, Dorothy 52
Elmhirst, Leonard 28, 52
Elvin, Lionel 156
Emberton, Joseph 63
Engels, Friedrich
 The Origins of the Family,
 Private Property and the
 State 197, 201

Ewer, William Norman 111, 149,
 165, 224

Fagan, Hymie 176
Feininger, Lyonel 59–60
Fenn, Charles 214–16, 221
Festival of Britain 213
Fielding, Lionel 117–18
Finella 17
Fisher, Kenneth 14
Fleischauer, Ulrich 49
Florence, Lella 12
Florence, Philip 12–14
Foot, Michael 212
Foote, Alexander 112–15, 157,
 159–61
Forbes, Allyn 140–1
Forbes, Mansfield 16, 17
Freud, Anna 183
Freud, Sigmund 85
Friedman, Litzi 91
Fritsche, Hans 131
Fry, Maxwell 31–2, 34, 50–52,
 224
Fuchs, Klaus 4, 158, 170–72

Gallacher, William 164
Gaster, Jack 225
Gathorne-Hardy, Ralph Edward
 39–40, 116
Gauntlet, G. E. L. 15
Geddes, Mr. 139
Gedye, G. E. R. 87–8, 90
General Strike, 1926 14, 79, 188–9
George VI 135, 168
George Knight & Partners 217–18
German Communist Party (KPD)
 67, 83, 86, 131–2, 134–8, 168,
 170–2
Giedion, Sigfried 53–4
Gilbert, Jean 157
Ginsberg, Marie 160
Glading, Percy 23, 24, 101–2

Glanville, Stephen 143–4, 146, 149, 176–7
Gleichen, Albert 72
Glover, Dennis 184–5, 187
Goepfert, Louise 20–1
Goldschmidt, Hans 139, 154
Goold-Verschoyle, Bryan 96–9, 103, 224
Gordievsky, Oleg ix–ix
Gouzenko, Igor 158
Gray, Olga 101–2
Gropius, Ise 47, 51–2, 65, 213
Gropius, Walter 4, 8, 19, 20, 43–54, 59–60, 62, 65, 67, 106, 141, 152, 195, 213, 221, 225
Grove, Marion 14, 16
Gurdjieff, George Ivanovich 20
Gusev, Igor 174
Guyon, René 22

Haire, Norman 22, 86
Haldane, J. B. S. 138, 190
Half Hundred Club 78, 109–12, 115, 168, 187, 189, 211
Hamburger, Rudolf 157, 159
Hammond, Frank 180
Harben, Kathie 108
Harben, Phillip 106–10, 139–40, 153, 164, 211–12, 216
Harrison, Tom 119
Heisler, Ron 147
Henderson, Francis 150
Hepworth, Barbara 43, 58
Herbert, E. F. 66
Heretics Society 13, 21
Heron, Peter 10
Heron, Tom 10
Herzog, George 66
Hesse, Fritz 23
Ho Chi Minh 214–15
Hollis, Roger 158, 162, 167
Horrabin, J. F. 188
Horrabin, Winifred 188

Hunt, H. A. 220
Hutton, Graham 212
Huxley, Julian 28, 108, 111, 115–16, 189, 200
Hyett, V. A 22
Hyndman, Henry 70, 72

Irwin, John 212
Isokon Long Chair 55, 146
Itten, Johannes 46, 60

Jagger, John 150
JAXPLAN 32
Jeanneret, Pierre 10, 19
Jennings, Humphrey 119
Joad, Cyril 75, 78, 107, 165, 189, 224
Johnson, Hewlett 136
Jones, Colin 219
Jordan, Robert Furneaux 120, 152

Kahle, Hans 137
Kandinsky, Wassily 45–6, 53, 59–60
Kapitza, Peter 81
Kapp, Edmond 183
Kapp, Helen 183
Kepes, György 62
Keynes, J. M. 13, 31
King, John Henry 96, 98
Klee, Paul 46, 53, 59–60
Klein, Leo 197
Klein, Melanie 43
Klishko, Nikolai 74–5
Knight, George 217–18
Knight, Maxwell 101–2, 137
Knights, L. C. 16
Kokoshka, Oskar 46
Korda, Alexander 64
Kossinna, Gustaf 200
Krassin, Leonid 75
Kremer, Simon Davidovich 172
Krivitsky, Walter 99

Kropotkin, Pyotr 70
Kuczynski, Barbara 68, 82, 224
Kuczynski, Berta 82, 224
Kuczynski, Brigitte 65, 67–8,
 82–3, 94–5, 100, 112–15, 147, 157,
 169, 224
(*see also* Lewis, Bridget)
Kuczynski, Jurgen 4, 67–8, 82,
 131, 134–8, 147–8, 156, 158–60,
 162, 167, 170, 224
Kuczynski, Margueritte 134,
 137–8, 160–2, 172–3, 224
Kuczynski, Renate 82
Kuczynski, Robert (René) 81–2,
 224
Kuczynski, Sabine 82, 225
Kuczynski, Ursula (SONYA) 4,
 67, 113–15, 156–162, 172–3, 224
Kun, Béla 56, 64

Lambert, R. S. 94, 188
Lancaster, Osbert 11, 35
 Homes Sweet Homes 11, 35
Lanchester, Elsa 64
Lansbury, George 78
Laski, Harold 91, 108, 136
Laughton, Charles 64
Layton, T. A. 106–7
Le Corbusier 9, 10, 15, 19, 23, 54
 Vers Une Architecture 9
League for World Sexual Reform
 (English Section) 21, 22, 86
Leeper, Rex 71, 73
Lehman, John 178
Lenin, Vladimir Ilyich 3, 71–3,
 76–7
Lewis, Anthony Gordon 65, 67,
 83, 116, 119, 173, 177, 224
Lewis, Bridget 65, 83, 95, 139, 173
 (*see also* Kuczynski, Brigitte)
Liebknecht, Karl 19, 44–5
Lindsay, Kenneth 31
Little, Renée 217

Litvinov, Ivy (nee Low) 74
Litvinov, Maxim 71, 74, 76
Lloyd George, David 71–3
Lloyd George, Megan 108
Loeffler, Francis 225
Loewenheim, Ernst 137
Loewenheim, Walter 137
London County Council (LCC) 2,
 35–6, 38
Lord Baldwin's Fund for Refugees
 152
Lovensteen, Edgar 65
Low, David 148
Lowry, Malcolm 5
Luxemburg, Rosa 19, 45

MacCarthy, Fiona 220–21
Mackley, Alan 11
Maclean, Donald, Sir 72
Maclean, Donald ix, 72, 166–7
MacNiece, Louis 108
Madge, Charles 42, 119
Maisky, Ivan 81, 166, 172, 174
Mallowan, Max 2, 143–6, 176,
 194–5, 197, 208–211
Maly, Teodor 95–6, 98–103, 161,
 224
Mansfield, Katherine 20–1
Marchbank, John 136
Martindale, Hilda 32
Massey, Raymond 64
Mass Observation 119
Massingham, Dorothy 21
Mathias, John 64
Maw, Fredrick Graham 152
Mayer, Hannes 23
McGrath, Raymond 16, 17
Mendelsohn, Erich 20, 47
Meusl, A. Professor 137
Meyer, Adolf 44
Meynell, Alice 74
Meynell, Francis 74–6, 78, 112,
 150, 165, 224

Meynell, Viola 74
Mies van der Rhoe, Ludwig 19, 20, 47–8, 61
Ministry of Information 118–19, 126, 154–6, 165, 170
Ministry of Supply 156
Mitchell, Frank 197
Mitrokhin, Vasili 1
Modern Architectural Research Group (MARS) 34, 54
Moholy-Nagy, Jeno 56
Moholy-Nagy, Lázló 4, 8, 43, 45–6, 53–66, 106, 152, 225
Moholy-Nagy, Sibyl (nee Sibylle Pietsch) 55–6, 60–64
Monckton, Walter, Sir 127, 155
Monsarrat, Nicholas 4–9, 66, 225
Morgan, Jack 217
Moore, Henry 4, 43, 58, 108, 179, 225
Moos, Charlotte 96–8, 224
Morris, Henry 52
Morris, William 19, 60, 224
Morrison, Herbert 38, 67, 192
Mott, Nevill 171
Mulgan, John 177–8
Munich Agreement 122–3, 132
Münzenberg, Willi 87, 135
Muth, Olga 159

Nash, Paul 10
National Guilds League (Guild Socialism) 12
Nazi-Soviet Pact 124, 126, 129–33, 135, 151, 160–2
Neal, Jack 14
Neumann, Lena 183, 188, 213–14
New Statesman 36, 138, 178, 188, 205, 216–20
Nicholson, Ben 43, 58, 111
Nicholson, Max 28
Norwood, Melita 3–4, 81, 158,
172, 223–4
(*see also* Sirnis, Melita)
Notting Hill Housing Group 222
Novembergruppe 19
Nussbaum, Hilary 225
Nunn May, Alan 158

Ogden, C. K. 13
Osman, Louis 146
Oud, J. J. P. 19, 20
Oundle School, Peterborough 11–14
Ozenfant, Amédée 9

Pankhurst, Sylvia 76–7
Parker, John 120
Parsons, Olive 150
Paul, Cedar and Eden 22
Pavement Club 13
Peierls, Rudolf 172
Perriand, Charlotte 10
Peters, Jacob 70
Philby, Kim ix, 3, 13, 17, 83, 86, 90–1, 94, 96, 99–100, 103, 161
Pick, Frank 34
Pieck, Henri Christiaan (Hans) 96, 98
Piggott, Stuart 198
Pinder, John 28
Piscator, Erwin 51, 54
Plebs Magazine 203
Political and Economic Planning (PEP) 27–32, 50, 52, 119–21, 224
Political Warfare Executive 189
Pollitt, Harry 133–4, 149, 154, 173
Pontecorvo, Bruno 158
Postgate, Daisy (nee Lansbury) 78, 201
Postgate, Raymond 78, 109, 111–12, 188, 201, 203–4, 211, 216
Potter, Jeremy 217
Pound, Ezra 42–3

Pranger, Lynda 190
Preston bus station 223
Prestwich, John 180–1
Pritchard, Clive Fleetwood 11
Pritchard, Fleetwood 11, 140, 156,
 164, 214
Pritchard, Jack Craven 9, 10–13,
 16–18, 20–22, 25, 27, 30–37,
 39–40, 43, 50–55, 58, 61, 75,
 92–94, 106, 108, 110, 112, 119–25,
 140–1, 144, 153–6, 164–5,
 169–70, 183, 187–8, 195–6,
 209–211, 216–17, 219–23, 225
Pritchard, Jeremy 140
Pritchard, Jonathan 140
Pritchard (nee Craven) Lilian 11
Pritchard, May 11
Pritchard, Nancy 11
Pritchard (nee Cooke) Rosemary
 (Molly) 9, 21–2, 34–5, 37,
 39–40, 107–8, 140, 195, 217,
 220–2, 225
Pritt, D. N. 108, 136, 187, 224
Pritt, Marie 187
Private Eye 219

Rachlis, Michael 154
Radó, Sándor 156–7, 162
Rathenau, Walter 48–9
Read, Herbert 42–3, 58, 61, 108
Reckitt, Eva Collett 2, 149–50,
 173, 224
Reich, Wilhelm 83–6
Reilly, Paul 139
Reiss, Ignace 103
Richards, Ivor Armstrong 16
Richardson, Ralph 64
Riss, Egon 139, 153
Riss, Erwin 153
Roberts, Colin 180, 187
Robertson, Arnot 190
Robertson, Howard 16
Rogov, Vladimir 174–5

Rote Drei (Red Three) 156–7
Rote Kapelle (Red Orchestra) 156
Rothfells, Kurt, Dr. 152–3
Rothschild, Victor 5
Rothstein, Andrew 78–81, 162,
 164–7, 173–6, 224
Rothstein, Theodore 69–78,
 80–1, 164, 167
Roubiczek, Lili 23
Routh, Dennis 28
Rowntree (nee Buckley), Diana
 140–1
Rowntree, Kenneth 4, 140–1
Royal Institute of British
 Architecture (RIBA) 50
Russell, Bertrand 21, 86, 190, 220
Russell, Dick 165
Russell, Dora 21, 23, 86
Russo-Finnish War 124–6,
 129–31
Rust, William 133

Sachs, Curt 65
Sanderson, F. W. 12, 14
Schawinsky, Xanti 60
Schlemmer, Carl 46
Schlemmer, Oskar 46
Schmidt, Vera 85
Schulz, Lucia 59, 61
Second International 73, 83
Serpell, M. F. 161
Seton-Watson, Robert William 72
Shand, Phillip Morton 50–2, 61
Shar, Rosa 23
Shaw, George Bernard 204
Sieff, Israel 2–8
Siepel, Ignaz 87–8
Sieveking, Lance 116–18
Sigilla Veri 49
Simpson, Alexander (Alec) 62–3
Sirnis, Alexander 3, 69–71
Sirnis, Gertrude 68–9, 82–3, 172,
 224

Sirnis, Gerty 3, 68, 81–2, 172
Sirnis, Melita 68, 225
 (see also Norwood, Melita)
Sitwell, Osbert 42
Smedley, Agnes 158
Social Democratic Workers Party
 of Austria (SDAPO) 22, 85, 87,
 89–90
Socialist Labour Party (SLP) 71,
 76–7
Society of Friends (Quakers)
 German Emergency Committee
 153
Sorge, Richard 158, 162
Springhall, Douglas Frank (David)
 113, 133, 173–4
Stauff, Phillip 49
Stokes, Adrian Durham 4, 8,
 42–3, 58, 225
Strachey, Celia 135
Strachey, John 120, 135, 138
Stravinsky, Igor 46
Stumpf, Carl 65–6
Sullivan, Francis 145
Sullivan, Louis 15
Sweet, Cyril 40

Tawney, R. H. 108
Taylor, A. J. P. 188–92, 212–13
Taylor, Duncan Murnett
 Macrae 224
'Tea Pots' 13
The Listener 9, 94, 188
The Protocols of the Elders of Zion
 49
Theta Club 220
Third International 83
Thomas F. S. 32–3
Thomson, Basil, Sir 75, 77
Tientsin blockade 123–4
Tillett, Ben 108
Tolstoy, Leo 69
Trepper, Leopold 157

Trevelyan, Charles 204
Trevelyan, George 95
Tuckton House 68–70
Tudor-Hart, Alexander 23, 25,
 92–3
Tudor-Hart, Beatrix 21–3, 25, 92,
 224
Tudor-Hart (nee Suschitzky),
 Edith 17, 22, 23–5, 26, 92–4,
 189, 224
 (see also White, Edith) 97,
 102–3
Tudor-Hart, Jennifer 140, 219
Tyrell, William, Sir 73

Uhlmann, Fred 113
Ulbricht, Walter 134

Vallance, Aylmer 188
Vallance, Phyllis 188
Van Doesburg, Theo 59
Venesta Plywood Company 9, 10,
 14, 20, 55
Vincent, Neville 217
Vivian, Valentine 92, 135, 137–8
Von Hornbostel, Erich Moritz
 65–7
Von Luschan, Felix 66
Von Ribbentrop, Joachim 99

Wake, Lieutenant-Colonel 72
Walker, Alec 9
Walker, Kenneth 217–18
Waugh, Alec 11
Weeks, Hugh 156
Weimar Republic 19, 45
Weissenhof Estate 18, 20
Wells, Gip 13
Wells, H. G. 12, 64
White, Edith 22, 92
 (see also Tudor-Hart, Edith)
Wilkinson, Ellen 135, 188
Wilkinson, John 149

Winterbottom, Connie (Frosty)
216
Woolf, Leonard 71
Woolley, Katherine 146
Woolley, Leonard 146
Workers' Socialist Federation
(WSF) 76–7

Yorke, F. R. S. 54

Zec, Phillip 67
Zvegintzov, Michael 28